THE COMPLETE GUIDE TO
WATERCOLOR

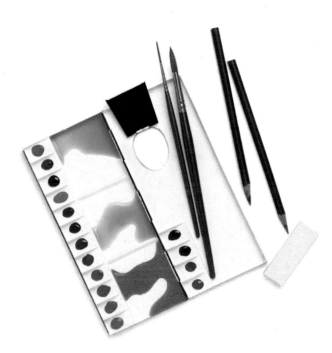

THE COMPLETE GUIDE TO
WATERCOLOR

RAY SMITH AND
ELIZABETH JANE LLOYD

DK

A DORLING KINDERSLEY BOOK

LONDON • NEW YORK • MUNICH • MELBOURNE • DELHI

IN ASSOCIATION WITH THE ROYAL ACADEMY OF ARTS

LONDON, NEW YORK,
MUNICH, MELBOURNE, DELHI

First Editions
Project editors Jane Mason, Susannah Steel, Marcus Hardy
Art editors Claire Legemah, Stefan Morris, Des Plunkett, Brian Rust
Assistant editors Joanna Warwick, Margaret Chang
Design assistant Dawn Terrey
Senior editors Gwen Edmonds, Emma Foa
Managing editor Sean Moore
Managing art editors Tina Vaughan, Toni Kay
DTP Joanna Figg-Latham, Zirrinia Austen
Production controller Helen Creeke
Photography Phil Gatwood
Additional photography by Susanna Price,
Tim Ridley, Steve Gorton, Andy Crawford

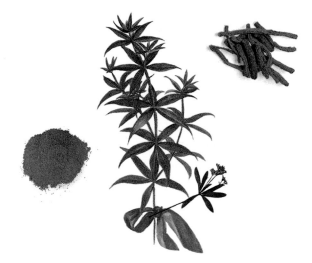

Artists' materials kindly supplied by
Winsor & Newton

First published as DK Art School/Art books: An Introduction to Watercolor © 1993;
Watercolor Color © 1993; Watercolor Landscape © 1993;
Watercolor Still Life © 1994

This edition published in 2002 as The Complete Guide to Watercolor by
DK Publishing Inc., 375 Hudson Street
New York, New York 10014

A CIP catalog record for this book is available from the Library of Congress
ISBN 0-7894-8798-5

Color reproduction by Colorscan in Singapore
Printed and bound by Toppan in China

See our complete product line at

www.dk.com

CONTENTS

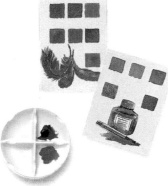

STILL LIFE

WATERCOLOR

O F ALL THE VARIOUS PAINTING MEDIA, including oils and acrylics, watercolor is by far the most convenient to work with. It has the range and adaptability for almost any kind of painting situation or style. All you need to get started is a small watercolor box, a couple of brushes, a pad of paper, and some water. When you look at a watercolor painting, you can see how it was painted, as well as getting a sense of the artist through the kinds of marks that have been made. This is because the nature of the watercolor painting method is such that almost nothing can be concealed in the painting. Unless you are using gouache paints (*see* pp.60-1), you cannot paint over something in order to conceal it, the way you can when you are painting in either oils or acrylics.

Picking up tips

What this means is that it is possible, just by looking at a painting carefully, to make a reasonably accurate guess at the means by which a particular effect was achieved. The implications of this are that anyone with a little experience and sense of how the medium works should be able to look at the watercolor paintings of artists they admire and pick up useful practical information. For this reason, each section of the book ends with a "gallery" of relevant paintings with examples of both historical and contemporary artists.

The power of transparency

What makes it possible to "read" a painting is that the watercolor medium is, above all else, a transparent painting medium. It relies for most of its effects on the fact that rays of light penetrate the watercolor paper and are reflected back to the viewer through the transparent paint film. The more the paint and the darker the washes, the less light is reflected back. In an opaque painting system, the rays of light would be reflected back off the surface of the paint itself rather than the paper, because the paint is too dense for the rays of light to penetrate. There is an opaque watercolor system based on gouache paint or bodycolor, and we shall be considering this later. There are also uses for bodycolor in largely transparent painting techniques where, for instance,

the artist may be working on an off-white or colored paper and wishes to put in a white highlight. Purist watercolor painters have tended to avoid the use of bodycolor, favoring overlaid washes of transparent color, and using the white of the paper itself for highlights.

Drawings and color washes

At its most basic, the watercolor medium provides an effective and "clean" method of applying color washes to a pencil drawing. For many artists, this is the very first stage in the development of their practical knowledge of paint and painting. It is an excellent starting point because, used in this way, watercolor is not at all intimidating and, with a little practice, the results can look extremely competent. A simple drawing can be transformed by the addition of a couple of washes of color. It is important for beginners to realize that if they start in this way and follow a few basic guidelines, they can achieve a surprising degree of expertise in a relatively short time.

Getting started

This book is designed to introduce the medium, its tools, and techniques in a way that is practical and accessible. The Brief History that follows sets watercolor painting in its historical perspective, while the many "tips" boxes give you a handle on painting technique. The most essential element in all this is that you enjoy what you are doing. Always paint the things that you want to paint, not the things you imagine you ought to paint. You will no doubt get frustrated at times – all painters do – but keep practicing or try another approach until you get it right. Remember too that the quality of your materials is important – you cannot paint a fine line if your brush does not come to a point, and thin paper will buckle if it has not been stretched. Having said all that, it is time to look at some fine historical examples of watercolors, and start painting.

Good luck!

A BRIEF HISTORY

THE FLOWERING OF WATERCOLOR PAINTING in Great Britain toward the end of the eighteenth century tends to foster the idea that this was when watercolor painting began. In fact, artists had been using water-soluble binding materials with pigments for centuries. As early as the end of the fifteenth century, Albrecht Dürer *(1471-1528)* produced a remarkable series of landscape paintings that can rightly be called watercolors. Dürer used water-soluble paints on parchment or on paper, overlaying transparent colors and using the color of the paper for the lights.

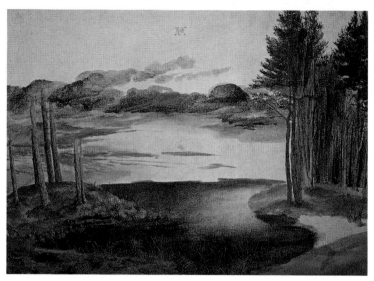

Albrecht Dürer, *Lake in the Woods,* **1495-97**
The brooding atmosphere of this famous early watercolor landscape gives it a particularly contemporary feel, with the trees on the left appearing to be blasted by war. The scene is deserted, as if not a human being is left alive.

THE SEVENTEENTH CENTURY saw a number of monochromatic drawings in pen and ink and wash, or simply in brush and wash, by such artists as Nicolas Poussin *(1594-1665)* and Claude Lorrain *(1600-82).* These studies may not be categorized technically as watercolors, yet they are very much the forerunners, in style and technique, of the work of later watercolor painters.

Toward realism

Wenceslaus Hollar *(1607-77)* was an artist from Prague who settled in England in 1636. His panoramic views of English towns and coastlines were an attempt to make faithful representations of places, rather than to create the kinds of imaginary classical landscape we associate with artists like Claude Lorrain.

Among other artists working in this way was Francis Place *(1647-1728)* who, in addition to his many panoramic works, produced a fine series of pen and wash drawings from nature – all characterized by a fluent and highly assured use of brush and wash.

The mid- to late eighteenth century saw the emergence of a number of painters who chose to concentrate on watercolor as their preferred medium. Paul Sandby *(1725-1809)* was one of the first British artists to recognize and fully exploit the potential of the medium in works that incorporated both transparent and bodycolor techniques. His architect brother Thomas *(1723-98)* was also a fine watercolor painter who had some skill in wash techniques.

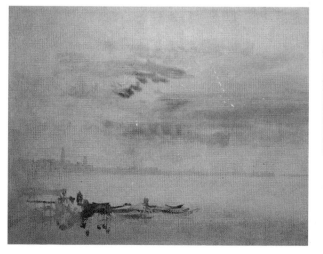

J.M.W. Turner RA, *Venice: Looking East from the Giudecca, Sunrise,* **1819**
This atmospheric study (left) is evoked with great economy of brushwork and color. The warm brown of the foreground creates a sense of distance across the lagoon.

Thomas Girtin,
Bamburgh Castle,
Northumberland,
1797-99
*This strong, fully
resolved landscape
is painted on warm
brown cartridge paper.
In order to highlight
certain details, Girtin
has used touches of
white bodycolor on
the cows and on the
gulls on the left, as
well as on areas of
the rock face.*

Alexander Cozens *(c.1717-1786)* made a number of simple, economical studies from nature. His son J.R. Cozens *(1752-1797)* made landscapes characterized by their intensity and the power of the atmosphere they generate *(center)*. They have a breadth of scale in which tiny figures and buildings are dwarfed by huge mountains or vast city walls.

By contrast, but no less striking in their effect, are the paintings of Francis Towne *(1740-1816)*, whose almost diagrammatic style is immediately recognizable for its sense of form, design, and order.

For other contemporary artists such as Thomas Gainsborough *(1727-88)*, watercolor was primarily used to give color and tone to chalk drawings. His studies, with their loose, vigorous brushstrokes, demonstrate a remarkable spontaneity of approach.

A new status

Toward the end of the eighteenth century, two of the great talents of watercolor painting emerged, J.M.W. Turner *(1775-1851) (bottom left)* and Thomas Girtin *(1775-1802) (top right)*. The quality, breadth, and directness of their work would bring a new status to the medium. It allowed watercolor paintings to be seen as works of art in their own right rather than merely as colored drawings or studies for oil paintings.

Thomas Girtin began to stretch the watercolor medium further than it had gone before. He made paintings on rough cartridge papers in order to work on a more mid-toned ground. He pared down his palette and found he could create all the effects that he needed with just a limited range of colors.

John Robert Cozens,
Chamonix and Martigny, c.1776
*The figures dwarfed by the overhanging rock
and the apparent insignificance of the fir trees
convey the immensity of scale in this vast
mountain landscape.*

John Constable RA, ***Landscape with***
Trees and a Distant Mansion, **1805**
*This is a very relaxed study with the warm
yellow browns of the trees and hedges set
against the blues of the distant landscape and
the sky. Constable liked to make direct studies
from nature. The handling here is assured,
with large, generous brushwork.*

Ahead of his time

It was J.M.W. Turner, however, who came to grips with watercolor painting as no artist had done before. Not content with mere coloring-in exercises, he constantly experimented with ways of moving the paint around and with new pigments and papers. He used color very directly, working wet-into-wet, scrubbing off, sponging, and scratching out (*see* pp.52-5).

There were many contemporaries of Turner, working both in England and in France, who made significant contributions to the art of watercolor painting. John Constable *(1776-1837)* made direct studies from the landscape in a vigorous and very immediate style, often using scraping and scratching out techniques to build up a textured effect. John Sell Cotman *(1782-1842)* produced unique paintings of a quite different order. These are carefully designed works in which flat planes of color and tone build like a jigsaw over the surface.

The landscapes of David Cox *(1783-1859)* are often turbulent or brooding in spirit. The speed of execution is visible in the large, rich brushstrokes dragged across the rough paper.

19th century developments

The mid- to late nineteenth century saw work in watercolor by a number of interesting artists in England, including Samuel Palmer *(1805-81)* *(right)* and Alfred William Hunt *(1830-96)*. In France, Camille Pissarro *(1830-1903)*, Paul Gauguin *(1848-1903)*, and Paul Cézanne *(1839-1906)* were among the artists who used the medium. Cézanne painted more than 400 watercolors and experimented with transparent effects on white paper and denser bodycolor effects on toned paper.

The diversity of movements and styles in the development of painting in the twentieth century has been reflected in the great variety of approaches to watercolor.

Camille Pissarro, *An Orchard, c.*1890
This delicate, watery study is one in which the colors are softly fused. But for all its delicacy and softness, it has great strength.

John Sell Cotman,
*Dolbadarn Castle, c.*1802
Bathed in early evening light, this quiet atmospheric work displays Cotman's characteristic sense of order and design.

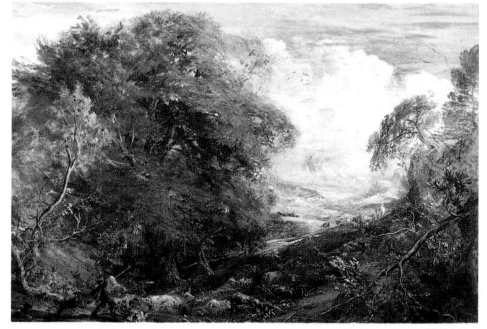

Samuel Palmer, *The Herdsman, c.*1855
Palmer's exuberant landscape is a celebration of nature, with its richly textured foliage and sense of sunlight. Using a variety of techniques,

Palmer has picked out the foreground highlights with white bodycolor, while in other areas he has scratched off the paint to get back to the white surface of the paper.

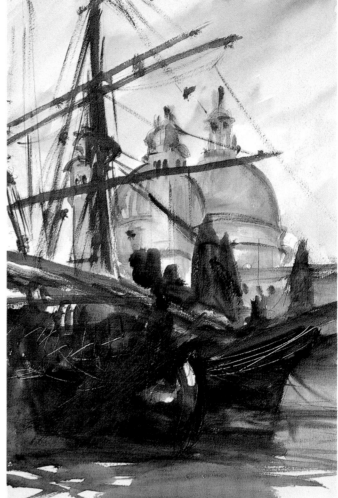

John Singer Sargent RA, *Santa Maria della Salute, Venice,* 1907-08
This is a loose and busy study by an artist who made many fluent sketches in watercolor. Here Sargent has juxtaposed elements of both color and design as the angular masts and spars of the heavily toned boats cut sharply across the pale, rounded domes in the background.

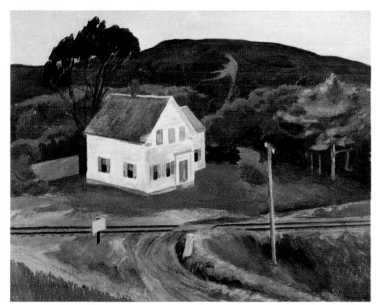

Edward Hopper, *Captain Kelly's House,* 1931
This painting shows Hopper's characteristic honesty. Nothing is concealed, and yet it remains hauntingly enigmatic.

Among the many groups of artists who were influential in reshaping attitudes to the medium were members of a Munich group, which included Wassily Kandinsky *(1866-1944),* Franz Marc *(1880-1916),* August Macke *(1887-1914),* and Paul Klee *(1879-1940) (see* p.36). Kandinsky, born in Moscow, was one of the first to develop an abstract visual language, freeing watercolor from an overly pictorial truth and allowing images to float on the paper.

Klee made many experiments with the medium, working with thin, freely applied washes and also with densely pigmented gouache on a variety of surfaces. His works often have a magical, almost childlike, quality.

Across the Atlantic, artists such as Winslow Homer *(1836-1910)* and John Singer Sargent *(1856-1925) (top right)* were developing a distinctly American style. Sargent spent most of his life in Europe, adapting the skills he had learned as a portrait painter to a broad range of subjects. He echoed some of Homer's themes while becoming increasingly interested in the interplay of light and color.

Another American to become interested in the effects of light was Edward Hopper *(1882-1967) (left).* His watercolors can seem disarmingly straightforward, but they are highly charged, demanding a response from the viewer.

One of the most impressive watercolor artists of this century was the German Emil Nolde *(1867-1956) (see* p.22). He would take his paints with him to the theater, working by feel in the dark. Like Turner a century earlier, he pushed the medium to its limits, constantly experimenting with techniques and materials. His vast body of work was a celebration of color and of form that brought a new richness to the medium.

Watercolor
MATERIALS

BEFORE YOU EMBARK upon a watercolor painting, you will need the basic equipment and materials. Painting with watercolor does not demand a complex set of accessories, but as well as the essentials – paints, brushes, water, and paper – you may want certain extras to help you achieve particular effects. By using different brushes you can make a variety of paint applications, from washes to dry bristle marks. Paper can be rough or smooth, heavy- or light-weight, ready-stretched or unstretched, so experiment with different materials until you discover what suits you – and your desired effect – best.

PAINTS

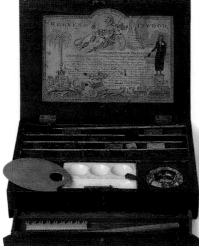

Early watercolor paint box

WATERCOLOR PAINTS ARE MADE by first mixing and then grinding powder pigments with a water-soluble binding material such as gum arabic. The pigments used to make watercolor paints are, in general, the same as those used in other types of paint, such as oils or acrylics. Gum arabic is a natural sap taken from the African acacia tree that gets its name from the species *Acacia arabica*. The type most commonly used nowadays is Kordofan gum arabic, which comes from the Sudan.

Rose Madder root

Pigments
Earth substances and animal substances form the basis of many pigments.

Terre Verte

Cochineal insects

THE GUM IS PREPARED in gum kettles as a 30 percent solution in water and subsequently mixed into a paste with the pigment. The paste is then ground on granite triple roll mills and, for tube colors, put into tubes, or, in the case of pan colors, dried off in large round cakes before being rammed through a die and extruded in strings. These are then cut to the whole- or half-pan size before being wrapped. Certain

additional materials can be added to the basic pigment/gum arabic mixture to create a stable product. These include glycerine, a syrupy liquid used in very small amounts to aid the adhesion and flexibility of the paint as well as keeping it moist. In the past, honey was often used for this

purpose. A wetting agent, such as oxgall, is used to help disperse the pigment particles. A thickener is often incorporated when the mix with gum arabic alone is too thin and requires more body. Dextrin is often used for this purpose and is occasionally used as a replacement for gum arabic when a particular pigment will not

How paint is made
The crushed pigment and gum arabic mix are left to dry as slabs of color (below) before being forced through a die and extruded as strips (below right). These are then cut into segments to form pan colors.

Slabs of dry color

Lengths of pan color

French Ultramarine

Viridian

Yellow Oxide

Cadmium Yellow

Crushed pigments
Pigments are the solid separate particles in various colors that form the basis of watercolor paints. They each have certain characteristics, differing in their strengths, in their lightfastness, and in their degree of transparency.

flow out to a flat wash with gum arabic or reacts adversely with it. Dextrin is also used as a substitute for gum arabic in cheap watercolors. It is very resoluble, and this can affect the success of certain techniques, such as overpainting.

Artists' quality

Raw Sienna

Manufacturers also tend to add a preservative to prevent the growth of mold or bacteria. There is a great art to making the best-quality watercolor paints, since each pigment will require more or less of each of the ingredients in order for a stable and workable color to be made. With pan colors, the manufacturer has to ensure that the paint does not dry out in the box but, equally, that it does not absorb too much moisture and get soggy. The difference between artists' quality watercolor paints and the cheaper lines is marked. The pigment loading in the artists' paints is so high that it is the pigment that controls the

behavior of the paint. The differences between pan and tube watercolors vary from pigment to pigment, but the main overall difference between the two is that there is more glycerine in the tube colors and this makes them a little more soluble than the pans.

The soft or moist watercolors used today are somewhat different than the early prototypes. J.M.W. Turner, for example, would have used blocks of straight pigment and gum mixes with no added moisturizer – what are now known as "hard" watercolors. Once Turner's washes had dried completely, they would have been

Tube and pan colors
Tube colors contain slightly more glycerine than do the pans, but not noticeably so. For large washes of color, tubes are the better option.

Gouache
Gouache or bodycolor is a watercolor paint that is characterized by its opacity.

easy to overpaint without disturbing the color underneath (subject to certain differences in particular pigments). Nowadays, if a color already on the painting is at fairly full strength, for example, one can find difficulty in overpainting it without redissolving it to some extent.

Paints and palettes
Saucers and paint box lids are just two of the many options for mixing paints. Painted color swatches can provide a useful point of reference.

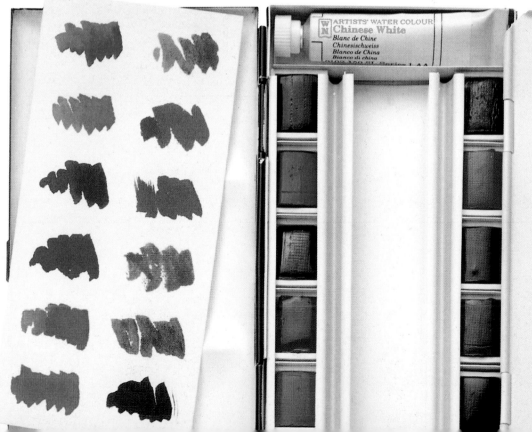

BRUSHES

THERE ARE TWO MAIN TYPES OF BRUSH: those with soft hairs, including red sable, ox hair, squirrel, and polyester brushes, and those with harder hairs, the bristle brushes. Soft hair and synthetic brushes are the more traditional in watercolor painting techniques, but bristle brushes are good for mixing up large amounts of color and also in scrubbing out exercises.

Earthenware vase for displaying brushes

THE ROUND SOFT HAIR BRUSHES, and in particular the sables, have been used to great effect in watercolor painting. They have excellent paint-carrying capacity, and they are springy and resilient. They come to a good point and can be used for fine work and also for laying in broader washes. Red sable is the tail hair of the Kolinsky, a species of mink. The soft wooly hairs are removed, and only the strong, "guard" hairs are used to make brushes. If you were to look at an individual hair through a microscope, you would see that, far from being smooth, it has a varying structure from root to tip, which allows it to retain the paint. Each hair has a "belly" – a wider section in the middle – and consequently it tapers above and below. The belly forms spaces in the brush that act as reservoirs for the paint.

The hairs are of varying lengths between 1 – 2½ in (25 – 60 mm). The long hairs are the rarest and the most prized and are around four times as expensive as the shorter ones.

Sable hairs

Ferrule

Sable brush

Anatomy of a brush
Brushes are made by hand; the lengths and quantity of the hairs are judged by eye.

The manufacturing process is all done by hand. The hair, which has previously been steamed under pressure and straightened, is put into a cannon, tapped, and combed out to remove short hairs.

The blunt "white" hairs are removed and the correct quantity taken to make an individual brush. The amount is judged by eye as just enough to fit snugly into the ferrule – the metal tube connecting the hair and the handle.

Made by hand
In the smaller sizes, the hair comes to a point naturally. In the larger sables, the hair has to be turned or twisted to form the shape of the brush. It is then tied with a clove hitch knot, trimmed, and cemented into the ferrule with epoxy resin for the larger sizes and shellac for the smaller sizes. The sable brushes are dipped into a weak gum arabic solution and individually sucked, so that they come to a point.

CARE OF YOUR BRUSH

- It is good practice always to paint with two jars of water, one for rinsing the dirty brush and the second for rinsing it again before mixing a new color. This way you will keep your brush and your colors clean. When you finish painting, wash your brushes with soap to remove all traces of paint and then rinse them thoroughly. Do not use hot water for this, as it may expand the ferrule, soften the glue, and make the hairs fall out.

- Brushes must be perfectly dry before being put away to avoid the possibility of mildew.

- You should keep your brushes clean and avoid building up deposits of paint at the ferrule, as this has the effect of splaying the brush open and ruining the point.

- You can judge a round soft-hair brush by its tip. A good one will always come to a point when dampened.

The toe (tip) of the brush *The heel of the brush*

The synthetic soft-hair brushes are generally made from polyester monofilaments, which, unlike the sable hairs, do not have a scale structure or surface irregularities. They tend to suck up the paint and also release it more quickly than the sables would. Generally, however, they are fine substitutes for sables. Manufacturers also produce brushes that combine natural and synthetic fibers in sable/polyester ranges. While they do not have the characteristic springiness of the pure sable, they still do a perfectly reasonable job.

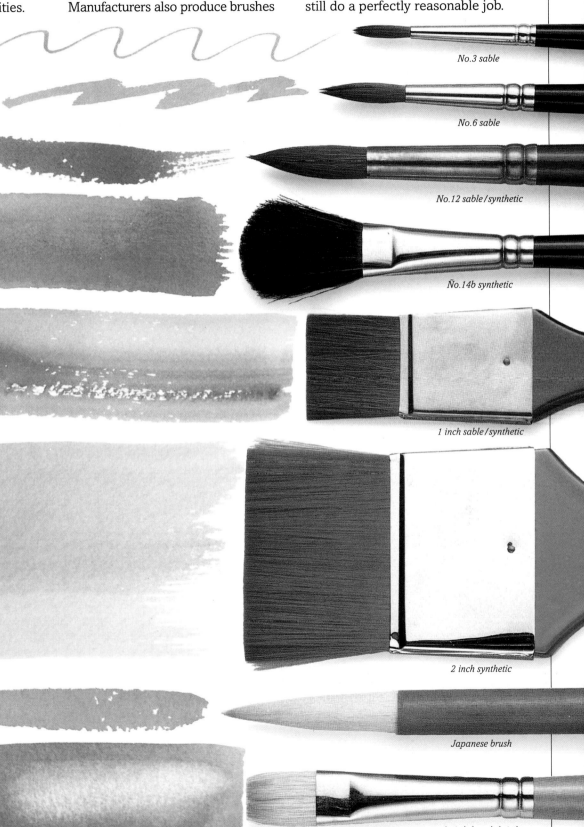

Round brushes
These come to a good point and, depending on the size, can be used for fine work or for laying in washes. The synthetic soft-hair brushes and the synthetic/sable blends are fine for most manipulations, although they are less springy than the sables.

No.3 sable

No.6 sable

No.12 sable/synthetic

Wash brush
This moplike wash brush is useful for laying down broad strokes of color over large areas.

Ño.14b synthetic

Flat wash brush
The flat one-stroke brush is good for toning paper or for laying a wash. It can also be used to modify a wash that has just been laid down.

1 inch sable/synthetic

Large wash brush
Useful for laying down very broad strokes of color, this extra-wide wash brush comes into its own when covering large expanses of paper. The synthetic fibers have good paint-holding qualities and are excellent for laying washes and controlling the flow of paint.

2 inch synthetic

Bamboo brush
Oriental soft-hair brushes are made of deer, goat, rabbit, or wolf hairs.

Japanese brush

Bristle brush
This boar's bristle brush is good for mixing up color and also for scrubbing out techniques when it can be worked into the painted area with water. The shorter bristles aid control.

Artist's boar's bristle short flat

19

BRUSHMARKS

BRUSHES CAN BE USED in a number of ways, depending on the style or approach adopted by the artist. They can be used vigorously and expressively, for instance, to create brushstrokes of great energy and immediacy, or they can be used simply as the invisible tool that allows a wash to be applied evenly within a prescribed area. Between the two lies a world of different approaches. Factors that come into play are the amount of paint in the brush, the speed of the stroke, the angle of the brush, and the type of brush being used. The nature of the paper will also play a part. These pages show the variety of brushstrokes that can be made using just one brush.

Brushmarks from a single brush
All the strokes on these pages are made with a No.9 sable.

With a well-loaded brush, gradually increase the pressure until the full width of the brush comes into play.

Using lumps of pan paint, apply them to the paper with a very wet brush.

Using the tip of the brush in a circular motion, gradually increase the pressure to use more and more of the brush hairs.

A thin line can be drawn by just using the tip of the brush.

Rotate the side of the brush in a circular motion.

Sponge the paper first, and then press the brush down firmly onto the dampened surface.

Roll a fully loaded brush on its side in complete revolutions.

The tip of the brush can draw fine dots and outlines.

THIS SIMPLE PAINTING puts into practice some of the strokes that can be made with a single brush, again using a No. 9 sable. It is all a matter of control and of getting to know the nature of the brush, the paint, and the paper.

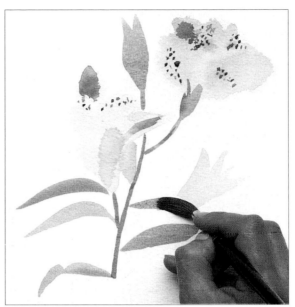

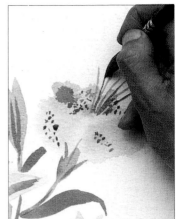

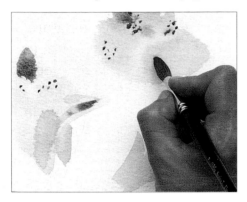

1 ▲ Wash in broad petal shapes with the body of the brush using Rose Madder and a touch of Ultramarine. Then, with a stronger mix, use the tip of the brush to dot in color. Where the petals are still wet, the dots will bleed.

2 ▲ Draw the stem in a thin line, using a mix of Rose Madder, Ultramarine, Sap Green, Viridian, Yellow Ochre, and Winsor Blue. Then, pressing harder on the brush, complete each leaf with a single brushstroke.

3 ▲ Using the finest point of the brush, draw in the filaments using Sap Green. If you are worried about being unable to control these fine lines, do a few practice lines on a rough scrap of paper before you begin, keeping your hand as steady as possible.

4 ▲ The anthers at the end of the filaments are Indian Red painted in dry brushstrokes. Applying the paint onto dry paper in this distinctive way creates a sense of depth and texture.

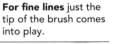

For fine lines just the tip of the brush comes into play.

To create a sense of depth, the background is painted in with a very dilute Yellow Ochre applied in broad brushstrokes.

You can make lines as fine as these with a No.9 brush by having just a touch of paint on the longest hairs.

The shadow from the vase is created by using the full body of the hairs to apply the paint both wet and dry.

The patterned surface is achieved by dipping the brush into a thick mixture of Winsor Blue and Ultramarine and then rolling the brush repeatedly on its side.

OTHER MARKS

ALTHOUGH PAINT BRUSHES are the tools that are traditionally used for applying paint and are essential for a vast range of techniques, there are nevertheless many alternative methods for applying watercolor paint onto your paper.

It is largely a matter of trying out different implements and seeing which you prefer and which get closest to the effects you are after. But you do not have to buy lots of expensive equipment – there are any number of ordinary household items that you can experiment with. Artists have used such diverse materials as pieces of cardboard, sponges, wallpaper brushes, combs, paint rollers, and even squeegees, in order to achieve interesting effects. You will need to try different dilutions of paint and various types of paper to achieve the best results.

This bamboo brush, with its mix of animal hairs, creates broad, loose brushstrokes.

Blotting paper is used here. First apply paint with a brush. Then dip an edge of torn blotting paper into wet paint, and press it down. Draw the blotting paper along to create the pattern.

Dip an old sponge in masking fluid, press it onto the paper and let it dry. Paint over it and, while the paint is still wet, lift it off with a tissue.

Dip one edge of the cardboard in some paint and drag it in vertical or horizontal strokes.

Cardboard
The gate has been painted with cardboard, while the grassy effects are the result of sponging.

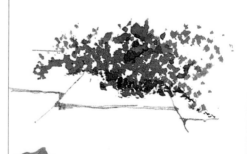

Gum eraser
Gradually build up a ball of gum. It will have a mottled, uneven texture. Dip it into some paint and press it onto your paper. Repeat the process with other colors.

Old brushes have their uses. Here a worn, splayed brush has been dipped into a pale blue-gray wash and used to paint this tree.

This tree is painted with a fine sable brush. There is more control, particularly in the trunk, than can be achieved with the splayed brush.

The rigger, with its characteristic long, fine hairs, is capable of perfectly controlled lines and so is good for more detailed work.

Dip a natural sponge in masking fluid and apply it lightly to the paper. After it has dried, paint a wash of violet over it.

Use a comb for this effect. First paint the two colors in turn and, while each is still wet, draw the comb across the paint to create the blades of grass.

Sold in most art supply stores, this small sponge roller is good for laying strips of color. The tone will vary depending on how much paint the sponge has absorbed and on how hard you press down on it.

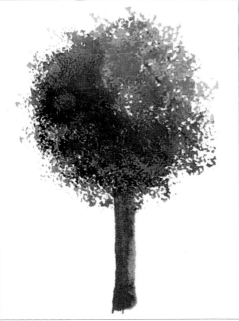

Natural sponge
The leaves are painted by dipping a sponge in light green and then dark green, and pressing it down on the paper. The irregular surface of the sponge creates interesting textures. For the trunk, dip the sponge in brown, squeeze it, and draw it down the page.

GALLERY OF BRUSHSTROKES

ONE OF THE PLEASURES of watercolor painting is that you really only need a couple of good-quality brushes to get started – a small round pointed sable for detailed work and a bigger, soft-hair round brush for washes and larger effects. Sables, with their characteristic springiness, are the traditional watercolor brush, but there are any number of excellent alternatives to choose from, including synthetic hair brushes and synthetic/sable mixes.

Julian Gregg, *Dieppe Harbor, Summer*
This study comprises a series of solid brushstrokes corresponding to areas of buildings in shadow and their reflections. Here the simple fluent line drawing was the essential starting point for the straightforward and economical brushstrokes. Gregg relied on just one or two brushes and a limited palette of colors, allowing the brushstrokes to remain clearly visible in the finished work. He built up the work swiftly and confidently, starting with the light areas and ending with the darkest reflections in the water.

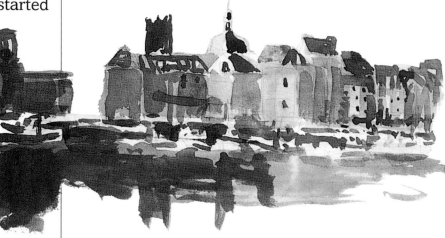

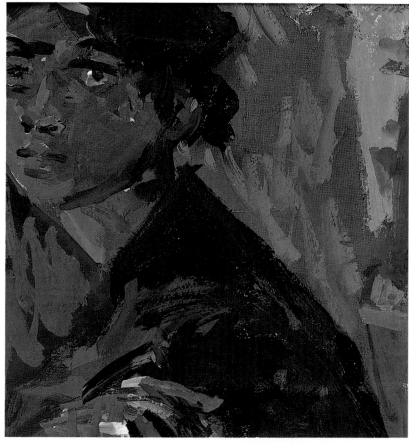

Ian Cook, *Head of a Girl*
The intense color of the highly pigmented gouache shows in the thicker, dense brushstrokes, especially in the face and neck. The brushwork here is closer in feel to that of an oil painting with its rich, impasto effect.

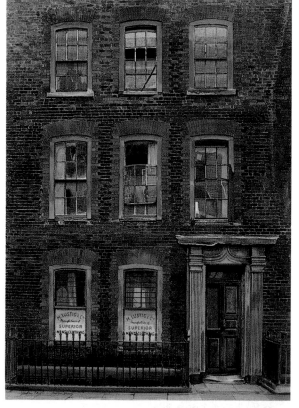

John Pike, *Number 10 Fournier Street*
The artist worked from photos, sketches, and color notes to arrive at this degree of realism. The brushwork is relatively invisible so that nothing detracts from the final image. Pike built up the painting gradually, starting with overall washes and then filling in the details with a fine brush.

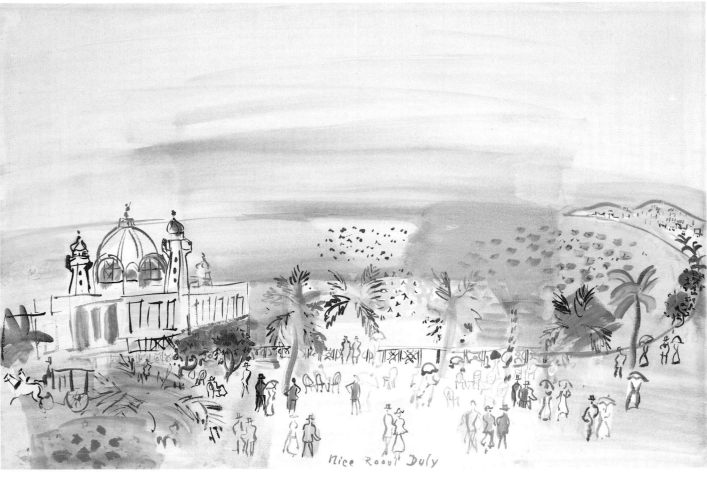

Raoul Dufy, *Nice, Le Casino*, 1936
This lovely loose study perfectly illustrates the artist's control over brushwork, with the figures, trees, and outlines of the building fluently touched in with the toe of a pointed, soft-hair brush.

These rapid and assured touches, balanced by the broader brushstrokes of some of the palm trees, are painted over sweeping washes of pinks, lilacs, and blues. The outlines of the buildings are similarly drawn in a wide range of colors.

Gisela Van Oepen, *The Sun Sets Behind the Tree*
Painted with confidence, the brushstrokes here are clearly visible, from the diagonal sweeps of the sky to the large frilly strokes used for the branches.

The bright rectangle in the lower left-hand corner of the window is light coming through from the far side of the building. Using a fine pointed brush, Pike painted carefully around this area, so that it is actually the paper, rather than any paint, that creates this bold shaft of light.

PAPER

Oriental sketchbooks
Unusual papers provide interesting textured surfaces.

WATERCOLOR ARTISTS REQUIRE paper in varying weights, of a quality that will not yellow with age, and with a range of surface types from smooth to rough. The paper should not buckle once it has been stretched and needs to be sufficiently strong to withstand rather severe treatment. Additionally, it should have the right degree of absorbency for the kind of painting the artist has in mind.

PAPER IS PRODUCED by the felting together of cellulose fibers, obtained from a variety of plant sources. In the West, most artists' papers are now produced from cotton fibers, while Oriental papers are made from a great variety of plant sources. These have fibers of varying length and strength, which impart very different characteristics to each type of paper.

The first stage of manufacturing is the pulping stage, during which the material providing the fibers is blended with water to produce a slurry. This is beaten and refined in

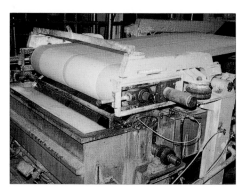

Cylinder mold machine
Here the pulped fibers are drawn over a wire mesh, arranging themselves in a random order.

order to produce fibers of the requisite quality. A neutral internal sizing is then added to the pulp. This, together with the additional surface sizing that may be added later, controls the absorbency of the paper.

Today, most watercolor papers are not made by hand but on a cylinder mold machine. From here the paper passes through a press on a woolen felt or blanket, which gives it a rough or a fine grain surface, depending on the weave used for the felt. The paper is still very wet, so it is passed through a press, and then around

Waterford Rough

Waterford NOT

Waterford Smooth

Winsor & Newton Smooth

Winsor & Newton NOT

Bockingford White NOT

Bockingford Gray NOT

Bockingford Oatmeal NOT

Mold-made paper
These are all standard machine-made watercolor papers. Note how the different surfaces affect the appearance of the paint, the blue looking much darker on the toned paper and much grainier on the Rough sheet at the back.

drying cylinders to remove the excess water. The paper is subsequently immersed in warm gelatin for surface sizing before being passed through squeeze rollers and dried. The function of the gelatin sizing is to decrease the paper's absorbency and make it harder. It allows it to withstand severe treatment such as constant repainting and scrubbing off.

Absorbency

This is determined by the amount of sizing used in the manufacture of the paper. (You can quite easily add a coat of gelatin sizing to make your paper harder and less absorbent.) A paper with no sizing is known as "Waterleaf". Many of the Oriental papers are very absorbent, taking up the brushstroke as it is made and not allowing any further manipulation.

Acidity is another factor you should consider. It is always preferable to use acid-free paper with a neutral pH. This ensures that the paper will not darken excessively with age.

Unusual papers
Oriental papers, such as the top two, are made from plant sources. Toned papers have a vegetable dye added to them.

Weight
This is measured in pounds per ream (480 sheets) or grams per square meter. Light, thin papers can be soaked through, if that is the desired effect, and can also be quite strong. Really heavy papers do not need stretching and so are ideal for vigorous painting techniques.

90 lb

140 lb

260 lb

300 lb

board

Blocks and pads
Watercolor paper can be bought in loose sheets, in spiral-bound pads, and in blocks. The blocks, which are bound on all four sides, have an advantage in that the paper does not need to be stretched before painting.

Hot-pressed or Smooth surface *NOT or Cold-pressed surface* *Rough surface*

Surface and weight

The three standard grades of surface in Western papers are Rough, HP (Hot-pressed) and NOT (Cold-pressed). Rough is just as its name suggests, a rough surface. Hot-pressed comes out very smooth, and NOT or Cold-pressed is a fine-grain or semi-rough surface – literally "not hot pressed". These categories vary enormously from one manufacturer to another, so look at several types before deciding which to buy. In terms of weight, both light and heavy papers have their advantages; it is largely a question of what you want to paint and which particular techniques you plan to use.

STRETCHING AND TONING

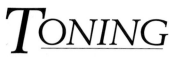

WATERCOLOR PAPER has to be stretched in advance to ensure that it does not pucker and buckle when you are painting on it but stays firm and flat on the drawing board. The procedure is quite simple: all you need is a board, masking tape, a sponge, and water. Once your paper has been stretched, you may want to tone it. Although you can buy toned paper, toning it yourself creates a somewhat different effect, since you are in fact laying a transparent color over white paper. Also, it allows you to create any color you desire.

Unstretched paper

Stretching paper

Unless you are going to use blocks of watercolor paper or very heavy paper, you should always stretch your paper before you start painting. You need to find a board that is about two inches wider than your paper on all four sides. It should be thick enough to withstand the tensions of the stretched paper without bending, and it should be slightly absorbent. Plywood, chipboard, particle board, or medium, density fiberboard make good surfaces and can be purchased cheaply from any lumber yard.

Materials for stretching

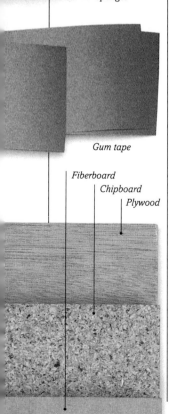

Sponges

Gum tape

Fiberboard
Chipboard
Plywood

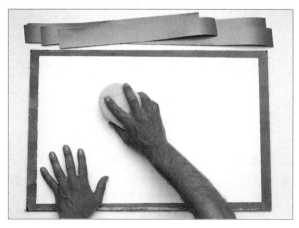

1 ▲ Start by preparing four strips of heavy-duty masking tape of the right length, one for each side of the paper, and put them to one side. Next, wet your sheet of paper thoroughly with cold water to allow the fibers to expand. Don't use hot water, as this might remove the gelatin surface sizing of the paper.

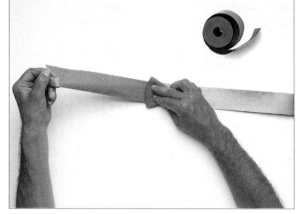

2 ▲ Make sure the whole sheet is uniformly damp. You can wet the paper with a sponge or immerse it in a bath of cold water for a few minutes, depending on the thickness of the paper. Once the paper has expanded, moisten your lengths of gum tape with a sponge. If they are too wet, they will not stick properly.

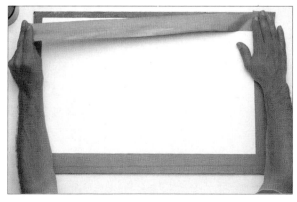

3 ▲ When your paper is thoroughly wetted, put it on the drawing board, smooth it out, and sponge off any excess water. Next, take the gum tape and stick the paper down firmly around the edges.

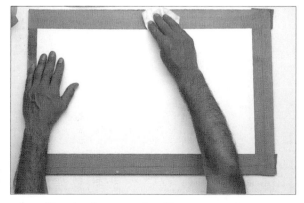

4 ▲ Now let the paper dry. You can speed up the process using a hair dryer on a low setting if you wish. When the water evaporates, the paper fibers contract, and the paper becomes hard and flat.

Toning paper

Most watercolor paper is white. While this suits those techniques that rely on the brightness of the ground to reflect light back through the color, the history of watercolor painting is full of works created on paper of widely varying tones. There are several advantages to toning paper yourself – it allows you to experiment with a wide range of different-colored grounds for your painting. Also, simple studies will look quite finished, with the color of the paper serving to unify the whole. One difficulty, however, is the problem of re-solubility – if you tone your paper with watercolor paint, you risk dislodging the color when you paint on it. Using well-diluted acrylic paints for toning will eliminate this risk.

Materials for toning

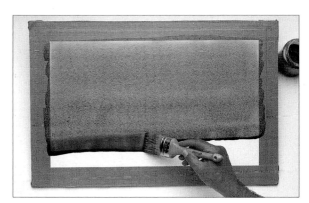

Acrylic paint

1½ inch wash brush

1 ▲ Mix up sufficient paint – in this case well-diluted acrylics – to cover the whole sheet. Apply the mix using a large brush with the board at a slight angle to the horizontal. Pick up any drips with each successive brushstroke. The secret to toning paper evenly is to work quickly, making smooth horizontal brushstrokes.

2 ▲ Be sure to let your paper dry thoroughly before painting on it. The reason for using acrylics rather than watercolors for toning is that there is a slight danger that a watercolor base might dissolve when you paint over it. Acrylic paint will not be re-soluble after it has dried, so it will be fine to paint on.

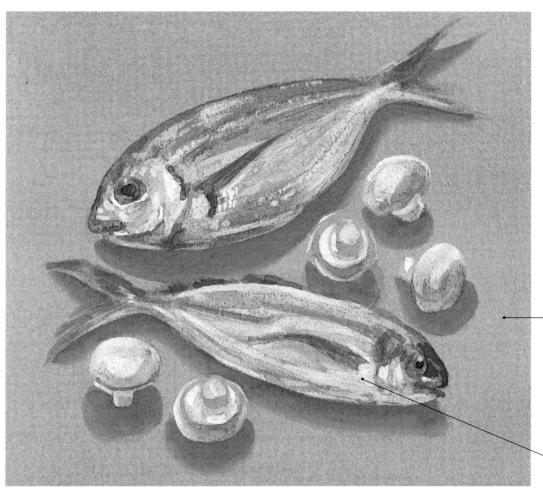

Painting on toned paper
Although sketchy, the still life has quite a finished appearance because of the colored background. The artist has painted on the blue acrylic toned paper, using watercolors for the darker areas and white gouache for the highlights.

See how much lighter the background is once the paint has dried. You will need to allow for this when you tone paper yourself, whether you are using a watercolor base or an acrylic one.

The use of gouache for the highlights on the two fish and on the mushrooms is particularly effective. Pale watercolors would be lost against the strength of the background.

GALLERY OF PAPER

T HE WAY YOUR WATERCOLOR PAINTING
looks depends as much on the
paper you use as on the way that you
paint. A weakly sized absorbent paper
will give a completely different look
than will the same manipulation
applied to a hard, surface-sized
paper. The texture of the paper will
similarly affect the appearance of
the paint, with a rough surface
giving a more textured look than
that achieved with a smooth, hot-
pressed surface, because the heavier
pigments settle into the hollows of the
paper. Another factor to consider is the
color of the paper. The use of toned paper
opens up a whole range of possibilities,
including the use of bodycolor for
highlights and a more low-key approach.

Although the paper is made by hand, there is nevertheless a regularity to the pattern that shows in the finished image.

The texture of the paper absorbs some of the paint and encourages a certain degree of bleeding of colors.

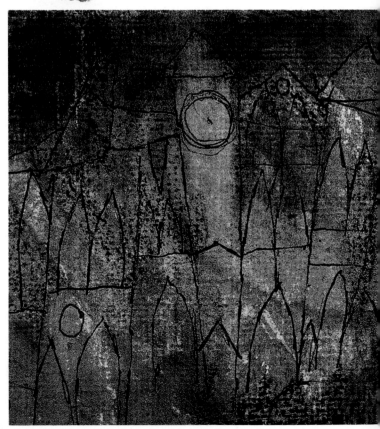

Jane Gifford,
Gathering Weed on Nagin Lake
*Painted on rough handmade Indian paper,
the water in this Kashmiri scene appears
slightly choppier than that in the similar
study on the right.*

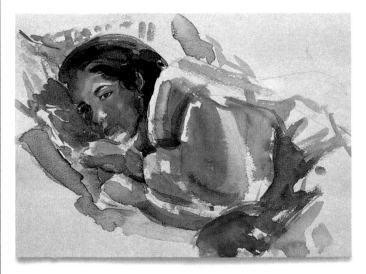

Sharon Finmark, *Portrait of Lia*
*Many watercolor painters who enjoy the traditional transparent use
of the medium tend to avoid toned paper, believing that it will adversely
affect the appearance of the color. But, as with this sensitive study, the
buff-toned paper actually creates a subtler and more effective backdrop
than would a white ground. So in the areas that have been left
unpainted, both to frame the girl and to act as highlights, it is the
warmth of the paper that serves to harmonize and unify the whole.*

Paul Klee, *Das Schloss, c.1925*
*Throughout his life, Paul Klee was fascinated by the materials and
techniques of painting, and his work reflects that interest. His constant
experimentation with watercolors made him acutely sensitive to the
innate quality of each new color and to the texture of a particular*

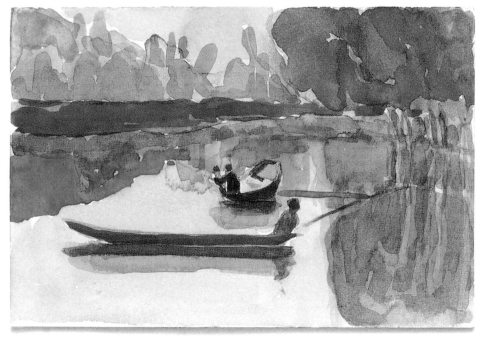

Jane Gifford, *Two Shikaras on Nagin Lake*

This sketch, done on location in Kashmir, seems altogether more peaceful than the one on the left. Gifford uses the smooth surface of the paper to emphasize both the clearness of the sky and the glasslike quality of the water as the boats glide along its surface.

Here the unsized paper dictates the nature of the painting, creating a typically Chinese effect. The washes of paint are absorbed immediately into the paper, but even the ink lines, applied lightly with a fine drawing nib, bleed the moment the ink touches the paper.

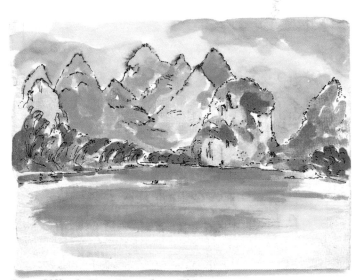

Jane Gifford, *Near Yangshuo, China*

An absorbent paper can give a softer, more diffused look than can a hard, surface-sized paper. This Chinese handmade paper automatically creates a Chinese-style painting. The quality of the paper prevents techniques such as washing off or masking.

piece of paper. It was factors such as these that led to the unique quality of his vision and his painting. Absolutely integral to the feel of this image is the heavy laid texture of the paper. The paint settles in its hollows and the scene is given a rough, grainy feel. The strong, scratchy ink line is the web holding this image together.

WATERCOLOR TECHNIQUES

THE BEST WAY TO UNDERSTAND the medium of watercolor is to experiment with a variety of techniques. As a novice, your painting technique will probably be led mainly by conscious decisions, but as you gain confidence and become more familiar with your tools, you will find the process becomes more instinctive. As your style develops, the results should be spontaneous, and the majority of techniques lend themselves well to this effect. But before you undertake to paint a picture, take a little time to practice washes, building up layers, scratching out, resist techniques, and all the other methods of application described in this section of the book.

WAYS OF WORKING

IT IS USEFUL TO HAVE a certain amount of knowledge about the tools and materials of watercolor because this allows you to make appropriate decisions about which colors to use, for example, or which type of paper would be best in a given situation. But far more than this, you need to practice working with watercolor so that you get a real feel for the medium, rather than just understanding it intellectually.

Two basic brushes

An image made with a cow gum eraser

Gaining confidence

Essentially, the art of watercolor painting is about developing an ability to allow the paint to do its own thing while at the same time remaining in control of the process. Gradually you will start to recognize what is going on in your painting and will respond to it instinctively. What begins as a somewhat self-conscious process, as you attempt to make the right decisions about your painting – what colors to use, the degree of dilution, the type of brush, and so on – ends up becoming a much more intuitive one. You will start to recognize what your painting needs at any given moment without necessarily having to think about it. And with experience you will know both what particular colors or techniques are called for and also be able to put that knowledge into practice.

Softening details with a natural sponge

Controlling the medium

At its most complex, the watercolor medium can be extremely testing because it relies on such a high degree of control. It involves control over the amount and density of paint in the brush; control over how the brush applies the paint to the wet or dry surface of the painting; and control in modifying and moving the paint around on that surface. Many of the techniques associated with watercolor require the rapid and spontaneous application of color, and in some instances there is only one

opportunity to get it right, if the whole thing is not to be washed off under cold water and begun again. But it also provides opportunities for artists who wish to create complex works involving, for example, building up layer on layer of thin washes of color using small and precise brushstrokes. In addition, there are a number of specialist techniques such as "stopping out" (*see* pp.56-7) and "wax resist" (*see* pp.58-9), in which different materials and skills are used in a painting to retain the original color of the paper or of a previous wash.

Masking fluid and a dip pen

A simple process

In general, however, the materials and techniques of watercolor are straightforward. For the most part, for all their manipulations, both beginner and professional are simply using watercolor paints mixed with water. Most techniques are variations on a basic repertoire that involves the laying of washes, working wet-into-wet, and painting in layers. In the next section of our *Introduction to Watercolor,* we look at these various ways of working, starting with the basics of pencil sketches, drawing and composition, and moving on to the application of washes, the building up of color in layers, and the more advanced techniques of resist (*see* pp.56-9) and s'graffito (*see* pp.54-5).

Crumpled paper towel

Natural sponge

Cow gum eraser

Toothbrush

Scalpel

Reaping the benefits

It may take time and practice to learn these skills so that the paint does what you want it to do and expect it to do, but the medium is rewarding right from the start. You will soon discover that watercolors can provide a satisfying and versatile challenge, as much to the beginner as to the more advanced artist.

Sandpapered surface

CAPTURING AN IMAGE

APART FROM MAKING PENCIL SKETCHES, artists today have a range of mechanical devices with which to record a scene, from simple drawing frames to cameras, camcorders, or slide projectors. Artists can project slides onto a screen and trace them or color-copy photographs, enlarging those areas that interest them the most.

Zoom lenses
Many cameras now have zoom facilities or wide-angle lenses so that you can get very close to a scene or record a much wider area, depending on what you want to record.

Drawing frame
You can use a drawing frame as a viewfinder, dividing the scene in front of you into manageable sections and then copying the grid onto a sheet of paper to guide you. You can make your own drawing frame by outlining a grid on a sheet of acetate.

Masking out
There may be details in your photo that you wish to exclude, in which case the simplest method is to mask them out. Here the artist wants to focus on the two girls with the rabbit, so she has "framed" the area she is interested in.

Here the artist has masked out superfluous details on the photo.

Color photocopies
The advantage of working from a photograph is that you can make a color copy of your print and then enlarge it (or a section of it) without losing quality. The larger of the two copies below has been blown up to 400 percent.

Tracing paper
If you lack the confidence to draw your image freehand, you can trace it from a photo. To tranfer it to your paper, copy the lines onto the back of the tracing paper, place it on your sheet and rub over the pencil lines.

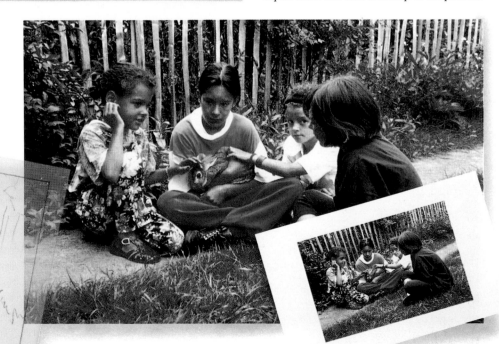

THERE ARE NO RULES about how you should start your painting. If you feel sufficiently confident, you can do a pencil drawing directly on your sheet of paper, or even start painting immediately. But if you prefer to work from a photograph, or even to trace an image on your paper before you start, that is also fine. For centuries, artists have used whatever aids were at their disposal. Albrecht Dürer *(1471-1528)* illustrated a framed grid as a drawing device, and Vincent Van Gogh *(1853-90)* had a portable grid made up for him by a blacksmith. Today, with all the technological advances that have been made, there are even more tools to play with.

VIDEO CAMERAS

Artists of today can use home video cameras to record scenes they might wish to paint later. Often the camera lens sees more clearly than the eye, having the facility to take close-ups and focus in on the smallest details. Depending on the type of camera, video tapes can then be projected onto a screen or run through a television. Either way, it is generally possible to freeze-frame a scene and then trace or copy it onto a sheet of paper. You can then enlarge or reduce your image by using the grid method outlined below.

The grid method
This is the means of transferring an image onto your paper. You can either draw a grid of squares on your original or on a sheet of acetate that you place over your original. You then draw an identical grid on your sheet of paper, although it may be considerably larger if you want to scale the image up. You can then refer to the grid on the original and plot the outlines square by square on your paper.

Ruler and pencil

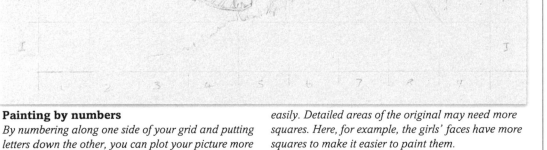

Painting by numbers
By numbering along one side of your grid and putting letters down the other, you can plot your picture more easily. Detailed areas of the original may need more squares. Here, for example, the girls' faces have more squares to make it easier to paint them.

COMPOSITION

KNOWING HOW BEST TO COMPOSE your painting is often surprisingly difficult, but there are some guidelines that are worth following. The position of the horizon line is critical. Looking down from a high vantage point will give you a high horizon line, and consequently you will be able to map out the whole landscape or seascape like a

THE POSITIONING OF the main features of your composition does not have to follow a particular pattern, but artists generally try to achieve a sense of balance. This can be done intuitively – if it feels right, it probably is right. Such a balance can emerge from the fact that tones are deeper in the foreground and become

Sketching in pencil

A vast panorama
Here the artist wanted to capture the vastness of the scene in front of her. The focal point of the hilltop village is slightly off-center, and the rooftops lead the viewer in a meandering line, from foreground to background.

carpet on your painting. A low horizon line, which allows you to look up at the scene in front of you, gives you an opportunity to make the most of the sky. It also means that large objects in the foreground will have the effect of towering above you. It is best to place points of visual interest slightly off-center and to avoid placing the horizon line right through the middle of the painting.

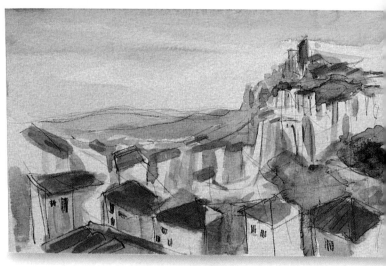

progressively lighter toward the horizon. Or the sense of balance might be due to the relative weight of certain features in the painting. For example, an artist might feel that the massive shape of a tree on the left needs to be balanced by something on the right.

Focal point

An alternative composition would be to place a large object, such as a tree, on a point off-center to the right or left, planted low but extending almost to the top edge. This would provide a focus or a pivot from which the rest of the composition would flow. Try looking at the painting and altering the edges with pieces of thick paper so that the tree is right in the center – you will see how much less subtle it is.

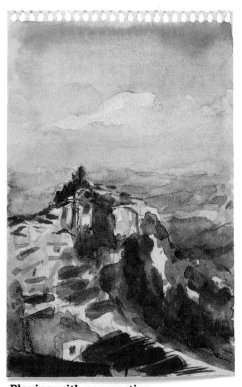

Playing with perspective
It is generally best to avoid placing the horizon line right through the middle of your painting. In the example above, the sky detracts from the points of interest; the low vantage point in the view on the right is far more dramatic.

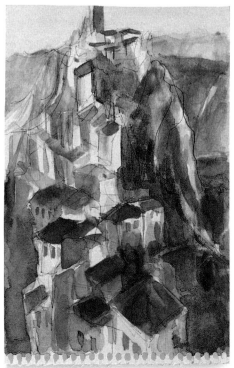

OPEN AND CLOSED COMPOSITIONS

In an open composition, the scene that you see is clearly part of a larger scene, while in a closed one what you see is all there is, like looking at a fish tank. Most compositions have elements of both. The important thing is not to let a key element of your composition slide off the page.

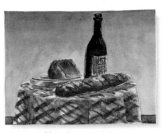

Closed composition

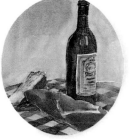

Open composition

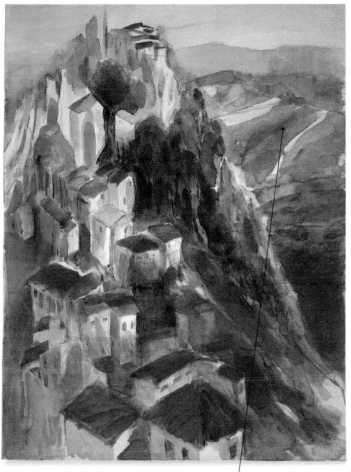

The final painting

The artist selected this view for her finished painting, opting for the high horizon line to capture the sense of the village reaching heavenward. There is virtually no sky, and we are drawn up and down the scene in an upside-down "V" shape as we follow the line of the rooftops up and the trees back down again.

Here note both a visual harmony in the balance of shapes and forms and a color harmony in the balance of reds to greens. The background hills provide a resting point for the eye.

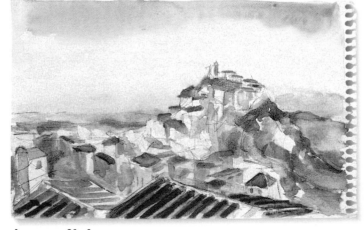

A sense of balance

In this composition, the artist has placed the focal point of the village slightly to the right of center, with the horizon line in the middle of the page. Although a centered horizon is something that should generally be avoided, it is not oppressive in this case because of the lightness of the sky. The viewer is led from the distant building on the summit of the hill, across the rooftops to the left of the page, and then on toward the nearest roof on the right. We are poised above the roof, looking out. The artist has achieved a sense of balance in the colors she has chosen, as well as with the positioning of the scene.

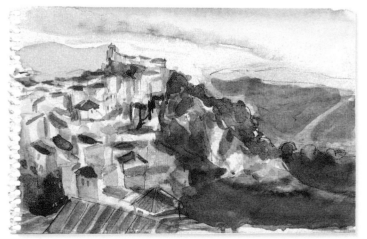

Shifting to the left

Here the points of interest are on the left-hand side of the painting. The horizon line has been moved up, so the sense of perspective is somewhat distorted as we look both down on the foreground buildings and up at the ones in the distance. The sun-drenched hills on the right tend to be more of a distraction than a harmonious counterpoint to the village.

DRAWING

DRAWING AND SKETCHING are an integral part of watercolor painting. Armed with just a sketchbook and a pencil, you can record the main features of a picture swiftly, or in greater detail. You can make notes about the particular colors and tones if you are going to translate your sketch into a painting later. Whatever your chosen method, making initial drawings gives you the space to reflect on what the focus of your painting should be and will tell you fairly quickly if something is going to work well as a final composition.

Conté crayon
Available in varying degrees of hardness, conté crayon comes in a range of colors, including black, white, and red. Less powdery than chalk, it still needs fixing before a wash is applied. Fixatives come in spray cans.

Charcoal
One of the oldest drawing materials, charcoal is very powdery and must be sprayed with a fixative to prevent it from smudging or mixing with the overlaid watercolor – unless this happens to be the desired effect.

Smooth paper

Rough paper

Conté crayon

Charcoal

Pencil

Graphite stick

Reed pen and ink

Drawing materials
The tool that you choose to work with depends on your subject matter, on the effects that you want to achieve, and on personal preference. Pencil is easy to erase if you make a mistake, while graphite sticks, which are in essence fat pencil leads, are better for shading. In these examples, the marks have been drawn on the paper and then overlaid with the wash. Note the different effects on the two surfaces and also how the charcoal has mingled with the paint. Still other effects occur if you dampen the surface first.

A PENCIL DRAWING can serve a variety of purposes, and different kinds of pencil are appropriate in each case. The traditional sketching pencil has a soft, fat lead that is good for tonal studies, but if you are making an essentially linear drawing you might prefer a clutch pencil with a relatively thin (.5 mm) lead no softer than about a B. Artists soon develop their own way of making drawings, but if you are not used to making pencil sketches, practice by making drawings of some small, simple objects. Before you begin, try to see the outline of the whole thing and then look to see how various lines and curves within the overall shape define the kind of object it is. It is best to start on a small scale before embarking on a larger picture.

Pencil drawing

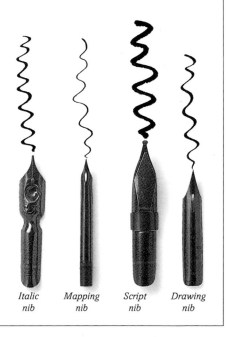

Pencil and wash

Pencil sketch
The artist did several sketches of her cat before settling on this particular pose. She tried it from different angles and with certain background details and decided that this simple study from a slightly raised perspective was the most successful.

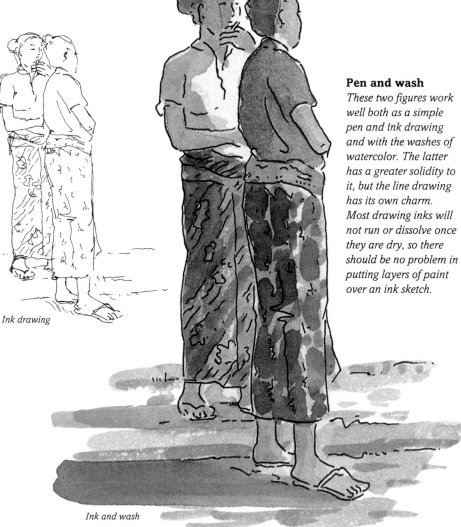

Ink drawing

Ink and wash

Pen and wash
These two figures work well both as a simple pen and ink drawing and with the washes of watercolor. The latter has a greater solidity to it, but the line drawing has its own charm. Most drawing inks will not run or dissolve once they are dry, so there should be no problem in putting layers of paint over an ink sketch.

DRAWING NIBS

There are many types of steel nibs that you can use for drawing – it is largely a matter of personal preference. There are the standard drawing nibs and then the script pen nibs, which can also be used. These come in a variety of widths, with or without reservoirs. They all have a springiness in the steel that allows the artist to vary the width and the quality of the line while drawing. Mapping nibs are good for very fine lines, while italic nibs can be either fine or broad.

Italic nib *Mapping nib* *Script nib* *Drawing nib*

41

LAYING A WASH

A WASH IS A THIN LAYER of watercolor paint, usually applied with a saturated brush over a fairly large area. It can be applied onto dry or damp paper, or it can be overlaid onto dry color already on the paper.

The wash can be manipulated wet, so that particular areas can be lifted and lightened, or other colors can be dropped into it while it is still wet. Alternatively, the wash can be adapted in various ways when it is dry.

How to lay a flat wash

1 ◄ Mix up enough paint before you begin and make sure it is well stirred. You will not be able to stop halfway through to mix more. It is a good idea to use a bristle brush for mixing the paint, as this will break it down more easily. Then for applying the wash, use a soft-hair brush; either round or flat is fine.

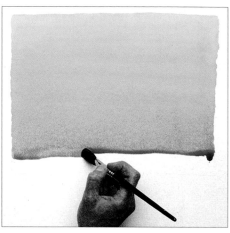

2 ▶ With a saturated wash brush, keep a continuous line of wet color forming along the bottom edge. You may find it easier if the paper is at a slight angle. It is also easier to apply a flat, uniform wash onto a NOT or Rough surface than onto a smooth one, since the smooth surface will show up any streaks.

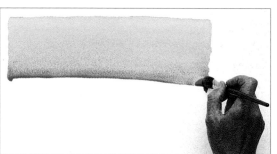

3 ▲ Pick up the paint with each succeeding stroke. Try to avoid any trickles, and apply the paint in a smooth, continuous motion. You can work left to right or in both directions.

Flat wash
This doorway has been created with washes of flat color, in this case a very dilute mix of Cobalt Blue and Permanent Rose. Note the granulation of the pigment on the NOT (semi-rough) surface.

**Graded
one-color wash**
A graded wash is one in which the tone moves smoothly from dark to light. Mixing a light, a mid, and a dark tone of orange in separate saucers, apply the darkest tone first and proceed down the sheet.

Laying a variegated wash

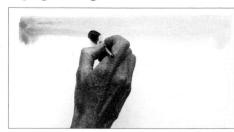

1 ▲ To help the wash flow out, you can wet the area to be painted first, with a sponge or a brush. Then with a soft-hair wash brush, either round or flat, apply your wash of Winsor Blue to the paper.

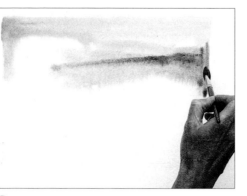

2 ▲ Remember to wash out your brush between colors. Then, starting at the right-hand side, wash in some Violet, touching the Blue in parts and allowing the Violet to diffuse across the page.

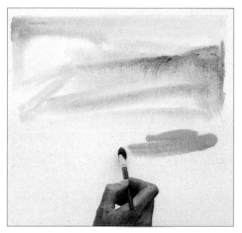

3 ▲ Working quite quickly, apply some brushstrokes of Lemon Yellow onto the wet surface, in the right-hand corner.

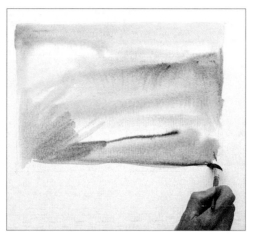

TIPS

● Mix up enough paint before you begin, and make sure the mixture remains well stirred, since many pigments have a tendency to settle in the saucer.

● It is a good idea to mix your wash color with a different brush than the one with which you apply it. A bristle brush is best if you are mixing a fair amount of paint from a tube, as you can break the paint down into a well-diluted mix more easily than with a soft-hair brush.

● Many artists like to work with their paper at an angle when applying washes, as this allows them to control the flow of the paint more easily.

● To achieve a more uniform tone, you can dampen your paper before you apply your wash.

● Remember that a watercolor wash dries lighter in tone than it appears when you paint it on, so you should compensate for this in your mix.

4 ◄ Here some areas of Carmine are added at the bottom. All the paints have been applied very wet, and the board has been moved around to allow the colors to flow in specific directions. Note how the different pigments react with each other and also with the surface of the paper.

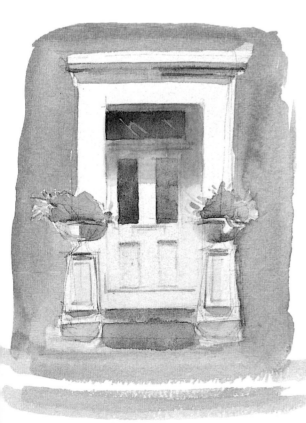

Graded two-color wash

Running one tone into another can be done with two or more colors. Mix sufficient quantities of the colors you require and apply them swiftly, allowing them to mingle and diffuse if you wish.

Variegated wash

To wash several colors over areas of your painting, pre-mix the colors and then paint them rapidly up to the boundary of the neighboring color. The colors will then diffuse into each other along the join.

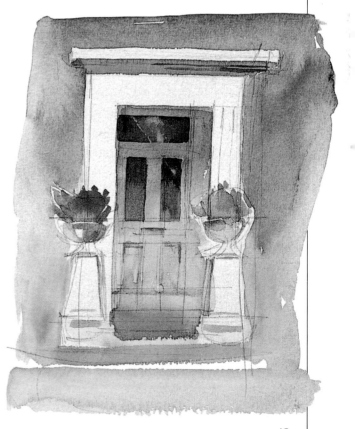

WASHES

WASHES WILL VARY depending on the pigments used, on how they are applied, and also on the quality of the paper. For example, on smooth paper there is a tendency for washes to appear streaky, while on a rough surface they may not penetrate the hollows of the paper. But washes can also be modified while they are still wet. Shapes can be sponged out of a wash, clean water can be dripped into them, or additional colors can be dropped in.

Smooth paper
The colors in the two studies are the same but appear deeper and more vibrant on the smooth paper. Washes should be applied in a continuous, even movement when a smooth paper is used.

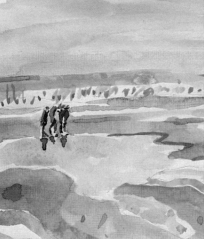

Rough paper
On Rough paper your brushstroke needs to be slower and firmer to ensure that the paint runs into the hollows. In this example, the Rough surface has created a sparkle effect.

Washing off
Sometimes a wash is not successful or the painting has become too dense with pigment to successfully overlay another color. If this happens, you can wash the whole thing off. You should use cold water to avoid removing the surface sizing on the paper. Very often a washed-off painting can look far better than it did before. It may only require minor adjustments to be complete.

The essential feature of a washed-off painting is that the texture of the paper is revealed more clearly since the process takes off the top surface. That is, the raised parts of a Rough or NOT surface will be left pale, while the pigment remains lodged in the deeper crevices of the paper. Washing off removes only part of a color. Once it is lodged in the fibers of the paper, watercolor is very tenacious. Some pigments have more staining power than others, but most resist the effect of washing off to some degree.

Washing off and overlaying a second wash

Pink wash

1 ▲ Using a Rough paper, paint a blue wash over a section of it.

2 ▲ Wash the blue off under cold water, using a bristle brush to help dislodge the paint.

3 ▲ Paint a layer of pink over the washed-off blue. You will produce a grainy purple.

TIPS

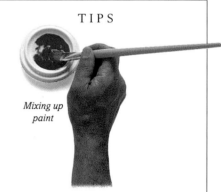

Mixing up paint

● Use a bristle brush to mix up the paint, but use a soft-hair wash brush, either flat or round, to lay the wash. Make sure you mix up enough paint before you start, as you cannot pause to mix up more while you are in the middle of laying the wash.

● Smooth paper will show up any streaks that have been created by (a) not having stirred up the paint well enough, (b) taking too long to apply it, or (c) pushing down too hard with the brush.

● Rough paper will have a sparkle effect in which spots of white paper show through the wash. If you wish to avoid this, you may need to work back and forth over the same area several times to ensure that the paint gets into the dips in the surface.

Wash techniques

Although we tend to think of washes as applications of paint that cover large areas of a painting, the technique is equally suitable for smaller areas. For these you simply use smaller versions of the same brushes, in particular, the small round sables. The following swatches are just a few examples of what you can do with washes of color. Some use the tip of the brush, others the toe, and still others involve two brushes being used simultaneously. The possibilities are endless.

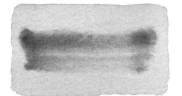

A thick application of Permanent Rose is dragged rapidly across a wet wash of Winsor Blue on a flat 1 inch brush.

The toe of a small, round, nylon brush with Permanent Rose is curled swiftly into the Winsor Blue wash to create this suffused vapor trail effect.

Two drops of Permanent Rose are dripped into the watery Winsor Blue wash and allowed to spread outward.

Using a medium-size, round, soft-hair brush, Permanent Rose is worked rapidly around the edge of this Winsor Blue wash.

A band of Manganese Blue and one of Winsor Green are allowed to fuse together. The granulated Manganese Blue wash contrasts with the more even green one.

Curling a dark tone of Winsor Green into the granulated Manganese Blue wash gives a very different effect.

Working simultaneously with two No.8 round brushes, fully charged with dense pigment, can give these rich effects.

After the Manganese Blue wash has been applied, the Winsor Green is scrubbed into the paper with a bristle brush.

Two colors have been applied onto a flat 1¼ inch wash brush before being dragged quickly across the paper.

Separate blocks of Violet and Rose have been applied and allowed to dry before being joined by using a clean, damp brush.

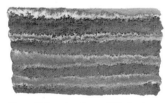

One thin stroke of Violet is followed rapidly by another thin stroke of Winsor Green, to create this layered effect.

The areas of Winsor Green and of Violet are allowed to run together to create this densely textured, yet fluffy effect.

APPLYING A WASH WITH A SPONGE

There are a number of ways of applying washes, from the traditional wash brush, for standard techniques, to small round brushes, for more confined areas, to household wallpaper brushes, for very large areas. Some artists, however, like to work with sponges because it allows them to cover large areas more rapidly and effectively. Try laying a wash with several types of sponges to see which you prefer.

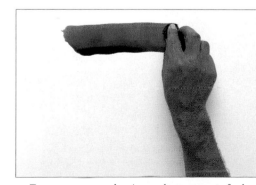

1 To sponge on a wash, mix up a large amount of color and soak your sponge in it. A small natural sponge is best, but you can use a household sponge for larger areas.

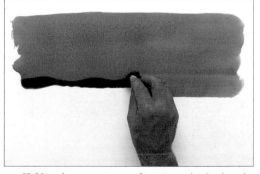

2 Holding the sponge in your fingertips, rub it back and forth, catching the drips as you go. The technique is to work downward as if you were washing a window.

GALLERY OF WASHES

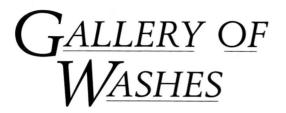

SUCCESSFUL WATERCOLOR PAINTINGS depend, to a large extent, on the application of washes. Learning to lay washes is a skill that has to be acquired through practice, as it involves an understanding of the amount of paint required to be held in the brush, the degree of dilution of the paint, the nature and angle of the surface being painted, and the appropriate choice and handling of the brush itself. Washes can be free-flowing over a large area, with color blending into color and with variations of tone, or they can be tightly controlled in small or irregular shaped areas. In addition, they can be manipulated wet, so that particular areas can be lifted and lightened or altered by having additional colors dropped in.

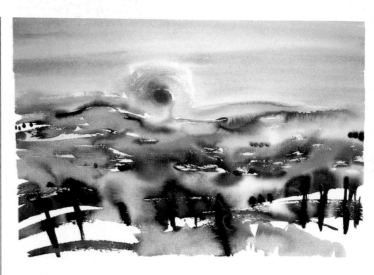

Gisela Van Oepen, *Pays de l'Aude*
This painting clearly demonstrates the effect of working into very wet areas with dense color. This can be done either by laying a clear wash over chosen areas and then dropping in the deep colors or by applying color first and dropping in water or additional colors afterward.

Miles E. Cotman, *A Calm, c.*1840-49
This peaceful scene demonstrates great control in the application of washes. Notice how the uniformity of tone in the wash for the sky is sustained right up to the edges of the clouds. There are no dramatic sweeps of the brush – just the kind of consummate skill that allows the image to speak for itself.

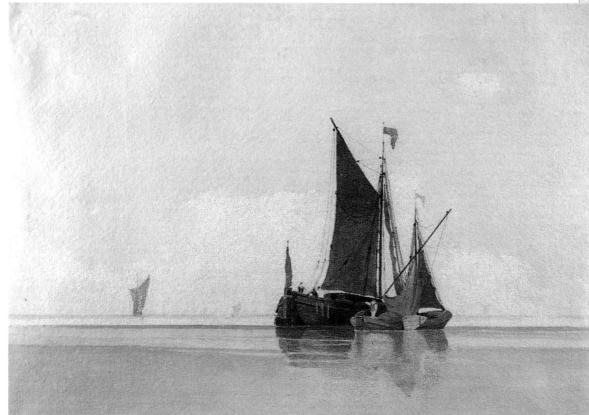

Two washes of color, carefully controlled, are all Cotman needed to realize this sailing vessel in the distance.

**Jane Gifford,
*Street Scene,
Madras***

In this simple yet effective study, the artist has carefully applied her washes in a form of "patchwork" to indicate the broad masses of color on the scene. She has allowed the washes to move around freely in areas where it is appropriate to the subject to do so, as on the dome.

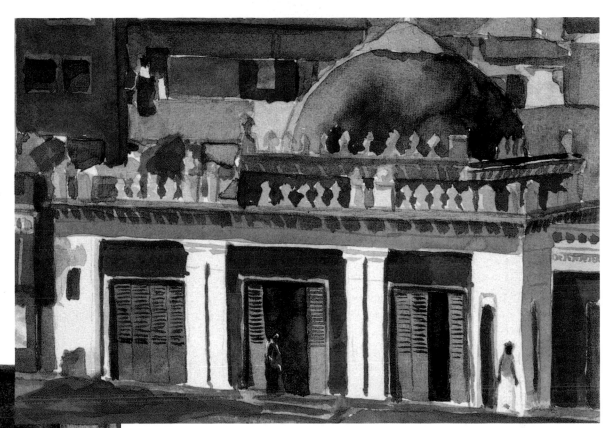

The deep blue wash of the entrance draws the viewer into the center of the painting and forms a striking counterpoint to the surrounding areas.

A couple of broad, loose brushstrokes is all that is needed to suggest this woman in her radiant sari, framed by the darkness of the doorway.

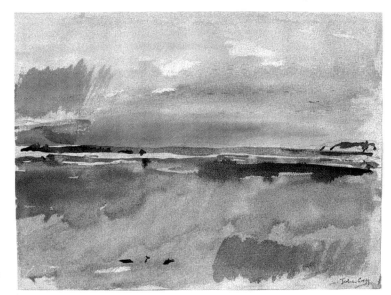
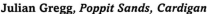

Julian Gregg, *Poppit Sands, Cardigan*
In this loosely worked sketch, there is practically no overpainting, and areas of the paper are left untouched. The artist has applied simple washes along the horizontal axis, allowing colors to bleed into one another wet-in-wet while relying on single, sweeping brushstrokes along the horizon.

Robert Tilling, *Low Tide Light*
Using broad wash brushes, Tilling lays large areas of very wet color across his paper, skillfully controlling the paint. Here the washes are swept across the painting, softening in tone in particular areas to create the effect of the light. Certain colors are allowed to bleed into the next to create an evocative sense of space and mood.

TONE AND COLOR

AFTER LEARNING TO LAY WASHES, the next stage is to practice building up tone and color. The easiest way to approach this is to work initially in tones of one color. In the past, it was quite common for artists to paint monochromatic studies, using colors such as Sepia (a dark reddish brown), made from the ink sac of the cuttlefish, and red and brown earth pigments. Other good colors to practice with are dark green, blue and black.

Tonal values
Tone is the relative darkness or lightness of an image. If you look at the crumpled paper, you will see that, although it is white, the play of light over its surface creates a range of tonal contrasts from white to gray. It is these that give the paper its form.

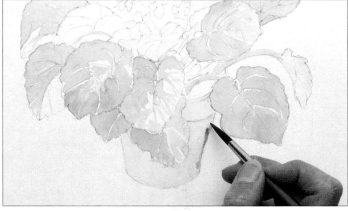

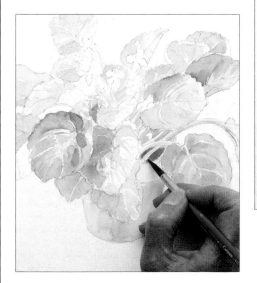

1 ▲ After making a pencil sketch of the plant, apply the palest washes first, in this case a very dilute Indigo, and start filling in the leaves. Notice where the highlights are, and leave these areas white.

2 ▲ Look hard at the plant, trying to see the tones rather than the colors. A useful device is to half-close your eyes. Once you have distinguished the areas of light and dark, start building up the layers, remembering to let each layer dry before applying the next.

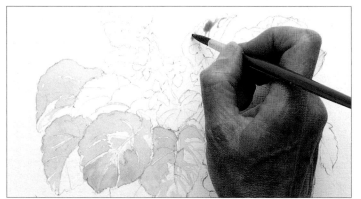

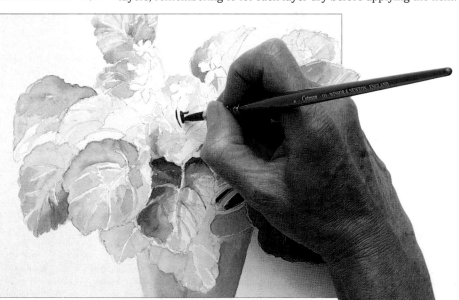

3 ◄ Start working in some of the details, remembering that the areas in shadow will be the darkest.

4 ▲ You may find you need a finer brush for the central area, with its intricate array of leaves and flowers.

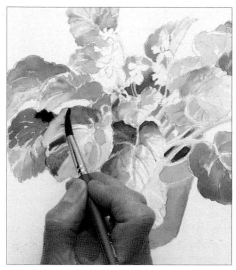

5 ▲ When you apply very wet washes of paint, keep some blotting paper handy in case the color starts to run.

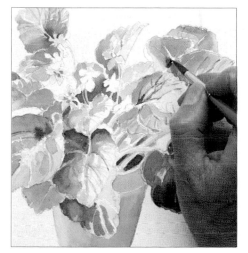

The delicate flowers of the African violet are among the lightest areas of tone in this composition. See how the fine outline of the petals serves to throw them into relief.

The sense of the roundness and solidity of the earthenware pot is created by the gradual darkening of tone from left to right, from the area where the light strikes it to the area of shadow.

6 ◀ As you work, you will notice that the color becomes considerably lighter as it dries. If you need a darker tone of blue, mix in some Payne's Gray with your Indigo. Use the darker mix for the veins in the leaves and for the areas that are in shadow.

If you look closely at this leaf, you can almost count the layers of paint that have been applied. It is the contrast between these very dark areas and the lighter ones that give the plant study its three-dimensionality.

Materials

Indigo

Payne's Gray

No.8 round

OVERLAYING A WASH

Although monochromatic painting is a rewarding technique in its own right, and one with a rich and celebrated history, watercolor painting is more traditionally associated with overlaid washes of color. To get a clearer idea of the nature of watercolor and the way in which each overlaid color affects the one below, do a simple painting in tones of one color and see what happens when you lay a wash of a different color over it. In the example below, the yellow landscape is transformed by the application of a Cerulean Blue wash. Note how the blue over the different shades of yellow results in a broad range of greens, even though no green was applied.

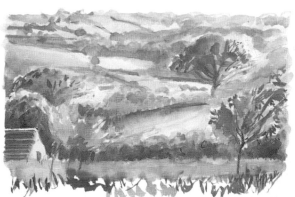

Range of yellows, Burnt Sienna, and Raw Umber

Swatches with overlaid blue

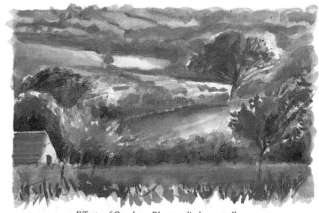

Effects of Cerulean Blue applied over yellows

BUILDING UP LAYERS

TRADITIONALLY, WATERCOLOR PAINTING is built up in stages. Since the watercolor medium is generally characterized by transparent color effects, with the color of the paper underlying all the painting, the overlaying of color is really a form of glazing. Any number of colors may be glazed over each other, and each will affect the look of the whole. The most important feature of the technique is that each color beneath must be completely dry before you paint over it.

Testing colors
It is good practice to try your colors out, both singly and by overlaying them, before committing them to your actual painting. These are the colors used for the painting of the lighthouse.

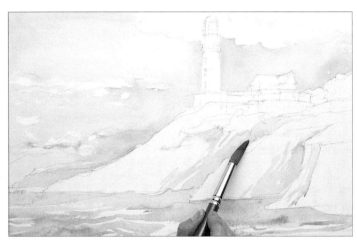

1 ▲ In this exercise, you will see how you can create a painting by building up washes of color. First, with a No.12 wash brush, fill in the sky, sea, and cliff areas with a mixture of Cobalt Blue and Payne's Gray.

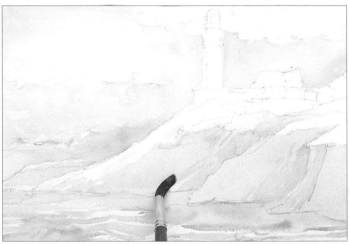

2 ▲ Once the blue has dried, mix up a wash of Alizarin Crimson and fill in some of the sky area and more of the cliffs. See how the blue shows through the pink and how it is affected by this single layer of overpainting, taking on a purplish hue.

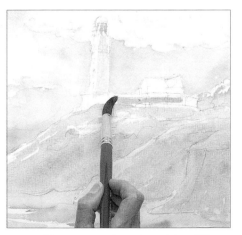

3 ▲ To warm up the color of the cliffs, add a wash of Raw Sienna. Use this color also for the basis of the lighthouse, the trees, and the grassy areas.

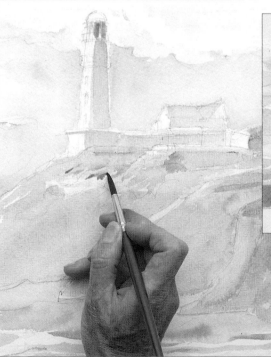

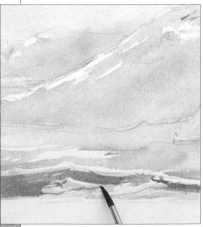

4 ◀ Again allowing the Raw Sienna to dry, add a layer of Prussian Blue over the trees and grass, building up those areas that need to be darker. Note how the blue over the yellow results in a green, the hue depending on the relative strengths of each.

COMPLEMENTARY COLORS

The balance of complementary colors plays an important part in painting techniques. If, for example, you are painting a predominantly green landscape, you can create a subtle balance in the color by laying a bright green wash, letting it dry, and overpainting it with a red one.

In the scene shown below, the sky as well as the foreground area have been overlaid with a red wash, with the poppies forming the final detail. The overall effect is to warm up the landscape, heighten the sense of perspective, and greatly enrich the feel of the work.

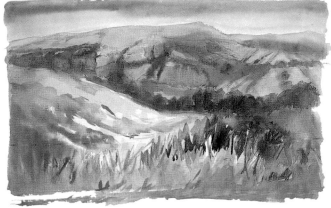
Landscape in blues and greens

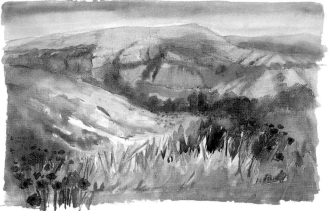
Landscape with overlaid red wash

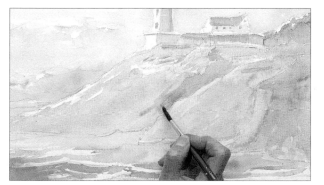

5 ◀ To strengthen the tone of the sea, add a second layer of Prussian Blue mixed with Indigo over some of the foregound waves. You will see that the colors appear brighter while the paint is wet, so you may need to deepen certain colors once your painting has dried.

Lighthouse study
Final touches of blue have been added to give definition to the windows and bring foreground areas into sharper focus.

Note how areas have been left so that the white of the paper forms the clouds and sides of the buildings.

Materials

Cobalt Blue

Payne's Gray

Alizarin Crimson

Raw Sienna

Prussian Blue

Indigo

No.8 sable / synthetic

No.12 synthetic

51

SPONGING OUT

FOR CERTAIN EFFECTS, you may need to modify your painting while it is wet, or even after it has dried. For example, you might want to create shapes that are lighter in tone in a certain area. In such a case, it is often easier to apply a broad wash of color over a complete section of a painting rather than trying to avoid or paint around certain areas.

You can subsequently sponge out or blot out those areas that need to be lighter, a technique known as lifting off. You can do this when the paint is wet or after it has dried, depending on which method is more convenient. The effect is largely the same, although lightening areas after the paint has dried may require some vigorous brushwork to dislodge the pigment.

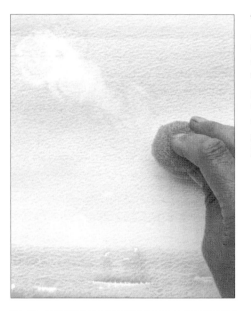

1 ◀ To sponge out cloud shapes, apply a wash of Cerulean Blue plus Mauve with a medium-size brush. While the paint is still wet, dip a small natural sponge in water, press it onto the blue wash, and remove it in one movement. The sponge will lift off the blue wash.

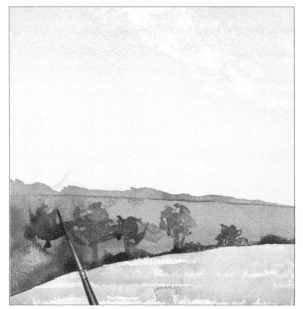

2 ▶ To practice sponging out from dry paint later, lay a green wash for the bank of the river, making some of the hills in the distance a little darker. Once this has dried, fill in the tree and grass details with a rigger – a fine, pointed brush with long hairs.

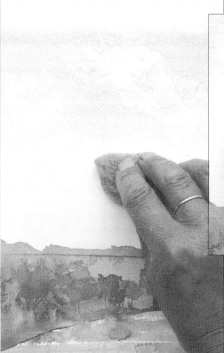

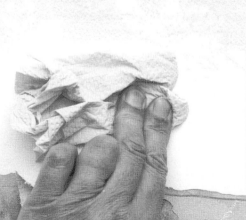

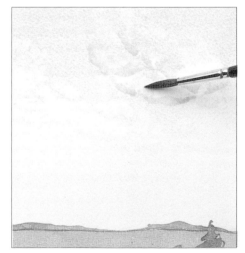

3 ◀ Wet your sponge and press it on an area of the sky, holding it there for a moment to loosen the paint. Lift the sponge off, and press a sheet of paper towel onto the area that has been wetted. Remove the paper towel to lift the paint off. The sponge will have created cloudlike forms.

4 ▲ To accentuate the shape of the clouds and build up the sky, mix up some Burnt Sienna and Cerulean Blue. With a medium-size brush, apply your blue wash to the sky, painting around the whited-out cloud areas in order to create shadows and give them a sense of three-dimensionality.

EXAMPLES OF LIFTING OFF

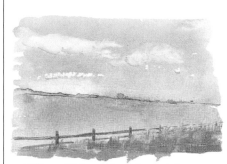

Lifting with brush from dry paint
Here the clouds have been created by working into the sky with a wet bristle brush until the paint has loosened sufficiently to be removed. To dislodge dry paint, you will need to use your brush quite vigorously. Some pigment may remain in the paper.

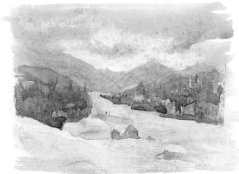

Lifting with paper towel from dry paint
A wet sponge has loosened the dried paint of the sky after which the clouds have been lifted with a paper towel.

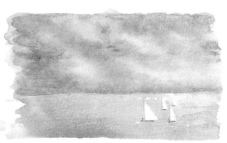

Sponging out from wet paint
Here the clouds have been sponged out using a moistened sponge on wet paint. The sponge has been rubbed onto the blue wash and lifted off, taking some of the paint with it. Notice the soft, diffused effect the sponge creates, particularly in comparison to the other methods of lifting off.

5 ▶ In order to lighten the foreground grass, load your brush with clean water and draw it across the area of dry color you wish to modify. While the water seeps in, work your brush between the trees to create greater definition between them. The degree to which you can wash areas out of your painting will depend on the staining power of the pigments you have used.

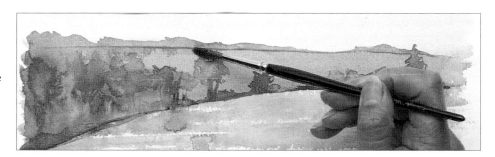

6 ◀ Press a sheet of blotting paper onto the wet grass, and then remove it. A good deal of the paint will come off. Repeat the process between the trees, first wetting the area you wish to modify with a brush dipped in clean water and then blotting it off with the blotting paper. You may be able to lift a tree out completely in this way.

Riverside study

In this finished version, you can clearly see those areas that have been lightened – the clouds, the foreground grass, and the details between the trees. What you cannot tell is which areas have been modified while wet and which while dry. It does not make much difference which way you choose to work. It is largely a matter of personal preference and convenience. If you are doing a quick study outdoors, you might even sponge out shapes when you get back to your studio.

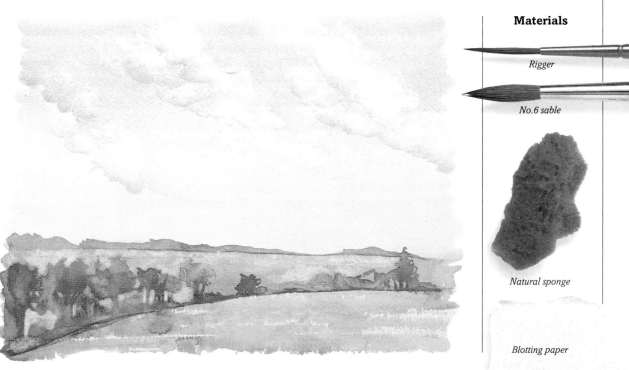

Materials

Rigger

No.6 sable

Natural sponge

Blotting paper

SCRATCHING OUT

Cornish graveyard

IN WATERCOLOR PAINTING, the technique of scratching out is a means of getting back to the white of the paper or to the dried paint film underneath the one that has just been applied. It can be used for highlights or for particular effects and is as applicable to wet paint films as it is to dry. With wet paint, the technique is to scrape the surface with the blunt blade of a penknife, taking care not to cut the paper. With dry paint, the method is to physically skin the dry paint off of the area you want to reveal. The way you handle your blade – using gentle strokes or vigorous ones – will determine the look of the technique.

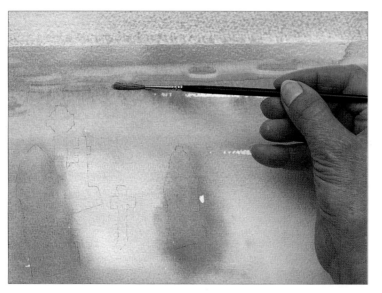

1 ◄ Using Rough paper, apply a wash of Raw Umber with a 1 inch brush, starting at the horizon. Dilute the paint as you work your way down; a somewhat patchy effect is fine. Once this has dried, draw a faint pencil outline of the gravestones. Next, take a small round brush and paint a wash of Cerulean Blue over all of the paper, taking care to avoid the gravestones. Apply the blue in loose horizontal strokes. You may have to go over certain areas since paint dries lighter than it appears when it is wet.

2 ▲ Once the paint has dried, cut a piece of medium grade sandpaper and wrap it around your pencil. Then, using the sandpapered surface, gently scratch the three front stones.

3 ▲ Build up the grass area by adding layers of Aureolin – a bright yellow – and more Cerulean Blue, always allowing the paint to dry between layers. You may use a hair dryer on cool to speed up the process.

Next, take a craft blade and use it to scratch highlights in the sea, pulling the blade down in short vertical strokes (or horizontal ones for headland waves). Notice how the blade reveals the Rough surface of the paper.

4 ▲ Mix Cerulean Blue and Sepia and use your fine, pointed brush to build up the background details. Now take a wet sponge and rub it over an area of dried paint to sponge out another gravestone.

5 ▲ Take a scalpel and gently score around the side of the house, cutting just deep enough to remove the surface of the paper without cutting right through it. Using the blade or a pair of tweezers, lift off the sliver of paper.

6 ◀ Do the same on the second house. The act of skinning these surface layers raises the nap of the paper. You need to burnish (rub down) the paper that you have revealed with your nail or the flat of a paper cutter. This is particularly important if you want to overpaint the area later.

7 ◀ To lighten the blue of the horizon and create a feeling of distance in your painting, dip a flat wash brush in clean water and draw it over the area that you want to modify. Allow the water to seep in for a moment.

8 ◀ While the surface is still wet, press a paper towel over the area and then lift the towel off. You will see that the towel removes some of the loosened paint. If you want to make the horizon even lighter, roll a small piece of soft bread over it while the paint is damp. You will find that this picks up still more of the pigment.

Finished work
For the final touches, the artist has used the wooden end of the brush to "cut" blades of grass in the foreground area while the paint is still wet. She has also rubbed sandpaper over the dried paint film of the gravestones, to give them their characteristic coarseness.

Sanding down certain areas of the grass reveals the roughness of the paper surface.

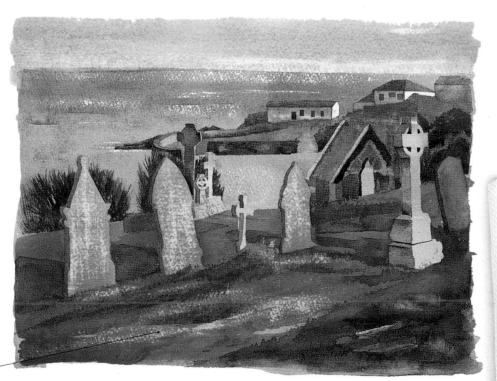

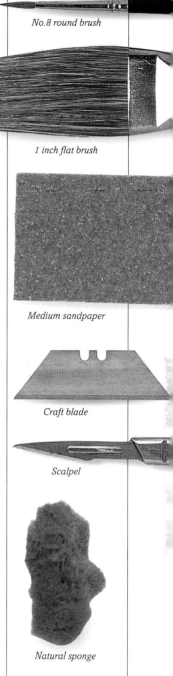

Materials

No.8 round brush

1 inch flat brush

Medium sandpaper

Craft blade

Scalpel

Natural sponge

Paper towel

RESIST TECHNIQUES

Pencil sketch

IF YOU WISH to protect certain areas of your painting so that you can paint over them without disturbing what lies beneath, you can use a method known as masking or stopping out – a "resist" technique. This involves applying masking fluid.

Once the fluid has dried and you have painted over it as much as you wish, you can rub off the masking fluid to expose the protected area of the painting. Masking can be used for highlights, as a means of keeping the paper white, or for safeguarding an area that is light in tone while you deepen the tones around it.

USING MASKING FLUID

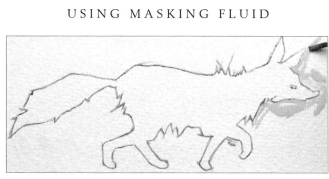

1 *Do a pencil drawing of your fox and carefully mask around the edge. Here it has been done in two stages, first with masking fluid applied with a dip pen and then more loosely with a brush.*

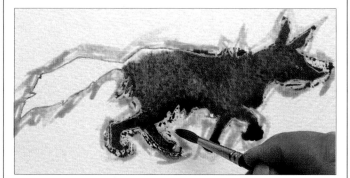

2 *Let the masking fluid dry and then dampen the area inside it so that the colors will merge when you apply them. Lay down washes of Burnt Sienna, Cadmium Scarlet, and Payne's Gray.*

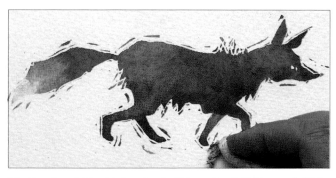

3 *Once the paint has dried, gently rub off the masking fluid. You can do this in a number of ways, either with a cow gum eraser, a putty eraser, or simply by using your fingers. You will find that the pencil lines are erased in the process.*

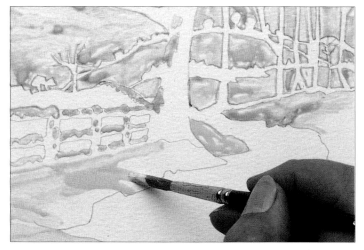

1 ▲ Again, starting with a pencil outline, mask out the areas you wish to protect. As the masking fluid tends to ruin the hairs, you can either use an old brush for this, or protect your brush by rubbing the hairs over a bar of soap before you start. Always wash the brush in warm soapy water as soon as you've finished.

2 ▲ Let the masking fluid dry naturally or speed the process up with a hair dryer. Then, using a medium-size brush, apply a wash of Cobalt Blue and Burnt Sienna over the unmasked areas.

Use an old brush for applying masking fluid and always wash it out in warm soapy water between applications. If you use a good brush, rub the hairs with wet soap before you start. This offers some protection as it prevents the masking fluid from clogging up the ferrule and adhering to the hairs. The lower brush was treated in this way, while the top one shows the effects of masking fluid having dried and coagulated on the hairs.

4 ▲ Dry the masking fluid with a hair dryer. You can test it to make sure it is dry by touching it lightly with your fingertips. Next, deepen the tones of the river with another Burnt Sienna and Cobalt Blue wash.

3 ▲ Apply more washes of Burnt Sienna and Payne's Gray to darken the tones of the trees and the fence, allowing each layer to dry between applications. Then mask out areas of reflection in the river using an old, smallish brush. Wash the brush in warm soapy water as soon as you have finished, to stop the masking fluid from ruining the hairs.

5 ◀ Lift off the masking fluid with a cow gum eraser or a putty eraser. Once it has been removed, fill in the sky with a wash of Alizarin Crimson, Cobalt Blue, and Burnt Sienna.

Materials

Dip pen

Old No.2 brush, trimmed

No.1 brush

No.2 brush

No.4 brush

No.6 brush

Masking fluid

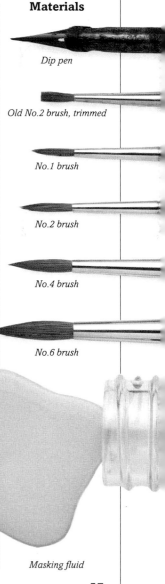

Masking fluid gives a hard edge to any shape that is masked out, a characteristic that can be seen most clearly in the snow-covered fence.

The sky is the final detail to be painted, having been masked from the outset.

Winter scene
With the removal of the masking fluid, several things happen: the whiteness of the paper is revealed and the original pencil lines are rubbed out at the same time.

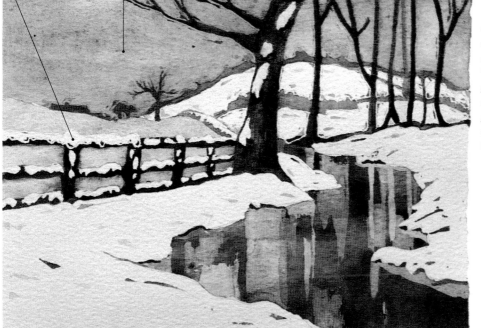

OTHER RESIST TECHNIQUES

FOR MORE SUBTLE MASKING-OUT effects than those achieved with masking fluid, you can use gouache paint, wax, or gum arabic. The results are slightly different in each case, and the gouache and the gum arabic have to be washed off the paper in order to achieve the resist effect. This means that you are disturbing the color you have just painted on, so remember that when you paint over the masked-out areas, you must use a deeper tone than the one you want to end up with. The effect of washing off gives a slightly softer-edged feel to the masked-out area than you would achieve with masking fluid. If you opt for gouache, it is best to use white. It has the least effect on the colors when it is washed off.

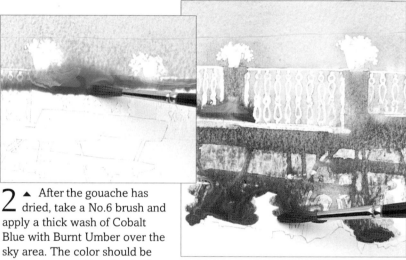

2 ▲ After the gouache has dried, take a No.6 brush and apply a thick wash of Cobalt Blue with Burnt Umber over the sky area. The color should be quite strong to allow for the fact that some of it will be washed off. See how the gouache paint repels the blue and umber wash.

3 ▲ Once the blue has dried, mix up a wash of Burnt Umber. Apply this smoothly and rapidly to the columns and benches so as not to disturb the gouache.

1 ▲ For gouache resist, draw an outline of the balcony details on a Rough paper and plan which areas will need to be masked out. Mix up some white gouache paint relatively thickly, like heavy cream. Then take a very fine brush and paint in the railings and the flower pots, and use a larger brush to paint the balcony floor.

4 ◀ For wax resist, use a sliver of a candle and draw in some foreground grass. Draw additional grass with olive green and light green wax/oil crayons. Both the candle and the crayons will repel washes of color.

5 ▲ Mix up a wash of Burnt Umber and Viridian Green and paint it thickly over the foreground area. Note how the wash refuses to adhere to the wax-resisted surface. Although the effects are quite subtle, if you look closely you will be able to distinguish individual blades of white and green grass once the wash has dried.

6 ▶ Add another layer of your blue and umber mix to deepen the color of the hills. Allow this to dry. Then lower your painting into water and gently sponge over the whole surface. The process will remove the gouache as well as dislodging some of the paint, but the candle wax and wax crayon will not be affected. Now stretch your paper on a board and leave it to dry.

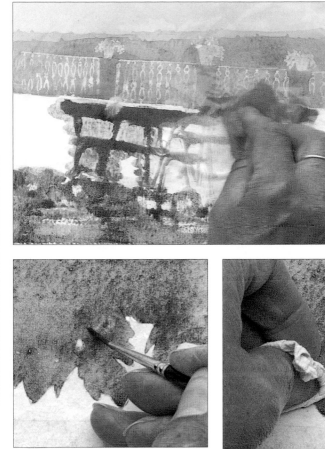

No.6 brush

No.1 brush

Wax/oil crayons

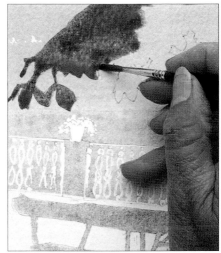

7 ▲ For gum arabic resist, make sure your painting is completely dry and then draw the outline of the overhanging leaves in pencil. Next mix up a wash of Viridian and Cadmium Yellow with equal amounts of gum arabic and water and apply it to the leaves. You can block in large areas of color, since details of sky around the leaves can be lifted out later.

8 ▲ Allow the paint to dry. It will appear quite shiny because of the gum arabic solution. Now dip a fine brush, perhaps a No.1, in water and "paint" an area in the foliage which you wish to lift off later in order to reveal some sky. Allow the water to sink into the paint for a while.

9 ▲ Now take some paper towel, press it onto the moistened area, and lift off the green paint. Because of the gum arabic, it will come off quite easily, without disturbing the blue beneath it.

Wax candle

Natural sponge

Gum arabic

Final touches
Because the washing-off process lifts off some of the paint, details have to be painted in or accentuated later. Here the flowers are painted in Cadmium Scarlet. The columns and the benches are darkened, and the shadows are then added as a final stage.

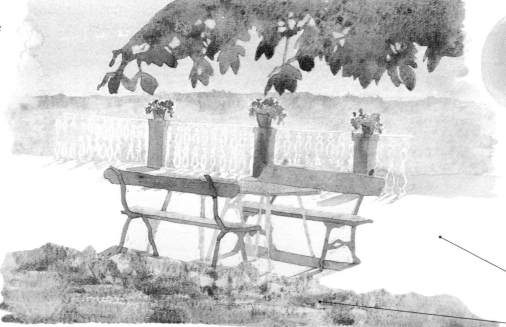

The white gouache leaves no trace on the paper and yet effectively blocks out any color. It also creates a much softer edge than masking out with masking fluid.

The wax resist adds texture to the foreground grass.

USING GOUACHE

GOUACHE, OR BODYCOLOR as it is also known, is a watercolor – but it is characterized by its opacity rather than by the transparent effects normally associated with the medium. Because of its different properties, it has specific uses in watercolor painting, for example, to create highlights in a traditional watercolor painting, or to provide a matte and uniformly even tone when that is what is required. It is generally applied more thickly than a regular watercolor and can create a more impasto effect. Because of its opacity, gouache works particularly well, and economically, on toned or colored paper.

SINCE GOUACHE PAINT is used more thickly than traditional watercolor, the paint film needs to be a little more flexible. It also needs to flow well to ensure that it can be brushed smoothly out in flat, opaque tones. Although gouache colors are made in almost exactly the same way as other watercolors, there are certain modifications that make them marginally more soluble than watercolors, an effect that is noticeable when overpainting them.

Highlights
Gouache paints are traditionally used for highlights, specifically for picking out details on buildings. Their opacity makes them useful in conjunction with traditional watercolors. In the image on the left, the white gouache creates the sense of form on what might otherwise seem a rather flat, two-dimensional structure.

OVERLAYING GOUACHE

Gouache is, in effect, just another form of watercolor. The paints can be used in the same way as straight watercolor paints, provided they are sufficiently diluted. They can, however, also be used much more thickly, when, for example, a flat uniform tone is required in a particular area, or a more textured look is desired. Between these uses lies a wide range of possible manipulations and effects.

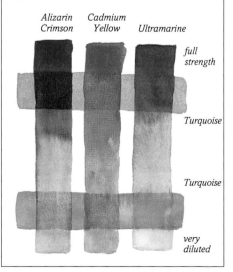

Alizarin Crimson *Cadmium Yellow* *Ultramarine*

full strength

Turquoise

Turquoise

very diluted

Toned paper
Gouache is particularly effective on lightly toned paper where the background color serves to unify the whole. To work in this way, begin by sketching in the main features. Then look for the lightest tones and paint them in by adding a touch of color to the white gouache. Next look for the dark tones and paint them using a more watery mix as above. Although similar to using oils as a technique, the finished appearance is quite different and displays a characteristic chalky matte quality.

High pigment loading

The opacity of gouache is often obtained by incorporating very high levels of pigmentation – far more than in watercolor. Gouache paints work well in washes, so they can represent good value for money as an alternative to watercolor.

The opaque nature of gouache means that for certain colors there is no other way to get a high level of brightness than to use brilliant but very fugitive pigments. Such colors may be fine for illustrators, whose work is designed for reproduction, but there is no point in using them in artwork that you wish to be permanent. It is a therefore advisable to check the durability rating before you purchase a gouache color.

Transparent and opaque

Gouache can be used in conjunction with transparent techniques or on its own, as in this nude study. Here the artist has exploited the diverse nature of gouache by using it both thickly, as in the face and neck area, and highly diluted, as in the legs. Generally, however, she has chosen to use it more like a traditional watercolor than as an opaque painting medium.

W M Ireland

A versatile medium

Having said that, gouache, with its wide range of manipulations and uses, is somewhat more versatile than traditional watercolor paints while being equally easy to handle. It has been used for such a diverse range of subjects as small-scale Indian and Persian miniatures and large-scale studies for oils. When used on a large scale, gouache paints are generally applied with bristle brushes. These are particularly good both for breaking down the paint and for blending it.

Although gouache can be used on its own, either thickly or thinly as in the two examples on this page, it can equally be used in conjunction with traditional watercolors. Indeed, some contemporary artists have made a point of juxtaposing the transparent and opaque techniques of the two forms of watercolor paint in the same work, in order to exploit their different natures and effects.

Impasto effects

Gouache can be used thickly, much like oil paints, with the advantage that it dries far more quickly. Here the artist was fascinated by the colors in the water and wanted a water-based medium to capture the shimmering, elusive quality of the fish. The gouache gives the painting a richness and density of tone not possible with transparent techniques.

GALLERY OF TECHNIQUES

THE RANGE OF TECHNIQUES available to the watercolor painter is limited only by the imagination of the individual artist, so you will no doubt devise methods of your own for controlling and manipulating the way you apply the paint. But there are particular techniques associated with the medium that range from the way washes are applied, to sponging and scratching out, washing off, wet-in-wet manipulations, and various methods of masking out. Artists have tried everything from toothbrushes to windshield wipers to create interesting effects.

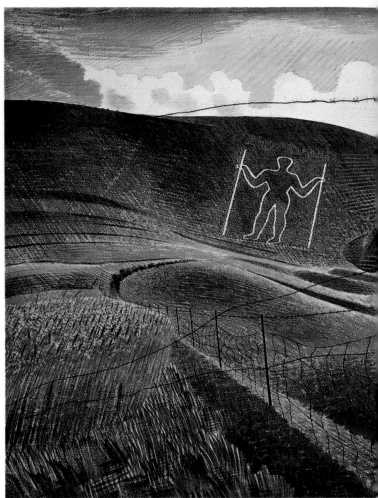

Note how pattern features throughout this painting, even down to the repeated elements on the rugs. The colors are both muted and vibrant, with an extraordinary richness due to a technique O'Reilly has devised. He has added certain inks and gums to the paint to heighten the textural effects and to give a sense of three-dimensionality to the kilims.

Philip O'Reilly, *Ali Baba Carpet Shop, Kusadasi*
This painting creates pattern through texture and vivid tonal contrasts. Contrary to conventional practice, O'Reilly likes to build up his paintings from dark to light, so that the view from the window here and the sun-drenched rug were his final touches.

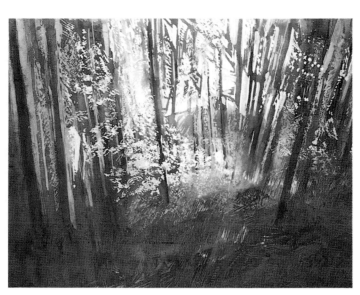

Philip Fraser, *Glade in Wood*
This work relies entirely for its effects on the use of masking fluid. Here you can see the characteristic hard-edged shape that shows where the dried masking fluid has protected the paper from the paint, creating suffused areas of light and color.

The roof was painted later with a mixture of traditional watercolor and gouache. It is the gouache that gives the color its density.

Eric Ravilious,
***The Wilmington Giant,* 1939**
Here a real sense of scale is created by showing the wire fence large in the foreground, then disappearing into the distance – at which point the massive figure of the chalk giant rises across the Sussex Downs of southern England. The work is characterized by the use of wax resist: the watercolor is repelled in those areas shaded by the wax.

The window details were masked at an early stage to retain the fine lines and clarity of outline.

Paul Newland,
Screen and Light
This unassuming yet atmospheric study in low-key color explores the idea of pattern and shape. The technique involves floating simple flat color washes into designated areas of the painting. Other areas are left unpainted, so it is the paper itself that creates the strong sense of sunlight.

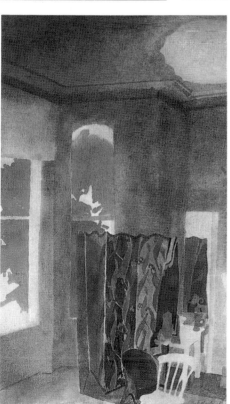

Colin Kent,
Evening Cottage
Fascinated by textures and techniques, Kent chooses smooth paper so that he can create his own surfaces with the paint and with particular methods of application. In this painting he used a pen for the blades of grass, a wallpaper brush for the sky, and a paint-soaked rag for some other areas. He has even been known to use windshield wipers if they achieve the desired effect.

63

WATERCOLOR
COLOR

Color IS A POWERFUL COMPONENT of any painting. It communicates the mood and message of a picture by making an immediate impact on the senses, evoking a variety of emotional responses. Artists often overlook the theory behind color, yet even the most practiced of painters may not understand why the colors in a painting do not work or why mixing colors can be so problematic. The following section sets out the theory of color in watercolor painting, from the basic principles of mixing pigments through to more advanced methods of painting with pure, expressive color.

THE LANGUAGE OF COLOR

THE TERM "COLOR" is a broad concept that encompasses three qualities of tonal value, hue, and saturation – or degree of lightness or darkness, innate color, and intensity. Mixing a small selection of pure paints gives unlimited possibilities for strong, vibrant colors.

Hue
Hue describes the actual color of an object or substance. Its hue may be red, yellow, blue, green, and so on.

Tonal value
Tonal value refers to the lightness or darkness of a color, according to the degree of light shining on it.

Saturation
This is the purity of a color in terms of its maximum intensity. It is unsaturated if painted transparently or mixed with white to give a tint, or mixed with a dark hue to give a shade.

Local color is the actual color of an object, or the familiar color associated with that object, independent of the effects of light.

Newton's theory that color coexists with light is a fundamental principle in painting. Transparent watercolor pigments allow light to reflect off the surface of the paper through the paint, so that the pigments appear luminous. Based on the principle of subtractive color mixing, watercolor painting is the gradual process of subtracting light as more washes of color are painted.

Primary

Primary

Primary

Mixing with three primary colors
It is possible to mix a full complement of relatively pure colors from three primary pigments: Permanent Rose, Winsor Blue, and Cadmium Lemon *(above)*. To mix a range of clean, pure colors requires much skillful practice, as each new color uses different quantities of each primary.

Commercial colors *(left)*
The alternative to repeatedly mixing primary pigments is to choose a limited number of commercial colors that are lightfast, or permanent. These paints mix well to give a range of clean colors. It is worth practicing mixing with just a few colors, although some beautiful colors, such as the earth pigments, cannot easily be mixed from this range.

Cadmium Lemon

Lemon Yellow Hue

Winsor Green

Cadmium Yellow

Winsor Blue

Cadmium Orange

Cerulean Blue

Watercolor pigments are available in tubes or in solid pans. Tubes are slightly preferable for mixing larger quantities of wash, but the same watercolor techniques can be used with either type of paint.

Cadmium Red

French Ultramarine

Permanent Rose

Cobalt Blue

Permanent Magenta

Cobalt Violet

Yellow pigments

Discovering the range of just one color, or using a limited range of colors to mix with, is a vital aspect of learning about the power of color. Yellow is a strong primary color that can range from a bright, luminous tint to a duller, heavier shade. Cadmium Yellow, used to paint this lemon peel, is a warm yellow that leans toward orange, while Cadmium Lemon is a bright golden yellow. Lemon Yellow Hue is a powerful pigment with a cool, greenish yellow effect that is both clean and pure.

Convincing studies can be painted by maximizing the range of just one color. Light tints give highlights while washes of stronger color absorb more light to give shades.

Lemon peel painted with Cadmium Yellow

Before painting an object, it is important to consider how its tonal range varies – how light or dark its color is.

Coffeepot painted with Cadmium Red

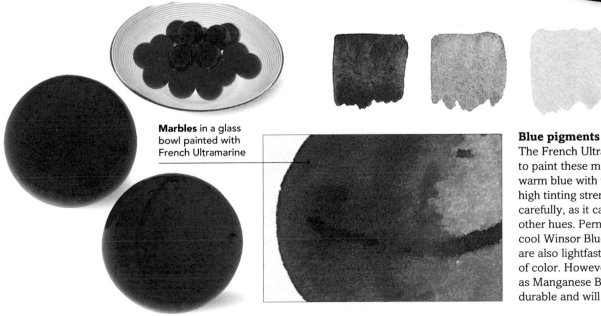

Red pigments

Some pigments have a higher tinting strength than others, and a small quantity of paint gives a pure, intense color on paper. Cadmium Red, an opaque orange-red pigment with a high tinting strength, gives this coffeepot a rich, red quality and strong depth. Permanent Rose and Alizarin Crimson, with their cool violet quality, have a natural transparency that makes them ideal for thin glazes. They also have a good tinting strength, and so are hard to remove without staining the paper.

Test the tinting strength of each color on rough paper first to see how powerful the tints and shades appear.

Marbles in a glass bowl painted with French Ultramarine

Blue pigments

The French Ultramarine pigment used to paint these marbles is a pure, durable, warm blue with violet undertones and a high tinting strength. It should be used carefully, as it can easily overpower other hues. Permanent colors, such as cool Winsor Blue and Cerulean Blue, are also lightfast and retain their purity of color. However, some pigments such as Manganese Blue are only moderately durable and will in time fade.

COLOR MIXING

BY MIXING THE THREE PRIMARIES in different combinations, a whole spectrum of color can be created. If any two of the primaries are mixed together, a "secondary" is produced. The three primaries of red, yellow, and blue, mixed in the combinations shown below, produce secondaries of orange, green, and violet. Each secondary color lies opposite the third unmixed primary on the color wheel, so that the green produced by mixing blue and yellow, for instance, lies opposite the third primary, red (*see* p.69).

Cadmium Red *Cadmium Yellow*

Equal quantities of Cadmium Red and Cadmium Yellow pigment, mixed together on a palette, give a warm orange hue.

A secondary hue can also be produced by laying a wet wash over a dry wash. This orange is brighter than if mixed on a palette.

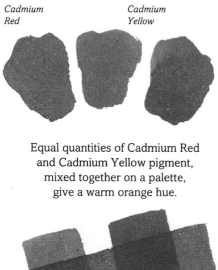

A third way of mixing pigments to create a new color is to allow very wet washes of each color to bleed together randomly.

Cerulean Blue *Lemon Yellow Hue*

The primary pigments of Cerulean Blue and Lemon Yellow Hue mix together effectively to produce a sharp acid green.

The vertical wash on the left lies below the horizontal wash, while the right wash on top gives a slight contrast in appearance.

This wet-in-wet technique creates spontaneous mixes of color of varying strengths and tones.

Alizarin Crimson *French Ultramarine*

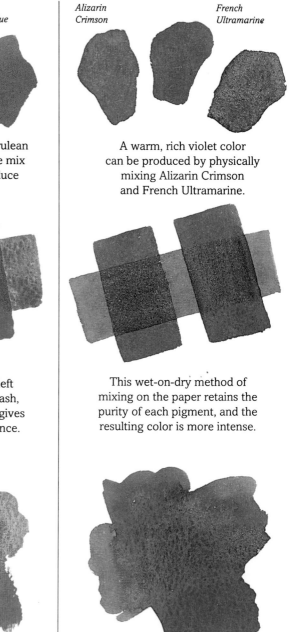

A warm, rich violet color can be produced by physically mixing Alizarin Crimson and French Ultramarine.

This wet-on-dry method of mixing on the paper retains the purity of each pigment, and the resulting color is more intense.

The colors will flood effectively if the paper is first dampened or if the pigments are mixed with plenty of water.

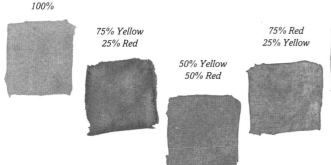

Cadmium Yellow 100%

75% Yellow 25% Red

50% Yellow 50% Red

75% Red 25% Yellow

Cadmium Red 100%

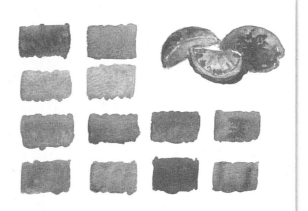

Experimenting with primaries

Equal amounts of yellow and red mix to give a strong orange, but invariably a deeper or a brighter orange is needed for a painting. Combining different proportions of the two primaries will produce a range of oranges. The colors above have been mixed on a palette, but layered washes of each primary will slightly vary the strength and luminosity of each orange hue.

Mixing a range of oranges

Use a range of primary colors to discover the best pigment mixes for different hues and strengths of orange. Experimenting with primaries in this way often produces exciting and surprising results.

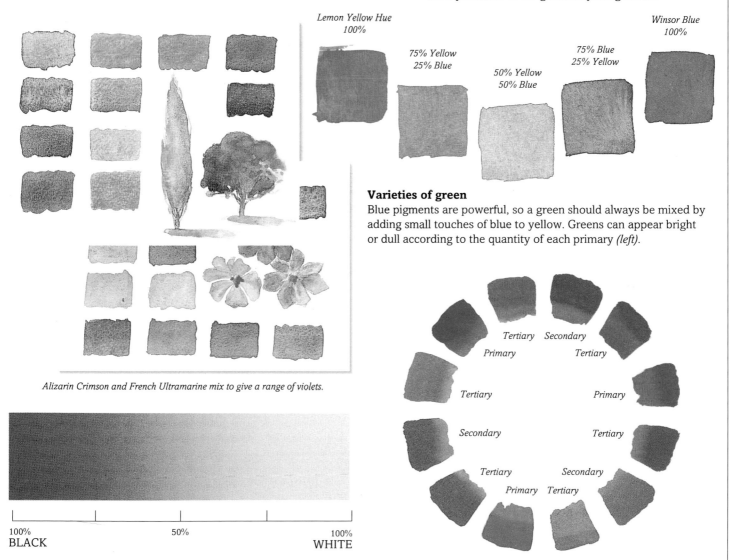

Lemon Yellow Hue 100%

75% Yellow 25% Blue

50% Yellow 50% Blue

75% Blue 25% Yellow

Winsor Blue 100%

Varieties of green

Blue pigments are powerful, so a green should always be mixed by adding small touches of blue to yellow. Greens can appear bright or dull according to the quantity of each primary *(left)*.

Alizarin Crimson and French Ultramarine mix to give a range of violets.

100%
BLACK

50%

100%
WHITE

Tertiary Secondary
Primary Tertiary

Tertiary Primary

Secondary Tertiary

Tertiary Secondary
Primary Tertiary

The tone of color

A scale of tone helps determine the tonal value of an area of color. This tone bar appears with a color wheel on every project to identify the colors used and the tone they are painted in.

The position of colors

The color wheel is organized so that every secondary color lies opposite the third unmixed primary. When secondaries are mixed with their neighboring primaries, they produce "tertiary" colors.

GALLERY OF LIMITED COLOR

THESE GALLERIES combine historical with contemporary paintings to show how artists have used color. The English artists Gwen John and J.M.W. Turner relied on a limited range of pigments to show the power of color. John used a minimal range of browns with perfectly controlled tonality, while Turner's range of seven spectral colors created a subtly atmospheric work.

Gabriella Baldwin-Purry, *Apples*
The use of primaries in this work shows how a full spectrum of color can be achieved by mixing and layering three pigments. Translucent washes react with white paper to give strong tints and dark shades of color.

J.M.W. Turner RA,
***Sunset Over a Ruined Castle on a Cliff,* c.1835-39**
Turner was a visionary painter, with an outstanding mastery of watercolor. He used the medium to explore the expressive properties of color and light. This sketch on blue-toned paper is striking in that it reveals the complete spectrum of light: each of the seven colors has been painted onto the paper in order, separately and unmixed. Such straightforward color placing creates a stunning and evocative sunset. This work also records Turner's fascination for experimenting with his media. He painted with gouache to create an opaque appearance; he used the blue-toned paper to heighten the brilliance and intensity of the gouache. The same effect could be achieved by building many layers of translucent, pure washes.

Pure color based on the spectrum of light creates an extraordinary intensity of color in this painted sketch.

Turner concentrated more on depicting light, space, and color than on describing detail. This sketch is simple, yet powerful.

The bands of individual color develop into an expressive atmosphere of diffused light and shade, to give a powerful sensation of nature.

Gregory Alexander,
***African Variation,* 1984**

Alexander incorporated mixed media into this painting, using designers' procion (dye) to give a powerful strength of color and luminosity. Each wash is painted as a simple, flat block of color, but the pigments are saturated and pure, so that the washes glow brilliantly. While the flat washes force the composition into a two-dimensional design, the vivid hues, heightened by a deep matt black, make the figures radiate with light.

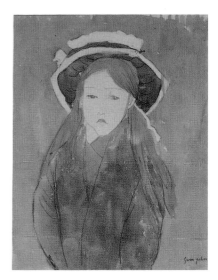

The limited range of pigments are painted as simple, flat blocks of saturated color.

Touches of white paper are left free to heighten the power of the intense exotic colors.

Human figures, painted with a flat wash of black paint, make a striking impact against the bright colors.

Gwen John, *Little Girl in a Large Hat, c.*1900

John's work was often modest in size, sober in mood, and muted in color, yet her paintings are powerful and tonally perfect. John laid colors on her palette systematically, to create subtle changes in hue and tone. This study is painted with a limited range of color, but the white paper that shows through in the face contrasts with the flat, soft brown washes, to create a subtle tension and stress the fragility of the child.

Edvard Munch, *The Kneeling Nude,* 1921

Themes of death and sexual anxiety predominate in many of Munch's early works. However, later in his artistic career, having recovered from a nervous breakdown, he produced some highly poetic works. Watercolor provided Munch with a direct means of setting down his feelings visually, and of experimenting with the emotional impact of color. This painting is composed of expressive rather than naturalistic color. Simple strokes of deep, serene blue and warm brown create a remarkable sensation of form and shape.

Translucent washes of deep blue and rich brown pigment have been painted using loose expressionistic and lyrical brushstrokes.

Freehand brush drawing and areas of untouched paper combine with the tranquil hues to give a sense of great artistic calm and control.

WARM AND COOL COLOR

ANY PIGMENT has a natural bias toward either warm or cool sensations (*see* p.67). It is important to understand how this quality can affect color mixing and to know which pigments will give the cleanest and brightest secondary and tertiary colors. Primary colors that are divided into warm and cool produce the best results.

These warm and cool colors can also be used as opposites in painting to create light, depth, and space; warm hues appear to advance on the paper, while cooler hues seem to recede. Such colors "complement" or react to one another, and lie opposite each other on the color wheel, such as primary red and secondary green.

Cadmium Red (warm)

Cadmium Yellow (warm)

Alizarin Crimson (cool)

French Ultramarine (warm)

Lemon Yellow Hue (cool)

Winsor Blue (cool)

Color bias
These sets of primaries are positioned in a color wheel to illustrate the natural tendency of each color to lean toward another. Cadmium Red veers toward yellow, and Cadmium Yellow has a red bias. French Ultramarine also has a red bias, while Alizarin Crimson tends toward blue. Lemon Yellow Hue veers toward blue, and Winsor Blue to yellow.

Warm and cool color
It is worth exploiting the tendency of warm and cool primaries to lean in one direction. Primaries that are positioned closest together on this wheel create intense secondary colors, while primaries farthest apart produce neutral, or even muddy, colors (*see below*). With this range of six colors, any combination of warm or cool, strong, or muted color is possible.

Cadmium Red

Cadmium Yellow

Alizarin Crimson

French Ultramarine

Bright, intense colors
A warm mix of yellow and red gives a strong orange, a cool mix of yellow and blue produces a vivid green, and a warm blue and a cool red give a deep violet.

Lemon Yellow Hue

Winsor Blue

Alizarin Crimson

Lemon Yellow Hue

Cadmium Red

Winsor Blue

Dull, muted colors
These primary combinations are not so effective and give muddier colors than may be wanted. Certain muted hues are more effective than others (*see* pp.92-3).

Cadmium Yellow

French Ultramarine

Traditional use of warm and cool color

There are three basic sets of complementaries; red and green, yellow and violet, and blue and orange. If you look at a lemon, you may notice that its shadow is a faint shade of violet. If this opposition is exaggerated in painting, the strong reaction created by complementary hues can give a convincing sense of space and light.

These lemons reflect the warm light shining on them, so that they too seem warm. The shadows are cool to heighten this warmth.

Warm highlights

An object painted with warm color appears to advance on the paper. These lemons are modeled with tints and shades of Cadmium Yellow. Where a sense of depth is required, a touch of cool violet pushes the underside of the lemon into recession.

Cool shadows

Painting cool shadows both heightens the warmth of an object and gives a sense of space and depth. The cool mix of Alizarin Crimson and Cobalt Blue makes the shadow appear to recede.

The lemons here are tinted by a cool light, so their appearance also becomes cooler. Shadows are warmer to give a strong contrast.

Unusual use of warm and cool color

Opposite colors also enhance each other, so that they appear stronger and brighter together than apart. This composition of cool yellow lemons and warm violet shadows still conveys a sense of space from the reaction of complementaries.

Cool highlights

These cool lemons have been painted with tones of Lemon Yellow Hue. The strongest highlights are created by unpainted paper, and the darkest areas have a faint wash of violet over the yellow.

Warm shadows

The lemons are painted with a cool primary pigment, so the shadows should be a warm violet. French Ultramarine and Alizarin Crimson mix to give a brighter, lighter violet wash to these shadows.

73

COMPLEMENTARY COLOR

Arrange a simple but interesting composition.

THE COMPLEMENTARY COLORS of red-orange and blue react together so strongly in this painting that they enhance each other and become more powerful together than apart. The strong artificial lighting illuminating each orange produces dark, well-defined shadows that appear cool and blue. Luminous yellow highlights on the oranges are also contrasted by subtle violet washes in the blue shadows. These sets of saturated complementary colors together create a vibrating tension that gives the painting a dramatic sensation of light and space.

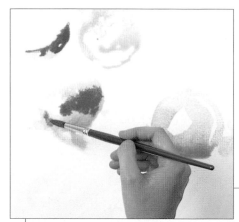

1 ◀ Draw the outlines of the oranges using a large brush, such as a No.10, with a light wash of Cadmium Yellow. Once the composition is loosely sketched, build up the form of each fruit with a strong wash of Cadmium Yellow. Use curved brushstrokes to model the general shape of each orange.

2 ▲ Leave the lightest tints to dry, so that they will not be obscured by additional washes. Although much of this picture is painted with a wet-in-wet technique, a hair-dryer is useful to prevent intermixing between washes and to check on the strength of a dried wash.

3 ▲ Mix a rich, vibrant orange from Cadmium Red and Cadmium Yellow. Mixed in different quantities, these hues provide a range of tints and shades. Use saturated washes to create shape and depth around the edge of the fruit.

Halfway stage
The violet-blue shadows that complement the fruit are cool enough to recede, yet strong enough to enhance the orange washes.

The paper is primed with acrylic Gesso primer to give the washes a mottled effect. It also prevents washes from being absorbed into the paper so that they float freely.

The white cloth both absorbs and reflects color from the oranges and their shadows. Lemon Yellow Hue gives highlights, and Cobalt Blue and Winsor Violet shadows.

5 ▲ Work around the painting, developing the objects and their shadows at the same time. Use a wash of Cobalt Blue and Winsor Violet to paint the shadows of the cloth. Paint a simplified pattern on the plate rim with a small brush, such as a No.5.

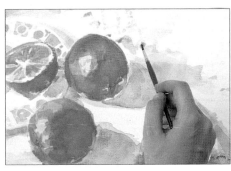

4 ▲ If you keep the washes wet enough, mistakes can be lifted out with a sponge. If the paint has dried, use a clean wet brush to soak the wash again. A painted wash may look too strong, so load a brush with clean water and dilute the pigment on the paper, or dab gently with a sponge for soft lights.

6 ◄ Overlay the blue shadows with washes of Cobalt Blue, Winsor Violet, and French Ultramarine to build up the right intensity of shade and depth. Use the same wash and a small brush for the lace holes at the edge of the cloth. Paint other fine details such as orange stalks with this brush.

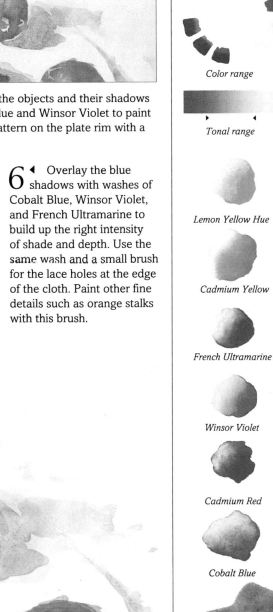

Enhancing color
Layers of complementary color contrast and enhance each other. Vibrating tints of orange advance on the page, while passive cool blue shadows recede into the background.

A wet-in-wet technique and spontaneous mixes of pure, saturated color capture the looseness and fluidity of watercolor.

Pure yellow highlights on the lightest areas of the oranges are subtly complemented by violet in the blue washes.

Materials

Color range

Tonal range

Lemon Yellow Hue

Cadmium Yellow

French Ultramarine

Winsor Violet

Cadmium Red

Cobalt Blue

Sponge

No.4 sable brush

No.5 sable brush

No.10 synthetic/sable mix brush

GALLERY OF COMPLEMENTARIES

MANY ARTISTS produce strong paintings by using the dramatic powers of complementary colors. The colors used by the French artist Paul Cézanne created a solid foundation for his stunning portrayal of light and form, while the German Emil Nolde relied on vibrant color combinations to create dramatic expression. This varied collection demonstrates the range of effects possible using complementaries.

Deep shades of blue cut across the angled profile of the man, casting him into obscure shadow.

Dramatic complementary washes of orange throw the face of the woman into uneasy relief.

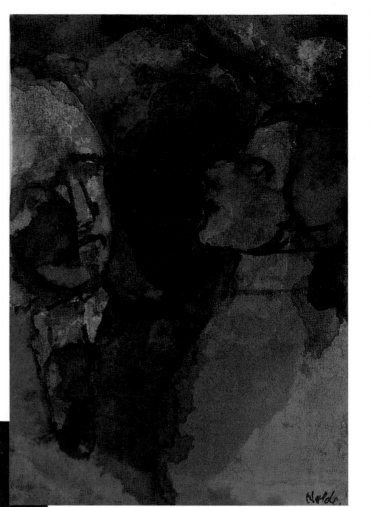

Emil Nolde (attr.), *Man and Woman,* *c.*1939-45
Nolde used stunning complementary color for this painting. He had a forceful, dynamic ability with color, appealing to the senses rather than to the mind. Nolde used color in order to describe the tension that he felt was prevalent in all human relationships. Dark shades of pure color cast the man into obscurity. The lifeless stance of the woman is accentuated by flat orange and pink washes, but her pulsating cold blue eye in the midst of the orange adds to the uneasy strain inherent in the painting.

Gisela Van Oepen, *Cadbury Hill*
The images Van Oepen paints in her landscapes are refined and pared of detail, and her complementary colors are dramatically pure and strong to create a brilliant reaction together.

Cooler blues recede into the horizon, while vivid startling hues of orange and red jump into the foreground, creating contrast and depth.

A thick stroke of French Ultramarine enlivens the orange wash, while the faint traces of weak yellow subtly complement the violet–blue skies.

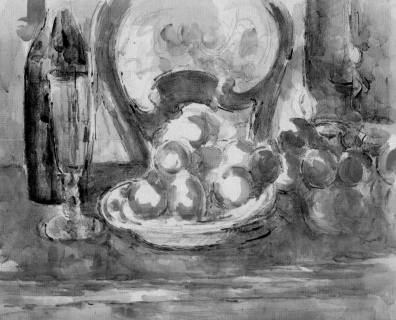

Paul Cézanne, *Still Life With Apples,* 1900-06
Cézanne was obsessed with light and color. He saw that light defined the outline and form of an object, and he used complementary color to recreate the effect of that light. Circular strokes of thin gouache suggest apple shapes, and the remaining off-white paper is left exposed to create space and light. Saturated violet-blue shadows react with the dull yellow, and the brushstrokes of intense bright green on the right offset the deep, warm red of the table. Subtle echoes of these colors in the background increase the lyricism and continuity of the painting.

Dante Rossetti, *Horatio Discovering Ophelia's Madness,* c.1850
A Pre-Raphaelite, Rossetti was inspired by medieval art and legends, and his works are full of decorative richness and strong color. Complementary reds and greens show fine details, while the blue dress at the center irradiates against a golden yellow background.

Cézanne used colors that encompass the spectrum of light, painting not the local color of objects, but their reflected light.

Complementary colors are painted as strong and weak washes to model and define objects and surfaces.

Christopher Banahan, *Roman Basilica*
Banahan's limited palette of pigments shows that simple contrasts of complementaries can look powerful in his paintings. Banahan works quickly and spontaneously with loose brushstrokes, letting the few colors he uses describe the main structures and shapes of a scene. Banahan does not allow more than one color to dominate a painting, so the saturated block of orange in the foreground becomes a focal point of the composition and is complemented by a large expanse of pale blue sky. This intense, dramatic shade of orange combines with quieter areas of muted color to give a sense of depth. The warm yellow of the dome and columns is heightened by lower shades of complementary violet.

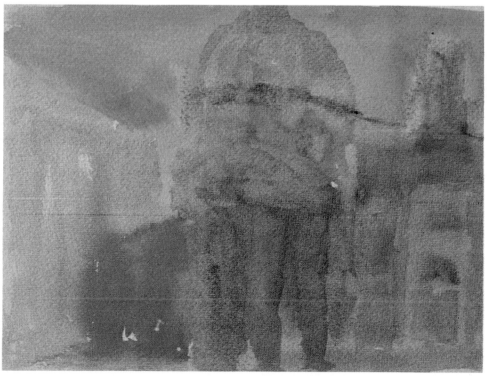

COLOR INFLUENCE

IF TWO COLORS are placed side by side, they have an immediate effect on one another, accentuating any differences or similarities and heightening the degree of saturation of each hue. Complementary colors exemplify this concept, enhancing and strengthening one another, if viewed simultaneously. This interaction, or color influence, adds visual tension to a painting and allows each color to achieve its optimum potential. Certain colors create a dynamic brilliance together, while other hues detract from one another.

Light colors within dark surroundings
If the eye perceives two adjacent hues, it automatically makes modifications that alter the intensity of each hue. A dark hue surrounding a light color looks denser and heavier, while the light color looks brighter and larger than it actually is.

Dark colors within light surroundings
A larger area of light color that surrounds a dark hue appears bigger and less dense than if an identical area of the same light hue were uncontrasted. Although the same size as the small white square, this dark square appears more intense and smaller.

An area of light orange on a dark blue square looks brighter and more saturated than on its own.

A green square on a red background appears lighter, while the red seems to darken.

The large area of light yellow looks less bright, while the intense purple vibrates.

A small dark blue square on a light orange background appears more vibrant.

The large area of green appears duller and darker, while the red gains in light and intensity.

A small amount of light yellow on the purple square appears to have an intensely bright quality.

How colors affect each other

It is important to understand the influence that colors have on each other. Some hues create discordant effects with certain colors, while others actually enhance them. The basic principle of complementary color is a good basis for determining effective contrasts. These dried flowers are full of muted, understated hues (*see* pp.92-3), but they can change appearance rapidly when set against a range of different colored backgrounds.

The dried flowers are a mixture of dark yellows and light ochres.

The terracotta pot appears a deep, rusty red under natural light.

Neutral background

When set against a neutrally-lit background of white light, the colors of this still life retain a "natural" appearance.

The warm yellow color of the background only serves to emphasize the lack of pure color in the still life.

The contrast created by the deep blue accentuates the muted hues, so that they seem brighter and purer.

Color that detracts

Positioned in front of a strong yellow background, the colors of the still life all appear dull and unattractive. They lose saturation and appear darker against the strong backdrop.

Color that enhances

When the still life is placed before a deep blue background, its hues are instantly enhanced. The orange or yellow accents in each flower are heightened, so that they glow brilliantly.

Set against a strong red backdrop, certain areas of the still life become lost, dissolving into the background.

Against a light blue color, the muted colors vibrate powerfully. The cool blue heightens the warmth of each hue.

This magenta influences the yellow hints in the flowers, so that they appear purer, but loses the definition of the pot.

The green background influences the orange and red qualities of the still life, so that they radiate strong, bright hues.

EXPLORING COMPOSITION

Composition is built up of elements that include shape, value, and color.

THE LIMITED RANGE OF COLORS in these paintings illustrates a useful way of exploring the potential of the same color scheme in four very different pictures. The variety of results from this small range shows how the placing of colors can significantly alter the success of a composition. Color combines with vital elements such as shape and tonal value in these quick paintings to create an overall balance of composition. All the paintings have a natural unity through the recurrence of the same colors, but a different sensation and effect have been produced in each work. Color is also used in this instance to evoke a mood rather than describe a subject.

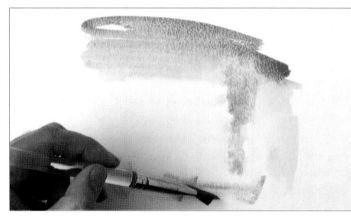

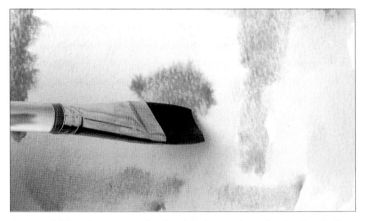

1 ▲ Paint a flat wash of French Ultramarine on a large sheet of cold-pressed NOT paper with a large brush. Cover the surface of the paper with a very light tint of the same wash, and then feed in washes of Ivory Black and Sap Green.

2 ▲ Add an intense wash of turquoise, and randomly sketch the form of a tree to complete the composition. The color should instantly bleed and blend into the wet paper. Composition and color are more important to consider than are details or objects.

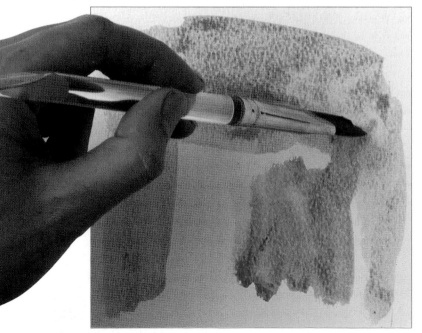

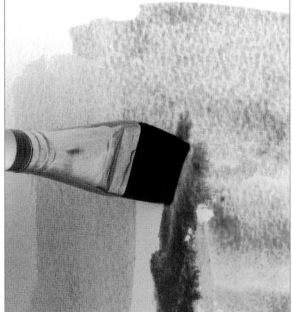

3 ▲ In this painting, the arrangement of colors is reversed. Paint a strong wash of Ivory Black over the sky and the background and a saturated wash of French Ultramarine in the foreground.

4 ▲ Add an intense stroke of Sap Green to the left of the composition to offset the cool blue and black washes. These strong hues give a powerful visual effect.

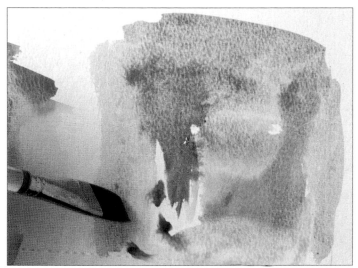

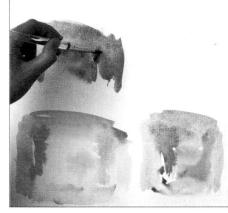

6 ▲ Paint the sky and background of the third painting with a dominant wash of Sap Green. Add blocks of strong Turquoise and French Ultramarine to the wet green wash, and let the colors blend, to produce more subtle secondary hues and to create accidental shapes and forms.

5 ▲ Apply dabs of very saturated, dense French Ultramarine to add a deeper tone to the painting and to break up and balance the large expanses of flat color in the composition. This picture relies on more intense shades of color than do the other images.

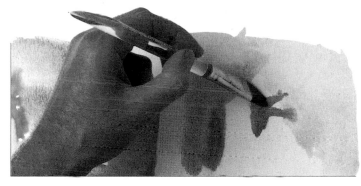

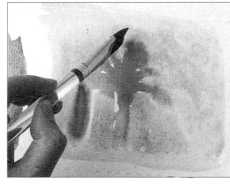

7 ▲ Use contrasting colors for the final work, to evoke a stronger mood. Paint a wash of Cadmium Red over the background and complement it with a rich wash of Sap Green in the shape of a tree.

8 ▲ Add a vivid stroke of Cadmium Red to balance the intense green, and work the red wash around the outline of the tree. Add subtle tints of Raw Umber to the base.

Exploring Composition
A limited palette of colors, combined with a variety of shapes and tones, produces four very different paintings. The mood of each painting depends on the intensity and relationship of colors.

The wet-in-wet technique allows washes to mix and edges to soften to create lucid, balanced compositions.

This painting has the most successful combination of color, shape and tone, creating a subtle mood.

Materials

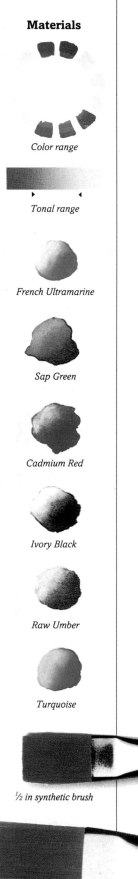

Color range

Tonal range

French Ultramarine

Sap Green

Cadmium Red

Ivory Black

Raw Umber

Turquoise

½ in synthetic brush

1 in synthetic brush

81

HARMONIOUS COLOR

TO PAINT HARMONIOUSLY is to compose with color to position a group of colors in an aesthetic arrangement. There are no fixed rules about harmony, but there are important guidelines that govern the relationship between colors. Harmony is determined by the order and proportion of colors: the simplest harmony, produced by mixing two

hues and placing the resultant hue between them, creates a common bond that unifies the initial hues. Harmony occurs if hues have the same tonal value or saturation, or a dominant color unites a range of tints and shades. Hues next to each other on the color wheel create "adjacent harmony." Correctly proportioned complementaries create "contrasting harmony."

Dominant tints
A harmony occurs if colors have a correspondence, a linking quality that unifies a composition. The different objects in this still life are linked through their association with the dominant primary color, yellow.

This still life is composed of a range of differently colored objects that can all be linked to one primary color.

Each color contains a certain quantity of yellow. The many hues include secondaries and tertiaries.

Adjacent harmony
The unity that the dominant yellow hue creates in this still life is known as adjacent harmony, which is based on colors that lie near or next to each other on the color wheel. Adjacent harmony can be based around any one of the three primary colors.

Adjacent yellows
Adjacent yellows range from light green to yellow and orange.

Adjacent reds
These range from dark orange to violet. Tertiaries lie at either side of the primary.

Adjacent blues
These cover cool violets through to deep greens. The secondaries lie at either end.

82

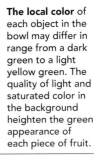

Monochromatic harmony

Pure Viridian Green (*left*) has been lightened into a tint and then mixed (in order) with yellow, blue, red, and finally black, to create a range of greens. The presence of green in each mix gives harmony.

Unifying color

The wide range of tones in this still life harmonize because of the dominant green hue in each object.

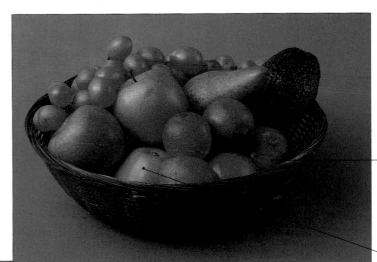

The local color of each object in the bowl may differ in range from a dark green to a light yellow green. The quality of light and saturated color in the background heighten the green appearance of each piece of fruit.

These objects produce a strong harmony because they have far more in common than in discord.

Subtle harmony

The pervading green that persists in this range of tones creates a subtle sensation. The degree of visual change between each colored object is minimal.

Contrasting harmony

Red and green are equal in intensity and light, so they should occupy equally proportioned areas of a painting.

Two-thirds blue and one-third orange together give the correct balance, as orange is more vibrant and intense.

HEIGHTENING A COMPOSITION

Correctly proportioned complementary colors will harmonize, but if these complementaries are painted in unequal proportions, a different look can be created that heightens the visual impact of a painting. The strong touches of red within this green still life generate an exciting vibrancy (*see* pp.78-9).

Yellow should only occupy one-fourth of an area that includes violet, or the strength of the violet will diminish.

A small area of red, surrounded by a large area of green, accentuates the visual impact of the still life.

The opportunity for a small amount of red to shine against the complementary green of this fruit means that it becomes increasingly vivid and concentrated.

The sets of complementary colors above are divided theoretically into proportional areas to illustrate the ideal balance of opposite hues. Yellow occupies less space than violet as it has a higher tinting strength and so is more powerful. These proportions depend on the maximum saturation of each hue. If their intensity and value alters, so do their proportions.

GALLERY OF COMPOSITION

E VERY PAINTING relies on elements such as color, tone, and form to create a successful composition. The German artists August Macke and Emil Nolde were masterly in the way they achieved stunning effects with bold, spontaneous hues, while the tones and subtle hues painted by the American Winslow Homer give a strong sense of depth.

August Macke, *Woman with a Yellow Jacket*, 1913
Macke had a fine sense of proportion, structure, and tone. The related shapes and colors in this arrangement create a unique visual impact. Macke placed his adjacent hues carefully to make one pigment irradiate beside another. The light yellow tint of a woman's jacket next to the dark saturated blue shadow of a man appears to brighten and advance. A small white gap left between the two pigments allows each to retain its own strength of color. Dark, shaded greens complement repeating vivid red and orange shapes. The eye is led around the picture by figures that move toward and away from the light and by two lines of perspective that control the movement at the right. A range of light and dark tones allows the eye to jump randomly from one rich area of color to another.

Repeating shapes and colors balance and complement each other to create a carefully structured composition.

Macke pitched the strengths of these pure hues perfectly, so that they enhance one another with a powerful radiance.

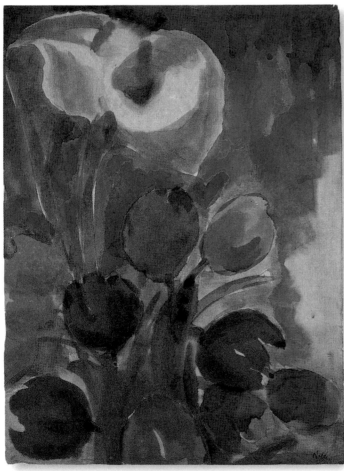

Emil Nolde, *Arums and Tulips*, c.1906
Color was the greatest means of expression for Nolde. His washes flow spontaneously into rhythmic, beautiful forms, so that color becomes the life and vitality of a painting. Nolde painted flowers because they are so temporary, bursting into bloom with rich, glowing color, only to wither and die. Just a small amount of saturated color on these red and yellow tulips makes them sing against the blue background. Their bright tints lift right out, without overpowering the quieter shades of green and the dark violet tulips that bend back. The two small strokes of orange stamen that control the mass of blue demonstrate Nolde's innate ability with color.

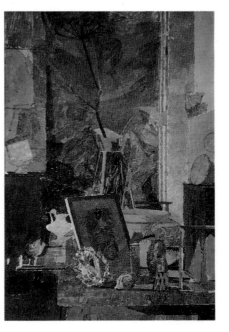

Paul Newland, *Interior*
Newland's aim is to build a coherent system of tones and colors into each painting to create a subtle composition. He works with a range of muted colors that give a warm glow and also imply depth. Each object exists in its own space and is gently modeled with toned color to give it form and substance. Softly illuminated objects on the table contrast with abstracted shapes and objects against the wall.

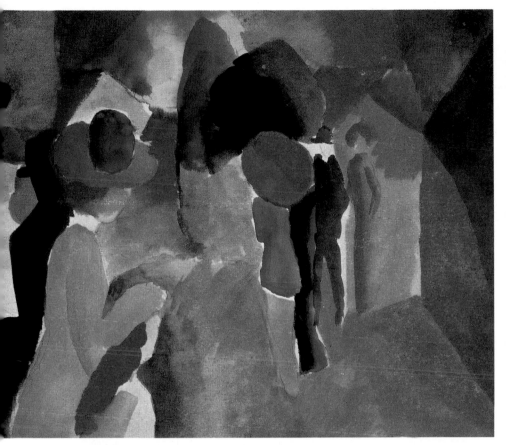

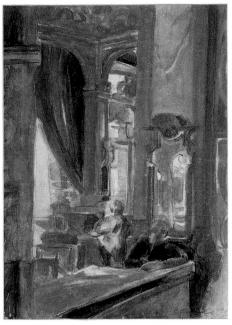

Sharon Finmark, *Café 2*
The space and light in this interior scene have been achieved with a combination of different tones and colors. The diagonal plane of intense yellow leading the eye up into the picture is strengthened by the cool violet and gray forms around it. A vertical block of light yellow holds the attention right up through the center of the painting and beyond. Light floods down from this area, warming the heavy rich reds and gilded orange hues. Small touches of pale cool green and violet shadows gently offset the large washes of red and yellow.

Homer captures the effects of outdoor light with a subtle range of tonal colors.

Controlled shapes and planes of color lead the eye around the painting.

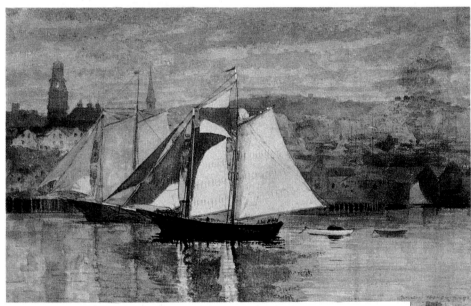

Winslow Homer, *Gloucester Schooners and Sloop*, 1880
These muted tonal colors are painted with fluid brushstrokes so that they produce a beautiful watery effect. Homer overlapped several transparent washes of luminous color to work up the right tones. He also defined the negative shapes between objects as much as the objects themselves, to emphasize the shape and depth of the picture. This is shown clearly by the shaded areas of sail on the main schooner. The paper becomes the white body of the sail, with the dark shadows painted as negative shapes on top. The strong white tint of the sail, balanced by the dark tones of the wooden hull, becomes a focal point of this composition, drawing attention to the extremes of tone in this subtle work. Homer often reworked his pictures using subtractive techniques such as rewetting and lifting paint layers. He also softened the edges of shapes with a brush, to create more subtle effects and visual sensations.

HIGH-KEY COLOR

HIGH-KEY PAINTINGS are built up of bright, saturated colors that evoke a feeling of strong light. The sharper the light in a setting, the more pure and dramatic colors appear. Clear, bright morning light will enhance the saturation of hues, while intense afternoon light can bleach out their strength. The color that we perceive is actually light reflected from surfaces in a setting. If the quality or strength of light changes at all, so do the colors of objects and the nature of the light being reflected. This change can create a completely different sensation. Lively, vibrant light can be created with a combination of techniques.

Bright morning light
This sketch captures the clarity of morning light shining on to a group of city buildings. Complementaries enhance one another to create a brighter reaction, so that light seems to gleam from the smooth surfaces of the buildings. Each color is at its most saturated and luminous to convey the quality of clear, radiant light.

Violet

Yellow

Flat, luminous color
High-key paintings can be built up of flat washes of saturated color. Placed side by side, the blocks of strong, pure orange and blue, and yellow and violet, influence one another to create a sensation of clear, powerful light striking the buildings.

Blue

Orange

Broken Color
Areas of broken color, created by painting individual strokes of saturated pigment beside one another, retain their maximum vibrancy while also appearing to blend. (This blending is known as optical mixing, *see* p.87.)

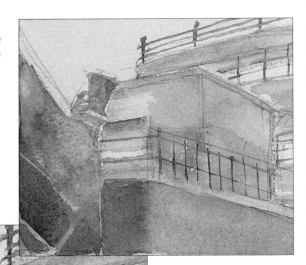

Hazy afternoon light
As the light changes, the dramatic, brilliant colors of the morning *(left)* are bleached out by a more intense light that makes this scene appear much paler *(right)*. Pigments are mixed with a larger quantity of water to create bright tints that give a sensation of hazy, high-key light.

Blue Violet Yellow

Creating different light effects
A small amount of water mixed with a pigment gives an intense, luminous, saturated wash *(top)*. As more water is added, the wash becomes paler and loses its intensity *(bottom)*, but it keeps its luminosity, retaining a sense of bright light.

Hazy effects
There are fewer dramatic contrasts in tone with the pale tones of hazy light *(left)*, so the flat washes of color blend softly into one another with a wet-in-wet method. In the areas where washes are layered, or painted as broken dabs of color, a third color can be perceived in the effect known as optical color mixing.

REFLECTED LIGHT

The perceived color of any object is actually influenced by the nature of colored light reflected back off the local hue of that object – whether a simple object or a complex cityscape.

The appearance of objects
White objects reflect most of the light shining on them, and this white bowl provides an effective illustration of the nature of reflected light. The bowl reflects the surrounding blue light and thus appears to be blue itself. Where white light shines on the object from above, it reflects back that light and looks white. Mixing pigments together is equivalent to the sensations of light reflecting off objects and surfaces.

The bowl changes color according to the color of light hitting its surface.

Blue light creates tints and shades on the bowl's surfaces.

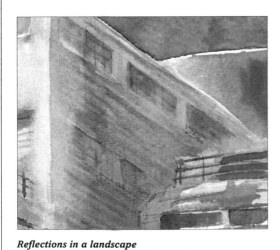

Reflections in a landscape
Sometimes surface reflections mingle together to create a new color. Where the bright yellow reflections of this building are reflected back into the violet shadows, the colors mix into a third deep, muted hue.

Under a green light, the bowl appears cool.

The bowl appears deep and rich under a red light.

Orange light makes the object appear light and warm.

HIGH-KEY STILL LIFE

THIS HIGH-KEY PAINTING is built up of a limited range of pure, saturated pigments, to create a sensation of intense light. The complementary colors of blue and orange and red and green have a powerful effect on one another and vibrate together, to create a visual tension of bold, pulsating color. This sense of high-key atmosphere is created by flat washes of translucent pigment, occasionally enlivened by small individual strokes of rich color.

These flowers sing so brightly because of the intensity of the blue background.

1 ▶ Sketch the composition lightly on NOT paper. Mix a strong wash of French Ultramarine and apply it with a medium brush, such as a No.9, across the background. Use fast, loose brushstrokes to paint around each flower, filling in the areas between flowers and stems to create interesting negative shapes. The heavy blue wash may appear granulated as it settles into the dips and hollows of the paper.

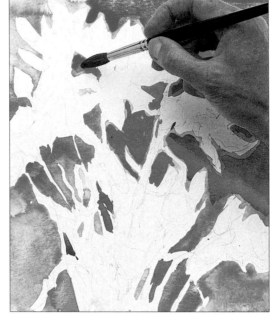

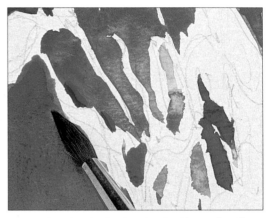

2 ▲ Overlay the background with another flat wash of French Ultramarine, if the first layer does not appear strong enough. Though this is a more unusual way of building up a composition, the reaction of the paler-colored orange flowers depends on the intensity of the blue background.

3 ◀ Once the background has dried, use a small brush, such as a No.6, to flood the petals with color. A strong orange hue can be produced either by mixing Cadmium Yellow with Cadmium Red on a palette or by painting a wash of Cadmium Yellow onto the paper, and then infusing the wet wash with pure Cadmium Red. These two pigments merge freely together to produce a vibrant orange.

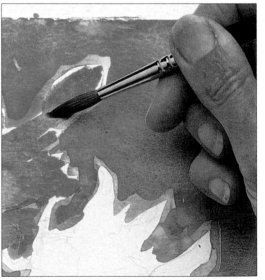

4 ▲ Add touches of new color to break up the washes of orange and blue. Mix Winsor Blue and Lemon Yellow Hue to give a secondary lime green for the unopened buds. This subtle hue should not overpower the two complementaries.

5 ▶ Build up the stems of the flowers with the same lime green wash. Paint right beside the strong background wash of French Ultramarine, overlapping the washes if necessary, to cut out any sight of white paper beneath. The absence of white in the composition should allow colors placed side by side to influence one another, to create the strongest reaction possible (*see* pp.78-9).

6 ◀ Work around the picture, building up the definition of each flower, and allowing washes of Cadmium Yellow and lime green to bleed together freely with a wet-in-wet technique. Mixing pigments together on the paper rather than on the palette ensures that each color remains as saturated and as brilliant as possible.

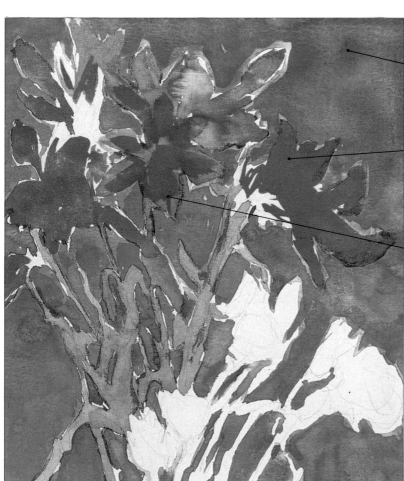

Heavier pigments, such as French Ultramarine, may settle into the hollows of the paper and appear mottled.

The purity and translucence of each pigment allows light to reflect off the paper and illuminate the whole painting.

Colors that bleed together freely with a wet-in-wet technique retain their tinting strength most effectively.

Materials

Color range

Tonal range

Cadmium Yellow

Lemon Yellow Hue

Cadmium Red

Winsor Blue

French Ultramarine

No.6 sable brush

No.9 sable brush

Halfway stage

In this unusual composition, created by closing right in on the flowers for a cropped image, the principal complementaries of orange and blue create a powerful impact. The large area of deep blue background contrasts and enhances the lighter orange petals of the flowers, so they glow brilliantly.

7 ▸ Use a small brush to apply a wash of Cadmium Red for the red flowers. This strong color contrasts with the bright green stalks, so that the balance of the composition is built around two sets of complementaries. Only a small quantity of red pigment is needed to offset the areas of green pigment, as its tinting strength is very high. Push the color right to the edge of the flower so that it will pulsate beside the blue wash.

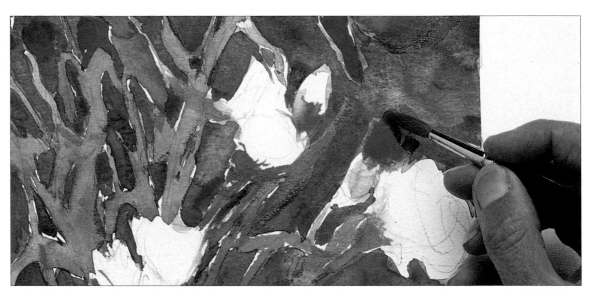

8 ◂ Mix a deeper wash of Lemon Yellow Hue and Winsor Blue, and lightly paint it down the edges of the stems and leaves with the small brush. The larger quantity of cool blue in this dark hue will push it into recession and enhance the predominance of yellow in the light green wash. This simple contrast in tone will give more form and interest to the stems.

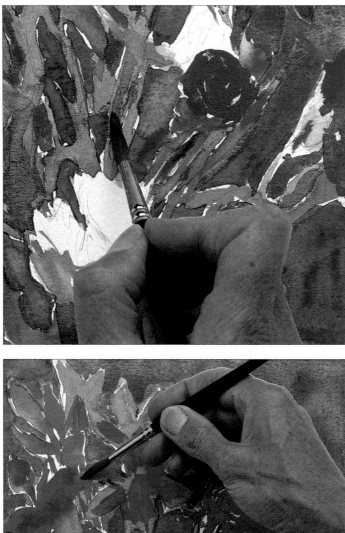

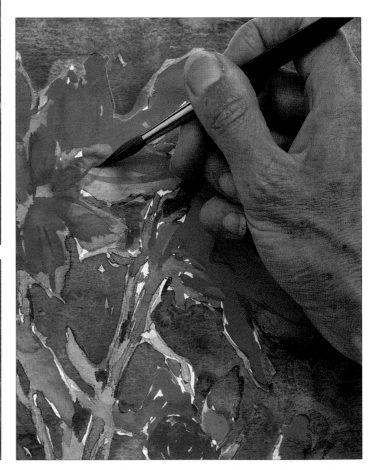

9 ▴ With the small brush, fill any unpainted areas of the flowers with more pigment. Continue to mix pure washes of Cadmium Red and Cadmium Yellow on the paper, and then merge touches of the light green wash into these wet pigments to give the flowers a greater variety of subtle secondary hues.

10 ▴ As the washes on the petals are drying, add some quick brushstrokes of pure Cadmium Red to the center of each petal to shape and define it. The wetness of the orange wash should soften the edges of the red lines. These strokes of intense, broken color fragment the larger washes and enliven the painting.

11 ◄ When all the washes are dry, rework a strong wash of French Ultramarine around the flowers and stems to define their shape clearly. Work the color right to the edge of the lighter hues with the small brush. Any brushstrokes of blue that overlap the orange or red washes will create deeper hues of violet and green and will also produce interesting patterns.

12 ▲ Finish the painting with final details, such as the filaments. Mix Winsor Blue with a small amount of Lemon Yellow Hue to create a wash of green, and apply several lightly painted brushstrokes at the center of each flower. Mix a very dark wash of French Ultramarine and Cadmium Red for the anthers.

High-key Still Life

The composition of this still life is arranged so that every shape, form, and color is balanced effectively. Diagonal lines created by the flower stems lead the eye right up to the focal point of the painting. The purity of every vibrating color gives this painting a powerful luminosity. Small details, painted lightly at the center of each flower using a dry brush technique, create areas of broken color among the flat washes of the complementary colors and increase the lively atmosphere.

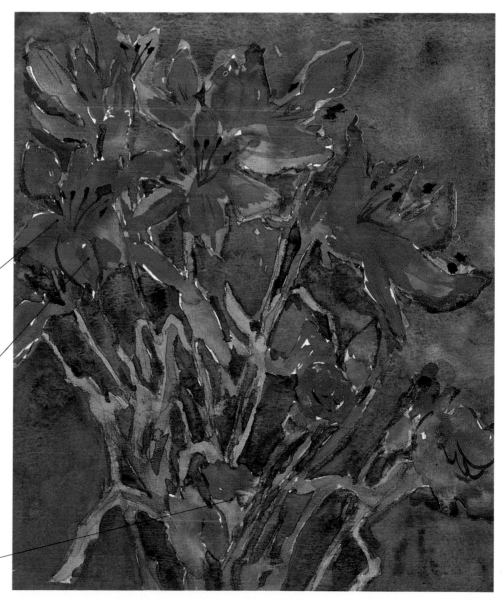

Pure, saturated colors have been optically mixed on the paper, rather than on a palette.

Small strokes and dabs of broken color emphasize the spontaneity and lightness of the composition.

The absence of white paper allows the complementary colors to influence one another. Each color is heightened by its opposite, so that its appearance seems to change.

LOW-KEY COLOR

WHILE HIGH-KEY PAINTINGS rely on bright, saturated color for their vibrancy and impact, low-key paintings depend on unsaturated washes of color to create subtle atmosphere. A pure color can be unsaturated if it is tinted (by using the white of the paper) or mixed with another color. If a primary and its adjacent secondary are mixed, they create a tertiary hue (*see* color wheel on p.69). If, however, any three colors are mixed, they form a colored neutral that harmonizes and enhances purer washes.

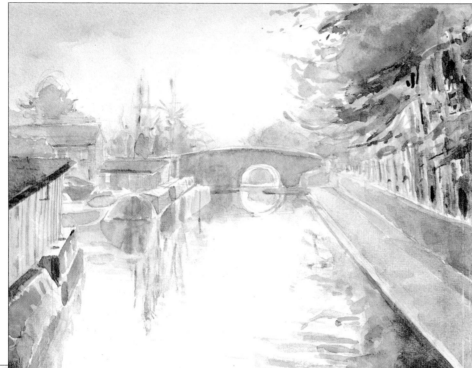

Unsaturated colors
Muted colors, such as the unsaturated hues above, are perfect for low-key atmospheric work. Their similarity in tone and strength creates harmony, and they enhance one another to appear more colorful.

Creating atmosphere
A subtle range of unsaturated hues describes this cool, misty winter's day. Pigments are mixed both on the palette and on the paper to create areas of gently glowing color. A final thin wash, or glaze, of Permanent Rose over the whole painting blends and unites any disparate elements.

Muted color
The deep shadows in this sketch have been built up with several layers of muted hues. Separate washes of pale color are applied individually to retain their luminosity and create gradual tonal changes. These soft, unobtrusive shadows that absorb the light create a quieter, more restrained mood.

Mixing unsaturated hues
These hues are gradually deepened by incorporating a cool primary blue into the washes. If too many pigments are added, the wash will muddy and lose its luminosity.

Colored neutrals
A flat, uninteresting neutral gray can be produced by mixing all three primaries equally. However, these colored neutrals *(left)*, created by mixing two pigments in unequal amounts, can enrich a picture with their warm or cool luminosity.

Blue and orange mixed in unequal amounts.

Green and red mix to give soft luminous hues.

Violet and yellow create warm and cool hues.

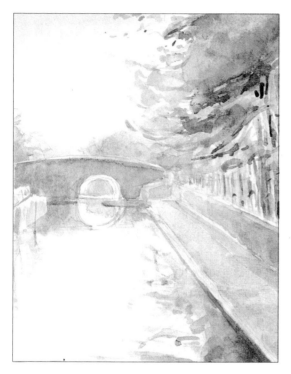

Toned paper
Toned paper *(right)* creates an underlying unity for a painting, harmonizing the hues with a dominant tint that influences the mood of a scene. The advantage of toned paper is that it performs like an extra wash, so less paint is needed.

Creating effect
The pigments here appear brighter and more luminous than those on the left, as fewer layers of paint are used to create the same effect. Although quite sketchy, it appears more finished than it would on white paper.

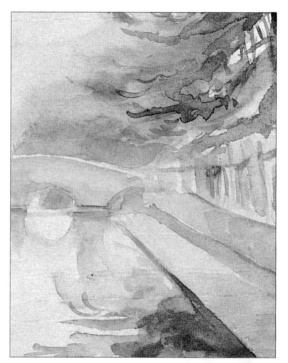

Soft, distant color
Fewer washes of muted pigment give a lighter mood. The washes are allowed to flow into one another, to produce more unsaturated colors.

LUMINOUS GRAYS

Luminous grays are vital to the gentle glow of low-key pictures. A primary or saturated color gains in brilliancy and purity by the proximity of gray. A wide range of grays can be created by mixing complementary pigments in a variety of unequal proportions. A luminous gray with a predominance of blue, for example, will heighten a wash of softly vibrant orange.

Winsor Blue and Cadmium Red give a warm luminous gray. If mixed equally, the complementaries cancel each other.

Cadmium Yellow and Winsor Violet mix to give a deep, rich gray.

Permanent Rose and Winsor Green create a cool luminous gray.

LOW-KEY INTERIOR

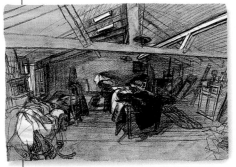

A tonal sketch defines lights and shadows.

THIS LOW-KEY INTERIOR is built up of soft, subtle hues that are restful to the eye, inducing a feeling of stillness and calm. The diffused evening light from the open door and window creates soft, deep shadows and fills the painting with a mellow atmosphere. Each object in the room has been gently molded with a variety of tones, so that they exist as separate images while still enveloped in the hazy light and remaining part of the composition. The shadowy areas of luminous gray enhance more delicate pure colors, so that they gain in brilliance and give the painting a glowing sensation of soft light.

Patterned fabrics provide an interesting feature.

1 ◀ Lay the first washes of Yellow Ochre, Ivory Black, Terre Verte, and Burnt Umber down with a medium brush, such as a No.9. Paint them simply as blocks of adjacent color to develop the directional light and transparency of pigments in the painting. Stretched, unbleached rag paper acts as a tinted base for this painting and warms up the pigments slightly. The paper is also rough and absorbent, so that the pigments do not sit in pools across the paper, but sink in and blend instantly.

2 ◀ Develop the different areas of the room at the same time, so the painting is built up gradually. If you deliberate over one area for too long, the work may appear unbalanced. Objects at the right side of the room have the least light and the most shadow, so paint the chest with a deep wash of Indian Red and Vandyke Brown.

3 ▲ Apply the wash with short brushstrokes, taking the brush off the paper frequently to create gaps in the wash and prevent it from looking heavy and flat. The white of the paper shows through the pigments.

4 ◀ Paint the shadowed area of the chest with a dark wash of Vandyke Brown. Keep the paint translucent enough to allow the lighter wash to show through and add texture. This tone is built up simply, but the result is effective – the contrast of shades creates depth and structure. Paint the edges of the chest with soft lines to create a diffused light.

5 ▲ Paint a thin wash of Yellow Ochre, Indian Red, and Burnt Umber over the ceiling to give a warm glow of softened edges and colors. This brown-tinted glaze over the top half of the picture also blends and unites separate washes.

6 ◀ Take out mistakes or thin any strong washes with a damp sponge or paper towel. Try not to blot too much when you paint low-key pictures – otherwise the shapes will lack definition and give a "drizzly" effect. If you overlay too many washes, the pigments will mix into a muddy confusion. Avoid having to lift out such heavy color by restricting the number of washes you paint.

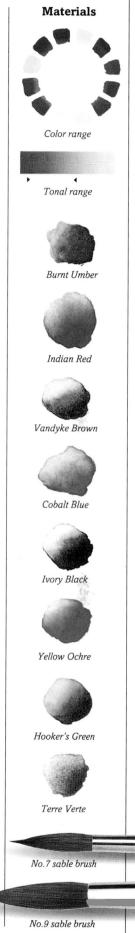

Materials

Color range

Tonal range

Burnt Umber

Indian Red

Vandyke Brown

Cobalt Blue

Ivory Black

Yellow Ochre

Hooker's Green

Terre Verte

No.7 sable brush

No.9 sable brush

Halfway stage
Simple washes of flat color have built into a pattern of balanced tones and colors. No one area is worked on more than is necessary to cover the paper at this stage.

Patterned fabrics
and furniture are suggested with swift lines of color, to create interesting features.

A subtle glaze
suffuses the surface with color, blending separate areas and uneven elements.

7 ▶ The variety of patterned fabrics and furniture all contribute to the personality of this painting. Mix together a wash of Vandyke Brown and a small amount of Cobalt Blue for the diagonal patterns of this fabric. The blue should cool the brown hue slightly to create a receding wash that will not dominate the other paler elements in the painting. Every object and piece of material should be molded gently with different tones so that each exists in its own space while still enveloped in soft light, and remaining part of the setting. Paint the details of the individual fabrics with rich, subtle colors, so that the patterns will retain their character. Use a medium size brush to keep the details of the fabrics loose and uncomplicated.

8 ◀ Use a thin luminous wash of Burnt Umber to determine where the shadows fall across this mattress before painting its striped detail. Mix together a cool wash of Cobalt Blue and Terre Verte to describe the directional stripes and apply the wash with the medium brush, letting the brushstrokes actually model the surface and shape of the mattress. If the stripes look too loud and sharp, paint over them with another glaze of luminous gray. This acts like a veil over the softly lit images, blurring and blending any edges so that an object seems to emerge from the shadows.

9 ▶ The painting is complete in terms of tonal contrast and diffused lighting effects, but there is still not enough visual interest and balanced color to the right of the painting. You can easily correct this aspect if you plan the colors carefully. The pigments that you choose should be strong enough to contrast with the green door and the folded material on the left, without unbalancing the coherence and strength of the original composition. If washes look flat, they can be livened up with a dry brush technique.

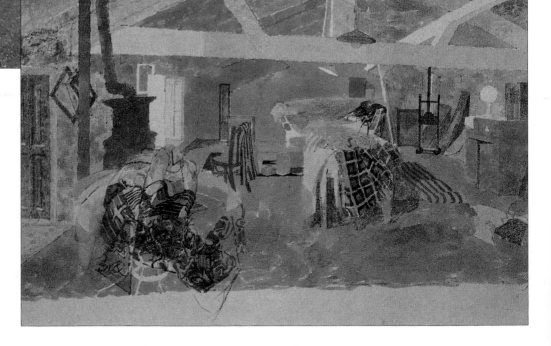

10 ◀ Mix a luminous wash of Ivory Black that is dark to conceal the details of the old chest. Transform the chest into an opened cupboard so that the original wash shows through as its interior. Use small touches of saturated Hooker's Green to create a backgammon board that balances the green color of the door. Such changes should improve the proportions of color and balance the tones. Deeper shadows will also heighten the tranquil atmosphere. A slight shadow over the top of the cupboard enables its lower half to glow beside the dark tones, and give a sense of reflected light at the far side of the room.

USING GOUACHE

If you overlay too many washes to create a dark tone, your colors may become muddied and lose their freshness. Gouache is an opaque rather than a transparent paint, and is very effective for concealing these cloudy colors. The chest below has been overpainted with gouache on the left, and although the density of the pigment is greater, the clarity and brightness of this area is stronger than the dull washes on the right. Gouache is also good for painting highlights on toned or off-white paper.

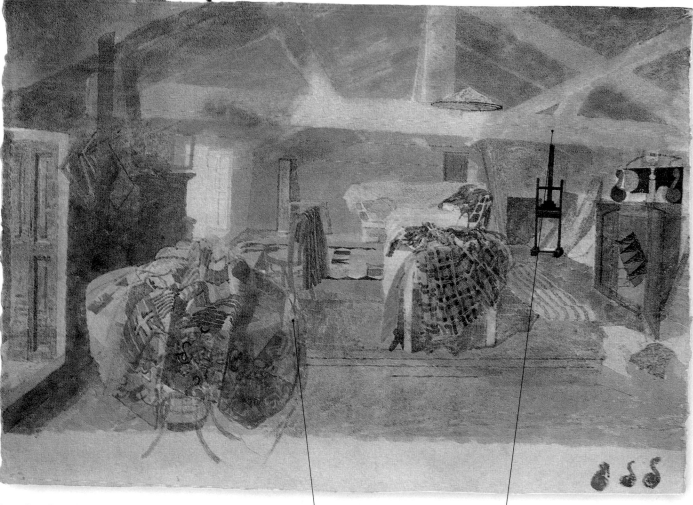

Low-key Interior
Washes of transparent color create a gentle luminosity throughout the painting. Dark recesses are penetrated by soft light, and subtle hues define and describe the objects.

Darker tones and shadows are more muted than lighter areas. Their edges and details are softer and less defined to give a sense of depth.

Soft, glowing colors are enhanced by areas of cool, luminous gray to create the illusion of surfaces taking and reflecting light.

GALLERY OF LIGHT

LIGHT INTENSIFIES OR MODIFIES the hues, tones, or temperatures of every color in these paintings, to capture a range of exciting sensations and subtle rhythms. The effects of light on a scene transform both ordinary and unusual compositions into fascinating studies of color and tone. The American artist John Marin interpreted the effects of light with pure, unmixed color. By contrast, the English artist Thomas Girtin allowed the white of his paper to reflect back the light through toned washes, to heighten the luminosity of his painting.

Thomas Girtin, *Egglestone Abbey, c.1797-98*
Girtin abandoned the traditional English watercolor method of painting gray underlayers and instead allowed light to reflect off the surface of his paper, to give each of his washes a transparent brilliance. He also rejected the popular palette of subdued colors and used strong colors in a naturalistic and atmospheric way. The warm browns and ochres in this painting create a rich, dense landscape, and strong, cold blue washes across the sky give a powerful sense of clear light.

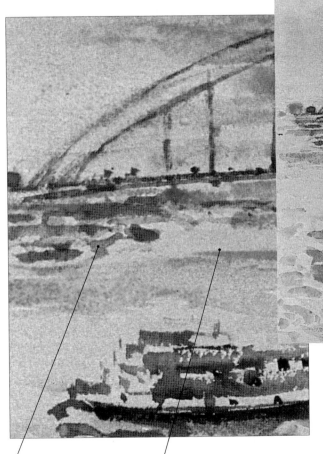

Individual strokes play across the paper as self-contained elements of pure color and light.

The source of atmospheric light in the painting is defined by a thin wash of luminous yellow.

John Marin, *River Effect, Paris,* 1909
Marin's watercolors are charged with energetic color and expressive line. Considered one of America's first watercolor modernists, he acknowledged the new dynamism of Cubism and Futurism, while still incorporating the essential beauty and balance of the natural world in his work. This scene has individual brushstrokes weighed down with pure color. The white paper surrounding each line heightens the pale luminous yellow light flooding across the scene. Hues are cool rather than hot, to imply the fading light of a sunset stretching along the river. The water looks quite realistic as the weighted lines of blue and mauve echo the constant motion of water. Marin avoided mixing his pigments into different tones, to ensure that his saturated color created the maximum vitality and mood.

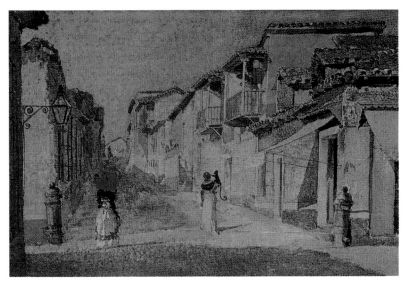

Winslow Homer, *Street Scene, Havana*, 1885
Homer preferred to work in the open to retain the freshness and vitality of the scene he painted, and his pictures are permeated with atmospheric light. Homer had a strong sense of composition and color, and he used broad brushstrokes of saturated pigment to create a powerful scene. He captures the effects of both the strong afternoon sun highlighting the deep folds of a woman's dress and large shadows created by a canopy and buildings. These warm yellow buildings reflect the hot glow of the sun, which permeates the whole street with a sleepy afternoon radiance. Intermittent touches of saturated red enliven the scene, while areas of very pale light wash suffuse the picture with bright light.

Sue Sareen, *Cat with Kitchen Sunshine*
Sareen's paintings of domestic scenes are absorbing studies of variations in color and tone and of the way in which light models, illuminates, and reveals images. This painting of warm, subtle tones captures late afternoon sunlight glittering on surfaces and edges and casting long shadows. The table top and floor become flat planes of spacious, illuminating color, controlled by a heavy wash of warm yellow that gives definition to the scene. Shadows lose their clarity as they elongate to give a sensation of weakening light. The cat, painted in the darkest tone with a dry brush, leads the eye to the center of the scene.

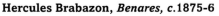

Hercules Brabazon, *Benares, c.*1875-6
Brabazon regarded watercolor as a perfect medium for capturing natural light and its effects at great speed. He combined this talent with an exquisite simplicity of detail and form. His sensitivity to the values of tone and light are reflected in this scene of Benares, India. The impressionistic nature of the details add to a sense of searing heat. The expanse of intense blue sky in the background is reflected in the waters of the river. The pale washes of the beige buildings create a bleached-out quality, and strong dark brown shadows emphasize the sense of intense sunlight and depth. Touches of Chinese White opaque watercolor paint add solidity and highlights to the smaller details of the painting.

Brabazon chose pigments that would fill this painting with sunlight and color. Impressionistic brushstrokes capture the sensation of brilliant light.

Strong, saturated blocks of bright green and blue washes are broken up by the brightly colored details of figures on the banks of the river.

WARM SUMMER LIGHT

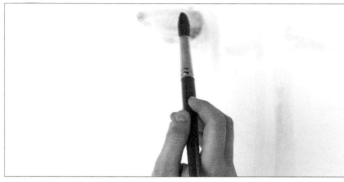

COLOR TEMPERATURE is the most important aspect of this bright painting. The hot summer light affects the temperature, or appearance, of every color (*see* p.87), so that warm colors appear sunny and stimulating and the warmth of these hues is heightened against the contrasting cool shadows. The clear distinctions between the light and shadowed areas of the painting are achieved by keeping the warm and cool colors isolated on the palette and by applying each pigment in its purest form.

Make a sketch to determine warm and cool areas.

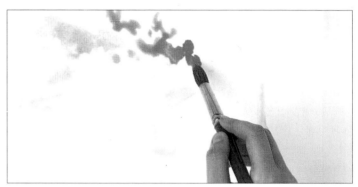

1 ▲ Use a large brush, such as a No.14, and a light wash of Cobalt Violet to sketch out the composition on hot-pressed paper. "Drawing" with the brush gives a looser, more spacious feel to the painting and avoids the inclusion of too much heavy detail.

2 ▲ The background vegetation is painted with saturated color to convey a sense of heat: Cerulean Blue and Lemon Yellow Hue are strong, yet cool, colors that create the distance needed for the background. They also mix well to give a fresh, vivid green.

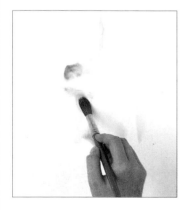

3 ◄ Build up separate areas of warm and cool color to develop contrasts of strong light and short shadows. Add a touch of Cadmium Red and Cadmium Yellow to give a warm orange-red wash to the tiles on the balcony floor. Painting a color in a light tone does not automatically make it appear warmer, so you may have to build up lighter washes in layers to achieve the right intensity.

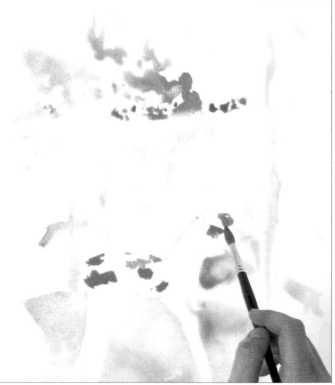

4 ► Add depth to the areas of background vegetation by mixing together Cerulean Blue and Lemon Yellow Hue. Keep the brushstrokes fragmented so that the white of the paper can show through this wash and intensify the saturation of each color. If you are working outside in the heat, the paint will dry far more quickly, so keep the washes wetter, to give yourself a little time to make changes or correct mistakes.

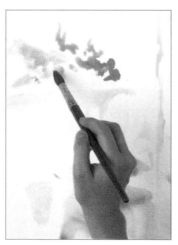

5 ▲ Use a medium-size brush, like a No.7, to paint more detailed areas like these patterned chair cushions. A very strong color such as Cadmium Yellow can become overpowering if used too much and can also lose its luminosity if applied too thickly.

6 ▲ Apply a wash of French Ultramarine and Cobalt Violet to the doorjamb with the medium brush, to create strong shadows. The violet in the wash will help complement the yellows, while the blue will retain the coolness necessary to heighten the warm colors.

8 ▲ Apply some dots of saturated Permanent Rose with a small brush, such as a No.4, to create definition and to contrast with the green foliage. If the washes look too pale, add some more intense color.

7 ▲ Apply a light wash of pure Cadmium Yellow around the edge of the balcony, leaving some areas of white paper free to give the sensation of hot, strong midday sunlight striking the floor. A mix of Cadmium Yellow and Cadmium Red creates a luminous tone of yellow-orange to paint over the lighter tiles. Continue to layer the warm colors on the tiles, until the desired level of intensity and heat is achieved.

The violet tones of the ceiling create an inviting sense of shade.

A line of Cadmium Yellow adds to the impression of direct sunlight.

Halfway stage
The vegetation is built up with economical and quick strokes, allowing the white paper to blend with the fragmented hues to create a lively, colorful atmosphere. The sky, painted with a pale blue wash, gives a feeling of white midday heat bleaching out the colors.

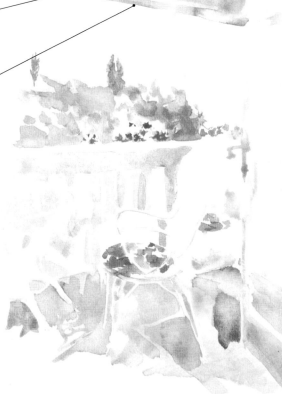

The glass panes of the doors are painted simply with a cool wash of Cerulean Blue to create a shiny, reflective feel.

The shadowed areas of the balcony are painted in receding cool colors, but the doorjamb is painted with a slightly warm violet wash. This pushes it into the foreground of the picture and creates a sense of perspective.

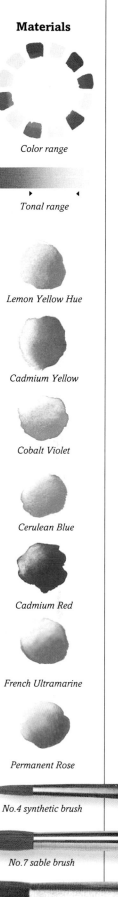

Color range

Tonal range

Lemon Yellow Hue

Cadmium Yellow

Cobalt Violet

Cerulean Blue

Cadmium Red

French Ultramarine

Permanent Rose

No.4 synthetic brush

No.7 sable brush

No.14 synthetic / sable mix brush

101

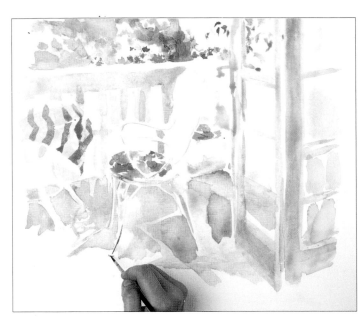

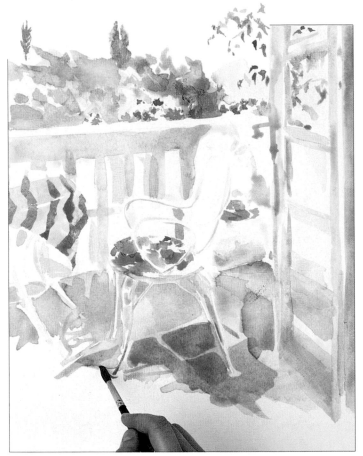

9 ▲ Paint the chair by using the negative shapes of the white paper to represent the metal frame. Use a small brush to paint a French Ultramarine wash on the shadowed area of the chair leg. Make sure you use strong pigments for the details; if too many layers are painted, the crispness of the object will be lost.

10 ▲ Make the balcony floor advance into the foreground by adding a deeper wash of Cadmium Red and Cadmium Yellow over the tiles with the medium brush. Fragmenting this wash will allow the areas of lighter color underneath to show through your final wash. Use the same brush to bring the tablecloth to life with stripes of strong Cobalt Violet.

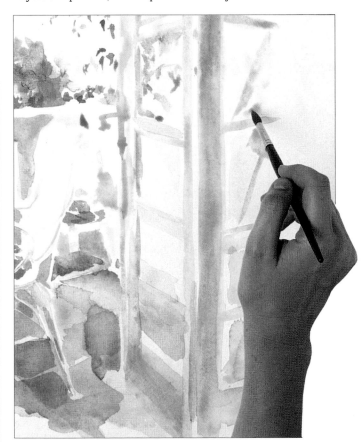

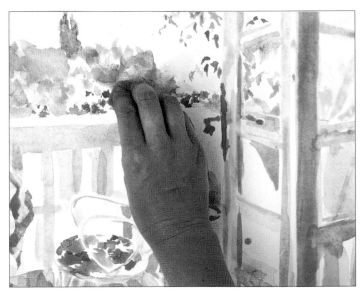

11 ▲ If there is still not a sufficient contrast of temperature in the picture, paint the shadows again with a cooler blue wash to heighten the warmer pigments. Paint pure Cerulean Blue on the glass panes of the door with the medium brush, to create colder reflections, and use bold brushstrokes to emphasize the short, sharp shadows produced by hot sunshine. Reflections should be built up of simple but strong contrasts of light and dark tone.

12 ▲ If a wash is too strong, or an area becomes too solid and heavy, take out the wash lightly with a sponge or paper towel, to let the underlying wash or paper show through again. Allow the wash you have sponged to dry thoroughly before you paint over or around it otherwise, new colors may bleed in.

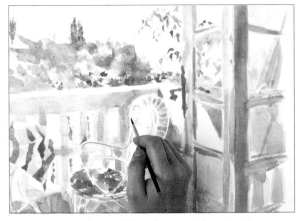

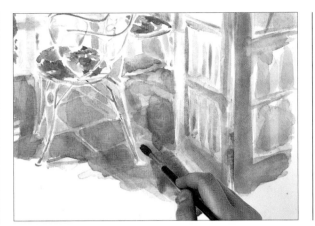

Sponge

13 ▲ Use the small brush to redefine details or to apply fresh color. If the chair appears lost in the painting, apply a fresh wash of Cerulean Blue to give cleaner and cooler shadows and better definition.

14 ▲ Paintings can be spoiled through overworking, so be sparing with your final touches to retain the freshness and translucence of the picture. Apply a final wash of Cadmium Red to add depth to the tiles.

Warm Summer Light
Painting negative shapes and shadows allows white paper to represent strong sunlight falling on objects, giving a "white-hot" feel to the picture. Layers of strong pigment are more intense and stimulating than pale weak tones, and they convey bright sunshine and lively color. The blue and violet shades in this painting both complement the warm orange and yellow tints and enhance them, making each hue vibrate and glow.

Keep details generalized and simple by painting with loose, economical brushstrokes.

Different washes of Cadmium Yellow and Cadmium Red on the floor create a rich mosaic of radiating colors.

The tiles to the right have violet undertones as they move into the shadows and become cooler.

COOL AUTUMN LIGHT

THIS AUTUMN LANDSCAPE relies for its success on the reaction of warm colors in a cool setting. The autumnal atmosphere is achieved by building up layers of warm, earthy colors for the tree and surrounding it with cool, receding blues for the hills and sky. The sense of depth in the painting is heightened by the use of strong light and dark contrasts in the foreground and of hazy details in the distance. The skyline right at the top of the painting contributes to a powerful sense of aerial perspective.

Make some sketches outside to study the sense of perspective created by the warm and cool hues.

Test the four predominant colors of Cobalt Blue, Raw Sienna, Burnt Sienna, and Olive Green as swatches of color, to discover the tones and harmonies they create.

1 ◀ Sketch out the basic images with simple blocks of Cerulean Blue, Raw Sienna, and Cobalt Blue on NOT paper, using a brush such as a No. 6. These initial cool washes will determine the temperature of the landscape, but they should not stain the paper if sponged off.

2 ▲ Mix up a cool, luminous wash of Aureolin and Raw Sienna, and paint it broadly over the distant hills near the horizon. Continue this process of building up a layered and harmonious landscape using light washes.

3 ▲ Apply washes of Cobalt Blue and Olive Green to develop the basic shapes of fields, trees, and houses. The dark green creates a subtle harmony with the warm browns and the cooler, misty blues. Use a sponge to lift out any areas that upset the balance of the composition.

4 ▶ Introduce warm hues of Brown Madder Alizarin, Raw Sienna, and Burnt Sienna for the autumnal leaves of the main tree in the foreground. This is the focal point of the picture, so apply the washes thickly to make them glow against the surrounding cool hues. Build up the form of the tree with loose, rough brushstrokes to create large shapes of color and to suggest, rather than describe, detail.

104

5 ◀ Paint the fine lines of the distant fields with a pale mix of Cerulean Blue and Indigo, using a brush such as a No.5. Paint trees in the far distance with strong, receding blues to add to the depth of the picture, and use mixes of Olive Green and Indigo for the fir trees in the middle distance. Apply washes of Brown Madder Alizarin and Yellow Ochre to the foreground.

6 ▶ Give the landscape a subtle harmony by laying a thin Olive Green wash over the blue and yellow fields, to temper the intensity of each pigment. Keep distant images small and undefined, to create a stronger sense of perspective.

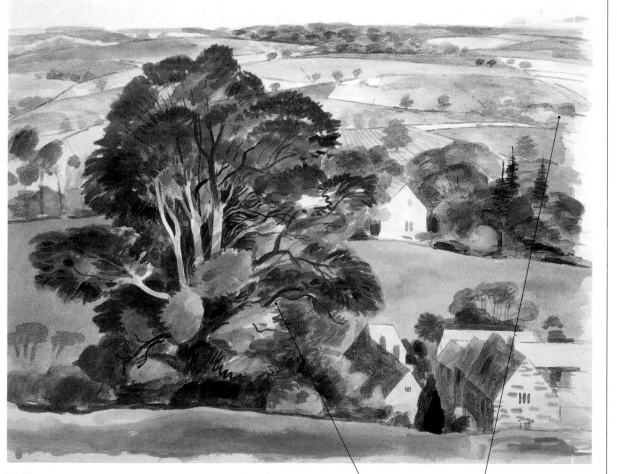

Halfway stage
The colors of the dying leaves on the tree are echoed in the houses and bushes in the foreground, pushing these areas of strong color forward against receding blues in the middle ground and distance.

The tonal structure is built up by using the four main mutually enhancing colors.

The weaker washes in the background create an illusion of space and depth.

Materials

Color range

Tonal range

Cobalt Blue

Raw Sienna

Burnt Sienna

Cerulean Blue

Aureolin

Brown Madder Alizarin

Sepia

Olive Green

7 ▶ Create a sense of crisp, cool light by mixing a wash of Cobalt Blue and Cerulean Blue and painting it between the buildings in the foreground with a small brush, to give deep shadows. This combination of blues produces translucent, yet strong, shadows. Add some more washes of saturated Olive Green to build up the depth of the trees, so that they are not lost in the dark blue shadows.

8 ◀ Sketch the rough shapes of the cows with a dark wash of Sepia and a touch of Cobalt Blue. Work out the proportions of the cows on rough paper before painting, so that their size is compatible with the linear perspective.

9 ▶ If you change your mind about an area of your picture, lift the paint off with a clean, damp sponge. If the paint has already dried, use a fresh brush and clean water to dampen the surface of the paper first. The trees at the left of the painting can then be lifted out with the sponge, and the paper left to dry.

10 ◀ The sponged area of the painting should dry without affecting the paper or the intensity of any other washes. Once the paper has dried thoroughly, paint in any obscured images again with their original color, and then mix a translucent wash of Cerulean Blue to develop the undergrowth of new trees and bushes with the medium brush. This pigment retains the overall coolness of the landscape, while also enriching the adjacent warm browns of the central tree. The autumnal atmosphere of the painting depends on these strong contrasts of color and temperature.

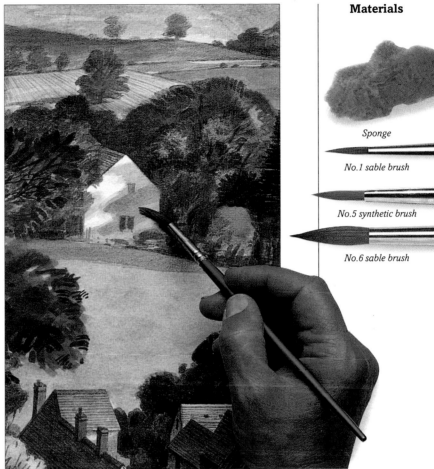

Materials

Sponge

No.1 sable brush

No.5 synthetic brush

No.6 sable brush

11 ▲ Allow the dark washes to dry before filling in any more detail on the cows. Apply a glaze of white acrylic paint with a fine brush to highlight details. It is important to apply acrylic paint thinly on this type of work so that you can apply a further wash of watercolor over the area immediately. A thin wash of the dark mixture over the cows gives an impression of cold shadows cast by the tree.

12 ▶ Paint thin washes over different areas of the landscape to harmonize and balance various elements. Mix a wash of Cerulean Blue and Cobalt Blue to deepen shadows and cool down areas so that the atmosphere of the painting is that of a clear and chilly autumn day. Allow the silhouette of the main tree to stand out against the background.

Cool Autumn Light
The unusual aerial and panoramic perspective of the painting is built up using contrasts of warm and cool color, drawing the viewer's eye to the warm tones of the central tree, and away over the fields to a cool misty horizon. The sensation of light and seasonal change has been achieved with basic perspective techniques and cool washes of pure color.

A rich tapestry of strong browns and oranges makes the tree the focal point of the work.

A final thin glaze gives the painting a sense of unity and balance while preserving translucence.

107

GALLERY OF ATMOSPHERE

THE POWER OF WATERCOLOR to capture atmospheric conditions is due partly to its fluidity and partly to its ease of handling, which allows a greater spontaneity. Many artists have used color most effectively to describe a range of weather conditions. Winslow Homer cooled his bright palette to portray an oncoming tropical storm, while another American artist, Edward Hopper, used strong washes of bright color and sharp shadows to convey an intense light.

Noel McCready, _Northumberland Rain_
This atmospheric painting describes the driving presence of tumultuous rain. McCready captures the stillness of the landscape behind a heavy veil of rhythmical rainfall, inspired by Japanese techniques. The rain has been drawn with a draftsman's pen loaded with watercolor paint. The three-dimensional effect of the landscape behind the sheet of rain is heightened by using warm colors in the foreground and strong dark blues in the distance. The pervading sense of gloom and impending darkness is created by powerful combinations of saturated color and strong impressions of light and atmosphere.

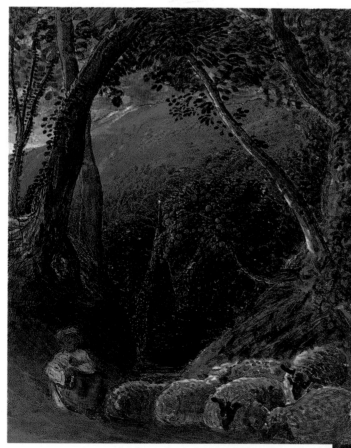

Samuel Palmer, _The Magic Apple Tree_, 1830
Palmer imbued his work with an Arcadian vision, so that his landscapes are richly textured and abundantly colored studies of an idyllic English countryside. The wealth of warm yellows and browns in this work represents the vital rustic beauty of agrarian life. There is a stark contrast between the warm glow of the valley and the brooding skies heralding darkness and the onset of winter.

The church spire, a focal point of the painting, is nestled deep in the valley and surrounded by strong autumnal hues of intense orange.

Palmer chose to describe the fruitfulness and fertility of nature in his paintings. He used rich colors for the details of this landscape.

Winslow Homer,
Palm Trees, Nassau, **1898**

As Homer's career developed, he came to rely on transparent watercolors rather than on gouache. The Caribbean light and the lush tropical colors of Nassau influenced Homer's palette toward brighter pigments and at the same time encouraged a new fluidity and freedom in his brushstrokes. The strong colors in this painting are full of light, despite the gray, windy conditions they evoke. The visual power of the composition is heightened by the exotic blue of the sea, and the loose, dark strokes of the palm leaves stretching out to the edges of the painting. The bold washes of saturated blue recede with a distinct coolness to create depth and perspective, while individual brushstrokes of different pigments merge together to form a warmer foreground. This subtle fusion of colors also contrasts with the large expanse of cool gray sky that dominates the whole painting with a translucent, luminous quality.

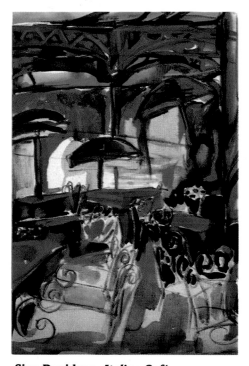

Sine Davidson, *Italian Café*

Davidson has used three main colors in this bright, sunny scene to create a spectacle of vibrant, dominating color. Architectural structures and metal spiral chairs have been painted spontaneously and simply to allow pure color to feature more prominently than actual shapes. Individual strokes of saturated pigment mingle together to create a fusion of different hues. The sharply defined shadow of the umbrella and the strong pigments react with the whiteness of the paper to give an unrestrained clarity of color.

Powerfully strong sunlight has transformed familiar everyday buildings into unexpectedly grand and beautiful structures. The light reveals and isolates parts of the building, turning some areas into flat planes of intense color.

Edward Hopper, *St. Francis Tower,* **1925**

Hopper was attracted to artificial objects and cities, and his paintings depict both a powerful architectural monumentality and an uneasy feeling of solitude. People are often isolated within stark interiors or alienated on deserted street corners. Hopper always worked on location, and he had a striking perception of structure and light that influenced the character, color, and surface of the buildings he painted. The short midday shadows in this work heighten a pervading sense of loneliness, and the intense heat is emphasized by extremes of light warm ochre and cool shades of blue. The absence of active movement, or of people passing by, creates an eerie silence throughout the painting and strengthens the significance of the buildings. The saturated washes have been painted with a direct simplicity that conveys both the heavy mass of the stone structure and a luminous quality of strong light.

EXPRESSIVE COLOR

THE HUMAN FIGURE reveals a complexity of form, surface reflections, and colors. The lights and shadows that accentuate the existing hints of color in flesh tones can be exaggerated to express the mood and character of a person, or to heighten an emotional or a cultural aspect of the subject. Using a limited palette of colors in an unusual way can transform a portrait from a descriptive recording, to an expressive interpretation full of vitality and personality. The fewer colors used, the stronger the statement.

The effect of cool light
Strong light affects the emotional content of a painting. If the light is cold, the reflections of skin tones will appear quite dramatic, and the shadows sharp and angular. Vivid colors emphasize a fresh, modern character.

Unusual color
The washes of French Ultramarine and Winsor Green create both a cool, expressive mood and deep, receding shadows. The pure pigments are mixed on the paper to retain their optimum strength and luminosity.

Washes of French Ultramarine and Winsor Green create unusually strong and powerful shadows.

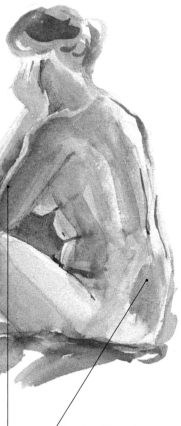

The effect of warm light
Warm light creates a golden atmosphere that affects each color and heightens the naturalistic tones of skin. Shadows are softer and less dramatic, but they still reflect unusual colors and create some interesting, striking effects.

Washes of Cadmium Orange, Alizarin Crimson, and Raw Sienna are used for the highlights.

Expressive color
Sharp contrasts in color and tone create vitality and movement in the composition. These qualities redefine the form and structure of the body as strong planes of bold color.

Translucent pigments
These pigments are overlaid on the paper so that they mirror the translucence of skin and glow gently to give a sensation of warmth and light.

Cadmium Red, Alizarin Crimson and light washes of Burnt Sienna give rich, warm highlights.

A mix of French Ultramarine and Winsor Green and dark washes of Burnt Sienna create subtly atmospheric shadows.

110

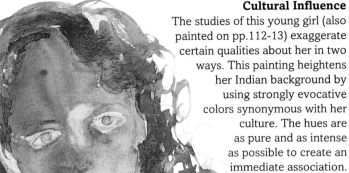

Interpreting form

These powerful hues interpret rather than describe the form and detail of the head. Some flat washes are overpainted with dark hues to suggest depth.

Bold shadows

The shadows around the neck are painted with strong, bold color that is as flat and expressive as the washes on the face. The cool quality of the green wash, however, helps it recede beside the brighter pigments of red and yellow.

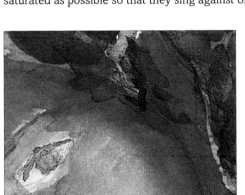

Cultural Influence

The studies of this young girl (also painted on pp.112-13) exaggerate certain qualities about her in two ways. This painting heightens her Indian background by using strongly evocative colors synonymous with her culture. The hues are as pure and as intense as possible to create an immediate association.

The purple wash is produced by mixing French Ultramarine and Alizarin Crimson.

Pure pigments of Cadmium Red and Cadmium Yellow are painted with loose brushstrokes.

Rich reds and purples dominate the picture and contrast effectively with washes of green and yellow.

Dramatic color

A limited palette of stronger colors will create a forceful statement. This painting exaggerates the youth and vitality of the girl, and colors are as saturated as possible so that they sing against one another.

Heightened color

The face is modeled with pure pigments to retain their maximum tinting strength. The intense wash of French Ultramarine in the background heightens the warm washes of Cadmium Red and Cadmium Yellow, so that they pulsate.

Color influence

The depth and shape of the face in this study is also built up with cool green washes of Lemon Yellow Hue and Winsor Blue that are more expressive than descriptive. The dress, mixed from Alizarin Crimson and French Ultramarine, and the green washes complement the yellow and red hues.

The limited range of fresh, saturated colors creates a dynamic visual impact.

Strong washes of adjacent color heighten one another.

PORTRAIT STUDY

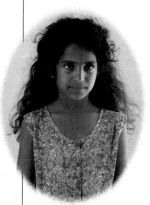

USING THE POWER OF SUBTLE COLOR to capture the mood and character of this young girl produces an interesting and evocative slant to a portrait study. The fluidity, subtlety, and translucence of watercolor combine with washes of slightly unnatural, expressive color to build up an impression of youth and a warm, rich atmosphere. The girl is lit in an interesting way, so that the shadows created affect the structure of her face, and colors from the surroundings are reflected in her skin tones.

The girl's rich skin tones are enhanced by the light.

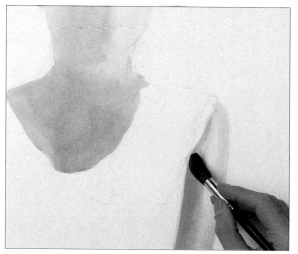

1 ▲ Sketch the features and proportions of the face, but keep them simple. As this girl's skin has a rich reddish brown quality, apply a light wash of Cadmium Red, Raw Umber, and Yellow Ochre with a wash brush, using sweeping brushstrokes.

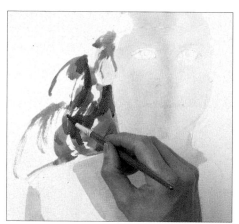

2 ▲ Use a medium-size brush, such as a No.7, to apply a wash of Vandyke Brown and Permanent Rose to build up the hair with rough, swift strokes. Adding Oxide of Chromium to Vandyke Brown cools the wash so that it recedes. Building up layers in this way creates a variety of tint and shade to produce volume in the hair and prevent it looking flat and heavy.

3 ▲ Mix together a large wash of Cadmium Red and Yellow Ochre and apply it with the medium brush around the neck and chest, to create angles and shadows. The jaw also needs to be defined against the dark tones on the neck. A touch of Oxide of Chromium helps the wash deepen and recede away from the highlighted jaw.

4 ◄ Develop highlights and shadows on the face with a wash of Yellow Ochre and Cadmium Red. Work around dark areas of the face, maintaining an even surface of color. Young skin is translucent and smooth, so allow the white of the paper to reflect through washes to create luminosity. Avoid uneven washes by using a wet, clean brush to blend any uunwanted marks.

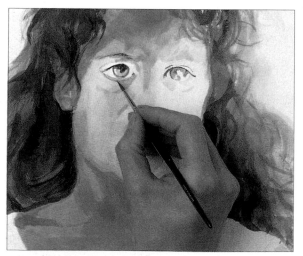

5 ▲ Use a fine, small brush for eye details. The eye is sphere-shaped, so use curved brushstrokes. Paint a faint wash of Cerulean Blue across the white of the eye to show the reflections of surrounding lights. Begin with light tints, and gently build up depth.

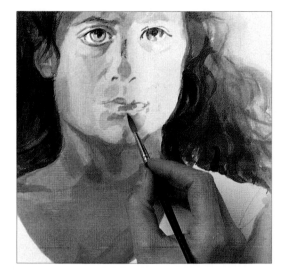

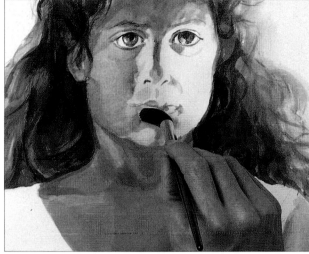

Color range

Tonal range

Vandyke Brown

Raw Umber

Yellow Ochre

Cadmium Yellow

Oxide of Chromium

Cerulean Blue

Permanent Rose

Cadmium Red

No.2 sable brush

No.7 sable brush

No.14 synthetic wash brush

6 ▲ Define and sculpt the lips with light tints and dark shades of Cadmium Red and Permanent Rose, using a medium brush. Soften the edges of the lips to blend them in with the rest of the face, using a clean damp brush.

7 ▲ Paint shadows and depressions around the mouth to give it more definition, but avoid overstating the lips. Mix a subtle blend of Oxide of Chromium with Raw Umber and Yellow Ochre to give a cool wash that will naturally recede into the cleft of the chin.

8 ◀ Paint a simplified pattern of the dress with pure washes of Cerulean Blue, Cadmium Red, and Cadmium Yellow. Mix some Permanent Rose with a touch of Chinese White paint, to create an opaque pastel-colored wash. Concentrate on creating a general impression of the dress pattern, rather than describing the intricate details.

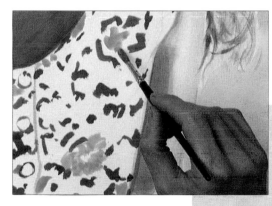

Portrait Study

Powerful interior lighting determines the mood of the painting and accentuates the highlights and deep shadows of the face and neck. Softer lights would smooth the planes and facets of the body to produce a gentler, more molded, effect. Flesh tones are influenced by the color of the lighting and the hues reflected from other objects. The color of the light also affects the highlights in the hair. Warm and cool washes, rather than harsh outlines, bring the face into relief.

Prominent areas of the face have warm washes containing Cadmium Red, which warms the pigments and makes them advance.

Shadows and depressions have darker washes containing Oxide of Chromium, a cool green, to help create depth and contrast.

113

COLOR AND PATTERN

INTRODUCING PATTERN AND SHAPE into a picture allows you to use color in an expressive and unusual way, freeing a work from a strictly descriptive realism. Color itself can become a repeating design, picking up on the light and the shapes of objects and translating them into flat planes of powerful color and suggested form. Stylized shapes and repeating patterns can also produce strong vibrant rhythms and symbolic imagery within a composition. Using pure color and repeating shapes in this way creates a stronger expression and lyricism.

Composing with shape and color
One of the easiest ways of building a series of repeating shapes and patterns into a painting is to concentrate on one still life in which the shapes of different objects echo each other. Using colors that relate to one another rather than to the natural color of these objects also conveys mood and movement.

Color themes
Colored lighting affects the mood and expression of a composition and establishes a strong theme through which to interpret objects and shapes, or emphasize their clarity in a particular light. A cool blue light over the same still life changes the mood and the detail of certain objects, projecting a sharp visual pattern.

Emphasizing shape
This painting, based on the still life above left, echoes and simplifies the effects of the warm yellow light over every object and exaggerates their cool violet-blue shadows. Repeating shapes and lines create a strong visual design, heightened by a limited range of strong, simple colors.

Interesting negative shapes and dark shadows create movement and depth.

Circles and curves repeat and echo each other across the paper. Small lines and horizontal planes of strong, flat color balance the composition.

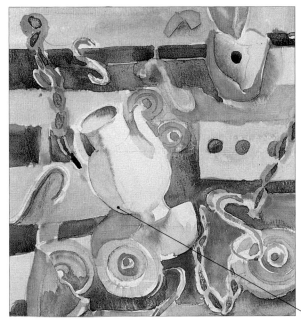

Stylized patterns

This picture stylizes the most obvious images of the still life and employs bold, flat, striking color to suggest their shape and form. Using just three strong colors creates a repeating pattern in itself, so that the same hues are used to imply both positive and negative shapes.

Painting from memory, or turning a picture upside down, can help reduce objects to their purest form.

Close up, objects lose their form and depth and become flat shapes of repeating color.

Restricting the palette to three dominant colors gives strong visual impact.

Random markings create a stylized pattern that becomes the most obvious link to the original vase.

The range of strong, cool, expressive colors pervades the work with atmosphere and mood.

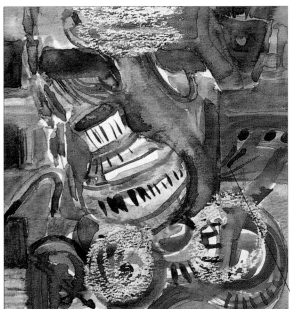

Atmosphere

This work captures the pervasive mood created by the cool blue lighting of the second still life. The painting emphasizes the lines and shapes produced by the interaction of new cool hues, ignoring the relationship and position of objects within the original composition.

Cool greens and blues, such as Terre Verte and Cobalt Blue, mingle with the cool, unsaturated hue, Indian Red.

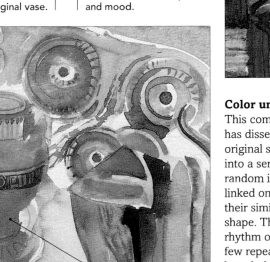

Color unity

This composition has dissected the original still life into a series of random images linked only by their similar shape. The rhythm of a few repeating hues hold these disparate images together.

Strong repeating hues link individual shapes.

Complementary reds and greens enhance each other.

Objects become floating shapes, stylized as pure form and line.

PATTERN IN LANDSCAPE

The inspiration for this painting came from stained-glass window studies of a waterfall.

USING PATTERN AND TEXTURE in a painting allows you to exploit the full potential of expressive, pure color. The pattern in this work is composed of a series of recurring shapes, lines, and tones, which can all be determined and defined by color. By using a variety of different brushstrokes, you can create a visual tapestry of dots and lines that will have the appearance of random patterning. This landscape is inspired by a stained-glass image of a waterfall, but you can use your imagination to combine negative shapes and texture with unusual colors to express your own ideas and interpretations.

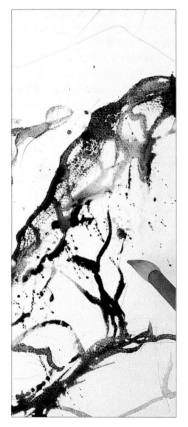

1 ◀ The aim of this painting is to work quickly and fluidly, building up a web of textural marks and accidental patterns. Develop a basic composition with a dark wash of Prussian Blue, Sepia, and Cadmium Red, using a large brush; Chinese brushes are particularly good for expressive lines of color. Load the brush with the wash and paint sweeping brushstrokes over the paper. Flick the brush occasionally, to give random spatterings and splashes. The rough, textured paper is strong and not immediately absorbent, so pigments sit in patterns on the surface.

2 ◀ Drag the brush lightly across the rough surface, so that it picks up the grain of the paper. Mix Cobalt Blue and Prussian Blue for a dramatic sky. Use strong, rich washes of exaggerated color. Try to maintain the freshness of the picture by not overpainting or adding too many layers of different color.

3 ◀ Blend the various markings together with a wash of Yellow Ochre and Cobalt Blue. This mix produces a dark green mossy hue, rather than a harsh vibrant green. Using a wet-in-wet technique and a fine brush will create random patterns.

4 ▶ Add pure dabs of Carmine to the horizon to produce a dramatic contrast with the earthy colors of the mountain banks. While the wash sits on the surface of the rough paper, manipulate it randomly with a small Chinese brush into abstract shapes and lines. The rich Carmine pigment creates an unnatural, almost fantastical, horizon against the surrounding darker washes. The effect is a two-dimensional pattern of strong, pure colors.

5 ◄ Strengthen the bank on the far side of the waterfall with a deep, saturated wash of Prussian Blue, using a large brush. Try holding the brush as upright as possible to paint unrestrained and interesting shapes, rather than careful, deliberate strokes. Drag the brush from the top of the waterfall, pushing the wash as far as possible in one continuous line of free movement down the length of the paper.

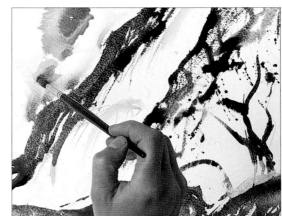

6 ▲ Wet the left side of the painting with water, and apply Yellow Ochre with a medium size brush, so that each brushstroke takes on a blurred, abstract look and spreads randomly over the paper.

Pattern in landscape

Random patterns of dark pigments give striking negative shapes and evoke a craggy landscape. Areas of broken color echo the natural patterns of the landscape while creating unusual and dramatic color combinations.

The whole landscape is made up of a visual pattern of individual dots and lines.

The painting allows color to further define the patterns inherent in nature.

The strength of each hue is heightened by visible areas of white paper.

Materials

Color range

Tonal range

Yellow Ochre

Sepia

Cadmium Red

Carmine

Cobalt Blue

Prussian Blue

Sponge

No.7 sable brush

Small Chinese brush

Large Chinese brush

117

GALLERY OF PATTERN AND SHAPE

B Y CONCENTRATING ON PATTERN and shape in a painting, these artists have escaped the confines of realism to celebrate the power of pure shape and color. The English artist John Sell Cotman painted intricately detailed areas with subtle dark hues that contrast with the rhythmical patterns of bold color by the French artist Sonia Delaunay.

Soft, luminous shadows are repeated across the painting to give the composition depth. Structural details are simplified and enhanced with glowing color.

Areas of the painting are covered with broken color and suggested shapes. Cotman preferred not to define intricate details that could swamp his subtle rhythms.

John Sell Cotman, *Doorway to the Refectory, Kirkham Priory, Yorkshire,* 1804
Cotman had a fine sense of structure and pattern in his paintings. He created these elements by contrasting dark silhouettes against light areas and by using soft, luminous hues in darker areas. Dark leaf shapes cover the right side of the paper in a rhythmic pattern, while repeating colors shine through the dark shadow on the left. Cotman tended not to swamp the expression of a work with too much detail, so areas of broken color give substance to his composition. Brickwork details to the right of the doorway add definition to the painting. The flat luminous wash on the top left is also broken up into surface pattern by the faint brick markings.

Sunlit areas of skin glow with luminous yellow washes, complemented by cool violet-blue shadows.

The painting is dominated by repeating circles and patches of light.

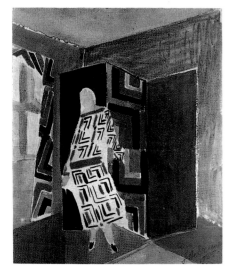

Sonia Delaunay, *Woman*, 1925
Delaunay, with her husband Robert, embodied the new dynamism of art at the start of the twentieth century. She celebrated a modernity of pure color and hue, developing an expressive style of abstract geometric form and pure pigment. These colors have a direct, liberating impact, creating rhythm and movement. Rich reds quicken the patterns, while geometric abstractions and dark areas repeat and echo across the painting.

Rachel Williams, *Valley Below*
This painting illustrates how pattern and shape work in the form of pure stylization. The artist has built up a series of simple, yet dramatically exaggerated, shapes and planes of color. Mountains and trees have been reduced down to their most basic, or symbolic, forms. The receding blues, warm greens, and yellows define shape and rhythm rather than depth and space. Curved brushstrokes and patterns within the stylized shapes echo the rhythms of nature and give the painting movement and energy. The river is painted as an exaggerated, simplified plane of color, leading the eye into a complicated rhythm of organic shape and dramatic form.

Philip O'Reilly, *Siesta*
O'Reilly structures his pictures with contrasts of deep color and intense light, surrounding strong shapes and patterns with soft texture. The exaggerated perspective of this work forces the eye to focus on circular patterns and horizontal lines over and around the sleeping figure. Hazy, undefined areas of color drift out to the edges, diffusing the bright light shining through the window. A strong interplay of warm and cool color defines the depth and structure of the painting.

Childe Hassam, *The Island Garden*, 1892
Hassam, one of the most impressionistic of American watercolor artists, captured nature spontaneously, evoking the fleeting effects of light with vivid color and pattern. This work is typical of his unusual approach of closing in on a scene to produce a flat, two-dimensional image of dots and lines and intense colors.

119

ABSTRACT COLOR

Dynamic color evokes a powerful reaction.

ABSTRACT ART PULLS AWAY from reality and returns to the essential questions of light, space, form, and color. It relies for its meaning and message on sensations of line and form and emotive color associations. Abstract paintings can be composed in a number of ways – here, the first painting has been built up of invented shapes that do not have any conscious association with the real world, while the second painting distills the natural appearance of a mountain scene into a lucid composition of shapes and colors that evoke its essential character. Colors can be at their most dramatic or their most sublime in these abstract paintings, influencing the expression and energy of each work.

Original Abstract

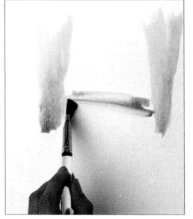

1 ◀ Using heavy, textured paper to withstand the wet washes, apply saturated washes of Permanent Rose and French Ultramarine with a large brush. The composition develops from the spontaneity of the wet washes and is free from any real associations. The range of colors used should be purely expressive, and the brushstrokes painted automatically.

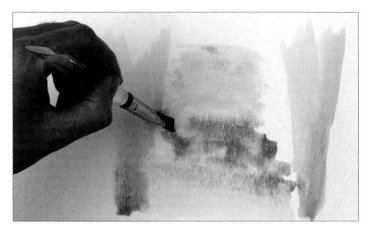

2 ▲ Add washes of Cadmium Red to the composition and let the wet edges blend with the areas of French Ultramarine to produce a subtle shade of violet. Mix the colors on the paper rather than on the palette, so that the washes will retain their luminosity. Abstracts rely more significantly on tone, light, and harmony to give rhythm and definition to the composition.

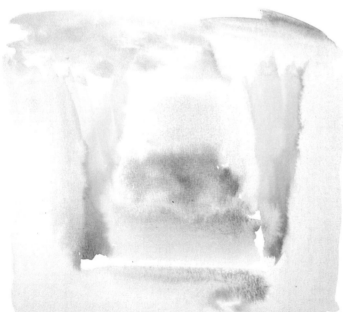

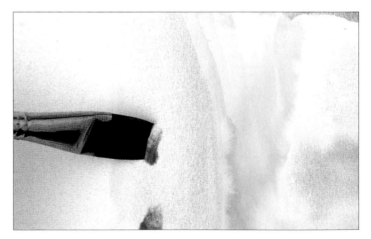

3 ▲ The three pigments form a basic composition, hinting at shapes and with light and dark areas starting to form in the wet pools of the washes. A sponge or piece of paper towel dabbed lightly on different areas of the painting creates further unusual shapes and highlights. These unfamiliar free forms give the painting a less realistic feeling.

4 ▲ Add a strong wash of Sap Green to the painting with a large brush. The dabs of green pigment around the edge create a repeating, patterned effect that breaks up the smooth flat washes of color giving the composition movement and rhythm. The green contrasts with the Permanent Rose so that the two colors increase and enhance each other's intensity.

5 ▶ Apply final washes of intense Cadmium Red and French Ultramarine as random shapes, free from any themes or motifs. The strength of the red pigment provides a focal point for the composition and also complements the French Ultramarine washes, so the painting relies for its strength and impact on two sets of complementaries. The initial lighter tones now add to a sense of space and depth, while the stronger final washes pulsate toward the front of the painting. The powerful areas of vivid red create a fast tempo countered by quiet passages of light color.

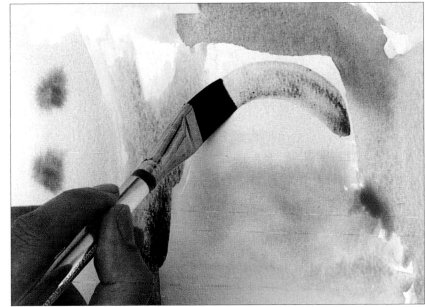

Materials

Color range

Tonal range

French Ultramarine

Sap Green

Cadmium Red

Permanent Rose

Ivory Black

Turquoise

Raw Umber

1in synthetic brush

Original Abstract
Invented forms and shapes are suggested by loose washes of color. The abstraction is heightened by the spontaneous and accidental effects of a wet-in-wet technique. Washes merge freely and settle randomly.

A mixture of dynamic color and quiet, subtle hues create a sense of space and light.

The range of tones and two sets of complementaries enhance the movement and rhythm of the composition.

Abstraction From Nature

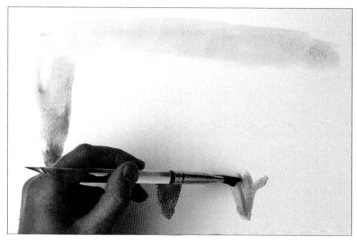

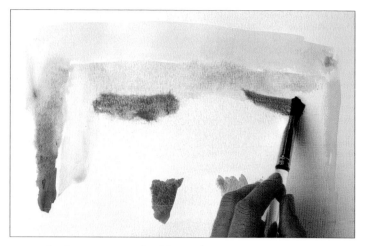

1 ▲ This second painting abstracts a mountain scene, painted from memory, so that the composition is pared of detail and reduced to its essential character. Apply a pure wash of Turquoise with a large brush around the edges of the painting, to symbolize the sky and give an initial sense of space and light.

2 ▲ Apply a strong wash of Sap Green with broad brushstrokes to the central area of the composition. Keep the wash as bright as possible, so that it symbolizes the freshness of green vegetation. Then paint a lighter wash of Sap Green and Ivory Black over the white of the paper, to signify the shape of the mountainside.

3 ▲ Paint the simplified shape of a green tree at the right side of the mountain. Give the tree more interest and definition by adding a few light strokes of Raw Umber on top of the green image. Painting objects in their most stylized form gives them a universal symbolism and frees the painting of any specific references.

4 ▲ Glaze over the strokes of Sap Green and Ivory Black with a lightly tinted wash of Raw Umber, to subdue the intensity and coolness of the purer paints. This will help both to warm up and harmonize the other washes of color, and give the composition a feeling of space and air.

5 ◄ Lightly paint suggested forms and objects, such as birds and bushes, with a wash of Ivory Black. This will also break up the flat washes and create more interest. These stylized shapes and images also give the composition a greater range of imagery and interest. Add another wash of Turquoise to the sky, if it appears too pale against the other hues.

Abstraction From Nature

The features of this subtly atmospheric landscape are stylized into their most basic form and represented by symbolic color. This abstracts the painting away from its subject matter and turns it into a stylized image of a mountain.

Light washes of flat color eliminate any sense of depth and perspective.

Tinted hues merge together to give a feeling of stillness, space, and light.

The lack of harsh lines enhances the sensation of continuous space.

COLOR SYMBOLISM

Color is regarded as a universal language, suggesting and expressing a multitude of immediate visual associations and instinctive emotions. Color symbolism is based mainly on associations derived from nature and religions, so it can be used in art to evoke powerful responses. In the twentieth century, western artists have reaffirmed the primitive emotional powers of color in their work.

Green is an ambivalent hue, associated with poison, envy, jealousy, and decay, and also of rebirth, Spring, restfulness, and security. Green was traditionally worn as a symbol of fertility at European weddings.

Red is the strongest color in the spectrum, and it evokes powerful emotions; it also symbolizes love and passion. It can be warm and positive, yet provocative and angry. The Chinese consider red auspicious.

Black is a traditional symbol of evil. It also has ominous, mysterious associations, such as death and the unknown – a black hole in space, or a black mood. Black, however, is also seen as sophisticated.

Orange is striking and sharp, like the color and taste of the fruit. Warm oriental spices such as turmeric and saffron exude orange. In the East it has religious overtones; Buddhist monks wear saffron robes.

Blue evokes tranquility, giving a feeling of space and height. It is emblematic of truth, divinity, and spirit. Despondency is also expressed in the term "the blues." American Blues music expresses sadness and despair.

White symbolizes good as black symbolizes evil. It can suggest the ethereal through its association with purity, innocence, and cleanliness. However, it also has associations with cold, unemotional qualities.

Violet is considered enigmatic. The Christian church uses violet for some of its ecclesiastical ceremonies to symbolize the passion and death of Christ. Purple is also used to suggest royal connotations.

Yellow, with its warm qualities, is evocative of Spring and Summer. It thus symbolizes joy, youth, renewal, and growth. By contrast it is also associated with sickness and cowardice.

GALLERY OF ABSTRACTS

THE ABSTRACT STYLE evolved as a modern twentieth century reaction to traditional European concepts of art as an imitation of nature. The American Sam Francis and the German Max Ernst used symbolic color and non-representational forms to articulate their vision of the world.

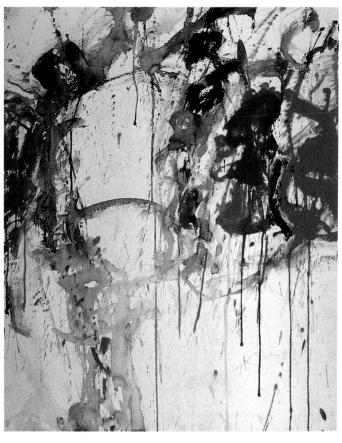

Sam Francis, *Watercolor Painting*, 1957
Francis deals with light rather than the reflections of light, and his hues are saturated without losing their luminosity. Reds and blues create movement, and rivulets of color signify chance meetings in silent space.

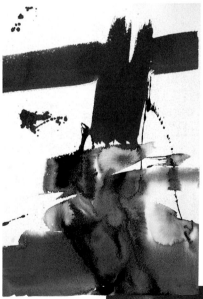

Gisela Van Oepen, *Watercolor No.564A*
Van Oepen relies on pure extremes of color and form in her abstract paintings. In this work she uses white expanses of paper to produce a balance of undefined space around a structure of powerfully bright hues. Contrasting hues of intense orange and blue recede and advance across the paper, while a small touch of vibrating red heightens the visual impact of line and color.

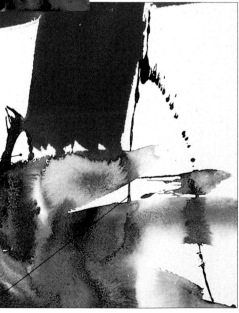

Areas of white space become an integral part of the composition, focusing attention more intently on the reaction of blue and orange complementaries.

Pure extremes of line and color determine the visual impact and strength of this painting. The proportions of each color are carefully balanced in the composition.

Max Ernst, *Landscape*, 1917
Founder of the German Dada movement, and later cofounder of the Surrealists, Ernst was one of the most successful early twentieth century artists to translate the ideas and dreams of the subconscious into art. His artistic desire to liberate the unconscious mind led him to produce some mysterious and beautiful images. In this painting, Ernst's fantastic colors and strange imagery predominate. The rich, saturated, luminous violets pulsate at the center of the composition. The strong harmony of adjacent colors that illuminates the painting shows Ernst's skill at combining theory and artistic instinct.

Christopher Banahan, *Venice*

Banahan has picked out the essential features of these buildings and abstracted them down to simplified images. These basic forms create an independent structure of shapes and colors that have an aesthetic appeal in their own right. Banahan aims to create an ethereal quality about his paintings, allowing the lyricism of his colors to describe the sensations of the painting. Deep shades of dark blue contrast with tints of mid-blue, creating a subtle harmony. These darker passages enhance the lighter areas so that they glow gently and give the painting a soft illumination.

Subtle variations of blue create a strong expression of mood and emotion.

Objects derived from nature are simplified into basic shapes and become unrecognizable.

Rich luminous colors enhance each other to create visual impact and strong sensations.

Ernst frequently used exaggerated shapes and forms to express his subconscious.

Carol Hosking, *Equilibrium*

Hosking's main influences are color and music, which combine with chance effects to give an experimental range of color, movement, and form. Hosking works intuitively with no preconceived ideas, so that her paints will flow freely and spontaneously. In this picture, universal shapes and symbols drawn from nature are painted with a smooth blend of colors. The strength of each pigment is controlled to avoid any dominating hues.

WATERCOLOR
LANDSCAPE

WATERCOLOR PAINTING has many attractions for the landscape painter. The materials required are simple – a few brushes, paint, and water – which means your artistic kit can be carried anywhere, while the fresh spontaneous quality of the paint makes you long to rush outdoors to capture the fleeting light and subtle shades of the landscape with free brushstrokes. Watercolor is also a medium that encourages you to draw as you paint, so keep a sketchbook handy. In this section landscape composition is explained and technical tips are given. Illustrations of historical and modern works of art are used to both inform and inspire you in your progress. Once you have practiced the basic techniques, you will soon be capable of painting skillful and professional landscapes.

GETTING STARTED

CHOOSING A LANDSCAPE to paint may be somewhat daunting at first. Try not to worry about the right "artistic" view; it is fine to work from a photograph or a postcard if you have one that you like. Starting in this way will allow you to develop the confidence to take your materials outdoors later. Remember, you are practicing, so accept any mistakes as part of your learning process. Watercolor is a superb medium for conveying impressions, so do not be overly concerned about reproducing the details in your photograph. In these examples the artist has used sweeps of paint to capture the effects of light found in his photograph. Try not to use more than three colors in your painting; work from a limited palette. Initially, apply the paint with a liberal quantity of water on your brush to keep the color pale. At this stage it is easier to darken the tone once the first layer of paint has dried than it is to lighten it after it has been laid on the paper.

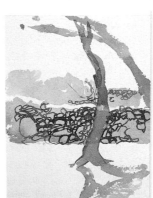

Colors at sunset
Only three colors have been used in this painting. The first application was Cadmium Yellow, followed by Alizarin Crimson, then French Ultramarine (referred to throughout as Ultramarine). Part of the first wash was left uncovered to create the light of the sun and its reflection.

Wash over pencil
Working from a photo the artist has done a pencil outline on the paper, sketching in the trees and the contours of the land. He has used a wash of Naples Yellow over the mountains. Some of the trees have been painted in Sap Green but others were left unpainted, giving the work a fresh, spontaneous look.

Monochrome study
Alizarin Crimson and Ultramarine have been mixed to create a mauve for use in this monochrome study. Subtle mixing of water and paint allows a variety of tones to be produced from one color.

Initial washes
The picture has been broken into three areas of color and the details sketched in with pencil. Sap Green has been applied to the land and Ultramarine to the sky and sea. The clouds and the sides of the buildings have been left unpainted so that the white of the paper serves to create their shape and form.

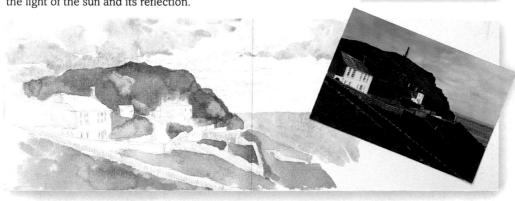

STRETCHING PAPER

Unless your paper is very heavy, you will need to dampen, then stretch the sheet against a board before beginning to paint. This process is essential since it prevents the paper from buckling when paint is applied.

1 *Cut the paper to the size required, and soak it in a flat tray for a few seconds.*

2 *Lay the paper on a board and, with a wet sponge, stretch it so that it is completely flat.*

3 *Tape the paper to the board with gum tape. Make sure it is dry before applying paint.*

BRUSHSTROKES

The technique of watercolor painting depends on a careful blend of color pigment with water and the skillful use of a brush to carry this mix across the paper. Some brushes will hold water freely, allowing a broad sweeping application of color; others are delicate enough to draw fine dry lines. Apply a basic wash with a thick brush, then use smaller brushes to overlay colors and tones. Synthetic brushes are fine for most manipulations.

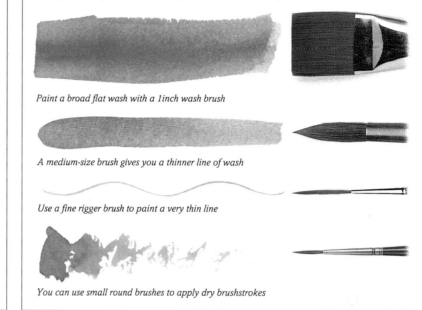

Paint a broad flat wash with a 1inch wash brush

A medium-size brush gives you a thinner line of wash

Use a fine rigger brush to paint a very thin line

You can use small round brushes to apply dry brushstrokes

National park
Here the valley and the outlines of the trees have been drawn in using fine lines of deep Ultramarine, then a pale tone of Sap Green is washed over the land and trees. Further layers of green have been added to deepen the color.

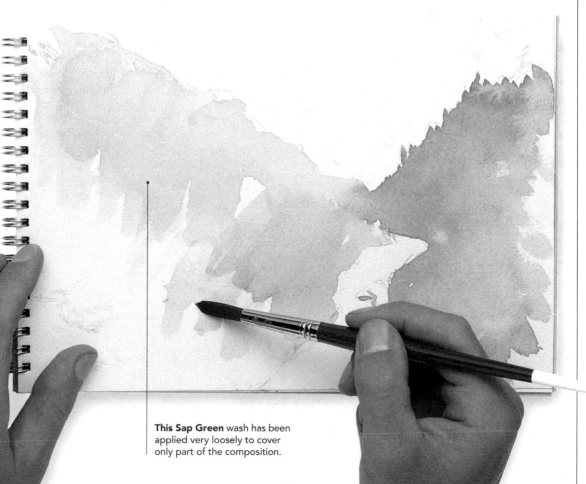

This Sap Green wash has been applied very loosely to cover only part of the composition.

VENTURING OUTSIDE

PAINTING FROM A PHOTOGRAPH is a good way to practice handling watercolor. Once you have more confidence in your painting ability, you can venture outside. Look out your window or take a walk in the park to observe how the sun alters colors. Note the different hues of shadows. Become aware of the balance between trees, hills, spires, buildings, and the horizon. Use a viewfinder to help train your eye in composition and abstracting details of the landscape. Try sketching some of these scenes before you begin to paint.

CARDBOARD VIEWFINDER

You can construct a very simple viewfinder from two L-shaped pieces of cardboard. To use the viewfinder, hold it at eyelevel, about 6 to 12 inches away from you, and move it around until you find a pleasing composition. Adjust the viewfinder to make a portrait (vertical) or landscape (horizontal) frame. When you have decided on the focal point of your composition, judge the balance of the surrounding shapes, taking care that they form a rhythmical pattern that surrounds and enhances the main focus of your study.

From stiff card, cut two L-shapes to a length that suits you. A rectangular shape is more versatile than a square.

Arranged like this, the Ls can be adjusted according to the size of your subject.

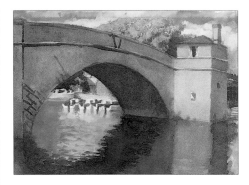

View through bridge arch
The bridge has been placed high on the paper so that its reflection echoes and accentuates the pleasing shape of the arch. The arch fills the width of the paper, making the view beneath it the focal point.

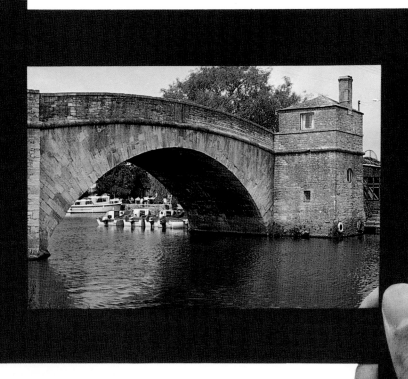

Arranging aspects of the panoramic view
As one composition, this view is far too large for a first landscape study, but it does offer a variety of studies. Section the landscape with a cardboard viewer, and consider the many scenic options before you start sketching or painting.

Figure study
This composition has a seated man as its focal point. He has been placed slightly off-center, an arrangement that allows the viewer a sense of the peaceful space that surrounds the figure. Note how the light falls on the back of the head and shoulders, in contrast to the shadows of distant trees and the reflection of the boat.

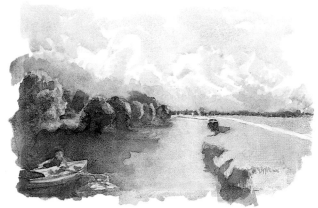

MEASURING

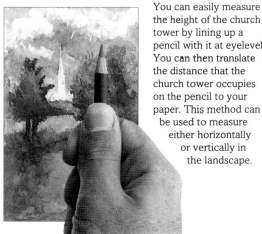

You can easily measure the height of the church tower by lining up a pencil with it at eyelevel. You can then translate the distance that the church tower occupies on the pencil to your paper. This method can be used to measure either horizontally or vertically in the landscape.

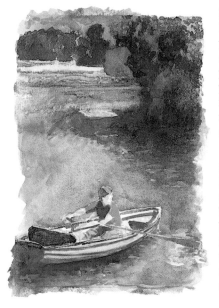

Landscape format
Here, the rowing boat has been placed in the foreground of the composition to provide the major point of interest. The rower is painted to give the impression he is moving across the picture. The river and path emphasize and continue the line of movement.

Portrait format
In this composition the man and boat are prominent, not only because they are in the foreground but because the light exposes them in clear tones while the encircling trees and water reflections carry darker tones in a subtle curve of shadow that enhances the boat.

Scale in the panoramic view
It can be difficult finding the proportion of things in the airy space of the landscape. Choose a baseline – the horizon or river bank – and then use your pencil to measure the heights of trees and buildings from that baseline.

MONOCHROME STUDY

Color photograph
You can use a photograph for this exercise in monochrome. Try to look beyond the color and analyze the picture in terms of light and shade.

IN WATERCOLOR PAINTING the tone of a color pigment is altered by the quantity of water mixed into that color. Thus Ultramarine, when mixed with a good quantity of water, makes a pale tone of blue, while a more even ratio of water to Ultramarine will make a vibrant blue. Once a color has dried on the paper, it is not possible to lighten it. So, when you start working on a painting, keep the color mix very watery. To darken the hue, paint one wash over another until you find the tone you want. A monochrome (one color) study demonstrates this essential characteristic of watercolor. Follow the steps given here, using Raw Umber.

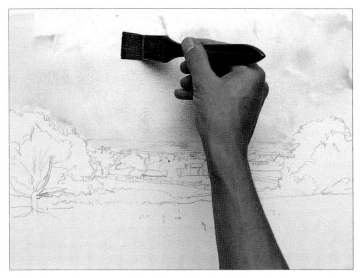

1 ▲ Draw the composition in pencil, simplifying the shapes of the trees and hills, ignoring details. Using a large wash brush, mix a small quantity of Raw Umber with water. Wash this pale tone across the sky, using a broad, sweeping stroke. Observe where the natural light lies, and leave those areas unpainted.

2 ▲ Select a slightly smaller brush, such as a No.10. Make a stronger tone by adding more color to the water. This darker tone is washed over the tree forms and foreground, but because light falls on the fields in the center of the composition, these are left unpainted.

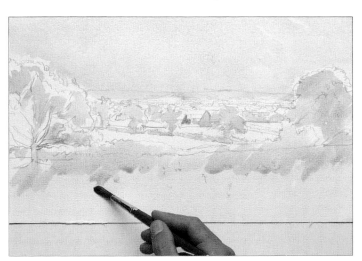

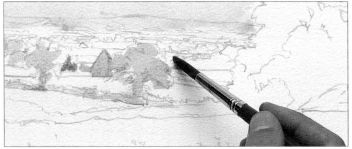

3 ▲ Mix a darker tone. Use this to define the foreground trees on the left and right, then wash the tone over the ground line between these trees. The same tonal mix can be used to block in the tree line in the middle distance. Use a wet brush and apply the color with smooth, regular brushstrokes.

4 ▶ Mix a strong tone to define the curve of the land between the trees and to deepen the foliage in the foreground and midground. Be bold in the strength of the tonal mix and use quick, short brushstrokes to give texture to the shaded areas of trees and earth.

Raw Umber

No.10 brush

1 inch wash brush

APPLYING WASHES

A wash is a thin layer of paint on the paper. It is the basic technique of watercolor painting. A wash can form one smooth tone, or the color may be graded into various tones, depending on the brushstroke that is used. This build up of layers of wash controls and transforms the translucent colors that characterize watercolor painting.

Adjacent washes
Paint a very dark flat wash with a very dry brush. Let the paint dry. In an adjacent unpainted area, apply a paler wash, pushing the paint toward and against the edge of the first application, but not over it. Repeat this process using successively paler washes. Each wash must dry before the next is begun.

Overlaid washes
With a thick brush, apply a light wash of uniform tone. Wait for it to dry. Using the same tone, apply a second wash but only partially cover the first area of wash. Repeat the process. You will see that the areas covered by layers of wash darken with each application. This method allows some control of tonal effects.

Graded wash
Apply washes quickly with a thick brush, working from the bottom of the page. Use a wash of almost pure color, then add layers of wash, each one more watery than the last. The top of the page will be light, and the base will be dark. Reverse the mix process – start watery and add color – to move from light top to dark base.

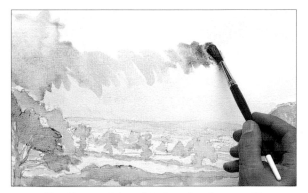

5 ▲ The first wash has dried on the sky area. Keep the tone used in Step 3, and use the brush in brief, jabbing strokes to illustrate the cloud formation across the sky. Where the first wash is not painted over, the tone will remain light, so this second wash will define the shape of clouds against the clear sky.

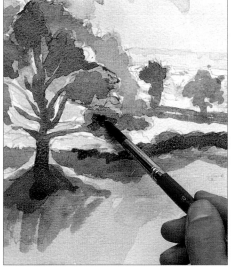

6 ◀ Mix a bold, deep tone, and with a fairly dry brush, start to paint in some details. Foliage can be given subtle tonal effects, while the branches and tree trunks are painted with a stronger mix of Raw Umber. You will see that the building up of particular areas and the emphasis on certain forms improves the perspective, as does the the increased contrast between light and shade. This contrast is fundamentally important in producing an effective monochrome.

7 ▲ Should you decide that parts of the sky need to be lightened, moisten the relevant areas with a wet, soft brush. Dry the brush, then use it to lift the newly wet color off the page, or use a sponge.

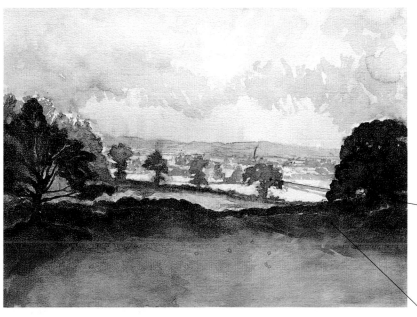

Tonal study
Layers of differing tones have been used in this painting to create, from one color, a sense of light and space.

These trees have been painted with a tone that defines the light on the fields beyond them, while emphasizing the dark trees in the foreground.

A light wash in the foreground is gradually covered with darker tones. These reflect the angle of the slope in the front of the composition.

MONOCHROME GALLERY

MONOCHROMES REVEAL the tones – the light and shade – of the world and so present a challenge to the artist's eye. Claude Lorrain observed complex tonal values, which he painstakingly reproduced in his works, while John Constable preferred to sketch his tonal paintings rapidly. Here are a range of monochromatic approaches.

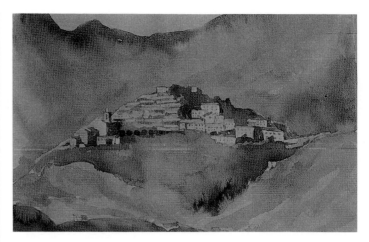

Ray Smith, *Monochromatic Study*
A distant village is seen as a group of cubes, clearly exposed in a pale light and forming the central focus of the composition. The artist has achieved a profound sense of space in his composition by his massing of dark tones, arranged to hold the lonely town within the grand scale of the mountains and valleys.

John Constable RA, *Bridge with Trees and Building at Haddon,* 1801
Constable preferred to paint outdoors where he could capture the fleeting effects of light. He favored oil paint, employing swift vibrant brushstrokes to capture color, but a gray and misty English morning of subtle light and little obvious color inspired this watercolor monochrome. A series of washes has been painted quite loosely, yet with masterly restraint, over a pencil sketch. The brushwork may seem slight, but there is not one superfluous brushstroke or tone in the entire painting.

The basic shape and some of the details of this stone bridge have been drawn with superb economy.

These washes illustrate the precision with which Constable balanced areas of light and shade.

Tim Pond, *Mountain Landscape*

Composition and tonal values combine to make a powerful spatial statement in this landscape study. The rhythmical contour lines, represented by clearly contrasting tones, also serve to create space and distance. There is no obvious focal point, but the eye is led gradually to the deep shadows of the central valley before moving to the paleness of the horizon.

The artist used toned, textured paper to complement the gray of this monochrome. This detail shows the subtlety of the layers of wash.

Broad washes of warm, dark gray are merged into black. White gouache has been added to enhance areas of light.

Claude Lorrain, *View of the Tiber from Monte Mario*, 1640

One of the greatest of watercolorists, Claude Lorrain introduced innovative wash techniques. In this powerful monochrome, the tonal values are very complex, portraying many changes of light within a vast and spacious landscape. Claude has left each wash to dry before applying the next, a system that let him build up, layer by layer, section by section, the most subtle variations in tone.

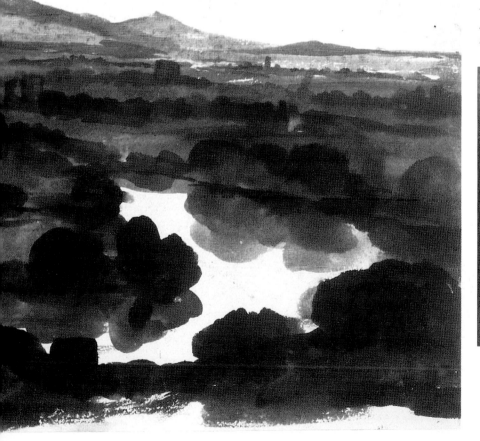

Bold, rich brushwork reveals a brilliant control over layers of wash. Study the tonal blending and note the inspired decision to leave the river surface unpainted.

RECEDING COLOR

Vacation shot
Photographs make a good starting point and can help you remember a scene or decide on how best to compose your picture once you have returned to your studio.

THERE IS A PAINTING CONVENTION, based on observation, that close objects have defined shape and detail and are strong in tone and color, while distant objects become weaker in color. This is known as "tonal recession." Landscape painting depends on this use of color and tone to create a sense of space. You need to learn which colors will recede and which you can use as strong advancing colors.

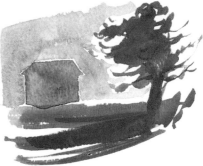

Red and blue
A warm color such as red will appear to advance, while a cool color such as blue will appear to recede. Here, the red house stands out against a blue sky.

Red, yellow, and blue
Adding yellow alters the space. The advancing red recedes when juxtaposed with the warmer tones of the tree.

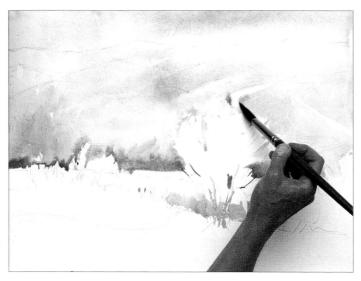

1 ▲ With a large brush, perhaps a No.14, apply washes of Ultramarine to the sky. The first wash must be almost pure color, the following washes have more and more water in the mix to achieve a dark horizon. Leave unpainted glimpses in the sky.

OVERLAYING COLOR

The transparency of watercolor allows the color of one wash to show through the layer painted over it. This is how tonal variation is achieved in this medium. Allow each wash to dry before applying the next, or else the colors will bleed or turn muddy.

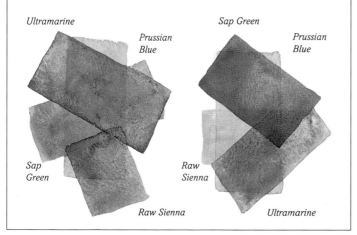

Ultramarine

Prussian Blue

Sap Green

Prussian Blue

Sap Green

Raw Sienna

Raw Sienna

Ultramarine

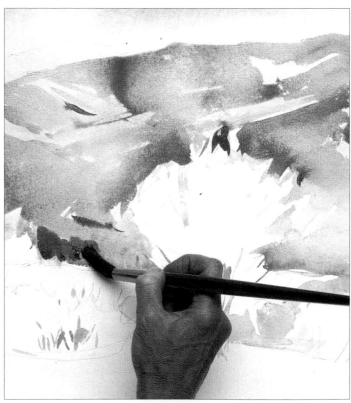

2 ▲ Let the Ultramarine wash dry. Prepare a watery Sap Green wash to represent the mountain shape. You will alter color and tone as you overlay the sky wash so, as the cool blue recedes, the mountain assumes form and height. The wash tends to "pool" when the brush is lifted off the page so use sweeping strokes.

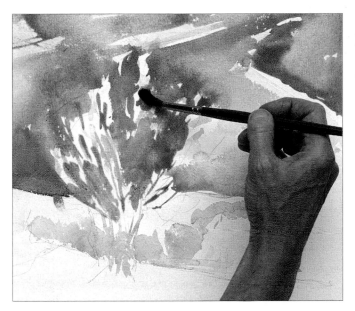

3 ◀ Allow the Sap Green wash to dry. Mix a Sap Green wash using less water than before. Choose a small brush, about a No.9, and with free strokes apply this wash to the tree. As it washes over the edge of the first green, a dark tone will outline the tree.

4 ▲ A pale wash of Prussian Blue is laid over the horizon just above the Sap Green of the mountains. This layer of Prussian Blue darkens the Ultramarine wash, but is still weaker in tone than the mountain Sap Green. See how this tonal variety in receding color gives a sense of space.

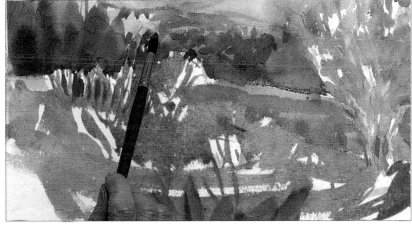

5 ◀ With a large brush, apply a watery wash of Raw Sienna to the foreground. Use broad brushstrokes. Let the wash dry. Mix a saturated wash of Sap Green and one of Raw Umber. With a fairly dry brush, add details to the objects closest to you – the foliage and the foreground.

Materials

Prussian Blue

Raw Sienna

Sap Green

Ultramarine

No.2 brush

No.14 brush

Warm and cool color
The washes in the midground have been layered to develop an interesting range of cool and warm colors. Varying tones create perspective and give a spatial quality to the study.

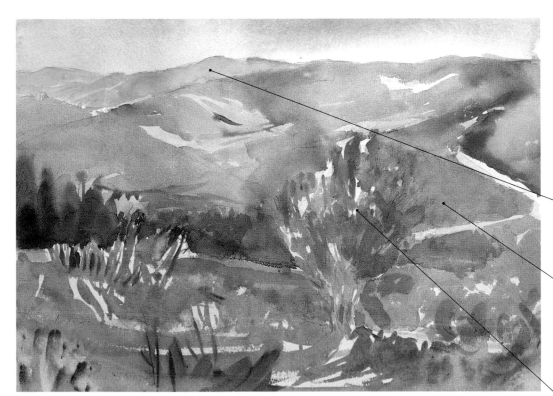

Areas of the Prussian Blue wash have been darkened to suggest another mountain and to create another level of recession.

The receding depth of the painting has been created by a wash of Prussian Blue behind the tree.

Raw Sienna and Prussian Blue have been applied to the tree to give it detail and form. To add textural interest, some of the Prussian Blue was lifted off with a dry brush when the paint was still wet.

LIMITED COLOR

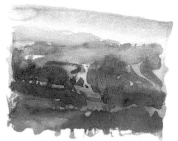

Planning your colors
Make a rough color sketch to work out which color mixes will work best, and where.

ONCE YOU HAVE MASTERED the principles of color, you will realize that it is not necessary to invest in a huge selection of color pigments – despite the fact that, as you look out the window or walk down a country lane, your eye is observing a multitude of colors and tones. In the exercise on this page, only seven colors are needed in your palette. By mixing these, you can greatly extend your color range. When you paint outdoors, consider the seasonal light and ensure your limited palette fulfills your needs – warm colors for summer, cooler tones for winter.

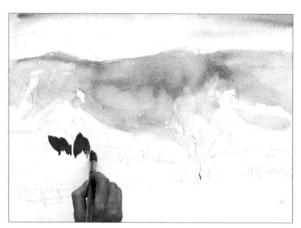

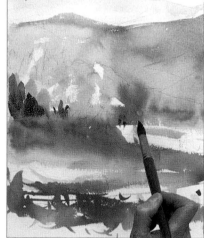

1 ▲ Apply Lemon Yellow to the sky, then Indian Red and Cadmium Yellow to the hills. Mix Cadmium Yellow and Alizarin Crimson for the foreground details.

2 ▶ Wash a watery mix of Indian Red and Viridian over the hills. With less water, wash an Indian Red and Viridian mix over the tree shapes in the mid-foreground.

3 ▲ Paint in the mountains with a mixture of Lemon Yellow and Prussian Blue. Then work a mixture of Viridian and Indian Red, with a bias toward the red, into the tree. The outline of the tree is a mixture of all the colors in the palette.

COLOR MIXING

In watercolor, you create your colors by judicial mixing, but the tone – that is, the intensity of the color – is determined by the amount of water that is added. Successful color mixing can be achieved through experimentation, but an informed choice of colors is an asset for achieving the most intense and effective of results. Practice the mixes given below, and as you progress you will learn to control the natural bias, mixing, for example, a bright red with a light blue to create a pale violet.

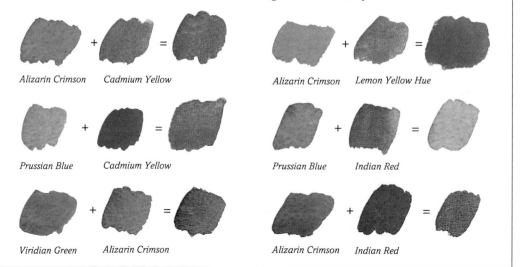

Alizarin Crimson + *Cadmium Yellow* =

Alizarin Crimson + *Lemon Yellow Hue* =

Prussian Blue + *Cadmium Yellow* =

Prussian Blue + *Indian Red* =

Viridian Green + *Alizarin Crimson* =

Alizarin Crimson + *Indian Red* =

4 ▲ While the last wash is wet, give detail to the foreground with a mixture of Alizarin Crimson, Indian Red, and Cadmium Yellow. Use a fine brush, and apply with quick, short strokes to indicate foliage.

Materials

5 ▶ Paint a wash of Prussian Blue over the dry wash on the mountains. Wash the lower hills with Lemon Yellow Hue and then wash Prussian Blue over the top. Gently wash the upper hills with Prussian Blue and Lemon Yellow Hue.

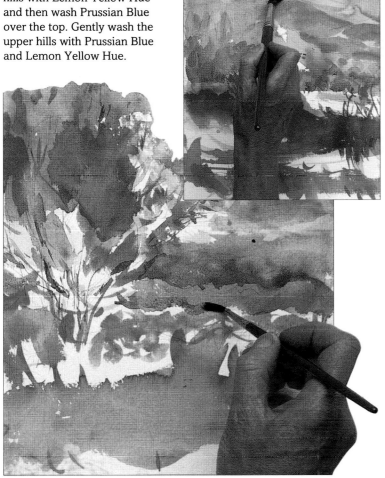

6 ▲ Paint a Prussian Blue wash on the mid-ground hills with a medium brush, perhaps a No.9. Use a watery mix to paint over the earlier, now dry, wash. This will bring the tree into sharper definition. Build up the tree's shape with a mix of Alizarin Crimson and Cadmium Yellow.

Viridian Green

Alizarin Crimson

Prussian Blue

Cadmium Yellow

Lemon Yellow Hue

Indian Red

Raw Sienna

7 ▲ While the last wash of step six is still wet, paint a mix of Prussian Blue and Alizarin Crimson to the right of the tree. Also apply some Cadmium Yellow around the base of the tree.

8 ▶ Wait for all the washes to dry and then apply a thin wash of Raw Sienna with a large brush over the Indian Red, Alizarin Crimson, and Cadmium Yellow washes in the foreground.

Building up color
Control your brushwork to ensure the many washes build the right color in the right place.

Lemon Yellow Hue is lightly washed across the mid-range hill line over all previous washes, and also over any unpainted paper. This creates a tonal recession giving a sense of space behind the trees.

Brown-gray mixture (step 3) has been applied to give the nearby tree detail. Some of the paint on the tree has been lifted out (*see* p.137) to reveal white paper which has been painted with Lemon Yellow Hue.

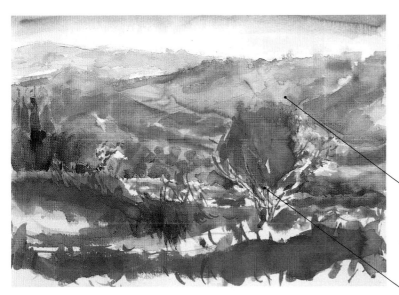

No.4 Synthetic Brush

No.9 Synthetic Brush

No.14 Synthetic brush

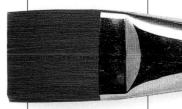

1inch synthetic wash brush

EFFECTIVE COMPLEMENTARIES

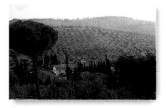

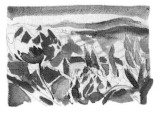

Sketch of photograph
Choose a photograph that you like and use this to make a simple color sketch for the following exercise.

COLORS JUXTAPOSED WITH EACH OTHER cause differing effects, changing the quality of each color. For instance, there are pairs of colors that, when placed together, are in maximum contrast and mutually enhance one another: these are complementary colors. Look at your color wheel to match the colors that face one another across the wheel. Orange and blue are complementary, as are yellow and violet, and red and green. This exercise demonstrates how to use and harmonize complementary colors most effectively.

1 ◄ Draw a free sketch of the scene in pencil. Then, using a large clean wash brush, wet the sky area with water to dampen the paper. Paint a wash of Ultramarine on the wet paper, and, while the paint is still wet, wash Cobalt Blue over the same area. Now allow the paint to dry.

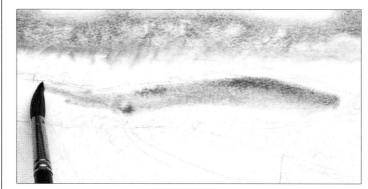

2 ▲ Mix Ultramarine and Alizarin Crimson to create violet. Then, with a large brush, wash the violet with bold brushstrokes on the mountaintops just below the skyline. Allow to dry.

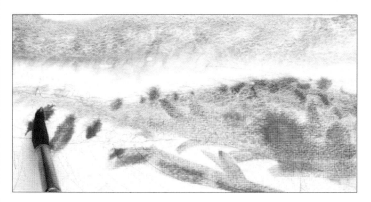

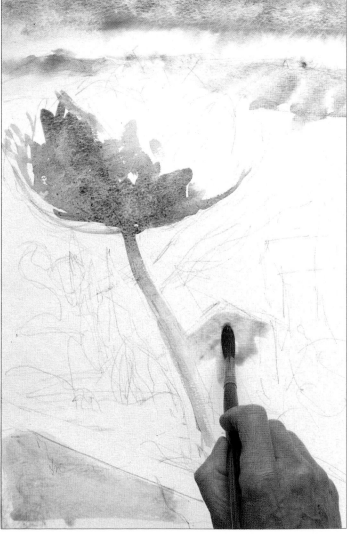

3 ▲ Pick out a few details on the top of the mountains with Cerulean Blue. Now apply a pale Lemon Yellow Hue wash below the violet mountains – complementaries side by side create a pleasing harmony.

4 ▶ When all previous washes are dry, wash violet into the tree. Now apply pale washes of pure Alizarin Crimson across the lower left corner of the page and behind the tree trunk.

PAINTING TREES

It is generally impossible for an artist to ignore the presence of trees in a landscape. It is therefore essential to concentrate some of your time on perfecting the basic shapes of a variety of trees. Sketch them on walks and study tree-tops you can see from your window. Draw the leaves and branches in isolation and look carefully at the light and shade held within the foliage. Practice this method of doing a color sketch.

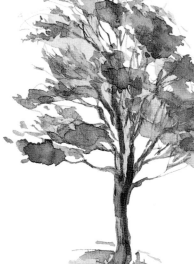

Materials

Cadmium Red

Cadmium Yellow

Prussian Blue

Ultramarine

Cobalt Blue

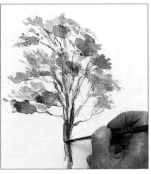

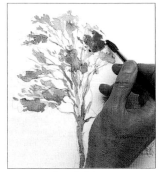

1 *Wash pale Cobalt Blue over a pencil sketch of the foliage and then paint Viridian Green shadows. Add a wash of Cadmium Yellow.*

2 *Strengthen tones with yellow and green washes. Mix Alizarin Crimson and Prussian Blue for the brown of the tree trunk and branches.*

3 *Finally, apply Cerulean Blue to the leaves and around the base of the tree.*

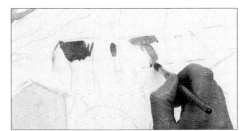

5 ▲ Create a pale orange wash from a mixture of Cadmium Yellow and Cadmium Red. Then, with a medium-sized brush, such as a No.9, block in the sides of the house beyond the tree.

6 ▶ Paint in the right-hand foreground area with a Cerulean Blue wash. When dry, paint foliage with Lemon Yellow Hue, then Cerulean Blue. This overpainting of transparent pigments will create green. Add small strokes of Cadmium Red for the flowers.

No.14 synthetic brush

1 inch wash brush

Bold contrast
The main areas of color have been mapped out, using complementaries.

The trees in front of the house have been painted with a mixture of Viridian Green and Prussian Blue. Cobalt Blue has been blocked in around this area and complements the surrounding orange.

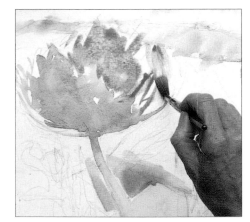

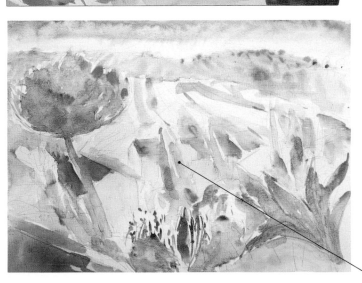

7 ▲ Paint Cadmium Yellow on the roof of the house beyond the tree and allow it to dry. Mix Sap Green and Lemon Yellow Hue to create a lime green, and then apply this to the top of the tree. This complements the violet (Ultramarine/Alizarin) wash.

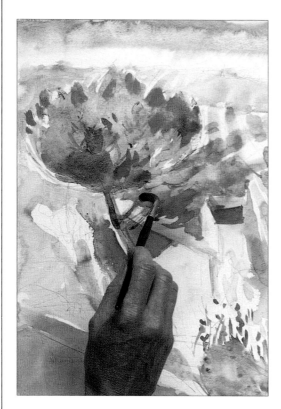

8 ◀ Strengthen the tree color by applying Cadmium Red and Prussian Blue to the foliage on the left using a medium brush, such as a No.7. Mix Alizarin Crimson with Ultramarine, and Cobalt Blue with Cadmium Red, and work both of these colors into the trunk of the tree. Then apply Cadmium Yellow to the remaining foliage while the previous wash is still wet.

9 ▶ Define the trees at the front of the house by overpainting them with a strong wash of Cerulean Blue, and then block in the wall of the house visible between the trees. When dry, delineate the edges of the house by carefully applying a paler Cerulean Blue wash.

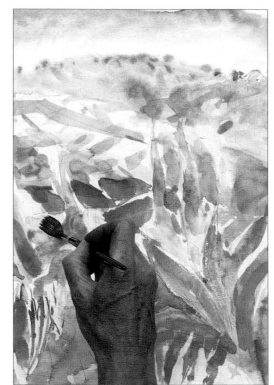

10 ▶ Paint a mixture of Cadmium Red and Alizarin Crimson over the area of Cerulean Blue on the side of the house. Then apply a darker wash of Cerulean Blue to the trees. This juxtaposition of complementary colors creates a vibrancy and an illusion of space between the house and the trees at the center of the painting.

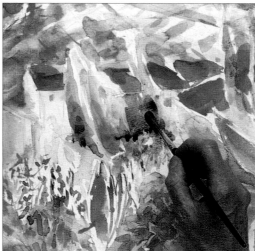

11 ◀ Apply a pale Prussian Blue wash to the hills in the top right-hand corner of the composition. This will become a layer over the earlier Lemon Yellow Hue wash and will make touches of green, introducing a light recessive tone in the distance while hinting at the presence of foliage.

12 ▶ Lay Cadmium Red over the Alizarin Crimson on the leaves of the foliage in the right-hand side of the image. Work in some Alizarin Crimson, and then add a few final touches of Cadmium Yellow to create a strong orange-red. Take care over the wet washes if you do not want your colors to bleed.

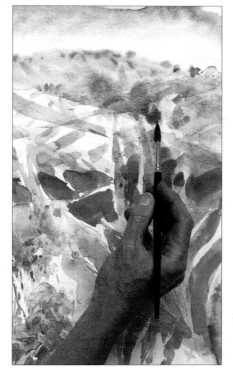

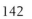

Materials

Alizarin Crimson

Cerulean Blue

Lemon Yellow Hue

Sap Green

Viridian Green

14 ▲ If you want to alter any details or areas on your painting you can wet the area with a brush and then lift the color off with a paper towel or sponge. This will lighten the color and may help restore balance to the composition. This technique can be used to modify a painting or more simply as a highlighting technique.

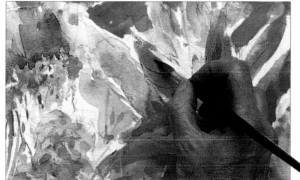

13 ▲ Apply a wash of Cadmium Yellow and Cadmium Red to strengthen the intense areas of color in the foreground and emphasize the pale hues in the distance. These touches of orange complement the blue, but be careful not to unbalance the composition with too much of one color.

15 ▲ Work some Cobalt Blue into the outlines of the leaves in the right-hand foreground, and lightly apply Sap Green within this outline. The scene appears bathed in sunlight as the strong high-key colors pick out and accentuate the foreground details of the foliage.

Sponge

No. 7 sable brush

No 9 synthetic brush

Layers of color

This painting has been built up with a range of complementaries. The strong tones in the foreground give way to the paler tones.

Alizarin Crimson mixed with Cadmium Yellow has been applied as a series of blobs across the mid-ground; Cerulean Blue dots have been added. These suggest rows of trees and terraces.

Alizarin Crimson has been applied to the roof. The windows have then been painted in with a wash of Cobalt Blue.

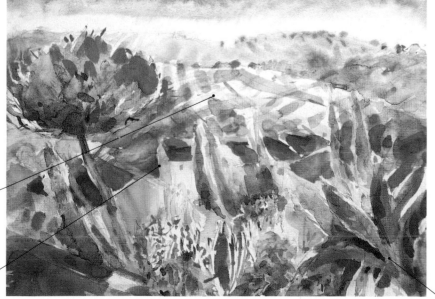

Washes of Cerulean Blue and Lemon Yellow Hue have been used to build up the area of foliage in the right-hand foreground.

GALLERY OF TREES

IT IS TEMPTING, when painting a landscape, to convey the presence of a tree with a simple sketch – a trunk, some branches, and an umbrella of leaves. Artists, however, are often faced with a great variety of trees, many of which are complicated and difficult to paint. Our illustrations show the different techniques used to create a detailed study of trees and a sketch that manages to suggest the movement of wind blown trees.

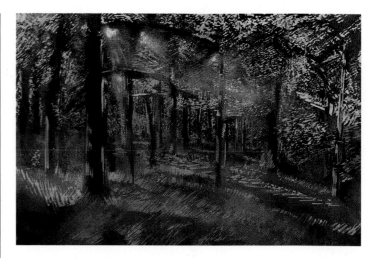

Philip Fraser, *Oakwood Wood*
In this painting, the artist was intrigued by the sharp tonal definition found within a grove of trees. He has masked out areas of the painting to preserve the white of the paper as shafts of pure sunlight penetrating the dense foliage. The dark trees are given further definition by a gradual build up of warm yellow washes. The artist's brushstrokes are short and delilineating to create a sense of sharp, intense light. This precise technique is exactly suited to the portrayal of forest light.

Once the initial broad washes of background color were dry, Varley used wet washes and short, deep brushstrokes for foliage. When these dried, he added another layer.

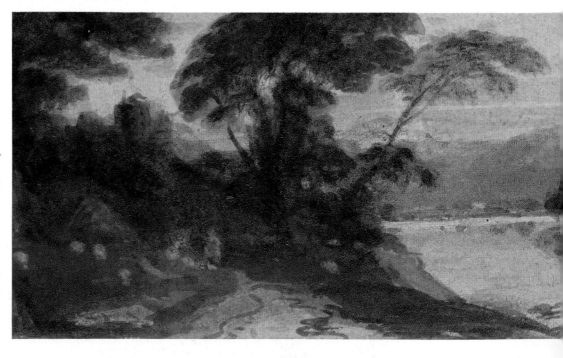

John Varley,
***Landscape*, 1840**
John Varley (1778–1842), through his teaching and books, did much to spread the popularity of watercolor in Victorian England. He knew how to manipulate washes to capture the slightest tonal change, and his brushwork was unerring – every stroke fits its purpose, whether it was to show smooth water or dry autumn foliage. This landscape study is about trees – how their branches break the skyline, how their shapes pattern water, and how their foliage dominates buildings.

Paul Sandby RA,
Landscape Study, c. 1750
Paul Sandby lived at Windsor Castle in England, where he painted many fine studies of the castle and its grounds. He was trained as a topographer, but as he grew older his work became more and more imaginative and painterly. His impact, during his lifetime, was to help watercolor emerge from its secondary role into a serious medium in its own right. Although the sky in this study (right) is masterly in its range of tone and unexpected use of color, the trees are the focal point. Sandby let his background dry, then with practiced dexterity sketched in his trees with a dryish brush.

Julie Parkinson, *Sun-Dappled Beech Trees*
This carefully observed tree study (left) shows a remarkable control of the medium. The artist has concentrated on the shapes of the trunks and the texture of the smooth wood, but she has also studied the movement of shadow around the cylindrical shapes of the tree. Compare her technique of depicting the tones in the grass and leaves with that of "Oakwood Wood" illustrated opposite.

Sharon Finmark, *Tuscany*
In this painting (below), broad, bold washes of complementary color were applied, and the artist allowed bleeding between colors to mark her tree line, yet these trees are not mere shapes but identifiable evergreens and olives.

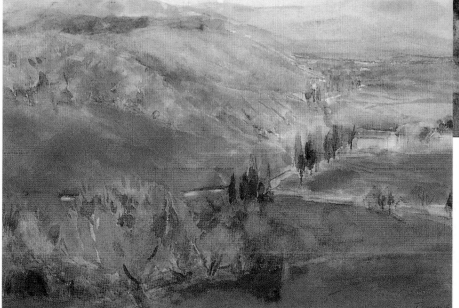

This detail reveals the very controlled tonal value of the painting achieved by an apparently free, easy use of brush and color.

COLOR UNITY

Color sketch
Make a sketch of a park or garden mapping out the main areas of color.

PAINTERS ARE AWARE OF THE "COLOR UNITY" in the landscape they are studying and how it alters with the time of day and the season. Color unity means that the predominant color, affected of course by light, is either "warm" or "cool." Obvious examples are that a misty morning is "cool," a sun-drenched beach is "warm." Colors with a red bias are warm, those of a blue bias cool, but green and violet contain both elements. Consequently, green and violet are used frequently, to harmonize a composition and provide color unity if placed judiciously with other complementary colors. The example given here is for a scene of cool color unity.

1 ◀ On the lawn, lay a wash of pale Cadmium Yellow with a medium-size brush. Overlay this with a mix of Lemon Yellow Hue, Prussian Blue, and a small touch of Cerulean Blue. Then wash Cerulean Blue with Lemon Yellow Hue into the trees. Apply a Cadmium Yellow and Permanent Rose mix to the tree foliage; overlay a mixture of Cerulean Blue and Cadmium Yellow on this to define the shapes of the leaves.

2 ▶ Wash a watery Permanent Rose on the flower bed. This is not a broad, sweeping layer, but one dotted here and there to indicate flowers. Add touches of Ultramarine, letting the two colors bleed where appropriate. Wash greens on the foliage in the flower bed.

3 ▲ When all previous washes have dried, use a large brush to paint the sky with pale Prussian Blue. Use this mix to wash over a few of the branches and some of the foliage of the trees. Controlled brushwork is needed for this.

4 ▶ When the sky wash is dry, wash a mix of Lemon Yellow Hue and Prussian Blue across the trees. Then, using a medium-size brush, apply Permanent Rose with a small touch of Cadmium Yellow to the fence.

Materials

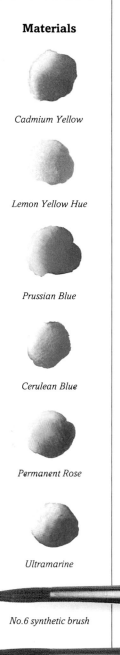

Cadmium Yellow

Lemon Yellow Hue

Prussian Blue

Cerulean Blue

Permanent Rose

Ultramarine

No.6 synthetic brush

No.9 synthetic brush

No.14 synthetic brush

5 ▲ Using a slightly smaller brush, such as a No.6, paint the path gray with a mixture of Permanent Rose, Cadmium Yellow, and Ultramarine. Use a higher ratio of the yellow than of either the blue or the red, because this will create a warm gray.

6 ▲ Mix up a wash of violet using Permanent Rose and Ultramarine and then wash it over the fence, taking care to leave a white outline around the shapes of the trees and foliage. Allow this to dry before adding further touches of violet to give definition to details on the fence and to any areas of shadow.

Harmonious foundations
By this stage the basic color unity of the painting has been established. This unity will provide the foundation for a build up of washes and will add depth to the different tones and perspective of the whole painting.

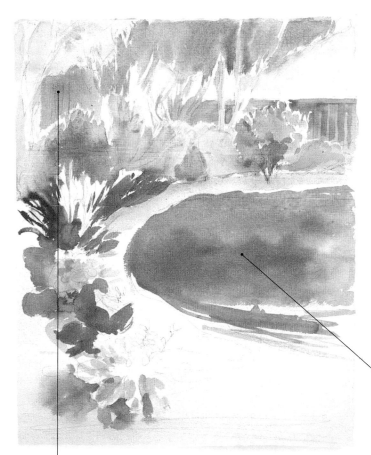

The colors used for shadows on the grass echo those used in the flower-beds. These colors are the useful greens and violets, which are both warm and cool.

The garden shed is painted in the same colors as the fence, Permanent Rose and Cadmium Yellow, and violet has been used on the window.

7 ▶ With a medium brush, such as a No.9, paint a large shadow across the path and the lawn using violet. This enhances a violet-gray in the path and a subtle gray-green in the grass. To indicate sunlight, apply a Lemon Yellow Hue wash across the lower section of the grass.

GALLERY OF LIGHT

P AINTERS BECOME OBSESSED with the quality of light, that mysterious element that alters color, form, and tone – or rather, causes an optical illusion of change. Turner was driven by the need to catch every nuance of change. Consequently he became one of the greatest of all watercolorists. The medium is ideal for rapid color work, and the innate translucency of the pigments is perfect for the reproduction of light.

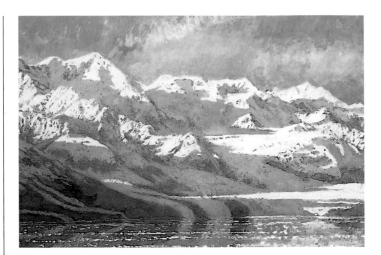

Tim Pond, *Alaska Sound*
This is a superb understanding of color unity despite, rather than because of, the obvious "cool" light. The artist could have conveyed this with very little effort, but he has given profound concentration to the elusive, changing tones of hard ice and scree, the soft-textured snow, and glassy water.

These washes reveal complex patterns of light – pale and dark areas of tone are cunningly mingled and have been painted with painstaking precision.

Anthony Van Dyke Copley Fielding, *A Moorland, c.*1800
Fielding was a prolific English painter, who made many studies of Wales and the Lake District, as well as numerous seascapes. This painting, technically a fine example of brushwork and control of paint, is nevertheless, slightly disconcerting. The composition is sharply divided between sunlit moors and bright craggy mountains, but the whereabouts of the source of the light, falling on both, is uncertain and the color unity fragmented.

Philip Fraser, *Tiana*
In this painting of a Spanish town (left), Fraser has used the deep shadows found in the Mediterranean as the focal point of the composition. The cool tones soon wash away in a haze as powerful light encounters the shade; warm tones gleam in distant sun. The white areas have been "masked out" by applying masking fluid to those areas in early stages of the painting and then rubbing the masking fluid off once it and subsequent layers of paint have dried.

A high degree of luminosity is achieved with a limited range of colors, relying also on the brightness of unpainted areas.

Noel McCready, *Valley with Bright Cloud*
This composition (above) gives the sense of a huge spreading land, yet it is really a study of a cloudscape. The immensity of the sky looms in vivid tones of blue, gathering in darkening tones to crowd the luminous, pale vapor of one great cloud. The horizon is a dark narrow line. The authority of the tonal values and the thick color of the air make this a masterly statement on the illusion of light.

Paul Cézanne, *Montagne Sainte Victoire*, c.1905
This painting (right) is one of many that Cézanne painted of Monte Sainte Victoire. He was primarily concerned with structure, not the analysis of light. This interest in shape and planes gave him a keen perception of tones but often led him to ignore subtle, seasonal changes – although he did not deny color unity, as can be seen in this watercolor. This hot landscape is typical of his later works, described as "sparsely composed and open, permeated with a sense of light and space." The large areas of unpainted paper add to the sense of light.

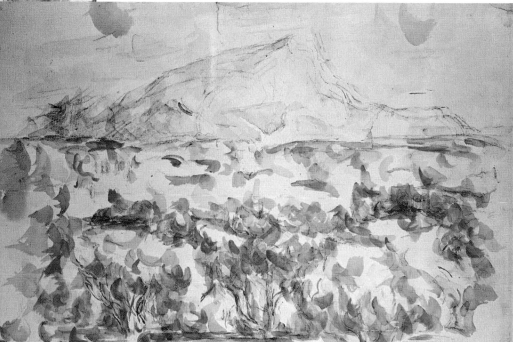

CREATING ATMOSPHERE

COLOR CARRIES A SIGNIFICANCE beyond its physical properties. It can be used symbolically and emotionally. The Virgin Mary is dressed in blue to symbolize purity and peace; warriors wear black and red to express anger and strength. Artists use color to reveal a mood or to evoke an emotional response from the viewer. Many abstract paintings are a color expression of emotion. In this example, we have chosen a mysterious moonlit night, dark, lonely, and majestic. The colors are brooding – deep tones of blue relieved by scattered notes of light. It is worth studying the methods described below in order to gain an understanding of how to create a sense of atmospheric color.

1 ▲ Sketch a brush drawing using Ultramarine on Turner gray paper. Apply an Ultramarine wash across the mountain range and the lake, ensuring that you leave the areas of light tones unpainted. The slightly tinted, gray paper used for this painting suits the "moody" range of colors, giving the light tones a muted intensity in keeping with the atmosphere being expressed.

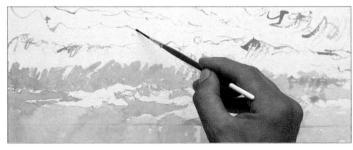

2 ▲ With a very fine brush, use Ultramarine to sketch cloud lines on the unpainted sky area. Apply your brush freely in thick and thin lines. Let the paint dry. You can use a hair-dryer on a cool setting to speed up the process.

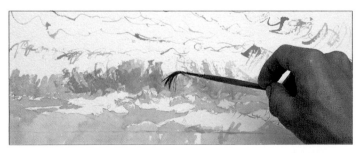

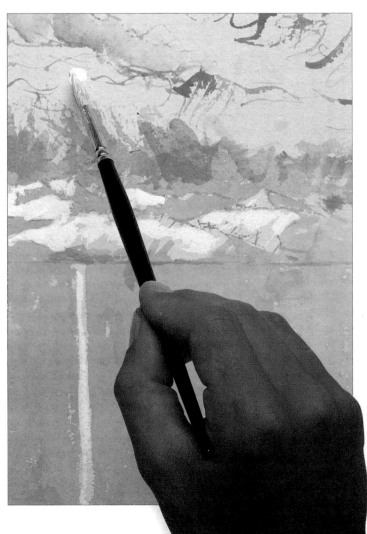

3 ▲ Move to the first wash on the mountain and lake area. Along the upper band, use a fine brush to add another Ultramarine wash. Vigorously rub the paint over the paper in loose, energetic brushmarks that make a pattern of changing tones. Allow the paint to dry.

4 ▶ Apply a touch of Permanent White gouache to emphasize the line of light on the water, the moon, and the light on the mountaintops; use a medium brush, such as a No.7. This will create sharp tones of light far brighter than the background gray paper.

PAINTING CLOUDS

Clouds do not really have color since they are merely vapor floating through the sky. As the light of the sun falls through the water of the vapor, it is reflected and refracted, giving an illusion of mass, form, and color. This exercise concentrates on how to capture this fleeting, elusive subject.

2 *Use a combination of Ultramarine and Alizarin Crimson; and Cadmium Red, Ivory Black, and Prussian Blue to bring tones to the cloud and sky. It is all too easy for watercolors to become muddy, so clean your brush between the application of each mix of colors, and apply the paint rapidly onto the wet layers.*

1 *Prepare a background wash of Cerulean Blue in pale layers, wet-in-wet in wide brushstrokes. Then sponge out some areas of the paint, making pale spaces to mark the cloud shape. Darken the tones of Cerulean Blue around the edges of these spaces.*

Materials

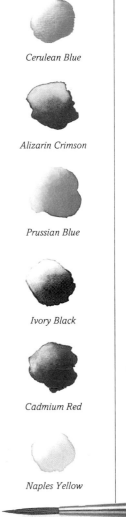

Ultramarine

Cerulean Blue

Alizarin Crimson

Prussian Blue

Ivory Black

Cadmium Red

Naples Yellow

No.2 synthetic brush

No.4 synthetic brush

No.1 synthetic rigger

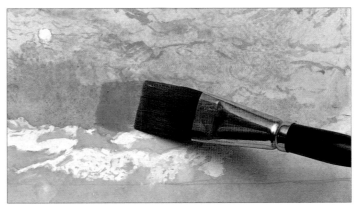

6 ▲ Still using a large brush, apply a wide, smooth line of Alizarin Crimson above the mountain range. This layer brings a subtle color to the clouds and an interesting range of tones.

5 ▲ With a large wash brush, paint pale Cerulean Blue across the sky area. Take care to sweep the brush evenly across the paper, particularly when the wash crosses over the line of the clouds and upper mountain line. Let the wash dry.

7 ◀ Using a small brush, such as a No.4, apply an Alizarin Crimson wash to the lake in the foreground. You should use a very wet brush for this, applying a loose uneven line, to produce a series of watery tones that suggest the constant movement of water.

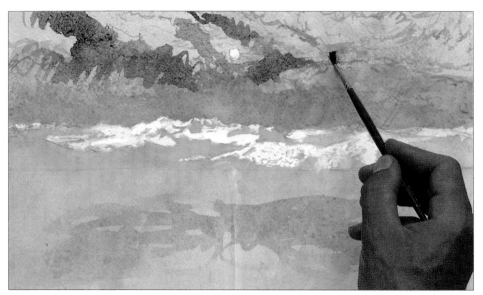

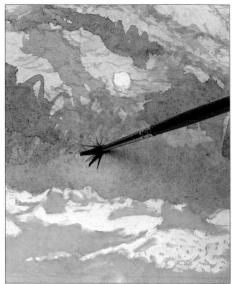

8 ▲ Continue to build up the clouds with a mixture of Prussian Blue and Ivory Black. Give this mixture a dash more of the Ivory Black than the Prussian Blue for a more intense hue. Using a fine brush, such as a No.2, make fluid, rhythmic brush movements as you add this dark tone to the cloud formation.

9 ▲ Develop further deep tones in the scene with the Prussian Blue and Ivory Black, but now use less water in the mix. Scrub the almost dry brush into areas requiring these deep tones. Small spots and specks of color from the previous layer will show through, giving a texture to the surface that is not achieved with an all-covering wash. This technique is known as "scumbling."

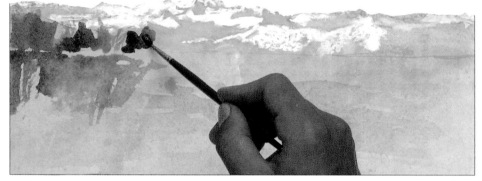

10 ▲ Paint the landmasses on the horizon of the composition with a mix of Alizarin Crimson, Prussian Blue, Ivory Black, and Ultramarine. You should also paint the reflections, which are the same color but of paler tone. Apply the colors on a wet brush, and again keep the brush clean. Observe the little glimpses of light tones. Keep them free of wash.

11 ▶ Develop the tones within the clouds by applying broad washes of a mixture of Ultramarine and Alizarin Crimson. You should sweep this over the washes of Ultramarine and Ivory Black previously applied to the sky. If you find that some areas are too dark in tone, lift the color off with a sponge. This can be done more easily when the paint is wet.

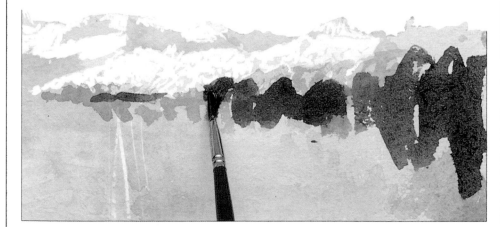

12 ◀ With a small wash brush, apply another wash of a mixture of Ivory Black, Ultramarine, and Alizarin Crimson over the two landmasses. You are now building up layer upon layer of color, making the tones deeper and increasing the brooding depth of this composition. Remember, that, each sweeping wash is pale with water – the depth of tone comes from the effect of layer upon layer of color.

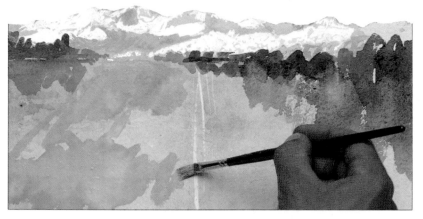

13 ◀ It is important to let your work dry before the next move. Now the light tones of moonlight should be washed in. Mix an Ultramarine wash with a touch of Permanent White gouache and cross this over the mountaintops. Use the same mix of colors to paint the broad sweep of moonlight reflected on the calm surface of the lake.

Materials

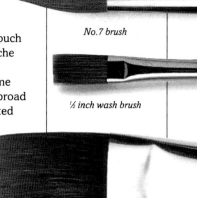

No.7 brush

½ inch wash brush

1 ¼ inch wash brush

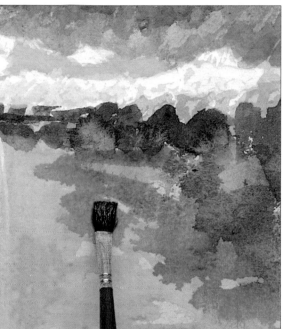

14 ◀ When the previous layer is dry, paint the reflections of the mountains on the lake surface. Mix Ultramarine and Alizarin Crimson and apply freely, while making sure the reflection matches the shape of the mountains.

15 ◀ With a fine brush, such as a No.2, paint a mixture of Permanent White gouache, Cadmium Red, Naples Yellow, and Alizarin Crimson just above the mountain line. Use a sketchy brush line, making rows of loose zig zags to let the previous layer show through. This tone represents the light that is reflected into the sky by the snowy peaks. Your final colors, though dark, should not be murky or muddy.

Atmospheric light
The light of the moon and the reflected light of the mountain peaks contrast very strongly with the dark tones of the lake and the lower mountain.

The moon has been defined with an application of Permanent White gouache. Ivory Black has then been touched on this, indicating the subtle tonal change caused by clouds.

This band of moonlight across the water has been given extra emphasis with a strip of White gouache. The opacity of the gouache captures the brightness of the light.

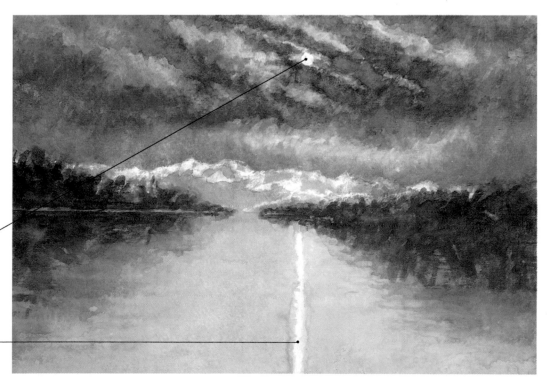

SKIES GALLERY

ARTISTS ARE FASCINATED by the changing panorama of the sky, but it is a subject that challenges every aspect of a painter's skill. Because clouds are both transient and of an unpredictable color, they are extremely difficult to record. Their tones are complex, as are the shadows they cast upon the earth. But these difficulties have neither frightened nor prevented artists from making studies of the sky. These pictures show different techniques used to capture its ever-elusive nature.

Noel McCready, *Autumn Landscape*
In this painting strong tonal contrasts cause the sky to advance visually toward the viewer. This use of tone creates the sensation of being poised high above the landscape. The dark details in the foreground add to the overwhelming vastness of the sky stretching into the distance.

Long horizontal brushstrokes are used for the smooth tones of light on the horizon, but a wide variety of strokes express the nature of clouds.

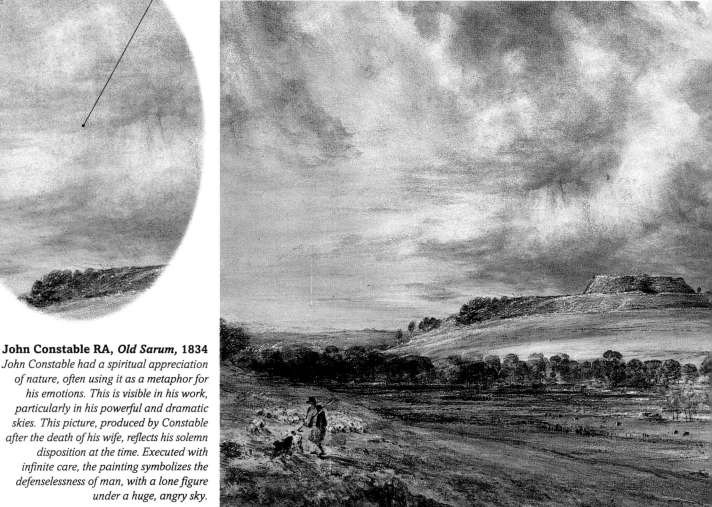

John Constable RA, *Old Sarum,* **1834**
John Constable had a spiritual appreciation of nature, often using it as a metaphor for his emotions. This is visible in his work, particularly in his powerful and dramatic skies. This picture, produced by Constable after the death of his wife, reflects his solemn disposition at the time. Executed with infinite care, the painting symbolizes the defenselessness of man, with a lone figure under a huge, angry sky.

Julian Gregg, *Sunset, Alexandria*
This is a very bold use of tone from a contemporary artist. The drama of the sunset has inspired the artist to lay, in apparent abandon, one wash upon another. In fact, the colors have been applied with deliberation, designed to catch the turbulence of sea and sky in a fading light. The loose brushstrokes emphasize the stormy sunset mood.

The sun is a red of such strong intensity that the surrounding cloud is colored by it, as are the tossing tips of the waves directly below.

J.M.W. Turner RA, *Bellinzona – Bridge Over the Ticino*, 1841
Turner's perceptive interpretation of light and his remarkably free brushwork inspired his fellow artist, John Constable, to write: "He (Turner) seems to paint with tinted steam, so evanescent and so airy." Light flows through this painting, falling from high sky to wide river. As a mature artist, Turner painted the world in abstract tones of light, and he is recognized as a radical genius whose original vision has altered our perception of the atmospheric power of light and color in the sky.

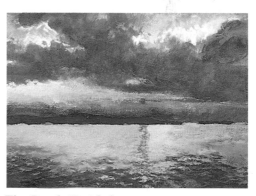

Tim Pond, *Untitled*
This sunset, although a wonder of color, is a reflection of a quieter climate than the sunset illustrated at the top of the page. The clouds here are calm, densely massed, and the water is a wide, smooth expanse of light. Changing tones of color are clearly defined. Brushstrokes are expressive but unhurried. This artist is an objective observer of the sea and sky, and his emotional statement is restrained.

SKETCHING BUILDINGS

MANY OF US MAY FEEL that our drawing ability is not strong enough to cope with the intricacies of a cityscape. We worry about perspective and all those details of road signs, neon lights, posters, traffic, and of course, people. Streets are crowded with detail and many buildings abound with architectural decoration. But it is not impossible to learn the basic rules of perspective, since the angular nature of buildings allows an easy freedom in interpretation. Reduce office buildings and stores to cubes; use color to reveal the mood of the street, not its physical reality; and use only those aspects of buildings that you want – abstract from the bricks and mortar the elements you need to express your own vision.

Perspective in a townscape

In this sketch a clever use of color and tone conveys a wealth of detail that, on closer inspection, has not actually been recorded. Dark shaded windows, the details of the balcony closest to the viewer, and the strong shape and color of the rooftops against a hazy horizon – all successfully record a view across a town. The sky has been painted with a wash of pale Cerulean Blue; the roofs with Cadmium Red; and the light playing on the trees in Naples Yellow.

These very dark areas of shadow, used to represent windows and doors, are derived from a mixture of Ivory Black and Prussian Blue. This mix achieves a tonal quality suited to the intensity of the natural light in this scene.

Here, the Ultramarine wash has been left as a thin, pale layer, giving a tone of distance behind the Cadmium Red of the roofs, which are struck by the force of the midday light. The entire composition is light, fresh, and uncluttered.

Dark Alizarin Crimson, applied to the front of the building, gives an intense deep tone appropriate to deep shadow, yet allows us to discern the color and architectural details of the facade.

Buildings on a horizon

This composition has a low horizon, broken by the height of a building. The vanishing points are relatively close together, and the steep angles of the building give the picture a strong sense of drama. The fence in the foreground and brilliant light behind the focal point create dark tones in the foreground that emphasize the dominance of the building. The sky has been painted with Ultramarine and Lemon Yellow Hue, the building with Alizarin Crimson, mixed with a small amount of Ivory Black.

Cylindrical shapes

The cylindrical shape of this mosque tower may seem a daunting drawing problem. However, the tower is simply a series of parallel ellipses that are then joined by vertical lines. If you can find a similar building to look at, you will observe that the curves of the ellipses turn upward because your eye is below them. The shadows, too, circle around the shape. Once the geometry of the perspective is understood and the tonal qualities observed, you should feel quite confident tackling the subject.

DRAWING PERSPECTIVE

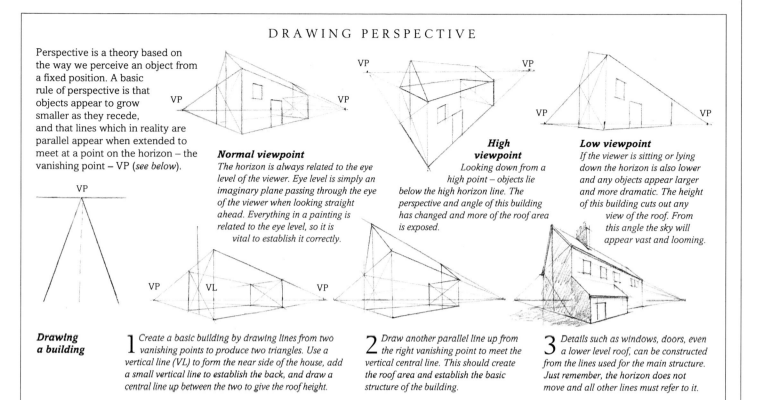

Perspective is a theory based on the way we perceive an object from a fixed position. A basic rule of perspective is that objects appear to grow smaller as they recede, and that lines which in reality are parallel appear when extended to meet at a point on the horizon – the vanishing point – VP (*see below*).

Normal viewpoint
The horizon is always related to the eye level of the viewer. Eye level is simply an imaginary plane passing through the eye of the viewer when looking straight ahead. Everything in a painting is related to the eye level, so it is vital to establish it correctly.

High viewpoint
Looking down from a high point – objects lie below the high horizon line. The perspective and angle of this building has changed and more of the roof area is exposed.

Low viewpoint
If the viewer is sitting or lying down the horizon is also lower and any objects appear larger and more dramatic. The height of this building cuts out any view of the roof. From this angle the sky will appear vast and looming.

Drawing a building

1 *Create a basic building by drawing lines from two vanishing points to produce two triangles. Use a vertical line (VL) to form the near side of the house, add a small vertical line to establish the back, and draw a central line up between the two to give the roof height.*

2 *Draw another parallel line up from the right vanishing point to meet the vertical central line. This should create the roof area and establish the basic structure of the building.*

3 *Details such as windows, doors, even a lower level roof, can be constructed from the lines used for the main structure. Just remember, the horizon does not move and all other lines must refer to it.*

View between two buildings

This composition is based around the central vanishing point established by the converging lines of the road in the distance. The steep planes of perspective of the buildings echo this vanishing point and create a dramatic effect, because they appear to shoot toward the viewer. The viewpoint here is low, causing the buildings to tower into the sky, and the inclusion of the bridge increases this sense of height. The window details represented by darker tones emphasize the receding perspective and increase the illusion of distance.

As the buildings recede toward the horizon they become Ultramarine. A small touch of Alizarin Crimson has been used to reassert a sense of balance in the painting.

The basic shapes of the buildings are sketched in with fine lines of Ultramarine mixed with a small amount of Ivory Black.

As the buildings recede into the distance their colors become cooler and paler and add to the sense of perspective.

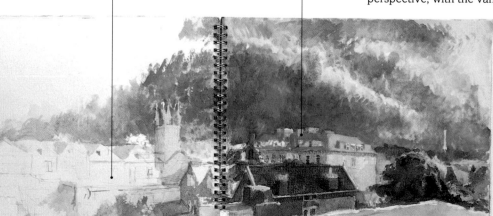

Sketching a skyline

The viewpoint in this picture is quite high and the horizon is low. The picture employs two-point perspective, with the vanishing points situated well off the page, and this gives the picture a restful atmosphere. The trees are Ultramarine mixed with some Naples Yellow to produce green. Pure Naples Yellow is also used for light reflected off the trees. Alizarin Crimson, as well as a variety of complementary colors, are used to paint the buildings. The whole skyline recedes gently into Ultramarine.

PAINTING THE CITY

Monochrome sketch
To obtain the correct tone and sense of perspective in your composition, it is worthwhile to make an initial monochrome sketch of the cityscape.

LIKE A LANDSCAPE, a cityscape is a composite picture consisting of a series of individual components. To place these elements so that they form a coherent unity is the art of composition. However, a cityscape differs from a landcape in that it often contains many more components whose relationship to one another is complicated by a wealth of angular details, such as chimneys or rooftops. Because of the height of buildings in modern cities and their proximity to each other, large areas of a city street are in shadow during daylight, and the tonal values are complex. At night the city is transformed by electric light. Choose a range of colors that will capture city light, and apply them thoughtfully to create a bold, well-ordered composition.

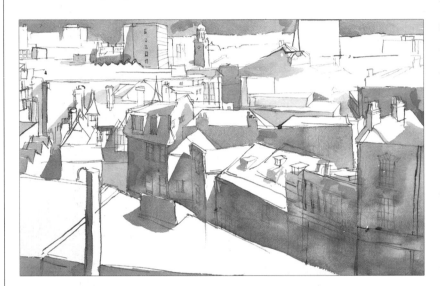

1◀ Paint the basic outline of this composition using Ultramarine. Paint in some of the fine detail of the cityscape, and lightly block in some of the main areas of shadow. Ultramarine makes a good initial ground wash for the range of night time colors that will subsequently be laid over it.

2▶ Block in areas of the composition with Alizarin Crimson using a medium brush. As with the previously applied Ultramarine, this color provides a solid ground for subsequent overlaid washes. Also overlay some Alizarin Crimson on the blue wash of the front of the house in the right-hand foreground. This will create a dark violet hue over which you can apply other dark washes. This technique of overlaying washes is ideal for developing shadows in the painting.

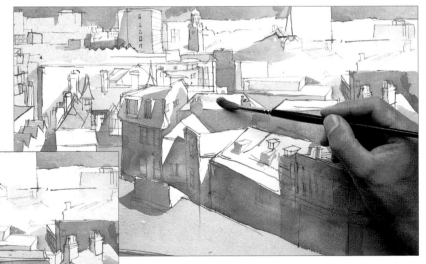

3◀ Apply a pale Cadmium Red wash to some of the rooftops and to the chimneys – this composition does not use naturalistic tones, though Cadmium Red approximates the natural color of chimneys and roof slates. By this stage, you should have established three levels of color throughout the composition and should be aiming to block in some of the color in such a way as to enhance the strong compositional style of the painting.

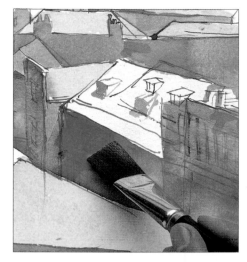

4 ◄ Continue building up the patterns of color in the composition. Using a large, perhaps 1¼ inch, wash brush apply Cerulean Blue washes along the horizon, to some of the buildings, and to the foreground in the left of the picture. Apply the same wash to the Ultramarine house front in the middle foreground of the composition to darken it.

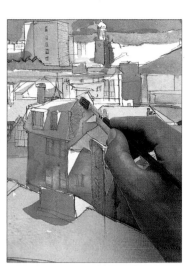

Materials

Alizarin Crimson

Cadmium Red

Cerulean Blue

Naples Yellow

Ultramarine

5 ▲ Using a smaller wash brush, apply Naples Yellow to some of the remaining areas of white paper. This will create the sense of sunlight falling on the sides of the buildings. Later you can add some lighter washes needed for pale tones in the composition.

6 ◄ Paint a second Ultramarine wash over the first with a small brush. Also, apply it to part of the building in the right-hand foreground over the already applied Alizarin Crimson; laying one color over another like this creates darker tones and the sense of areas of the cityscape in shadow.

7 ◄ Overlay Ivory Black on to some of the composition's light areas to create some of the darkest parts of the painting. These are mainly the windows on the buildings, which have been simplified in keeping with the style of the rest of the composition.

8 ▶ Fill in the remaining areas of white paper by applying a mixture of Cerulean Blue and Viridian Green. Use this wash to paint over some of the lighter Cerulean Blue washes. This dark green color complements the strong Cadmium Red, which is applied next and is the first in a series of darker tones to be used.

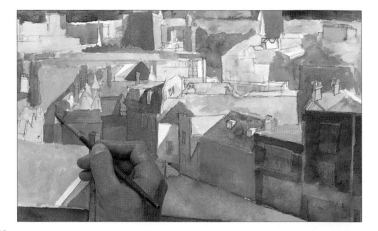

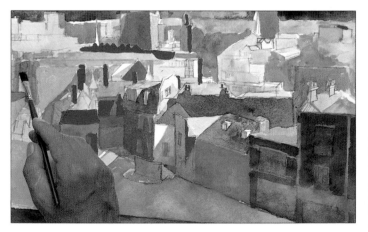

9 ◀ Paint a dark Cadmium Red wash over the initial ground color of pale Cadmium Red using a small wash brush. This red complements the green washes, and it adds deep tones.

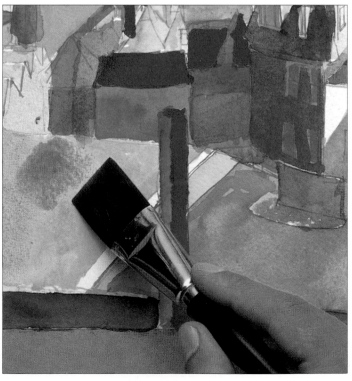

10 ▲ Block in the composition with dark colors. Here, you should apply a mixture of Prussian Blue and Ivory Black to darken some of the light Cerulean Blue washes. Be sure to keep this dark wash thin enough so as not to obscure the original Cerulean Blue washes.

11 ▶ Apply a wash of Lemon Yellow Hue over the Cerulean Blue area in the left foreground of the picture. This has the effect of creating a pale blue-green area, representative of light. Elsewhere in the composition, apply the wash over the Yellow Ochre rooftops to create a similar effect.

12▸ With a medium brush, paint thick, dark washes of Ultramarine over the pale Alizarin Crimson and Ultramarine in the right-hand area of the painting. This will create swathes of shadow running across the composition, darkening it toward its main tonal bias. It will also help to make the painting tighter and more balanced.

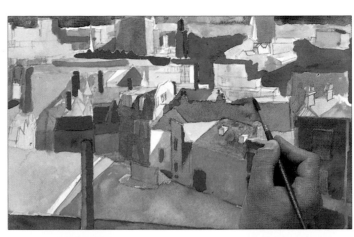

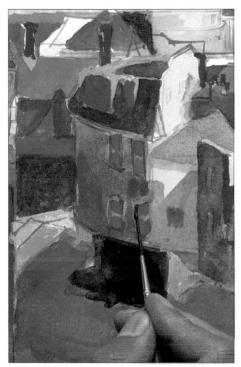

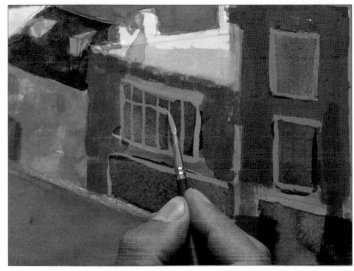

Materials

Yellow Ochre

Ivory Black

Lemon Yellow Hue

Viridian Green

Raw Umber

No.4 synthetic brush

No.1 synthetic rigger

No.7 sable brush

¼ inch synthetic wash brush

1¼ inch wash brush

13▴ With a very fine brush, paint dark squares of Ultramarine over a lighter, dry Ultramarine wash to create the shapes of windowpanes and frames.

14▴ Using a medium-size brush again, apply Ultramarine and Alizarin Crimson, mixed with a Permanent White gouache for these window frames. Draw them in loosely around the dark squares of Ivory Black that have been applied for the windowpanes.

Light effects
Permanent White gouache has been applied to some of the remaining pale washes in the composition. Painted over Naples Yellow and Alizarin Crimson, it creates a textured effect in keeping with the overall style of the composition.

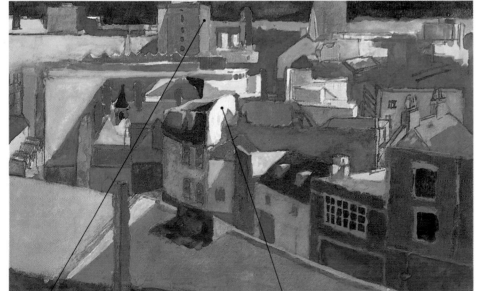

This complex cityscape uses bold planes of color to reflect the dramatic variations in light created by tall buildings and sharp angles.

The Permanent White gouache that has been applied to this area of Naples Yellow softens it and brings a tone of pale evening light into the picture.

GALLERY OF BUILDINGS

CITIES ARE TRIUMPHANT PROOF that human experience has been transformed beyond its struggle with the earth. Cities are symbols of man's beliefs and dreams. The English Victorian William Holman Hunt painted Jerusalem, the Holy City, as a radiant city of light, a symbol of faith, but more personal symbolism has inspired other cityscapes. August Macke's vision of Tunis revealed, in a series of paintings, a view of the city that is both mysterious and sublime.

Ray Smith, *Marciana Marina, Elba*
This study was painted from the harbor wall facing the town of Marciana Marina on the Island of Elba. The buildings are geometric and regular, and interest is generated by the warm afternoon light enhancing the terra-cotta and golden colors of the facades on the buildings. The use of the complementary orange and blue hues expresses the harsh tones of the sunlight.

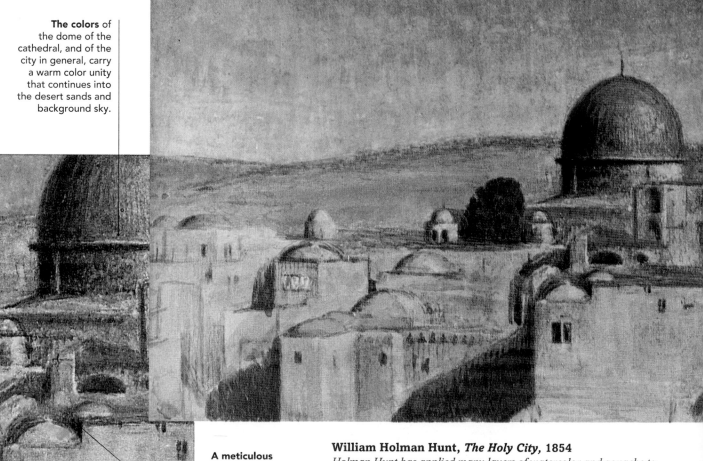

The colors of the dome of the cathedral, and of the city in general, carry a warm color unity that continues into the desert sands and background sky.

A meticulous handling of light can be observed in the tonal contrasts between the bleached-out walls and coppery domes.

William Holman Hunt, *The Holy City,* **1854**
Holman Hunt has applied many layers of watercolor and gouache to create this dazzling view of the Holy City of Jerusalem. Some washes have been laid over each other while others have been juxtaposed against each other. Color contrasts are achieved through the use of complementary colors within the range of pale oranges and blues. Hunt has expressed the religious significance of the city with his inspirational use of light.

Tim Pond, *Untitled (right)*
The scene shows the variety of structures that may be present in a modern city: an old-fashioned wooden fence and rooftops in the foreground, with an apartment block in the background. The buildings are simplified until the composition is nearly an abstract of shapes and colors. Primary colors give an intense brilliance to the scene and bright light has been translated with the use of sharp Permanent White gouache. Texture is subtle and designed to give perspective.

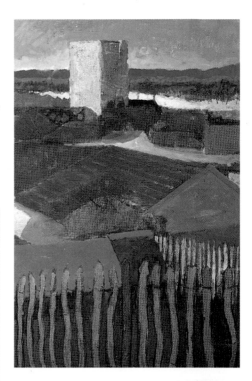

A perfect study of tonal recession is demonstrated in this detail. Macke did not entirely abandon tonal conventions.

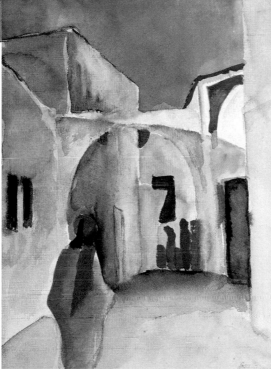

August Macke, *A Glance Down an Alleyway, c.* 1914
In 1914, August Macke, together with Paul Klee, set off for Tunisia, where Macke painted his final works. In the same year, at only 27, he was killed in the World War I. In this study the street has been arranged with a geometric order. His palette is radical in its intensity and he experiments with the conventions of tonal recession. He has managed to hint at dark secrecy in the blazing heat.

Judith Feasey,
Autumn, Norland W11 (above)
This painting evolved slowly, with tremendous care and patience in recording details. This contemporary representational painting uses watercolor in an unusual way, in that the sense of spontaneity usually associated with the medium is not present. However, the artist has used watercolor because of its translucence, and despite the careful labor of her brushwork, the lucid light of the autumnal scene remains.

The artist has looked out her window to observe all the elements of the cityscape: crowded buildings, bewildering architectural detail – and foliage.

165

SKETCHING WATER

AN ARTIST MAY DECIDE that water itself will be the focal point of their painting, or that other subjects such as boats or wildlife on the water will provide the main interest. Either way, the element is a difficult one to capture. It is rarely static; it carries not only its own color and tonal values, but reflects those of the surrounding land, the sky, and even the land below the water. Any time spent studying and sketching water will prove invaluable when you start painting. Composition needs careful thought, especially when there are clear reflections. Your brushwork will need to vary to catch the movement and tones of the water.

Sketching outdoors
Before you start a sketch, take time to observe the shape and form of the water and its areas of dark and light. These will be changing constantly, so use rapid sketches to record your impressions.

Dark Ultramarine has been painted into the foreground, its warm tones an important note in tonal recession.

A thin, rapidly applied wash of Winsor Violet creates the effect of light reflected off distant sea.

Flat sea
In this simple sketch of the sea, the sky wash is still wet as the sea wash is applied. When both have dried, the central horizon has been painted in very rapidly to create the impression of reflecting light. More washes have been allowed to bleed into each other to create a light, vaporous sky.

Cadmium Red bled into Winsor Yellow creates atmosphere; Manganese Blue overlaid along the bottom of the picture subtly blends the sea into the sky.

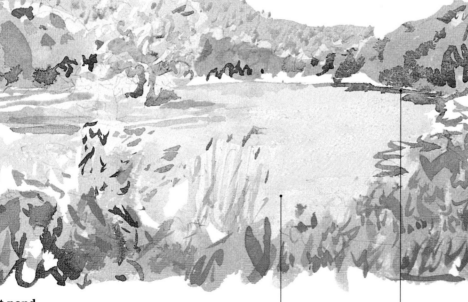

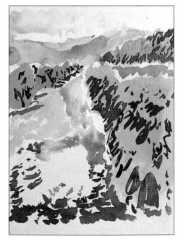

Slow-moving river
A large amount of white has been left in this painting of a river winding through hills. The tones of course lighten toward the distance, but the water has reflected a swathe of light in the foreground. This has been left unpainted.

Flat pond
An initial Ultramarine wash has been laid down to paint the surface of the still pond. Reflections are then added. Like shadows, reflections are affected by the direction and intensity of light. Part of the blue wash of the pond has been scratched out to show sprays of water and reflected light.

By scratching out the surface of the pond, the effect of dappled light can be created.

Light shadows here are similar in tone to the shadows found among the trees.

SCRATCHING OUT TECHNIQUES

Scratching out, also known as *s'graffito*, allows you to pick out highlights from a dry wash by scratching down to the white surface of your paper. It can be used to create the range of complex or simple light patterns that may be found on the surface of water. For a slightly different effect you can apply one wash over another, and then scratch the area you wish to define to the previous layer of paint – this will allow the first wash to show through the second. Here, three different methods create three quite distinct effects.

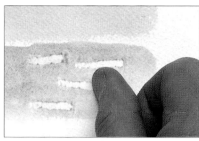

Thumbnail
Score thick, loosely formed streaks from the dry wash by using your thumbnail. These streaks are suggestive of the white crests of waves or breakers in the distance.

Scalpel
Use a scalpel to very gently scratch out parts of a wash. Here, this creates the effect of dappled light reflecting off the surface of water near the shore.

End of brush
Use the end of a brush to score lines across a wet wash. The brush makes grooves on the paper and the paint flows into it.

Lines of rolling waves
These waves are depicted as broken horizontal lines, the effect of which is created by painting over wax resist. The colors and tones do not simply recede here, but reflect the depth of the water and the shapes of the waves. Wide areas of white have been left to portray the pale crests of the waves.

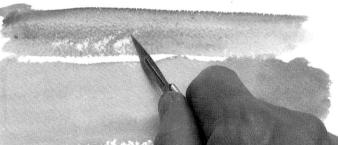

Pure Manganese Blue laid over a pale initial wash creates the effect of light reflecting off the shallowest water next to the shore.

Single wave *(below)*
A variety of brushstrokes are used to create a loose composition that moves from light to dark. Color has been layered along the bottom of the wave. Other parts of the wave have been painted in a single wash and dark spots added. The center of the wave is a very pale Cadmium Red.

A light Manganese Blue wash has been added for the outer edges of the wave.

Prussian Blue, Violet, and white paper are combined to create a rough, foamy sea.

PAINTING WATER

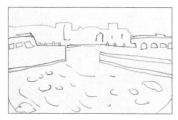

Drawing your composition in pencil allows you to adjust the composition before painting. The boats have been placed to give distance to the perspective. Their angle causes the horizon to recede.

THE ARTIST WANTED A COMPOSITION that was symmetrical, and he balanced the objects within it. The overall harmony of the colors also appealed to him. The picture was painted in January, early in the morning, and the color unity was cool. There are two boats, one in shadow and the other in light. The light and dark tones of each are reflected in the water, which the artist has tried to capture. Light is also reflected onto the boats and onto the buildings that line the harbor, which are painted in the same colors as the water. Though there are other objects of interest in this painting, the artist was intrigued by the water and its reflected light.

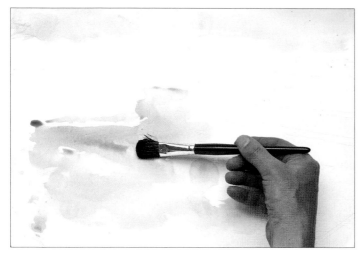

1 ▲ Start by applying a mixture of Ultramarine, Prussian Blue, and Yellow Ochre to the sky with a small wash brush – this creates a gray sky that will set the mood for the painting. Then start to build up the water by applying a mixture of Prussian Blue, Cadmium Red, and Ultramarine.

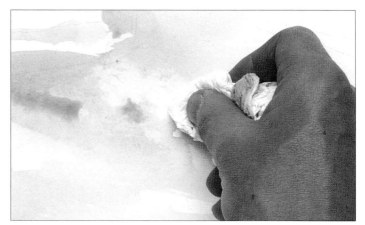

2 ▲ Apply a mixture of Cadmium Red, Ultramarine, Winsor Violet, and Prussian Blue wet-in-wet to show the water beneath the boat. Then partially lift it out with paper towel to allow some of the white paper to show through. This should create the effect of light reflecting off the surface of the water.

3 ◄ Mix Ultramarine with a very small amount of Cadmium Red and apply it to the foreground. This will create a darker underlying tone that, in the final composition, will contrast with the mid- and background water to create a sense of recession.

Materials

Cadmium Red

Alizarin Crimson

Winsor Violet

Ultramarine

Manganese Blue

Prussian Blue

Winsor Yellow

Yellow Ochre

No.11 synthetic brush

*¾ inch mixed fiber
wash brush*

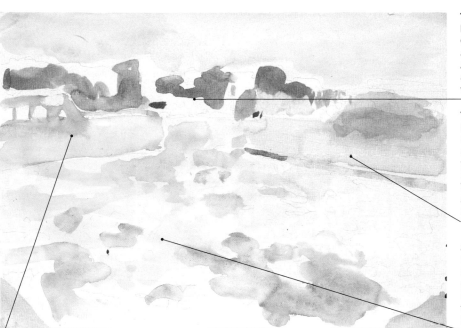

These buildings have been painted with Yellow Ochre mixed with a small amount of Ultramarine. Areas of white paper have also been left so that later washes can be applied.

The bottom of this boat has been washed with a mixture of Yellow Ochre and Ultramarine, which will give it a dark tone in the final composition. Winsor Yellow mixed with Alizarin Crimson has been used to paint the red line.

A wash of Ultramarine mixed with Cadmium Red (with a bias to red, creating purple) has been used to improvize the shapes and tones in the foreground.

Winsor Violet has been applied to this boat, painted darker at the top than at the bottom. Subsequent overlaid washes will reflect this tonal range.

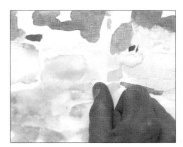

4 ▲ Use your thumb to scratch out some of the paint. This simple technique will give the appearance of light reflected off the water's surface.

5 ▲ Consolidate both the light and the dark tones in the water by applying a mixture of Ultramarine, Manganese Blue, and Cadmium Red. This gives an impression of depth.

REFLECTIONS

Reflections are created when light rays strike water. They do not travel through water as they do in the air. Instead, they are deflected back, causing a mirror image of what lies above the water. The proportion of light that is reflected varies according to atmospheric conditions, the angle from which it is viewed, and the clarity of the water. Painting reflections is essentially about capturing the tone of light on water. Water has the effect of diluting color reflected from it, so the same hue is present, but of lighter tone.

1 *Carefully sketch the patterns that reflections make on the surface of the water. Then apply the area that has the most color. Here, it is the dark blue color of the surface of a river.*

2 *Loosely block in some of the colors that you see reflected on the surface of the water. The objects will not always be recognizable due to the movement of the water and the play of light. However, note the blue, almost mirror-image of a boat in the top right-hand corner of the scene.*

3 *Finally, pick out those areas of color that display the greatest movement. Painted over the more stationary elements reflected in the water they will create a shimmering effect and will add to the overall impression of random movement and light.*

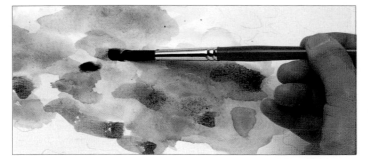

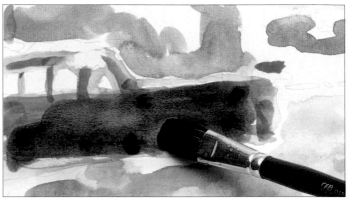

6 ▲ Mix together Winsor Yellow, Ultramarine, and Yellow Ochre. Using a large brush, perhaps a No.11, apply it to the foreground of the painting. Again, you should allow some areas of white paper to be left unpainted to create the effect of bright light reflecting back off the water.

7 ▲ With a small wash brush, build up the color on the boat on the left by applying an initial dark wash of Winsor Violet as under painting. You should then paint a mixture of Prussian Blue, Cadmium Red, and Ultramarine over this.

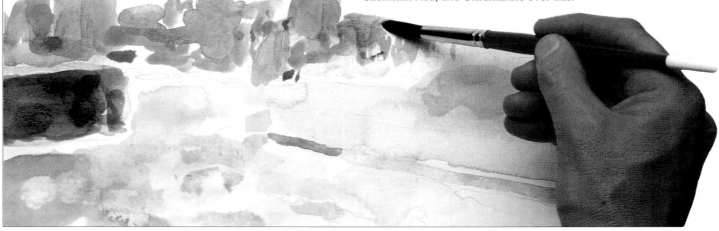

8 ▲ Mix Cadmium Red with a selection of blues and yellows to obtain a grayish blue color. Overlay this on to the buildings to create shadows. The color is similar to the colors found in the water and gives the impression that the buildings are dappled in light reflected from the water's surface.

Building shadow
Ultramarine and Manganese Blue have been applied to enhance some of the shadows on the water.

More gray-blue washes are added, this time with a bias toward Prussian Blue, to build up the shadows on the buildings.

Winsor Violet and some Cadmium Red are applied to the water, also to the windows of the boat above.

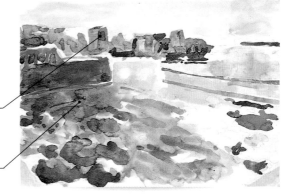

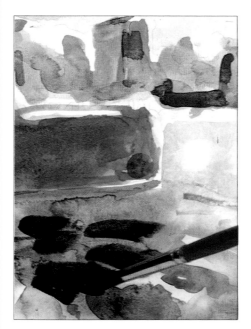

9 ◀ Paint reflections on the surface of the water with a mixture of Ultramarine, Prussian Blue, Yellow Ochre, and Cadmium Red. The color of the reflections corresponds to the boat above it, except that Yellow Ochre makes the reflections lighter.

10 ▶ Apply a mixture of Prussian Blue, Cadmium Red, and Ultramarine to the windows of the boat on the right hand. The color of the windows finds an echo in the range of colors that have been used so far throughout the composition.

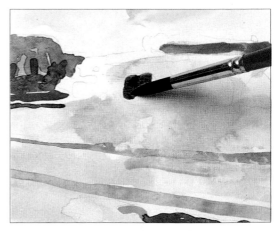

11 ▲ Remove some of the Yellow Ochre from the buildings with a paper towel. Then add some more gray-blue mixture. The final effect should be a balance of the light and dark tones that make up the play of shadow and light.

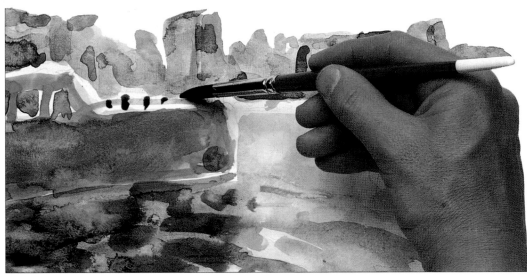

12 ▲ Paint vertical lines along the harbor wall using a mixture of Prussian Blue, Cadmium Red, and Winsor Violet. Though this is only a small part of the overall composition, it is an extremely important one. Because the composition as a whole tends to run along horizontal lines, the addition of vertical lines very subtly compensates for this and produces a more balanced picture.

13 ▶ To create the reflections of this boat's windows, apply a dark blue mixture of Cadmium Red, Prussian Blue, Ultramarine, and Winsor Violet.

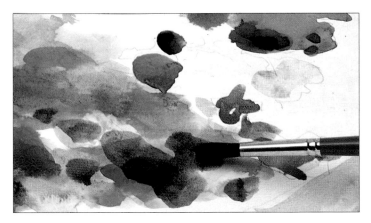

14 ◀ Continue working up the water until you feel satisfied with the end result. Continue to apply colors that follow the range of colors you have already applied. For example, mixes from Yellow Ochre, Winsor Yellow, Winsor Violet, Cadmium Red, Ultramarine, and Prussian Blue could be used to paint in the foreground of the composition to create a warm dark green.

Creating space
The artist has made a point not to overwork this painting in order to retain its light, uncluttered feel.

A mixture of Cadmium Red and Winsor Violet has been used to build up the shadows on the water even further.

As areas of color have been sponged out, the remaining paint has run together to create a complex yet subtle play of light in this part of the composition.

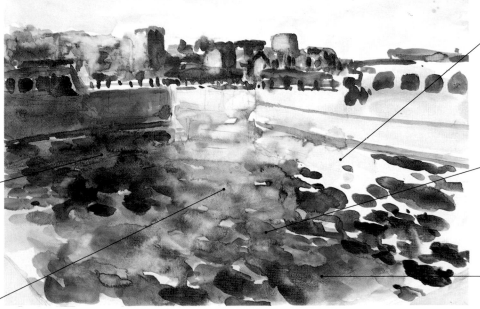

Large areas of white have been left to add to an overall feeling of light in the painting.

Winsor Violet has been laid over Manganese Blue and Ultramarine. Doing this will darken a light area, so that it emphasizes the surrounding tones.

This mix of yellow and gray blue has been built up in several layers to achieve the right balance of light and dark tones.

GALLERY OF WATER

UNTIL THE SEVENTEENTH CENTURY when Dutch painters such as Rembrandt (1606-69) and Vermeer (1632-75) began to paint the sea, European artists did not make serious studies of water. Turner, however, loved the sea for its light, and many watercolorists later shared this passion. Here, water has been painted by a variety of artists, each interpreting its complex nature in their own unique way.

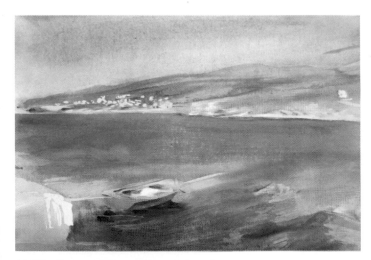

Philip Fraser, *Moored Boat (above)*
In this composition, strong, warm Mediterranean sunlight governs the use of color. The artist has managed to capture the very bright blue of the Greek Islands and the dazzling brilliance of the sea by applying, and slowly building up a series of intensely colored washes. Touches of white detail stress the intensity of light hitting the surface of the water.

The ripples on the surface of the water have been painted in with broad, flat brushstrokes. Stark contrasts in tonal value give a sensation of solitude and strong reflections of pure bright light.

Andrew Wyeth, *Morning Lobsterman, c.* 1960
In this painting, Andrew Wyeth captures the play of early morning light on water. This effect of light bleaching the sky and sea until they merge into one is created by using the same color for both. The foreground water is delineated by a very light application of tonal washes, and this creates the effect of clear, translucent shallow water. The color unity of this composition is cool. Wyeth's palette is extremely low-key, but very effective in recording a chilly morning and the dogged concentration of the lobsterman as he pursues his lonely work.

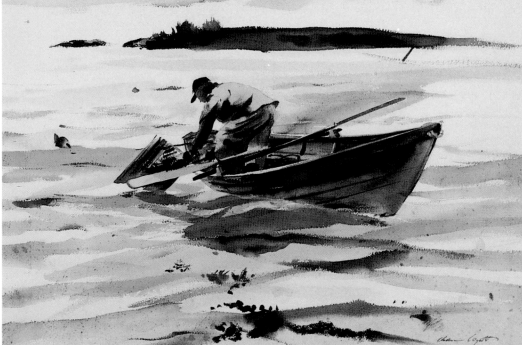

Winslow Homer, *Rowing Home,* **1890**
Winslow Homer was a New England realist, whose main goal was to paint things exactly as they appeared. However, he also sought to imbue his paintings with a high degree of luminosity, albeit within a firm construction of clear outlines and broad planes of light and dark tones. Fascinated by water, he uses dense washes of warm color in this painting to suggest the soft, brilliant sunset on the surface of the sea.

Light coming from behind the oarsman casts him as a silhouette, while the dense brushstrokes, that he has been painted with, mirror those used for the sea.

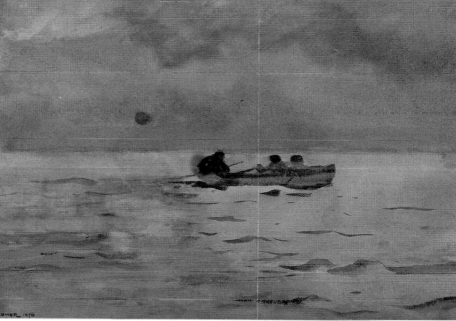

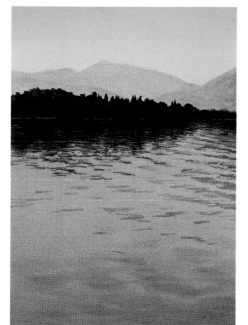

This wave has been painted simply by overlaying touches of bright color on a darker wave shape; this depicts a small flash of light reflected from the wave's crest.

Julie Parkinson, *The Island of Scorpio, Lefkada (above)*
This picture has been painted from memory, with the artist trying to capture the feeling of tranquility that the island inspired. The sea has been painted to reflect the calm, warm, early autumn light and the dry olive-and-cyprus tree green of the Greek Islands. The painting has a luminous quality, which the artist has created by building up a series of dark washes on handmade, slightly shiny paper.

Julian Gregg,
Cornish Coast (left)
Here, the sea has been reduced to large, colorful, almost abstract brushstrokes. Plenty of white paper has been left, and the loose arrangement of brushstrokes gives the painting its light, airy definition. The impression of depth has been created by carefully painting one color in front of another.

SKETCHING FIGURES

W HEN PAINTING A LANDSCAPE, you may want to include figures. These provide interest in a composition, also create a sense of scale. Before attempting a full-size composition, though, it is a good idea to make a few quick sketches. Use your family or look at photographs – most newspapers have good sports studies that show how bodies move. Your pencil sketches should be very simple, with details kept to an absolute minimum. When you start your color study, you can fill in the details of your figures with your brushwork and use color to give the body dimension through the tonal value, as with any other subject.

Areas of dark and light on the figure correspond to the surrounding landscape. The colors representing light here are warm compared to those on the right of the composition.

Advancing figures
A mixture of Indian Yellow and Yellow Ochre is applied as an underpainted band that runs down the center of the figure and unifies any color and tone that is applied afterward. Positioning this figure close to the bottom of the paper gives a sense of her walking into the foreground. As a result of the direction of the light the figure is cast partially in silhouette, accentuated by strong areas of light and dark.

Pencil sketches
Pay attention to the overall form of the figure, rather than to detail. The position of a figure can change the dimensions of part of the body. For example, with a sitting figure, legs are slightly foreshortened.

The shadow is sketchy and fluid, barely conforming to the pencil outline. This suggests, rather than emphasizes, its form.

Figures in bright light
Because the light is so intense in this sketch, the figures are reduced to sketchy, almost impressionistic splashes of color – a lot of white space has been left, and color has been arranged around this. On the legs of the figure on the left, for example, the right leg is almost totally white, except for a very dark shadow running down the left side of the leg. This contrasts with the dark, warm tones on the other leg.

The figure has been painted into its own white space – a white border runs all around the figure. This slight tonal recession pushes the horizon far from the woman.

The footprints move closer together as they recede. The light and dark shadows inside the footsteps (see detail below) reveal the direction of the light in the composition.

The figures on the horizon have been loosely sketched and painted in the same color as the background (right). This conveys the diminishing effect of distance.

Receding figures
The hazy colors and loose style of this composition reflect a mood of calm contemplation. The solitary figure moves through intensely bright space and the dark tone of her form stands out against the white sands. The footprints left in the sand decrease in size to accentuate the perspective of the figure moving across the vast beach.

The shirt has been loosely painted in with violet, and has then been partially dabbed out using a sponge to create an area running from a dark tone to a light tint.

Close and distant figures
The shadow on the near side of the sleeping figure has been simplified and slightly extended. This, combined with the flat red of the towel behind the girl, has the effect of tipping the figure forward slightly. In this way the figure does not recede into the landscape, but lies comfortably in it. The spots on the girl's bathing suit emphasize the curvature of her body.

Group sketches
In this sketch the composition and use of colors reflect the mood that surrounds this group of women. The women are working in bright light and this has a strong influence on the colors that have been used. The definition of each figure is picked out in terms of the strong light and shadows falling across them (see detail). When a group of people are being sketched, it is important to pay as much attention to the space between the figures as to the figures themselves. The spatial relationships between figures will suggest how the relationship of color and light may affect the composition.

175

TOWARD ABSTRACTION

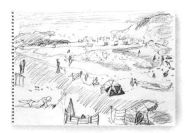

Pencil sketch
This rough pencil sketch of the composition has been drawn to run diagonally from left to right, with the receding landscape being framed by the cliffs.

SO FAR, THIS BOOK HAS DEALT WITH STYLES of painting that could loosely be called representational. They portray the landscape and objects in it in a such way that we can easily identify them. It is, however, true to say that any painting will involve a degree of reinvention on the part of the artist. Here, the artist has painted a seascape so that though water and beach are still identifiable, they have become abstract nuances of light and shadow. Figures have been included in this landscape, and these have been treated in a loose, abstract manner. Rather than being painted from photos or life, this picture was painted in a studio by amalgamating several on-the-spot sketches of figures, with a sketch of the landscape done some time before.

Reducing form
When drawing figures, you may find it helpful to see them in terms of rectangles or triangles. Here, the girl lying down forms an elongated triangle from her toes to her head, and her head is framed by the oval shape of her arms.

1 ◀ Before painting any washes, mask out some of the objects in the landscape with masking fluid – this will preserve the white paper from layers of washes. Paint three bands of color across the composition using a medium wash brush – Winsor Blue for the sky, Manganese Blue for the sea, and Yellow Ochre for the sand in the distance. Paint the foreground sand Cadmium Red, and apply Yellow Ochre to the figures at the left of the picture.

2 ◀ Mix some Winsor Violet and Ultramarine, and using a large brush, apply the mix with a zigzag movement, wet-in-wet over the Cadmium Red wash in the foreground. You should apply this wash quickly so that it conveys a sense of spontaneity. This darker area provides a point of interest and heightens the sense of perspective.

3 ▸ When all the initial washes have dried thoroughly, carefully peel off the masking fluid. The resulting hard-edged objects can then be painted in are now more defined in the landscape.

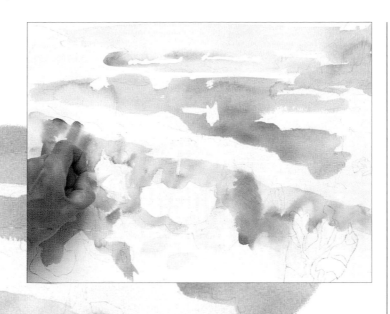

Cadmium Red

Ultramarine

Manganese Blue

Yellow Ochre

Winsor Violet

Winsor Yellow

4 ▲ Start to paint in some of the objects. You should paint this windbreak with Winsor Violet to contrast with the surrounding Violet and Cadmium Red. Partially dab out some paint with a paper towel to further develop the light areas where necessary.

Extra fine pen nib

No.11 synthetic brush

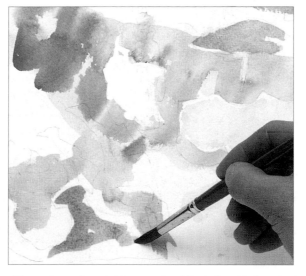

¾ inch mixed fiber wash brush

5 ▲ Paint in the two umbrellas. Their shape is only suggested, and is recognizable. Paint the top umbrella with Cadmium Red to correspond to the wash that runs along the bottom of the composition; paint the bottom umbrella with Yellow Ochre so that it corresponds to the wash that runs along the top.

6 ▲ Loosely paint in a wash of Cadmium Red to depict the towel, which the figures, in the bottom left-hand corner of the composition, are lying on. This relates to the color of the wash above it, but should be painted slightly darker in tone. Like all the other objects in the landscape, the figures and their paraphernalia are reduced to the overall style of the painting – their form is suggested rather than literally represented.

7 ▲ Apply a loose
Winsor Violet wash around the
top and bottom of the yellow area of sand in the
background. This should suggest a ground contour in the
foreground
of the picture and wet sand in the background.

8 ◄ Draw in the outlines of the figures
with a fine pen and watercolor to
give them emphasis. The colors used
here relate to the other colors in the
composition but are stronger. Shadows are
suggested with dark color, while Winsor
Yellow suggests sunlight on the figure.

9 ▶ Apply just a few brushstrokes to the
figures. Here, apply Yellow Ochre so
that it loosely follows the shape of the figure.
This helps the figure to stand out against
the landscape.

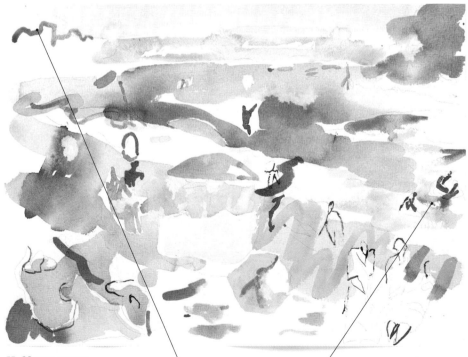

10 ▲ Paint a band of Yellow Ochre
straight across the figure. Apply
the brushstrokes in the same direction as
those used in the rest of the composition
to create a consistency and visual
coherence within the painting.

Halfway stage
Some of the figures in the
painting have been outlined
in ink with a drawing nib, in
a loose, unfinished style.

The cliff tops have
been defined by free
brushstrokes of pure
Manganese Blue.

A Manganese Blue wash has
been painted over wax crayon
to create light on water. This
technique is called "wax resist."

11 ◀ Maintaining this expressionistic style, loosely paint in the cliffs using a wash of Manganese Blue. Apply the paint very rapidly to create a series of squiggles, that subtly suggest the jagged, uneven rock surface of the cliff. These cliffs are a vital part of the composition, as they help to create a framework within which the other elements of the composition are able to work.

12 ▲ Use a mixture of Ultramarine and Winsor Violet to apply shadow to the overall composition. Here, shadow is applied to the windbreak in the center of the painting. When trying to place objects in a landscape, it is important to observe the tonal qualities. Study how the light falls at different times of day and consider how this affects your composition.

13 ▶ Apply shadows to the figures in the left-hand corner of the composition. The color used for the shadow is echoed by the colors that have been used elsewhere. When planning your composition, check that shadows will not disturb the color balance. If necessary move the object that causes the shadow or lift it out of your study using a wet sponge.

Adding abstract marks
A variety of colorful dots and blobs have been dropped into the composition in a random manner. On the yellow sand in the background they are a mixture of Cadmium Red and Winsor Violet, and on the sea they are Prussian Blue.

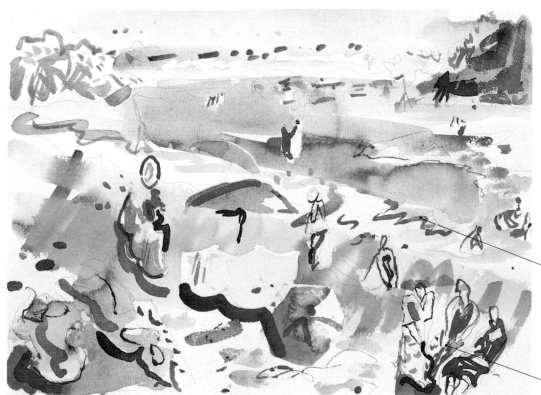

Overall in the painting, the artist has created the effect of the paint simply adding substance to the pencil line drawing.

The artist has left some of the figures unfinished, and this retains the air of spontaneity created by the brushwork.

ABSTRACT LANDSCAPE

P AINTING STYLES MAY BE LOOSELY DIVIDED into two very broad categories: representational, which reproduces the visual world as we see it, though not necessarily with photographic reality; and abstract, which does not convey the visual world but makes an intellectual or emotional statement in color. Painting a landscape as an abstract is to create a composition of colors and shapes evocative of the actual landscape. Here, the artist is inspired by the immensity of nature and singles out landmarks that capture the sense of scale and which move him. The artist modifies what he or she sees, and then incorporates it into abstract studies that suggest the feel of the natural world as he or she perceives it. The artist uses the landscape as a springboard to express feelings: "The landscape is a backdrop, upon which I can project, and reflect, my internal subconscious."

Brushwork
Brush technique is integral to the look of the painting, so use your paintbrush rapidly and with confidence.

1 ▲ Apply a wash of Ultramarine to the paper with a large wash brush. This is the first brushstroke of the composition and as such will govern all subsequent brushstrokes. Do not plan, but allow the process of applying the paint to lead you. The amount of paint on the brush will dictate the intensity of colors on the paper and consequently the equilibrum of the whole painting.

2 ▲ Apply a lighter wash of Turquoise mixed with a small amount of Cadmium Red. In contrast to the darker tone below it, the tone of this part of the painting is consciously lighter. Next, paint the dark tone – apply paint to this until your brush has no paint left on it.

3 ▲ Work up the latest wash to create a shape, roughly in the form of an arch. You should then apply a wash of Terre Verte with a touch of black to fill in the area of white space in the middle.

180

4 ◄ Run this wash of Terre Verte into the initial mixture of Cadmium Red and Turquoise. Then apply Terre Verte along the bottom of the painting and also use it to paint in the small abstract marks that could represent trees. However, in keeping with the painting, the form of these should be deliberately vague.

5 ► Using Terre Verte, paint two large "trees" at either side of the abstract structure in the center of the composition. Also paint in some smaller ones. Paint in an arch by applying an Ultramarine wash along the bottom of the composition, and then scrub it out with paper towel. This will remove paint from this area and allow the paints to mix into each other.

6 ◄ Apply a further wash of Ultramarine to the right-hand corner of the painting, and then work this up with a wash brush. The way that you control the flow of paint on the paper plays a major role in creating the painting's qualities of color, tone, and mood.

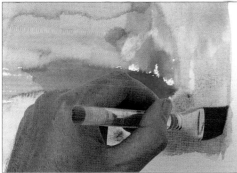

7 ▲ Overlay a Cobalt Blue wash on the worked up area of Ultramarine. Finally, paint in a few more "tree" symbols.

Materials

Cadmium Red

Rose Madder

Terre Verte

Ultramarine

Cobalt Blue

Black

Turquoise

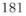

1 inch synthetic wash brush

Colosseum, Rome

This picture is of the Colosseum and is based on a similar painting that was done from life. Though the composition seems very abstract, its starting point was the physical building in its famous Italian setting.

181

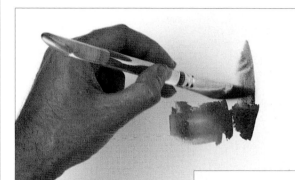

8 ◄ Start a second painting on the same paper, above the first. This will allow you to refer to the first painting, which should have a direct bearing on the final appearance of the next. Apply an initial strong wash of Ultramarine, and then paint a Terre Verte wash beside it.

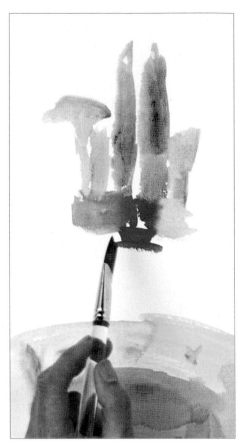

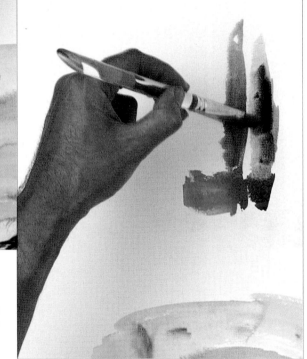

9 ▶ Roughly extend the Terre Verte into the form of two "trees." Apply paint to paper in a way that is both free and controlled. This will create a range of light and dark tones that looks spontaneous.

10 ▲ Overlay Black on the trees, and then paint in some more trees, now with Terre Verte. Also apply more strokes of Black as a separate detail, and then apply a Turquoise wash along the bottom of the painting.

11 ▶ Apply the Turquoise to the left-and right-hand side of the composition. Again, the tonal difference in its application is dictated by the amount of paint that you have on the brush and the degree of dilution – the thicker the paint mix, the darker the color. Remember that colors become lighter as the paint dries, so allow for this in your mix.

13 ▲ Apply Turquoise along the bottom edge of the painting, separating it in an area of white paper.

12 ▲ Paint an intense circle of Turquoise at the top left-hand side of the picture. If you take into account the rules that dictate the style and content of these paintings, you may be able to perceive a symbolic or representational meaning in an abstract mark like this. On the other hand, this stroke may have been included to create a point of focus or a visual balance, two crucial factors in any composition.

14 ▲ Overlay a wash of Rose Madder on the Turquoise wash running along the bottom edge of the painting. You should then work this up with a wet-in-wet technique, so that the colors blend together.

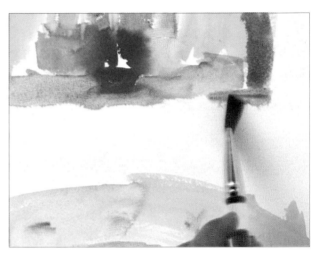

15 ▲ Apply more Turquoise along the right-hand edge of the picture. Paint it on loosely over an already dried wash of turquoise, but without working it up. Bring the second wash to a hard edge to create an abstract detail that represents a part of the landscape.

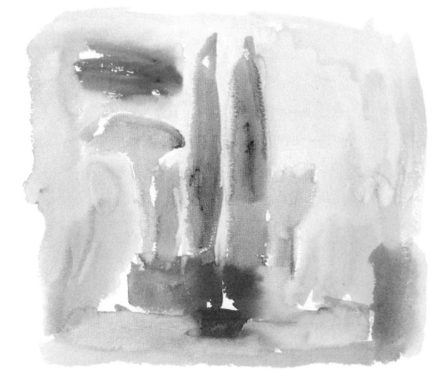

The Island of the Dead

In technique and color, these two paintings bear a strong resemblance to each other. The studies are the result of the artist's need to experiment on a range of different images using the same tonal qualities and colors. In doing this he explores the possibilities of expressing a variety of moods and scenes within the technical limitations he has set himself. He based his first study on a scene from nature and has succeeded in conveying a lost, misty landscape. The second is an imagined landscape and is entitled *The Island of the Dead*. The artist intended it as a metaphor for the perils that accompany artistic and human endeavor. Both works share a quality of loneliness.

ABSTRACT GALLERY

IN PARIS, JUST BEFORE the First World War, (1914-18) a group of painters made a radical departure from traditional painting. They introduced Cubism, an approach to pictorial art that disdained realism in favour of a more abstract reality. It was the start of a great movement that proclaimed that painting need "no longer be an image of something else but an object in itself." The selection here ranges from largely emotional paintings to abstract graphic designs.

Christopher Banahan, *Mount Purgatory*
This artist works intuitively, allowing the drying time of the paint to dictate the "period allowed for creativity." However, his brushstrokes and understanding of the characteristics of watercolor reveal that a practiced and skillful painter is at work. A very subtle use of color and an uneasy sense of height, despite the lack of conventional visual cues, make a simple yet powerful, emotional impact on the viewer.

Rachel Moya Williams, *Stained Glass Design*
This watercolor was conceived as a design for a stained glass window. The outlines around the shapes and forms give definition to symbols of boulders, sunbeams and trees.

Concentrated pigment has been applied to the flat washes while they are still wet, and this has the effect of building up a variety of tones and hues.

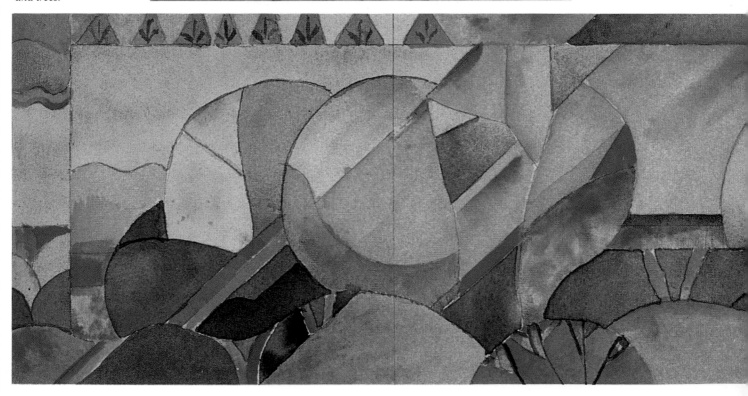

John Marin, *Sunset, Maine Coast,* **1919**

John Marin was influenced by European art during time spent in Paris. On his return to the United States, he became influential in leading his fellow artists away from naturalistic representation toward an expressive semi-abstraction. His ideas are revealed in this watercolor. We recognize the sunset, but it is a thing of fiery emotion, set in a turbulent sea. Conventional depictions of atmosphere and light are abandoned and color is used to reveal the artist's subjective response to the scene.

Simple, broad bands of color have been arranged with a lyrical mastery. Very little mixed pigment has been applied and brushstrokes are bold.

Gisela Van Oepen, *Untitled*

This painting is the final image in a series of studies of one mountain range. Van Oepen observes with intense concentration and prefers to go through a period of meditation before she starts to translate her subject into paint. During her work on this series, she looked for the essence of the mountains. This led her to discard and reject anything superfluous in her images. The logical conclusion to her search is this final study where land and light are reduced to pure line and color.

185

WATERCOLOR STILL LIFE

WATERCOLOR IS A WONDERFUL MEDIUM for painting still lifes. The translucency of traditional watercolor paint allows underlying color to show through, enabling you to capture the unique quality of glass or water. Or if you want a more solid effect, you'll find that gouache, with its greater concentration of pigment, is ideal for creating deeper colors and adding highlights. The following section will help you select the type of paint you need for your choice of composition – whether arranged by you or whether stumbled upon *in situ* – and show you how to focus on the space, light, and tone of your still life painting.

INTRODUCTION

STILL LIFE PAINTING conjures up images of luscious displays of fruit and flowers or the beautiful arrangements of objects. As a genre, still life evolved from the detailed studies of nature in the sixteenth century to today's more personal approach and wide diversity of subject matter. Watercolor has gradually established itself as the natural medium for painting still lifes because of its purity of hues and its immediacy – it is ideal for capturing color and form quickly.

The development of still lifes

The painting of inanimate objects came about around the seventeenth century, when art patrons wished to be portrayed with symbols of their material wealth. Portraits would include sumptuous displays of food and prized possessions. This form of painting found favor with the wealthy merchants in the Netherlands. Indeed, the term "still life" came from the Dutch *still-leven* meaning motionless (*still*) and nature (*leven*). Artists such as J. Brueghel (*1568-1625*), Rubens (*1577-1640*), and Rembrandt (*1606-69*) produced great works of art in oils in this genre. It was the lesser-known artist Giovanna Garzoni (*1600-1670*) who painted still life in tempera, a water-soluble medium not unlike watercolor. She was, however, way ahead of her time. It was not until the eighteenth century that still life gained a wide popularity in Europe with the spread of the doctrine "Art for Art's sake." Artists started shifting away from formal portraits and religious studies to a more individual approach. This liberal attitude allowed such painters as Jean-Baptiste-Siméon Chardin (*1699-1779*) to depict, with great sensitivity, everyday objects such as kitchen utensils, fruit, and game.

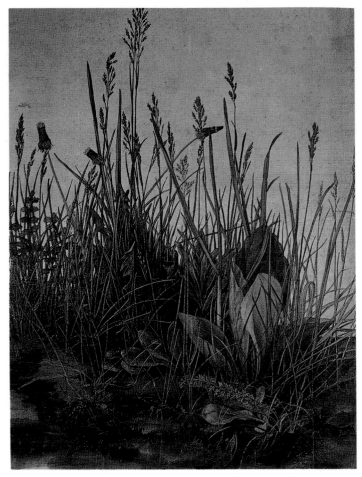

Albrecht Dürer, *The Great Piece of Turf,* **1503**
In this exquisite study of wild grass, Dürer shows us that beauty can be found in even the most humble of subjects.

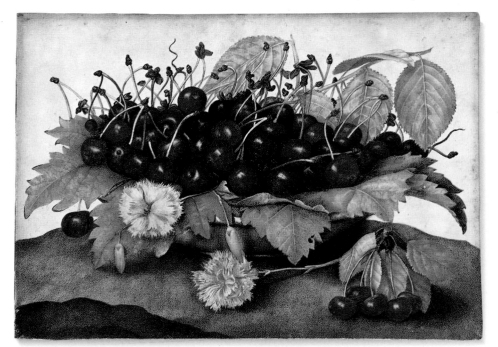

Giovanna Garzoni, *Still Life with a Bowl of Cherries,* **c.1650**
Garzoni's study of a bowl of cherries is executed in egg tempera on parchment. The paint used was water-soluble, and the addition of egg yolk to the pigment created a stronger medium. The composition is simple without being static. The cherry stems appear to gyrate in a sensuous dance conveying a tantalizing sense of joy and lightheartedness. The sparkling red ripe cherries spill over onto the delicate cool white and pink carnations to produce a striking contrast of form and texture.

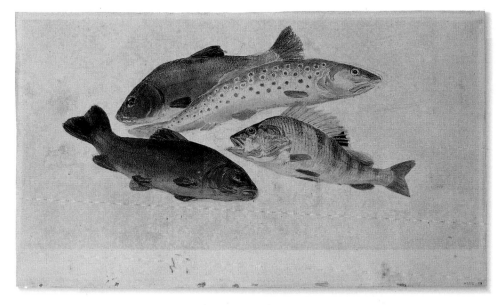

J.M.W. Turner,
Study of Four Fish,
c.1822-24
Turner has positioned
the fish carefully so
that they appear to be
leaping and moving
together. The fine
texture of their flesh
is described vividly.

Paul Cézanne,
Still Life with
a Jug, **1892-93**
The interest of this
study lies in the
rhythms of the
rounded forms. The
objects were placed
so that they created
a fine visual balance.

Modern still lifes

In the nineteenth century the course
of painting altered radically with
artists such as Edouard Manet
(*1832-83*), Vincent van Gogh (*1853-90*),
and Paul Cézanne (*1839-1906*), whose
still lifes rank among the finest
works of any kind. Cézanne, who
painted in both oils and watercolor,
is considered the master of modern
still life painting. His still lifes present
to the viewer not an imitation of
nature but a re-creation of it, revealing
to us the beauty of colors and forms;
making us see as though for the first
time the most ordinary objects such
as apples or a jug. In
contrast to the sensuous
appeal of the nineteenth-
century paintings, the
twentieth-century artists
such as Pablo Picasso
(*1881-1973*), Georges
Braque (*1882-1963*), and
Juan Gris (*1887-1927*)
embarked on a totally
different approach to
the subject. They
were concerned with
representing objects
in two-dimensional
geometrical shapes
devoid of emotion or
empathy, asserting a
conceptual rather than a perceived realism. Some
other notable modern watercolor still life painters
were Emil Nolde (*1867-1956*), Raoul Dufy (*1877-*
1953), and Oskar Kokoschka (*1886-1980*). But
whatever the style of an individual artist, a good
still life should always convey to the viewer a purity
of vision that is exciting and inspiring, whether it be
of an arranged subject or one painted *in situ,* as in
the paintings of the American artist Andrew Wyeth
(*b. 1917*), whose still lifes of stark rustic objects
kindle a feeling of poignancy and timelessness.

Andrew Wyeth, *Bucket Post,* **1953**
Wyeth made watercolor sketches on his travels of scenes
and objects that interested him. The beautifully rendered
sketches made in his famous notebooks were worked up
into finished paintings at a later time in his studio. In this
instance, Wyeth was perhaps struck by the gleaming
whiteness of the buckets against the dark hedge.

189

GALLERY OF COLORISTS

A PAINTING'S USE OF COLOR connects the onlooker to the poetic imagination and creativity of the artist. Color is one way in which the artist conveys emotion and reveals his own interior feelings. Color can suggest mood and depth but, like music, it also acts on the senses to excite, relax, or move the viewer. Color can be vibrant and high-key, or muted and low-key, or subtle combinations of the two. Stunning effects can be achieved with bold hues and subtle atmosphere can be created with soft cool hues. The artist's choice of colors signifies the perceived world. The painting, even momentarily, provokes an immediate response – a gasp or a sigh – and remains as a vibrant memory in which color resonates.

William Hough, *Apples and Plums,* 1869

The technical proficiency of Victorian watercolorists is demonstrated well here. The paint is dexterously applied to suggest the fine bloom of the plums; their soft blues and purples shine softly against the broken texture of the ground on which they lie. Yellow and orange apples create a change in the picture plane: their warmer colors stand out against the muted colors of the foreground. The whole composition has been painted with infinite care using tiny, meticulous brushstrokes.

Hercule Brabazon, *Red, White, and Blue, c.*1885

Brabazon is best known for his sketches of his travels executed on Turner Gray paper using white body color and watercolor, with a transparent glaze over the white body color. Here, using the same method, Brabazon has worked on a toned ground. Pure colors laid on top of the white body color shine clearly as glowing highlights.

For the flowers Brabazon has used Chinese White overlaid with red and blue watercolor to glaze the petals. The red, blue, and white blooms resonate against the deep blues and browns that create tone in the subdued background.

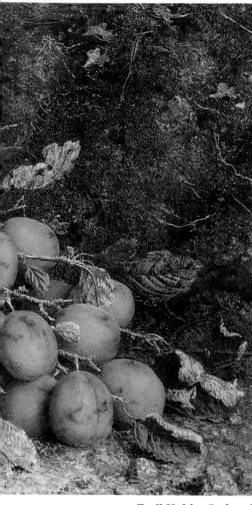

Emil Nolde, *Red and Orange Poppies, c.*1900
Nolde is an expert in using color as a poetic expression. Central mauves and blues create an amazing depth of space, while the bloodred poppies burn against the ground, and the exotic orange petals vibrate against the mauves.

Paul Newland, *The Nursery*
This subtle balance of complicated forms draws the eye back and forth across the room. The areas of light – the lamp and the open doorway – form the main focal points against the muted colors of the interior. The painting is divided into thirds; balance is created instinctively within the intimate space.

Geraldine Girvan, *Embroidered Cloth*
The vibrant colors of this composition are cleverly felt and placed. Blue patterns hold the yellow backdrop in its spatial position, away from the dominant tablecloth. The vermilion of the cloth is emphasized by the glowing oranges and apples.

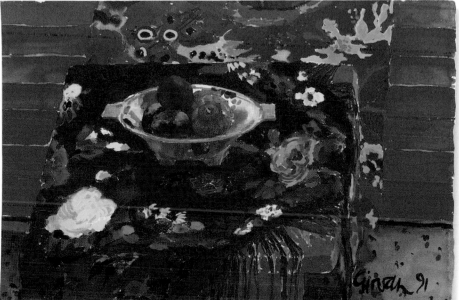

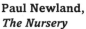

Dark green leaves become almost black where the cloth falls over the edges of the table, dropping away from the picture plane.

The artist makes fine use of complementary colors on the far wall, where soft blue-mauves throw the shades of burning orange forward.

191

MAKING SKETCHES

IDEAS FOR PAINTINGS ARE ALL AROUND US. You never know quite when the urge will strike you to record a fleeting moment or capture a scene on paper. It is always useful to carry a sketchbook with you so that you can jot down images that strike your interest. If you are planning a still life painting, there are many variables to consider. You may want to play around with your objects and experiment with how the light falls on them. Sketches are an ideal way to try out various compositions before committing yourself to a full-scale painting. Although many artists work in charcoal or even pen and ink, pencil remains the most popular tool for sketching. Practice making different marks with a pencil; it is capable of an enormous diversity of line and tone.

Sketchbooks
Sketches can be as brief or as finished as you choose and can be in whichever medium you prefer.

HB pencil

2B pencil

4B pencil

Sketching pencils
Pencils vary in strength from "H," which stands for hard and produces a very soft line, to "B," which stands for black and produces a rich, dark line. "HB" is midway between the two. The 4B is slightly softer than the 2B, but any of these three pencils is fine for drawing with line, for hatching, or for shading.

Plastic eraser

Kneaded eraser

Modifying your drawings
You can delete pencil lines with a rubber or plastic eraser, but a kneaded eraser is better for removing pastel or charcoal. Form the kneaded eraser into a point to use with ease.

Hatching and highlighting
Practice different types of lines to suggest tone or create texture. Hatching and crosshatching (*above and right*) can be used to interesting effect in a drawing. If you want to create highlights in a pencil drawing, you can lift some of the lines or tones with an eraser.

By pressing harder with your pencil you can modify the line to create a **sense of form.**

Studies of apples and cherries

The sketches on this page show some of the ways that you can approach a subject. It is a question of both how you look at your arrangement and how you choose to draw it. You can concentrate on the beauty of the shapes of your apples and cherries, for example, as in the very linear drawing below, or you can look for the spatial patterns they make or study the tonal contrasts of light and shade. A painting can consist of all these elements; making preliminary studies allows you to become aware of some of the possibilities that are available to you.

Line drawing

In the image on the right, the artist uses gentle fluid lines to describe the shape and features of the fruit. The seeds and cores of the cut apples are deliberately accentuated to echo the curved lines of the larger shapes. The stems of the apples and cherries also add to the rhythm and flow of the lines. This deceptively simple drawing is produced with a great degree of confidence and skill. You will need to practice a great deal to achieve this degree of mastery with your pencil.

These simple outlines are sufficient to capture the essence of the fruit.

Spatial study

The fruit seen in context against the dark background (*left*) and the whiteness of the paper beneath emphasizes the sense of three-dimensional space. The eye is led from the sharp horizontal lines in the foreground of the sketch into the darker recesses at the back. The inclusion of delicately modulated shadows anchor the fruit firmly on the table.

Charcoal sketch

This charcoal drawing (*right*) establishes the pattern of the dark and light tones. The addition of a piece of crumpled paper enhances the tonal contrasts. Modeling with charcoal is easy because you can apply the dark strokes swiftly.

The vigorous charcoal marks suggest bold brushstrokes, making this sketch look quite painterly.

The shadows cast suggest a table top.

Highlights are made with an eraser.

Study in composition

The drawing on the left is similar to the linear drawing at the top of the page although considerably more finished. The artist here is not only concerned with the outlines of the fruit, but she has also modeled the shapes to give them form and volume. The highlights on the cherries make them look glossy as well as indicating the direction of the light source. The placing of the fruit has been adjusted to make it look less static. The cut apple on the left is tilted to catch the light while its other half is moved slightly forward to break up the horizontal grouping.

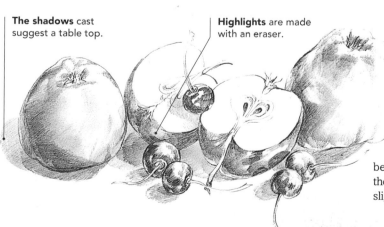

THE WORKING STUDIO

IF YOU ARE GOING TO WORK seriously as a painter it is important to set up a space of your own. Choose a position that is near a large window where natural light will fall on your work table or easel, but try to avoid direct sunlight since this will cast strong shadows in the room. To work into the evening, you should add extra lighting using daylight bulbs that will not distort the quality of your colors. It is also useful to have a sink for cleaning brushes and as a fresh supply of water for mixing your paints.

Allocate a time to work regularly. You should allow two or three hours to practice basic techniques, brushstrokes, and sketching, then increase the time as your interest and confidence grow. Create an atmosphere in which you feel at ease so that you can devote all your attention to seeing and developing your ideas on the subjects you are painting.

Essential equipment

You will need a chair or stool to sit on, and you could also use an upright chair as your easel, resting your drawing board against its back. Alternatively you might prefer to work with your board on your knee or propped up on a table. If you decide to invest in an easel, spend some time trying different models before you buy one, because you must feel confident about your choice. Try various layouts until you find the one that suits you best. A cart is useful for carrying paints, palettes, and pots of water. Keep some rags or tissues within reach in case you accidentally spill water or need to lift color washes from your painting.

Paul Newland

CREATING A COMPOSITION

To CREATE A STILL LIFE composition the artist first of all decides on a theme, then selects several suitable items to construct a visually interesting entity. The overall structure of this composition should reinforce the theme, convey an idea, or suggest an ambience. For example, a low viewpoint may imply a dynamic tension, whereas a horizontal arrangement may evoke a quiet stillness. There are other devices you can employ that rely on close color harmony or contrasts, or unusual juxtapositions of shapes and forms. A device that is often used is the classical principle of the "Golden Section." In this, the painting surface is divided into what is felt to be harmonious proportions – a square and a smaller, upright rectangle – with the focal point of the composition positioned roughly two-thirds along, at the point where they meet.

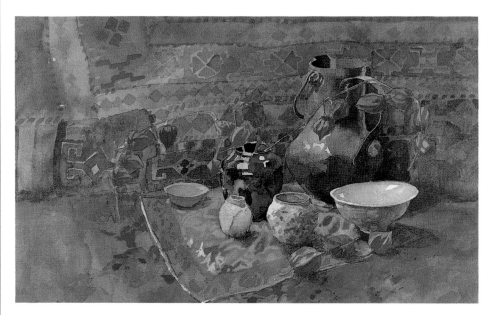

Off-center focal point
For her painting entitled *Chinese Lanterns,* Annie Williams has selected fabrics for the background and the foreground to complement the colors of the vases, dishes, and sprays of flowers. The fabrics provide the overall color scheme of soft, diffused hues: orangey pinks echo the colors of the Chinese lanterns. The blue, lilac, and yellow of the jars and dishes are also subtly echoed in the fabrics, creating a rhythm of repeated tones and colors. The fine overall tonal balance of the composition builds a strong visual harmony: the objects have been positioned slightly off-center, as the artist instinctively follows the ancient rule of the Golden Section (*see below*) – sometimes known as the "law of thirds" – in a visually pleasing arrangement, allowing the eye to move into and around the painting.

Applying the rule of the Golden Section
The dotted line on the rectangle (*right*) divides it into two proportional sections, a square and an upright rectangle, forming the basis of what is known as the Golden Section or the law of thirds. In painting, the point of visual interest is positioned along the upright vertical (roughly two-thirds along the picture plane), thereby creating a pleasing visual balance and harmony.

Rhythmic patterns
The arc placed over the painting on the left shows how the eye is drawn across and into the painting, both from left to right and from the front to the back of the composition. The main areas of interest lie within the arc, with the main focus resting in the second, smaller Golden Section formed by the "tail" of the spiral. Most artists use this principle intuitively, positioning the most significant area of their composition within the smaller rectangle.

A sense of depth
There are many areas of attraction in this skillful painting by Paul Newland (*above*). The objects on the table extend from left to right, and to the back, drawing the viewer right into the composition.

Horizontal format
This elongated format (*right*) draws our attention to the bottle of oil and the teacup. The placing of the cup in the center of the image is somewhat disturbing, although the blocks of color make interesting patterns in the background.

Vertical format
By looking at the painting through a viewfinder you can select various aspects of it and other possible compositions. The vertical "portrait" format (*left*) shows you how different views and formats can transform the visual impact of a painting.

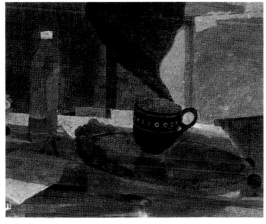

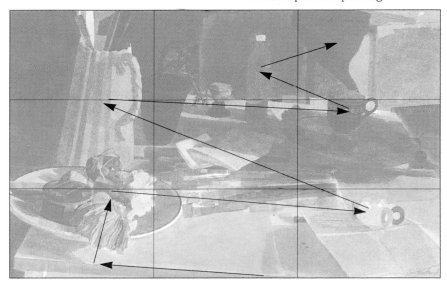

Making space
The grid and the directional arrows placed on the surface of the painting (*left*) show how the eye is drawn from the front to the back of the painting via many areas of visual interest positioned in the foreground, midground, and background. The artist has instinctively arranged the composition according to the Golden Section or law of thirds.

197

SELECTION VS INSPIRATION

ESSENTIALLY, STILL LIFES FALL INTO TWO MAIN categories – those that are arranged by the artist into a pleasing composition and those that are painted just as they are found, without artistic intervention. Although the former is by far the more familiar of the two, as in the traditional fruit or flower arrangements, there is a lot to be said for the inspirational painting – the one where the artist has been moved to paint a particular scene or setup because it is intrinsically beautiful or interesting. Each approach has its advantages: the arranged still life allows you to move forms around and play with aspects of lighting and tone until you are fully satisfied with the result; the "found" still life has an immediacy and vitality not possible with a controlled setup. To see a scene and be so moved by it that you want to paint it makes for a powerful painting indeed.

Hazelnuts
Autumn provides a richness of delights for the artist as nuts and berries fall to the ground.

Buckeyes
Nature abounds with colors and textures. Here the horse chestnut fruit combines both a rough, spiky shell and a smooth, shiny nut.

Hazelnut study
A fine pencil drawing overlaid with delicate washes of earth colors captures the sinuous rhythms of the hazelnut fruits.

Chestnut study
This broken twig with its hanging chestnuts inspired the artist to do a quick sketch. Notice how the line varies from strong dark lines for the spikes to lightly shaded areas for the soft inner skin of the shells.

Medlar fruit
As leaves dry out, they change in texture and tone. The pale greens become darker and browner, and the soft, supple leaves become thin and cracked.

Horse chestnuts and hazelnuts
Although arranged, this basketful of nuts retains an air of spontaneity, as though the artist has just collected all the nuts from the garden. The composition is made up of a symphony of greens and ochres, with the rounded form of the nuts being echoed in the curved weave of the basket.

Elizabeth Jane Lloyd

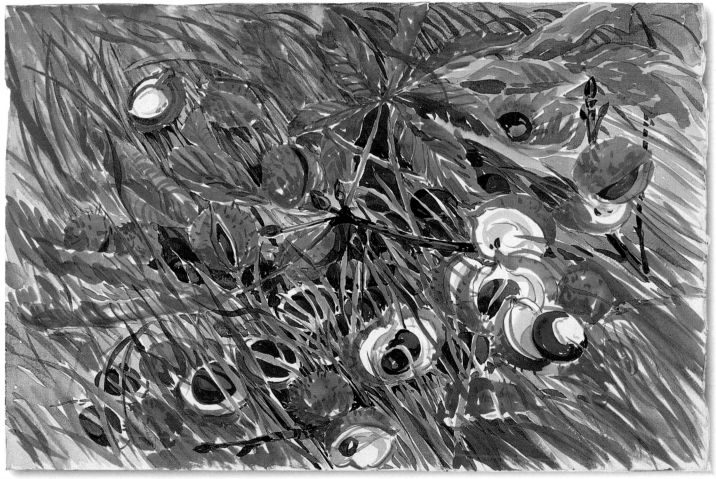

Fallen chestnuts
It would be easy to miss the beauty of these chestnuts nestling under a tree. Part of the skill of being an artist is learning how to look. There is a richness to this simple scene as the multicolored blades of grass twine their way around the buckeyes, forming almost abstract shapes and patterns across the surface of the grass. The whole arrangement is just as the artist found it. Moved by this unexpected find, she made a watercolor sketch of the scene *in situ*.

199

SEASHORE VISION I

Gray whelk shell

WHEN PUTTING OBJECTS together for a still life painting, the artist carefully selects and arranges them to construct a visually attractive composition. There are a number of variables to consider, including, the lighting, juxtaposition of shapes, color arrangements, and contrasting textures. On the following pages you will see how two very different artists have chosen to portray the same objects. The first artist used the unusual shapes of the shells, a coconut husk, and a piece of driftwood to form an asymmetrical pattern of triangles upon a triangle. The objects appear to pull away from the apex of the pen shell, creating a dynamic tension as if they are being washed away by the tide.

The two spiral shells, the coconut husk, and the piece of driftwood are placed on the flat, open pen shell in a tightly controlled arrangement.

1 ◀ Outline the composition using a soft 2B pencil. You may find a detailed sketch allows you to paint with more confidence later. Select your palette and mix all the colors you require. Establish the darker tones first. Use Burnt Sienna and French Ultramarine to create a deep gray for the shadows, then block in the area surrounding the coconut husk using pure Burnt Sienna.

2 ◀ Draw in fine lines for the husk using the tip of a small brush. Once these have dried, lay a dilute wash of Cobalt Blue over the line work. To create warmer tones, add a wash of Raw Umber over some areas of the husk. Because the colors will become lighter as they dry, you may need to return to them to add further layers of Cobalt Blue and Raw Umber. A softer effect is achieved when details are painted in before the wash than if details are laid over the wash. The layers of colors also enhance the solidity of the husk.

Coconut husk

200

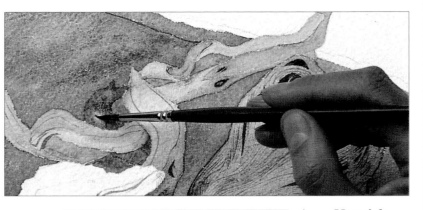

3 ► For the driftwood, lay in a wash of Raw Umber and Yellow Ochre, using a medium-sized brush. Add a touch of Cadmium Red and Cobalt Blue using a wet brush, and then allow the colors to dry. To emphasize shadows on the driftwood, wash Cobalt Blue over the gold tones.

Bleached driftwood

Materials

No. 4 round

No. 6 round

5 ◄ Add fine lines to describe the texture of the whelk shell using the tip of a small brush. Apply a further wash of Cadmium Red mixed with Crimson Lake to the pen shell, and then overlay its edge with a wash of Yellow Ochre.

4 ▲ Apply Raw Umber, Ultramarine, and Alizarin Crimson to the surface of the large pen shell. Dot gray and Alizarin Crimson into the foreground and background, then use a medium brush to blend in the colors, following the curve of the shell.

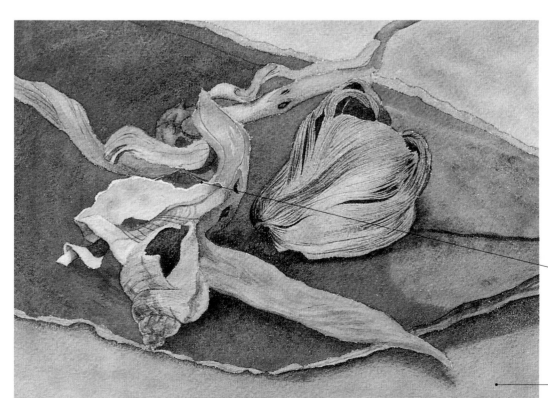

Seashore still life
The painting has been created with subtly blended warm and cool tones in a fairly limited color range. The composition pulls the viewer into the center as the eye is led back and forth from shell to driftwood to coconut husk, in a balanced rhythm of movement. The use of cool shadows creates an illusion of the objects floating against the sandy ochre ground.

Small areas of clear white paper create the brightest highlights.

This still life was painted in a studio, but, by laying a flat wash of yellow ochre with grays and red dotted in, the artist has transformed the background to become a beach. This suggests that the objects were painted *in situ*, heightening the sense of immediacy and energy.

Rita Smith

201

SEASHORE VISION II

IN THIS SECOND COMPOSITION, the artist has involved the imaginative use of light effects to create an unusual scenario. Her intention is to render a painting of strong psychological impact rather than to portray the chosen objects as they are in a re-creation of literal reality. To accomplish this, she exploits the presence of long, eerie shadows, the central one appearing like a chameleon or iguana that is quietly slithering upward through the burning sand of the foreground toward a cool, beckoning sea beyond.

The selected shells, driftwood, and coconut husk are silhouetted in front of a strong light, placed at ground level, so that they cast long, dramatic shadows into the foreground.

Gray whelk shell

1 ◀ Use a large brush to build up light washes of Winsor Blue and French Ultramarine for the background. Block in the dark areas, leaving the edges undefined for a loose textural effect. Lay a wash of Carmine for the large shell and Indian Yellow for the midground. Dry the washes with a hair dryer.

2 ▶ Add a wash of Indian Yellow over the big shell, then build up the shadow areas and the small shell with Burnt Sienna washes. Dry with a hair dryer to prevent hard edges from forming. Define the driftwood with Brown Madder Alizarin and a gray mix of Ultramarine and Burnt Sienna.

Pen shell

3 ▲ Deepen the blue background with a gray-mauve wash mixed from Indigo and Brown Madder Alizarin. Apply dilute washes of Cadmium Red to the foreground. Let the paper dry, then add gouache tinted with Cadmium Red and Indian Yellow.

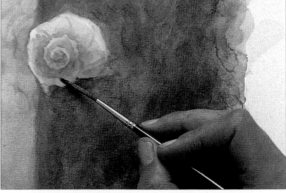

4 ▲ Use a rigger (a long, thin brush) to paint the delicate details of the whelk shell with French Ultramarine. Use little curved strokes to describe the spiral pattern, and deepen the tone toward the center of the shell to give it a rounded effect. Add a touch of diluted Ultramarine to the shadow cast by the shell.

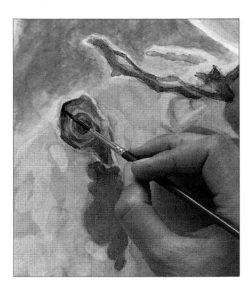

Broken shell

5 ◀ Add details to the broken spiral shell, then deepen the shadow falling in front of it, using Burnt Sienna and Brown Madder Alizarin to make the shadow echo the shell's form.

6 ▲ Add a dense wash of Carmine to the large shell, allowing some of the wash to run down onto the coconut husk. The touch of Carmine at the top of the husk gives the impression of a rosy light cast on it. Overlay the husk with a wash of French Ultramarine.

7 ▲ Use a rigger to paint strong veins of Carmine on the large shell. Then darken the background with a wash of Winsor Blue and French Ultramarine with a very large brush. To add dimension to the shell, apply a dilute wash of Indian Yellow to the rim; this produces a luminous quality, as if light were radiating from it.

Shadow play

This painting is in strong contrast to the realistic rendering of *Seashore Vision I*. The artist has used the objects as the central dramatic elements in the composition. Their colors are heightened for strong visual impact and are juxtaposed to create tonal variety within the painting as a whole.

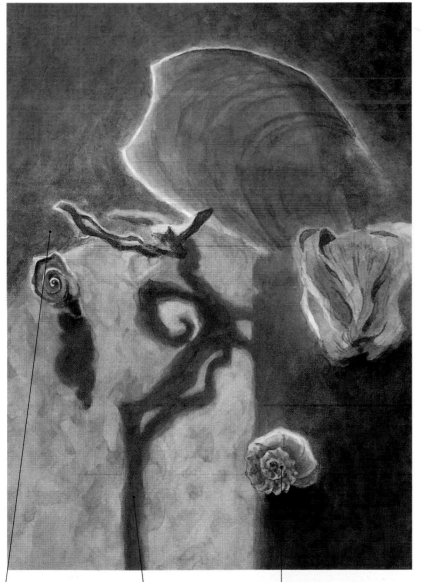

A thin wash of Burnt Sienna lights up the deep blue background on the left, heightening the sense of three-dimensional space.

The shadow cast by the driftwood dominates the image, mirroring the actual structure of the driftwood in a repeated pattern.

Sarah Holliday

Luminous blues and intense crimsons are poetic interpretations of color rather than literal descriptions of objects.

Materials

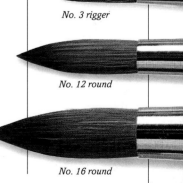

No. 3 rigger

No. 12 round

No. 16 round

GALLERY OF COMPOSITION

THE ART OF GOOD painting relies to a great extent on composition – on the ability to place the focus of your painting correctly within the confines of your paper. Although most artists do this instinctively, there are certain rules that can be followed. The Greeks devised the "Golden Section," dividing a rectangular canvas into what were judged to be harmonious proportions – a square and a smaller, upright rectangle. The focus of the painting would occur where the square bordered the rectangle, roughly two-thirds along. Generally, as seen here, paintings with an off-center focal point are more aesthetically pleasing than ones where the focal point is in the center. In painting, this device engages the viewer and draws us into the heart of the picture.

Pablo Picasso, *Still Life in Front of a Window, St. Raphael,* 1919

A stylized violin, open music books, and a mirror create fluid shapes echoing the clouds and the sea. Black railings make stark patterns in front of the sea, and shadows of the railings are reversed in blue on the pink foreground. The composition is contained by the blue-green shutters and the gray ceiling, while the earth colors of the window frame lead the eye toward the sea.

Hercule Brabazon, *Still Life,* c.1885

Dark washes and rich tones are held back by a cascade of white fabric. The red roses positioned just off-center are balanced by the dramatic diagonal brushstrokes of Chinese White. These bold brushstrokes stand out on the tinted paper, imparting drama and richness to the painting.

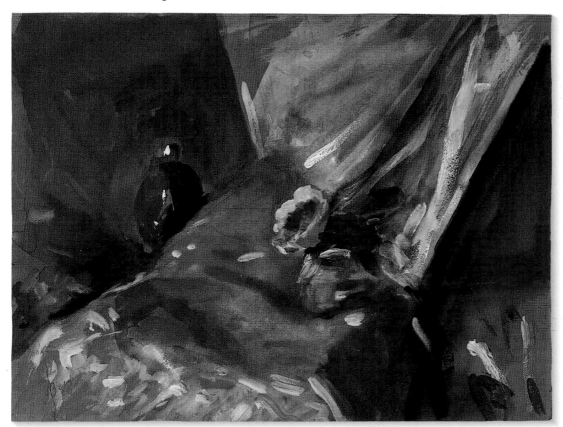

Rita Smith,
The Studio

Many artists paint their own studios, perhaps because it is where they are often inspired and work begins. In this painting, images are encompassed or framed by other images. The drawing board rests on an easel, and an outline of masking tape breaks up the surface of the board. Strong verticals and horizontals are created by the stand of the easel, the board, and the frame of the mirror, dividing the composition into thirds. Reflections in the mirror over the tiled mantlepiece add depth to the painting; the scale rather than the tone tells us that the two paintings on the far wall, seen through the mirror, are most distant from us.

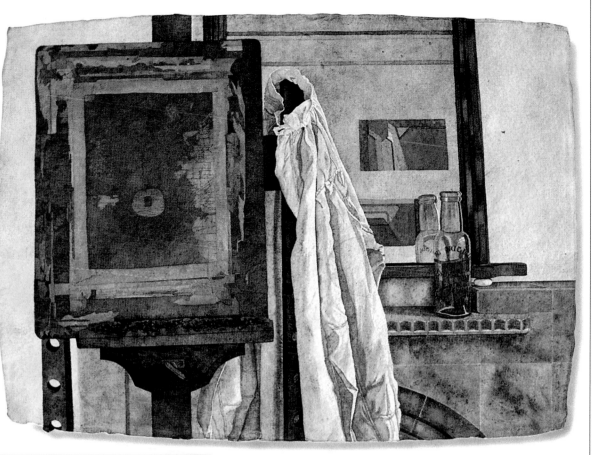

Claire Dalby, *Three Pears on a Shelf*

The individual pears that make up this simple composition have been placed so that they please us with their shapely simplicity. The placing of both the pears and the shelf has been carefully planned. The painting is divided into thirds by the shelf that holds the pears suspended in midair. The artist has also positioned the light source very deliberately so that light pours in from the left, revealing the pear on the far left most distinctly. The right-hand pear is the darkest of the three, held in place by the deep shadow falling on the shelf. The simplicity of this painting is deceptive, however – details such as the angle of the stalks of the fruit have been planned in order to draw us in and focus our attention on the exquisitely patterned red and green skin of the pears.

Sarah Holliday, *Composition with Snail*

This study of poppy heads, Chinese lanterns, a silver dollar branch, and a snail shell relies on organic, curving shapes. Curves work most powerfully when set against straight lines and geometric forms, and they are well balanced in this composition. Some edges, for example, where the light hits the round bowl, are strong and bold; others, such as the glowing forms of the Chinese lanterns, are intentionally softened. The spaces between the objects – known as negative space – are as important as the objects themselves, creating subtle patterns within the painting.

LIGHT AND FORM

LIGHT TRANSFORMS and enriches everything we see – light is life, as painters say. When light falls on any surface or object, the effect changes our perception of forms profoundly. Light and shadow create new shapes, new visions, and new depths. Everyone will have experienced the serendipity of a shaft of light or sunlight falling on a vase of flowers or a bowl of fruit. In still life painting, the artist strives to capture this fleeting beauty by skillful manipulation of paint and tonal balance. It is the quality of the vision that drives an artist to paint, to portray the incandescent quality of light on forms. Form is essentially the shape and the three-dimensional appearance of an object. In painting, forms are achieved by investing shapes with varying degrees of light and dark colors or tone to depict highlights, midtones, and shadows. When setting up a still life, try manipulating the light to add interest to the forms; place the light source at different angles until you like the effect.

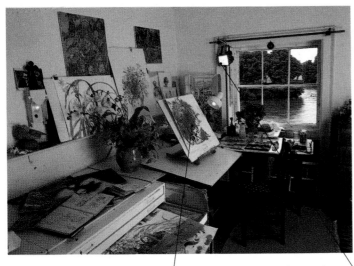

Choose a working area where you are not in your own shadow. An easel allows you to alter the angle at which your paper sits.

A halogen spotlight supplies a superb quality of light, comparable to daylight. The colors of your subjects and paints remain true.

Lighting your studio

Natural light is vital in a painter's studio; traditionally, a northern aspect is thought to be the best. Whether or not you can achieve this, try to ensure that your workspace has a large window that admits as much constant daylight as possible. There are many advantages to indoor lighting, because controlled light sources allow you to manipulate your environment. You can use artificial lights to simulate daylight, to create unusual effects, or simply as a constant light source so that you can work into the evening.

ANGLES OF LIGHTING

If you take a simple subject – here an elegant china cup and saucer with a silver teaspoon – and experiment with different lighting effects, you will begin to appreciate how the local (true) color of any objects changes in different light conditions. When the teacup and saucer are viewed in a fairly even, diffused light we see their innate forms most clearly. We also see the local colors of the china cup and saucer, unaffected by shadow. By changing the angle of the light, we can distort the color and the appearance of the objects.

Backlighting the teacup
Powerful light shining from behind the cup throws the white bowl of the cup into deep shadow; the cup's interior appears to glow in a deep orange-gold. The local color of the china is considerably altered.

Low light from the right
Caught in a beam of light, the teacup casts a long shadow across the saucer and onto the white tabletop. Light hits the bowl of the teaspoon and is reflected back onto the cup, creating a bright silver nimbus of light.

From the front left
In this lighting arrangement, the shadow echoes the forms, duplicating the outline of the cup's handle. However, the teaspoon's form and color are almost lost in the shadow cast by the cup.

Lighting a still life composition

When you are setting up a still life, the lighting is often as crucial as the selection of objects. If you compare the painting *Seashore Vision I* with *Seashore Vision II* (pp.200-03), you will see how dramatic lighting transforms the same five objects. Here a simple tea tray, complete with teacup and saucer, napkin, plate, knife, and fruit tart, has been placed on a batik cloth. Strong lighting picks up the brilliant white china and creates highlights on the rim of the cup and the raised folds of the napkin. Deep shadows occur within the folds of the napkin, and the shadow of the fruit tart subdues the bright silver knife. Light and shadow effectively unify the composition, making connections between the separate objects.

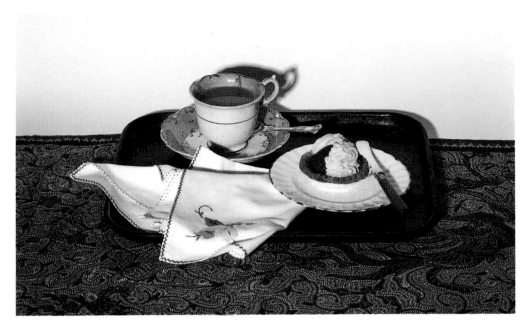

Margaret Stanley

Afternoon tea for one

Every painting relies on color and tone for its effect, and these factors in turn depend on light. It is helpful if both the lighting of the subject and the light used by the painter to work by can be controlled. During the course of a day, natural daylight will produce very different effects; the angle of sunlight will change, creating new highlights and shadows throughout the day. The tea tray above has been lit by artificial light directed at the subjects from a position at the front of the still life and to the left-hand side. Shadows fall to the right on the batik cloth and behind the cup.

Golden filigree decorates the china cup and serves to accentuate its form; the fine gold line that encircles the cup adds to the sense of perspective.

The shadow cast by the handle of the cup echoes the form of the cup itself and creates a repeating rhythm of circles and ellipses within the painting as a whole.

A batik cloth makes an intriguing foreground. The painter has simplified the elaborate pattern but has retained the muted mauves and golds of the fabric.

TONAL PAINTING

TONE IS THE DEGREE OF DARKNESS or lightness of an object. It is important to understand how tone works because it defines form and helps to create a three-dimensional image on a two-dimensional surface. Although every object possesses its "local" or true color, this color will be altered by the effect of light and its relationship to other colors. For example, the red petals of a rose will range from pink to violet to almost black, depending on how the light hits them. White objects make good subjects for tonal studies since they force you to look at the enormous variations in a single color. In the photograph below, notice how dark the areas in shadow become, so that the white marble appears virtually black in places. When painting in watercolor you may want to let the color of the paper show through for highlights, or rely on the opacity of white gouache to cover darker, toned paper.

Ingredients for "Garlic Mushrooms".

1 ▶ Draw the ramekin, garlic, and mushrooms in Burnt Sienna with a very small brush. Use French Ultramarine to add blue tones to the dish and then fill in the areas of shadow in a mix of the Ultramarine and Burnt Sienna. You can soften the tone by "painting" water over it.

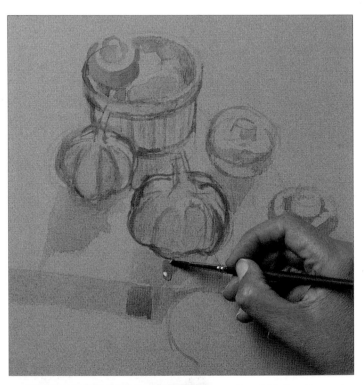

2 ▲ Mix Permanent White gouache with a little gray to paint the marble surface. Add veins to the garlic cloves in Burnt Sienna then, with a small brush, add highlights to the mushrooms and to the rim of the ramekin using Permanent White gouache. Deepen all the shadows to build up tonal contrasts. As highlights are added, the composition becomes more asymmetrical and interesting.

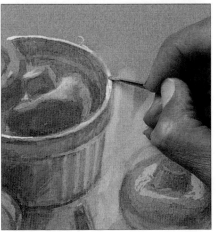

3 ◀ Define the fluted sides of the ramekin with a gray mixed from French Ultramarine and Burnt Sienna, and then highlight the rim of the ramekin with Permanent White gouache. You need to use gouache for highlights since the paper surface is quite dark and needs to be obscured in order to create a strong white.

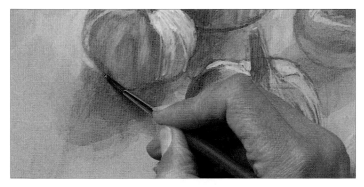

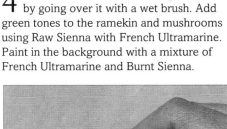

4 ◀ Soften the outlines of the garlic bulb by going over it with a wet brush. Add green tones to the ramekin and mushrooms using Raw Sienna with French Ultramarine. Paint in the background with a mixture of French Ultramarine and Burnt Sienna.

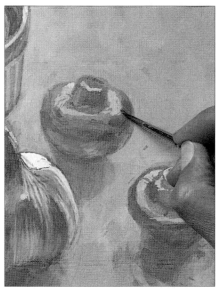

5 ◀ Apply Burnt Sienna toned down with a little French Ultramarine to add detail to the mushrooms. Define the marble slab and lighten its edge in the foreground with lighter gray mixed from white gouache.

6 ▶ Working with gouache allows you to change your painting at a late stage. Here you can extend the mushroom stalk to strengthen the whole composition.

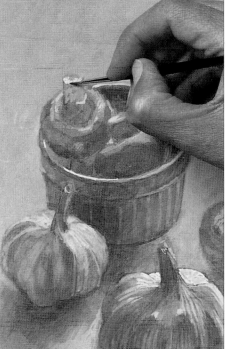

Garlic mushrooms

This simple subject, with its strong back-lighting, is subtly and effectively placed. The tonal quality of the near and far edges of the board are very well defined, creating an extremely strong sense of three-dimensional space. The triangle of the marble slab and its interaction with the edges of the painting hold the round forms in the forefront of the picture plane. Darker tones on the near side of the objects make the solid forms strongly felt and establish the quiet, thoughtful mood. Each element is meticulously drawn, resulting in a striking study.

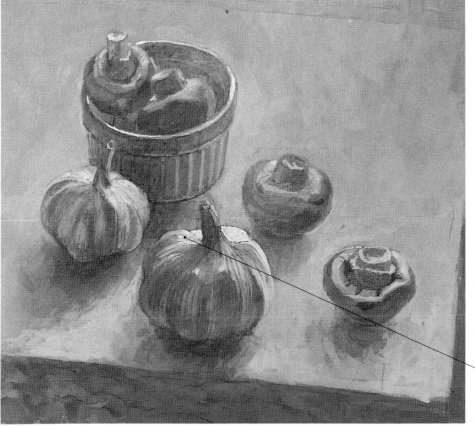

Highlights painted with Permanent White gouache shine on the far side of the garlic bulb closest to us.

Claire Dalby

Materials

No. 0 round

No. 4 round

CREATING FORM AND TONE

*A child's
school bag disgorges its brightly
colored contents to create an intriguing
composition of strong forms and shadows.*

THERE IS REAL DELIGHT in discovering a pleasing subject in a mundane or familiar situation. A briefcase, a basket, a purse, or a school bag creates a challenging, complex composition. To break a composition that appears too square or regular, try the effect of introducing a diagonal or a linear object such as an umbrella. In this subject, a cricket bat emerges from the bag, creating a strong horizontal line. Shadows are slowly built up with layer upon layer of washes, while fine lines drawn in with a rigger brush create definition and detail to pull the composition together.

1 ▸ Take a soft 4B pencil and outline the forms of the objects, making sure that they are in proportion. If you wish to modify the arrangement, for example, changing the position of the toy rabbit, now is the time to do it. When you are satisfied with your sketch, begin by blocking in the larger areas of bold color. Work with light washes and a large flat brush.

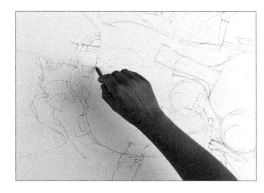

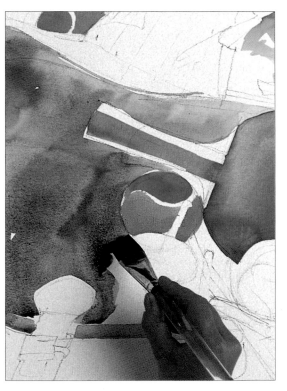

2 ▸ Define the main zones of color and tone by building up washes. Wash in the black interior of the bag using Payne's Gray with Cobalt Blue and a little Hooker's Green with a generous amount of water. Leave white highlights on the shiny spinning top and the buckles unpainted.

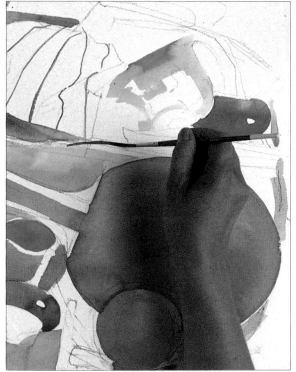

4 ◂ Mix Cobalt Blue and Ivory Black with a touch of Indigo, and wash in areas of shadow using a broad wash brush. Use the soft pencil outlines to guide you around the bats, balls, and spinning top. Burnt Sienna and Raw Umber are applied with a small round brush to create the shape of the rabbit.

3 ▲ Mix up a dense black from Payne's Gray, Cobalt Blue, and a little Hooker's Green, and use a rigger to draw in the panels of the baseball cap. Then outline the exercise book using Vermilion, applied thickly with a rigger brush. The pencil marks look intrusive here, but can easily be erased as the painting begins to take form.

5 ▸ Begin to add fine details to the composition, such as the red lettering on the comic book and the baseball hat in Alizarin Crimson. Allow the painting to dry completely before erasing the pencil marks using a kneaded eraser. Increase the three-dimensional quality of the painting by adding darker washes of deep gray to create areas of shadow and tone.

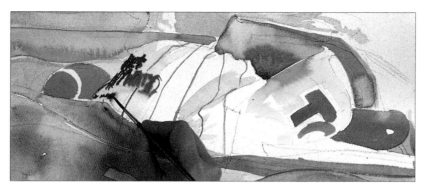

Materials

No. 3 rigger brush

½ in wash brush

1in wash brush

6 ◂ Overlay the areas of shadow with less dilute washes of blue-black made from a combination of Cobalt Blue and Ivory Black with a little Payne's Gray. Give the dark areas a crisp outline using the same blue-black wash, applied with a rigger. Use a little Hooker's Green to darken the foreground of the painting. Add fine detail such as the buckles of the bag and the laces of the shoes using a rigger brush.

7 ◂ Intensify the shadows falling across the ground and within the bag by applying a wash mixed from Ivory Black, Indigo, and Hooker's Green with a flat brush. A dark wash throws into relief the white highlights (clear paper) on the top and baseball cap.

Domestic scenes

This familiar collection of "found" objects has been composed so that the balls and the round Ping-Pong paddle build up fluid rhythms within the composition. The handle of a cricket bat breaks out of the open bag, creating a more informal composition. The furled comic book and school exercise book create shadows within the bag. Areas of white highlights such as the baseball cap, the spinning top, and the soft brown of the toy rabbit are thrown forward in contrast with the graded washes of the shadows.

Light washes are painstakingly laid to give the painting its tonal quality.

Pigment dries with a hard edge on the heavy unstretched textured paper. Fine lines such as the shoe-laces stand out clearly.

Pam Garnett-Lawson

211

NEGATIVE SPACE

WHEN YOU LOOK AT A COMPOSITION as a whole – rather than focusing purely on the objects being painted – you start to view it quite differently. Instead of seeing it in a flat, linear way, you begin to appreciate how the painting works three-dimensionally, with some details coming closer to you and others seeming farther away, and with the spaces between objects being integral to the look of the whole. Before embarking on a still life, study the "negative spaces"; it is only by viewing the positive and negative shapes together that we can learn to see, and to paint, with maturity.

The vivid flowers and dark foliage of exotic succulent plants mesh together in front of folds of brilliantly colored Indian sari silk.

1 ▶ Make a drawing of the composition. The criss-crossing pattern of leaves is quite complicated, and you may find that you can simplify the plan for the painting by drawing in the spaces between the leaves, where the turquoise and purple shine through. Block in areas of blue using a Manganese Blue wash, applied with a large brush. Use a small brush to paint in the smaller "negative shapes." Build up the blue tones with Cerulean Blue.

ALTERNATING IMAGES

This simple image demonstrates the idea of negative space – sometimes you see a pair of faces, sometimes a white vase on a dark ground. The two subjects are so perfectly balanced that it is difficult to decide which is the foreground and which the background. In most paintings, foreground and background need to be read simultaneously to see the whole.

2 ▶ Outline the yellow-gold patterns on the silk with a dilute wash of Yellow Ochre, using a small brush. The gold panel helps to define the folds of the fabric as it falls. Use a wash of Cadmium Red to start blocking in the red of the fabric.

3 ◀ Blend French Ultramarine with Sap Green for the fleshy leaves of the cactus. Already the soft greens have begun to interact with the fiery red of the silk. Working wet-in-wet, lay in the striped patterns of the cactus leaves using a small brush. Paint in the pale pink flower of the cactus using a dilute wash of Alizarin Crimson. Then mix Cadmium Red with Alizarin Crimson and a little Cadmium Yellow, and paint in the form of the deep coral flower on the left.

4 ▲ Paint in the network of spiky leaves using Sap Green with a little Viridian. Deepen the shadows with a more intense green. Darken the larger leaves using Ultramarine mixed with Sap Green – their dark forms will throw the coral flower forward in space.

5 ▶ Alternate between working on the plants and the background seen behind them. Deepen the tone of the red fabric, overlaying the first wash with an intense wash of Alizarin Crimson mixed with Cadmium Red, applied with a medium brush.

6 ▲ Paint in the shadows falling on the cactus using a wash of French Ultramarine with a little Manganese Blue for the leaves in deepest shadow, working with a medium brush. Add a little Sap Green to brighten the wash and suggest the shadows cast by the bright overhead light.

Full of Eastern promise
This jungle of exotic plants forms a complex network of leaves and flowers against a rich backdrop of brilliantly colored sari silk. Working first on the fabric, then on the plants, and then alternating between them, the artist ensures that the elements of the painting receive equal shares of our attention. Curving shadows cast by the leaves appear as deep red echoes of the forms of the leaves themselves, and the blue of the silk has been accentuated by the addition of an intense wash of Manganese Blue over the shadowed areas. Forms, shadows, and background coexist in a painterly unity.

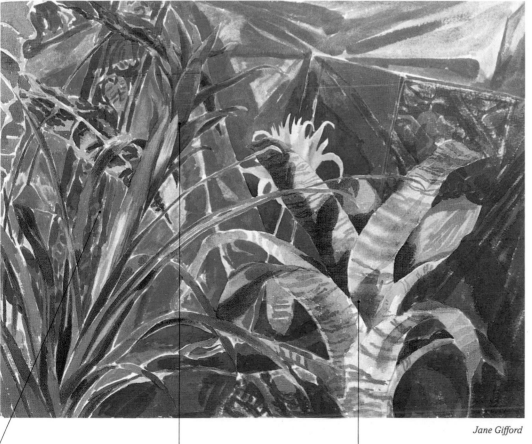

Jane Gifford

The intricate patterns that appear on the silk have been carefully worked out in pale yellow and then overlaid with Yellow Ochre.

Notice how effectively the deep coral red flower stands forward in space against the powerful turquoise blue of the silk sari.

By overlaying the gentle green of the cactus leaves with a blue wash of French Ultramarine, softly defined shadows are created.

Materials

No. 4 round

No. 6 round

No. 9 round

213

GALLERY OF PERCEPTION

EARLIER IN THE BOOK we looked at watercolor techniques for painting still life. Although important, techniques are only part of the creative process. A painting is essentially a form of expression – it can convey ideas and feelings: joy or sadness, excitement or serenity. To be able to express yourself in paint you need to follow your instincts and give rein to your imagination, so that you paint what you see and feel. Trust your own intuition – your personal vision will impart to the viewer an enriching, new, fresh way of seeing. You might not paint a masterpiece, but you can create a piece of the world as you see it, in all its richness and infinite uniqueness.

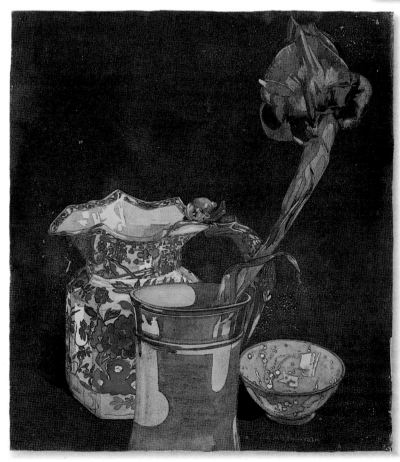

Philip O'Reilly,
Kusadasi Kilims
This unusual still life subject was developed from a series of studies O'Reilly made in a carpet shop in Turkey. The deliberate lack of perspective allows the kilims to become an almost abstract pattern of rich, stratified colors.

Light enters obliquely from a nearby window, softening the colors and texture of the densely packed kilims.

Charles Rennie Mackintosh, *Grey Iris, c.*1922-24
Originally trained as an architect, Mackintosh brought his fascination with aspects of structure and pattern to his painting. Here, he draws the viewer's attention to several interesting contrasts of forms, textures, and colors. The streamlined shape of the smooth silver mug, positioned in the center between an elaborately decorated pitcher and a small round painted china dish, creates an aethestically balanced composition of contrasts. The grayish purple iris looming off-center above the mug echoes the color of the metallic luster, thus establishing its relationship with the mug. Its soft bulbous organic shape also acts as a splendid foil to the manufactured objects.

Paula Velarde, *Turkish Rug*
The viewpoint, from above the vase, creates an unusual angle of vision. The richly patterned rug with the chair leg settled upon it offsets the vase with the sprigs of silver dollar almost exploding out of it. The ochre marks across the base of the vase hold the two planes together, creating a sense of space. A loose, instinctive use of color, applied wet in wet, makes this painting visually exciting. The brushwork is varied and dynamic, ranging from very fine pale strokes to strong lines and washes of vibrant color that transform household objects into a dramatic image.

June Berry, *The Bird Jug*
The scale of the jug in this painting has the effect of dwarfing the two figures in the background, while shafts of light create an interplay of diagonals leading the eye back and forth between the jug and the figures. The painting relies on a series of repeated patterns – the jug's handle echoes the angle of the figures' arms; the chair, the portfolio, and the palette produce a zigzag motif that is repeated in the surface pattern of light and tones seen across the room.

Catherine Bell, *Striped Leaves*
The interest of this painting lies in the dramatic change of scale and use of color. When examined in minute detail, any subject can become an intriguing, dynamic interaction of colors or shapes. Here, interesting negative shapes created by the intricate, interwoven leaves become part of a complex pattern of twisting and turning forms. Warm colors remain closest to us, while the cool colors retreat into the dark space. It is the dark negative spaces that bind the tangle of linear shapes and colors into a unity.

215

TRANSPARENT PAINTING

An intriguing collection of glassware catches and reflects light in the artist's studio.

WATERCOLOR PAINT IS PARTICULARLY SUITED to capturing the effects of glass or transparent objects because of its own innate translucency. When you lay a wash, or a thin layer of watercolor, light rays penetrate to the paper surface and are reflected back through the transparent paint film, allowing you to see a thin veil of color. You can lighten a wash by increasing the proportion of water to pigment, or darken it by decreasing the amount of water. By laying further washes, you can build up tones or create new colors. When painting transparent objects, however, apply washes of color sparingly and work with light colors first, so as not to muddy the purity of the hues. The evocative painting below shows how to depict the solidity of forms that are essentially transparent.

1 ▶ Lay a dilute wash of Indigo and Yellow Ochre in the window. Next, block in the window frame with a brown wash. Wait for the paint to dry before you lay in a green overlay to describe the roundel. Then define the edge with a gray wash.

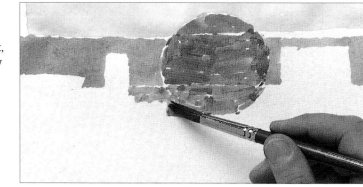

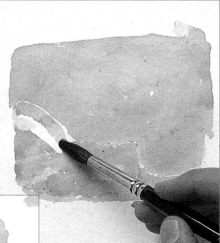

2 ▲ With the same gray, lay a wash in the area within the glass bell jar. Leaving a tiny margin next to the gray area to suggest a reflection, put in a wash of Cobalt Blue, Lamp Black, and Indigo for the foreground. Dry the blue paint with paper towel to prevent it from seeping into the gray.

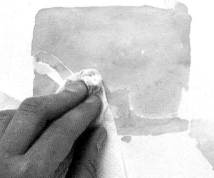

4 ▶ Paint the rose-colored glass with a diluted wash of Rose Madder. When the wash dries, lightly paint in the stem with a small brush. The rather distorted form and color of the stem will accentuate the transparent quality of the pink glass.

3 ▲ When applying the gray wash for the wall in front of the window ledge, reserve some areas of the white paper as highlights. These light up the tones and add a glow to the painting. Dilute the gray to paint in the sunlit window ledge and tabletop.

5 ▸ Use Light Red mixed with Rose Madder and Indigo to block in the shape of the angel mobile. Displayed in midair, it contributes to an illusion of depth, a suggestion of space beyond the window. The angel also breaks up the blue and gray horizontals in the foreground and mid-ground, leading the viewer's eyes upward from the tabletop.

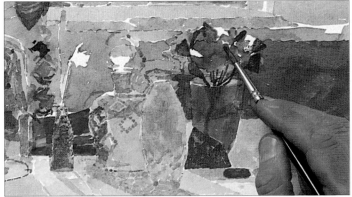

6 ▴ Paint in the petals of the violets with a medium brush using a mixture of Rose Madder and Indigo. For the leaves, use a wash mixture of Cadmium Yellow and Cobalt Blue.

7 ▴ Now that the paint on the body shape of the angel has dried, return to it to add details to the sleeves using Cobalt Blue. Finally, outline the head of the angel with Brown Madder Alizarin. Also fill in the angel's reflection on the window.

Reflections on glass

The cluster of objects in the foreground arouses our curiosity and draws us into the room toward the bright window. The artist is concerned with both the reflective qualities of glass and with the mood evoked by the scene. The visual poetry of the subdued colors create a sense of great stillness and calm, enticing the viewer into contemplation, to reflect, on the transience of the material world and the tranquility of the ethereal.

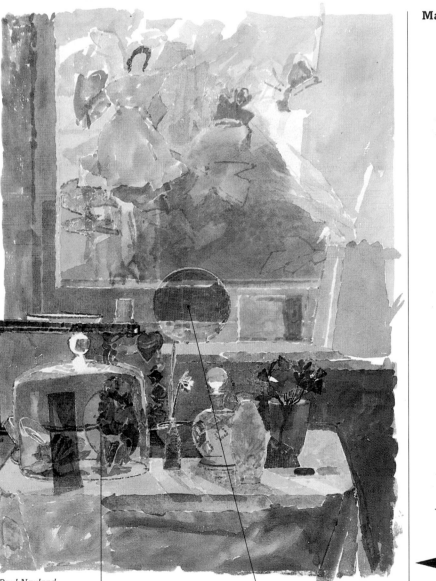

Paul Newland

Main materials

Indigo

Yellow Ochre

Indian Red

Cobalt Blue

Rose Madder

Vandyke Brown

No. 4 round

No. 6 round

No. 9 round

The light washes on the glassware show them off to advantage. Other objects are visible through the vases, and bottles, and the bell jar – a myriad of mysterious images.

The hues of the green glass roundel vary in their intensity to indicate the reflections of solid and transparent materials against which it rests.

217

OPAQUE PAINTING

Arrangement of potted plants and gardening equipment

ALTHOUGH WATERCOLOR PAINTING relies heavily on the translucent nature of the paint, building up colors in layers, not all watercolor paint is designed to be used that way. Gouache, also known as body color, is an opaque watercolor paint containing a far greater density of pigment than traditional watercolor. It can be applied thickly, somewhat like an oil paint, or heavily diluted, like a denser version of watercolor paint. It can be used in conjunction with other watercolor paint to create highlights, or it can be used on its own. Mixing a little gum arabic with your gouache pigments will make them more luminous. and of a texture similar to that of oil paint.

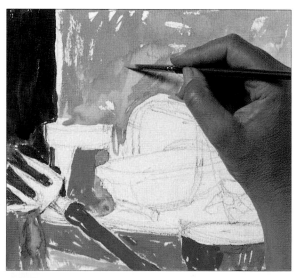

1 ◀ Arrange your gardening items into a pleasing composition and then make a pencil sketch of the arrangement. When making a complicated setup, it is important to get the different shapes and proportions right at this early stage.

2 ▶ Use a medium-sized brush, such as a No. 5, to start filling in the background. Block this in quickly so that you are not distracted by the white of the paper. Mix brown from Spectrum Red, Spectrum Yellow, and Lamp Black, and make the cool gray of the wall from white with a touch of French Ultramarine.

3 ▶ With the smaller brush, outline details such as the basket and the rim of the hat. Draw in the ivy shoots with a mixture of the Ultramarine and Spectrum Yellow, adding some Raw Umber for the darker leaves. Once all the main areas are covered, it is a question of adjusting the color balance. Work from the outside of the painting into the focus and highlights, building up darker tones to give greater definition to each form. If the colors seem a little flat you can make them brighter by adding gum arabic. Mix half a teaspoon of gum arabic with the same amount of water, and use this to dilute your paints. Gum arabic keeps pigments moist as well as making them more luminous.

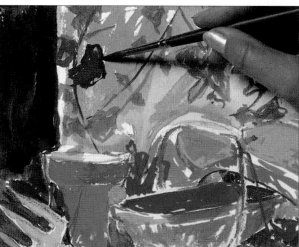

4 ▶ Start refining your painting, working over the composition as a whole. Add details using the tip of a No. 3 brush. Although the ground was blocked in fairly quickly, the finer detail should be painted in slowly. Work on the flowerpot and the wooden stand behind it to create a sense of perspective. Adding lights and darks to the pot will make it appear more three-dimensional and make it stand out from the other items in the arrangement.

5 ▲ The woven nature of the sun hat demands careful treatment, so use the finer brush to accentuate the pattern. Use darker colors for the areas in shadow and a mix of white and yellow for the highlights.

6 ▲ Mix Yellow, Black, and French Ultramarine gouache to create an active, interesting pattern of hanging ivy for the background.

7 ◀ Use Black to pick out the plant's stalks, and Crimson and White for the flower bud, changing the dilution to reflect the tones.

In the garden
The depth of color and range of tones in this gardening still life are achieved by underpainting the whole in muted earth colors. Because of the opaque nature of gouache, the artist has been able to add lights to darks rather than simply building up tones as in traditional watercolor painting. She has also been able to work into the painting at great length, modifying tones, lifting out details with blotting paper, and blending colors to achieve the range of colors and textures.

Materials

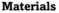
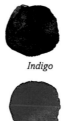
Indigo

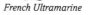
French Ultramarine

Raw Umber

Alizarin Crimson

Spectrum Red

Spectrum Yellow

Zinc White

Lamp Black

No. 3 round

No. 5 round

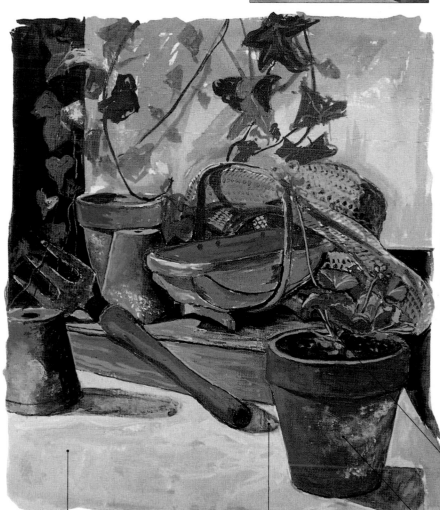

Carolyne Moran

The artist has blended a mix of whites and very diluted earth colors into the table using her fingers.

Sharp shadows help to define the sense of form.

White gouache has been added for the highlights. In traditional watercolor techniques, highlights would be created with the white of the paper so that these would be "first thoughts" rather than "last thoughts."

Notice how many colors have been used on the pot.

GALLERY OF PAINT TYPES

Y OUR CHOICE OF WATERCOLOR medium is integral to the appearance of your painting. If you want to capture the quality of glass or water, the translucency of traditional watercolor is perfect since it allows the underlying color to show through. Gouache, with its greater concentration of pigment, is ideal when you wish to create denser colors or add highlights to toned paper.

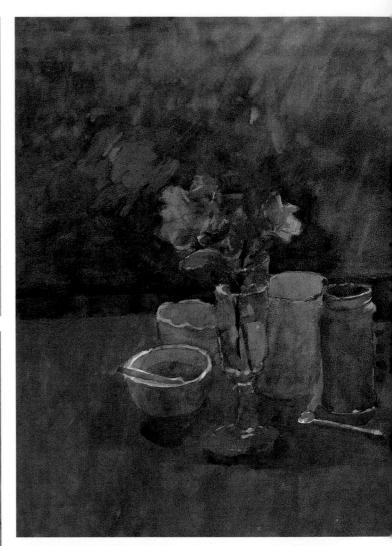

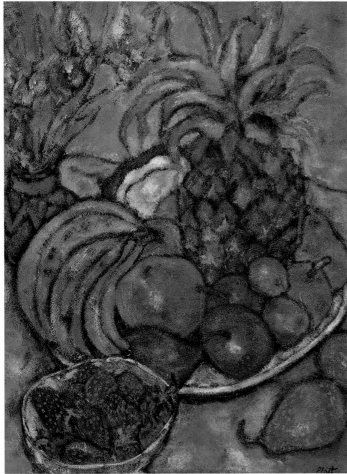

Lorraine Platt, *Pineapple, Irises, and Strawberries*

Platt has used gouache here, exploiting its opaque qualities and somewhat matte appearance to create an essentially flat surface. Distant fruits float on the picture plane, challenging our notion of objects receding in the distance.

Martin Taylor, *Apple Stores II*

Gouache and traditional watercolor combine to great effect in this powerful "found" arrangement. Subtle layers of translucent color add solidity to the apples, while white body color models the underlying newspaper, contrasting with the shadow below.

220

Christa Gaa, *Camellia Still Life*
Watercolor has been applied densely in layers to conjure an intimate scene glowing with light and warmth. Shades of earthy browns and orange-reds dominate and set off the earthenware to advantage. The camellias break up the expanse of browns, as do the touches of pale gouache, which bring out the highlights on the objects.

The simple forms of the camellias break into the subtly blended far wall.

Dry brushstrokes of gouache stand out particularly clearly against the dark background.

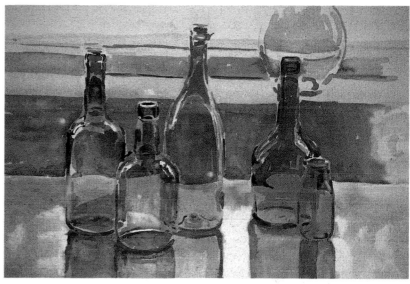

Sue Sareen, *Six Green Bottles*
Watercolor is the perfect medium for suggesting the transparency of glass. Dark accents and white highlights define the bottles, while negative shapes between them become equally important. Here, masking fluid was used to protect the areas of bright reflected light. The sill, wall, table, and finally, the bottles themselves were washed in with loose, free brushstrokes. Notice how the quality of the bottles is suggested by highlights and by the distortion of the table's edge by the glass.

Giovanna Garzoni, *Still Life with an Open Pomegranate*, c.1650
This still life was painted on parchment with egg tempera, a painting medium consisting of pigments mixed with egg yolk, popular before the advent of oil paints. Using the full tonal range of a limited palette, Garzoni has beautifully portrayed the subtle variations of colors and textural contrasts in this composition of natural objects. The exquisite gemlike flesh of the pomegranate, encased in its rough ochre skin, rests on a contrastingly smooth marble dish.

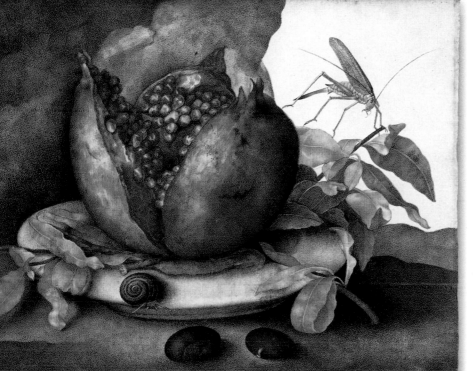

221

DAY AND NIGHT

A window arrangement viewed by day.

THE GREAT MAJORITY OF STILL LIFES are painted in an indoor setting simply because this is the most practical and comfortable circumstance for the artist. Apart from the ease of setting up the painting, working indoors allows greater control over the quality of light. For example, artificial light can be used to provide a steady light source or to create dramatic lighting effects. Natural light is unpredictable – a day can be bright and sunny one moment and then suddenly overcast, and all the colors change. Light from a window can make interesting shadow patterns, but remember that they will not remain the same for very long, so you will either need to make a sketch to remind you of how they fall or work very quickly. Changes in the quality of light affect the appearance, form, and tone of a still life (*see also* pp.206-07) – as you can see from the daytime and nighttime studies of the same window scene.

1 ◀ Sketch the forms of the sunflowers, melon, and peaches with a light yellow wash. Paint in the petals of the sunflowers in Indian Yellow with Chrome Yellow, applying fluid brushstrokes with a flat brush. Mix Cerulean Blue and Yellow Ochre for the sepals at the base of the petals. Paint in the peaches with a wash of Chrome Yellow and Vermilion, using the same technique. Steady your hand by using your little finger to create firm, controlled brushstrokes.

2 ▶ Wash in the sails of the sailboat in Cerulean Blue, using a half-inch wash brush. Paint in the rowan berries with Vermilion using a small brush. You can leave dots of white paper clear to form the highlights. Next, mix a deep wash of Chrome Yellow and Vermilion to paint in the dark centers of the sunflowers.

3 ▶ Mix a wash of Permanent Rose and Cerulean Blue and block in the shape of the vase. The paper's texture can be seen through this very light wash. To deepen the tone of the petals and centers of the sunflowers, paint an intense wash of Indian Yellow over the first pale yellow wash. Use a large brush to intensify the pale green of the small leaves using Emerald Green and Lemon Yellow Hue.

222

4 ◄ Mix Permanent Rose with French Ultramarine and paint in the gray-mauve tone of the white window frame, seen here in shadow. Use a very dilute wash of Cerulean Blue for the cool blues of the sails so that the clear light outside the window appears to shine through them. With a dilute mix of French Ultramarine and Cerulean Blue, start blocking in the shapes of the distant trees seen on the far shore of the riverbank using a large brush. You will work these up later.

Main palette

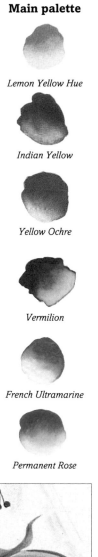

Lemon Yellow Hue

Indian Yellow

Yellow Ochre

Vermilion

French Ultramarine

Permanent Rose

5 ▲ Deepen the color of the sunflower centers using an intense wash of Chrome Yellow mixed with Vermilion. Overlay the rowan berries with Vermilion, applied with a small brush. When the sunlight becomes brighter, the tone of the composition changes and the mauve shadows in the foreground become stronger.

6 ▶ Mix an intense wash of Magenta and French Ultramarine with a touch of Sap Green to paint in the knife lying next to the melon. Blend Permanent Rose with Cerulean Blue and deepen the color of the body of the vase, working with a medium brush. Now strengthen the knife by adding darker tones of purple. Apply a deep, dark green to accentuate the shadows among the leaves of the sunflowers. Add form to the melon by painting in deep golden tones using Indian Yellow. The painting relies to a large extent on complementary colors, with the purples and the yellows being mutually enhancing.

7 ◄ Paint in the patterns of the vase, using Ultramarine for the basic pattern and Permanent Rose for the fine details, applied with a small brush. Stand back and judge the progress of the painting: you can view the painting upside down to assess it as an abstract composition, or use a mirror to reverse the image (*see* p.197). Some elements of the painting may need to be brought forward; others can be made to recede. Adding "warm" colors such as reds and vermilions will make objects appear to advance; "cool" blues and purples will make them appear to recede.

8 ◀ Overlay the Cerulean Blue of the sailboat's sail with an additional wash of the same color. By gradually building up color in this way, it is possible to retain the translucent quality of the watercolor paint. The paper has already been saturated with paint once and has dried. As a result, you may notice that when further washes of color are applied, pigment is absorbed more quickly but dries more slowly. Now deepen the color of the vase by overlaying a mauve made from Winsor Blue and Magenta. Enhancing the moody purples and mauves will bring the rich golden yellow of the sunflowers forward in space.

9 ▶ Strong sunshine casts deep shadows, so an even darker tone of yellow is needed for the sunflower petals. Apply an additional wash of Indian Yellow to the petals shaded by the main flowerhead. When painting the river, seen behind the sail, make a sweeping movement across the paper, but touch the brush down to the surface only intermittently to create a dappled effect.

10 ◀ Paint in the branches of the rowan in a dense blue-gray. The addition of these branches to the composition helps balance the painting. Add the leaves of the branches in Sap Green. Make simple, fluid strokes, turning the width of the flat brush sideways to its thinnest profile, to create their oval forms.

11 ▲ Add Chrome Yellow and Cadmium Orange stripes to the petals, making fluid strokes with a small brush. Darken the pattern of the vase and work your way around the painting building up the tones. Finally, using an almost dry brush, add dots of pure Cadmium Orange to the centers of the sunflowers.

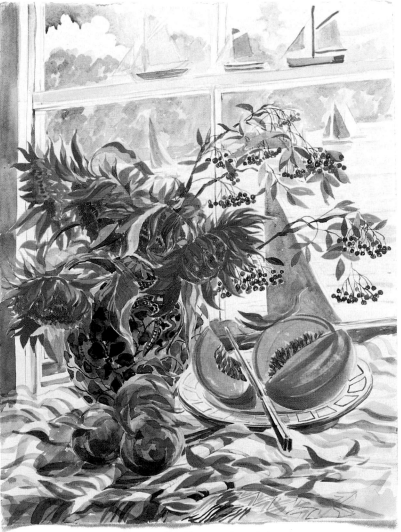

Sunflowers by day
In the daytime painting, bright sunlight shines through the window, backlighting the vase of flowers. Shining shapes appear in the negative space seen behind the composition, where light falls on the river or upon the distant shore. The peaches in the foreground and the vase appear as dark forms; their shadows come forward toward the viewer. The heart of the yellow melon is also in shadow. The geometric forms of the sails balance the rhythmic brushstrokes of the cloth, vase, and the petals. A knife, placed at a diagonal, leads our gaze into the central space of the painting.

Each sunflower petal has been created with a single deft stroke, using a flat wash brush.

The cool green leaves, or sepals, enhance the warm yellow and orange petals.

Elizabeth Jane Lloyd

Brilliant shades of sunlit yellow are expressed by Lemon, Chrome, and Indian Yellow pigments.

Sunflowers by night
Observed at night, the still life is lit from the front by artificial light and the mood of the painting has changed. Bright light falls onto the white cloth, and the vase, warming its blue and purple hues. Reflections of light on the window mask out all but the nearest sailboat on the river but pick out the toy boats perched on the window frame, which were almost invisible by day.

The rich color of the flower's center is deepened by the addition of Burnt Sienna.

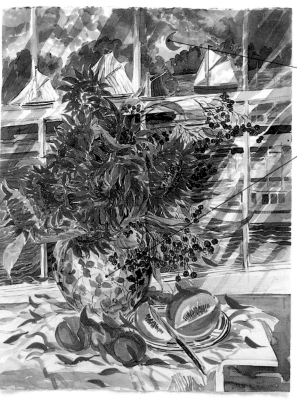

The shape of the crescent moon echoes the sections of melon and the fallen petals of the sunflowers.

The shiny ceramic surface of the vase reflects back the bright artificial light within the studio.

Seen at night the center of the sunflower appears darker simply because the artificial lighting is not as bright as sunlight. Rich Indian and Chrome Yellows have been overlaid with blue-mauve shadows.

Materials

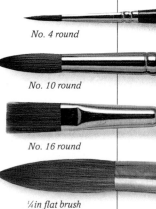

No. 4 round

No. 10 round

No. 16 round

¼ in flat brush

225

SPECIAL EFFECTS

THE USE OF RESIST techniques and unusual surface patterns can add great interest to watercolour painting. In resist techniques you can protect the paper's plain surface or a pale wash against the subsequent layers of pigment by rubbing candle wax over it. Alternatively, scratching the surface of the paint with a comb or even the other end of the brush will create rich textural patterns which will vary slightly depending on whether the paint is wet or dry. Even such a simple device as working wet-in-wet makes a dynamic and natural effect in contrast to the crisp outlines and highlights defined with a fairly dry brush on dry paper. The combination of traditional and experimental watercolour methods can produce a bold, yet controlled, painting full of visual interest and technical complexity.

1 ▶ Arrange slices of pumpkin, tomato, and watermelon, then sketch them with a soft pencil. Use a pale wash of Prussian Blue to paint the melon seeds. With a large brush, wash in Cadmium Orange mixed with Permanent Rose for the flesh tones. As the paper dries, work with slightly less water on the brush and use a less dilute mixture to lay in deeper tones.

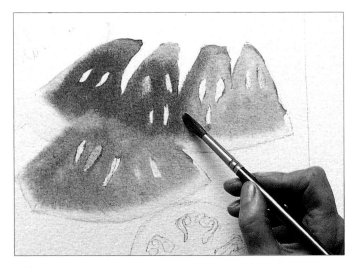

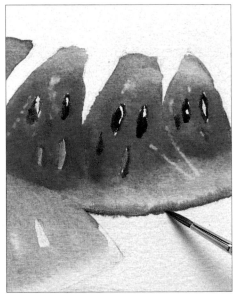

2 ▲ When the paint is completely dry, wet the outer flesh of the melon and lay in a wash of Naples Yellow and Sap Green. Trace a line of Sap Green for the skin with the tip of a small brush. Flatten the brush against the outer edge and green will bleed into the yellowy-green wash but remain sharp along the outside of the melon.

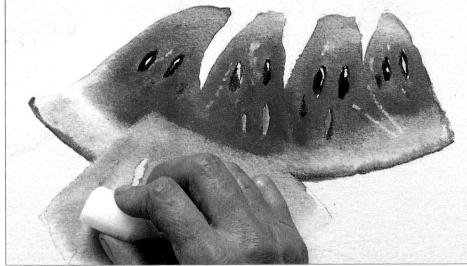

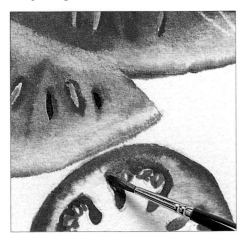

3 ▲ Rub a piece of white candle over an area of the melon in the foreground. Wax will resist further applications of paint and create shiny highlights in the finished painting. Overlay an intense wash of Permanent Rose and Orange Cadmium to deepen the flesh tones. Outline the darker seeds with Indian Red and Prussian Blue.

4 ▶ Wet the area of the outlined tomato with clean water. Mix Light Red, Indian Red, and Cadmium Orange and wash into the wetted paper. For the tomato, paint areas of intense red with a drier brush. Build up the colours using a richer blend of Indian Red, Light Red, and Cadmium Orange and apply with a fairly wet brush.

5 ▸ Outline the pumpkin seeds with diluted Cadmium Orange. Wet the area of the pumpkin flesh with clean water, using a large brush. Then apply an intense wash in Cadmium Orange. Because the paper is wet, the darker orange will bleed into all the surrounding area. As the paper dries and pigment settles into it, work with a drier brush. Apply another wash to the pumpkin working on the dry surface to produce a bright, glassy wash.

6 ▴ Mix Winsor Green with a touch of Indian Red and lay in a flat wash with a wet brush. Re-wet the area and overlay a darker wash. Mix Winsor Green, Indian Red, and a little Prussian Blue and apply with a larger brush for the darkest corner.

7 ◂ Overlay the light green wash with a deeper green to create the ribs of the lotus leaves. While the paper is wet, use a section of comb to create distinct patterns for the veins of the leaves. Add in shadows, using Winsor Green, Indian Red, and a little Prussian Blue. The drier the brush, the greater the control you have over the pigment.

8 ▴ Mix Prussian Blue and Indian Red with a touch of Purple Lake. Wet the background with clean water and then drop in the wash using a large brush. Lift paint with blotting paper to soften the effect.

Materials

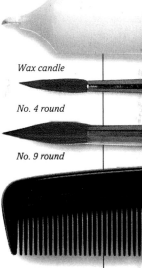

Wax candle

No. 4 round

No. 9 round

Comb

Rich textures

This painting relates to the texture and surface of the paper. Wax resist techniques and sgraffito, using the teeth of a comb, create strong rhythms. Flowing washes for the leaves and melon flesh contrast with the dark staccato strokes of the melon seeds and the leaf veins.

Areas waxed with the white candle resist the many overlaid washes of deep red pigment.

Combing deep green pigment creates a textured effect that suggests the delicate veins of the lotus leaves.

Josh Partridge

GALLERY OF EFFECTS

THERE ARE NO ABSOLUTE rules to follow in painting. The best guide is your personal feelings or response, born of your own experience. Use your imagination and every means at your disposal to create your own unique artistic statement. The intensity of seeing makes the painting; the execution follows instinctively. The more uninhibited and individual the seeing, the freer the painting will be. Some artists enjoy the tight forms of a limited structure, others the open spaces between the objects. Follow your instincts and paint what you feel is a beautiful whole. This gallery focuses on aspects of structure, color, and composition and how you can work with each to create different effects. Experiment with gold leaf, transparent glaze, wax, or even pastel!

Elizabeth Blackadder, RA, *Still Life with Irises*
This painting combines disparate shapes and tones. The brushstrokes themselves vary from delicate marks and patterns to broad linear strokes. A yellow background, enhanced by gold leaf, throws the objects forward so that they appear in isolation, like shapes on the surface of the moon. Connections in tone and color create vibrations between the objects.

Hans Schwarz,
Studio Still Life
The table, jars, and bowl form a painterly unity developed through varied brushstrokes. Glowing yellows pervade the rich darks and shine through the cooler blues. The image works well as a balanced whole; each element interacts to create an intense harmony.

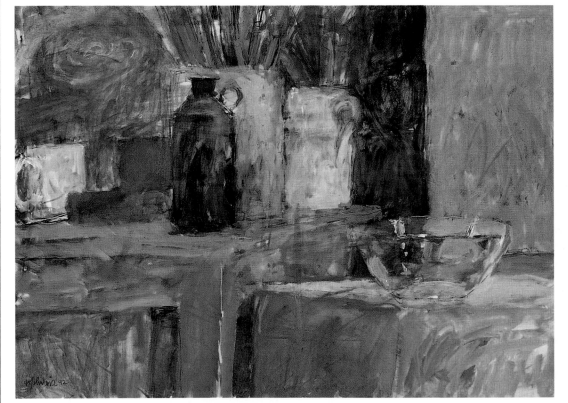

Light coming in from the right of the painting focuses our attention on the luminous glass bowl. Highlights on its rim are picked out by delicate lines of Naples Yellow gouache.

Juan Gris, *Three Lamps*, c.1910
In this sophisticated painting, spiral patterns are created by the oil lamps. The lamps on the cloth create vertical forms casting strong horizontal shadows, while the glass bulbs repeat the spiral forms of the lamps to make an architectural whole. The pure white cloth and the wall behind the lamps vary in tone subtly; the lamps stand forward boldly and are painted with effortless grace.

Jonathan Cramp, *Black Cup, Teapot, and Milk Bottle*
A cup and a milk bottle are placed in front of a starkly metallic teapot in this startlingly photorealistic painting. Three surfaces, three objects, move back within the picture plane. The red milk-bottle top focuses the eye just above the teapot, whose brilliant highlights are distorted by the clear glass. The artist studied his subjects at length in order to achieve such exquisite simplicity and clarity.

Mary Fedden, RA, *The White Cliffs of Dover*
This well-balanced composition of different patterns and shapes is placed according to the law of thirds, as defined by the cherries and the window frame. Fine black lines on the border of the yellow cloth contain the main forms. A dark triangle of shadow on the left and the white sweet corn lead the eye to the pitcher. The delicate gray pattern of the curtain is echoed by the pitcher and distant cliffs.

229

PRESENTING YOUR WORK

THE TYPE OF FRAME YOU CHOOSE for your painting is as important as the colors you used when you painted it – it can make or break an image. If you select a complementary frame, you will enhance the appearance of your work, whereas an inappropriate choice will have the reverse effect. Another benefit of framing is that the glass will protect the painting from dust and dirt, and help keep the colors true. Some painters like to frame their own paintings, while others prefer to rely on professional framers. Whichever option you choose, it is worth experimenting with a range of colored mats and frames to see which styles and tones are best suited to your work.

Defining your image
The way in which you decide to crop an image plays a vital part in the final presentation of your work. When you begin to mask off the edges of a painting, you immediately lose any slightly messy brushstrokes that border it. You can also crop the image even more to create a different view altogether.

Cardboard mats
The mat that surrounds the work provides a visual bridge linking the painting and the molding. The mats come in a vast range of colors, so you will need to decide whether to pick out a color from the painting or use a neutral one.

Picture glass is thin to minimize distortion.

Mats are made from acidfree paper that will not fade or yellow with age.

A paper lining shields work from the screw fixtures on the back.

Hardboard backing keeps the frame rigid.

Final assembly
When choosing a frame, try not to be daunted by all the choices open to you. Experiment with a range of ready-made moldings and some colored mats: the dark, medium brown, and pale limed wood of the moldings (*far left*) all echo colors in the work itself. The pale gray mat (*above*) brings this painting forward quite naturally, because it picks up the brightest highlights in the composition. Rose pink (*above*) is too strong for the earthy coloring of the image, so neutral cream proves to be the best choice.

Frame moldings
A huge variety of frames is available, from simple wooden ones to carved or gilded frames. Consider the color and width of each frame seen in relation to the mat, and the effect it has on the painting.

The pale cream mat picks up the painting's highlights and relates well to the pale bleached-blond fragments of driftwood.

The soft coral red of the inner mat defines the painting to great effect and echoes the coral color of the large shell.

The classic molding of the mahogany brown frame complements the warm earth colors of the painting and makes a strong contrast with the cream mat.

Sympathetic coloring

Here, the frame, mat, and inner, recessed mat have all taken their colors from the painting itself; the result is a harmonious whole. The cream-colored outer mat has been made deeper at the bottom of the painting in the traditional manner, so that the eye is drawn upward to focus on the image itself. Compare this treatment with that given to the dramatic interpretative painting at the bottom of the page, whose very simple mat is the same width all around the image, a style chosen in accordance with contemporary taste and in keeping with the arresting image.

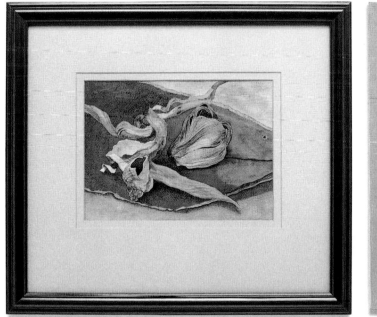

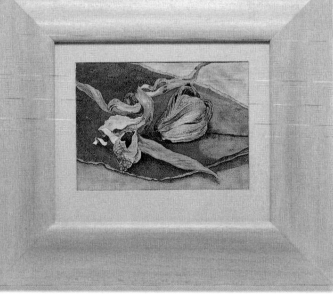

Good as gold

Gold frame and cream recessed mats are a conservative choice, which suits many "traditional" watercolors. The mat is deeper at the bottom, again a traditional feature. However, this approach might not suit a dynamic painting such as the study of striped leaves on the right.

A modern approach

This bold semi-abstract work is full of color and interest. It is well complemented by a plain, simple wooden frame and an off-white mat that allow this striking painting to make its statement unchallenged by superfluous decoration.

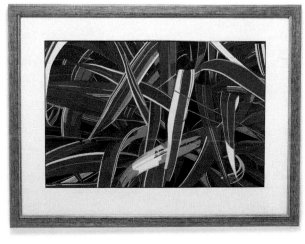

Double cream

This extravagantly wide wooden frame (*above*), combined with a cream mat, conveys a feeling of opulence despite its simplicity. The wood of the frame has a lustrous, pearly quality that harmonizes elegantly with the bone white driftwood seen in the painting itself.

231

GLOSSARY

ABSORBENCY The degree to which the paper absorbs the paint, often due to the degree of surface sizing.

ABSTRACTION To reduce or synthesize the visual reality of the subject by depicting only one or some elements of it in a way that may or may not bear a resemblance to the subject.

ACID-FREE PAPER Paper with a neutral pH that will not darken excessively with age.

ACRYLIC Synthetic resin used in an emulsion as the binding medium for artists' acrylic colors.

ACRYLIC GESSO An acrylic primer occasionally used to prepare watercolor paper when special effects are required.

ADDITIVE COLOR MIXING Color that is produced by mixing together different colored lights. It is known as additive because as each color is added, the resulting combination is more intense. The three primary colors of light are orange-red, green, and blue-violet. Orange-red light and blue-violet light produce Magenta (red) light. Green and blue-violet give Cyan (blue). Orange-red and green give yellow. When all three primary lights are mixed they produce white light.

ADJACENT COLORS Literally, those colors closest to each other on the color wheel, but also used to describe colors that lie next to each other in a painting. Adjacent complementary colors appear brighter as each reinforces the effect of the other.

ADJACENT HARMONY A harmony made up of a series of colors placed adjacent to one another, and often relied upon to give a composition a subtle color unity.

ADJACENT WASH A wash that is applied directly next to another wash.

ADVANCING COLOR The perception of a color, usually a warm (orange/red), as being close to the viewer.

AERIAL PERSPECTIVE This describes the effect of atmospheric conditions on our perception of the tone and color of distant objects. As objects recede toward the horizon they appear lighter in tone and more blue.

AFTER-IMAGE In painting, the visual effect that results from looking at a strong color, *i.e.,* perceiving the complementary color of the color we have just been looking at. If, for example, we look hard at an orange-red area and then look at a bright yellow, we might see the yellow as green because we are carrying a blue after-image of the orange-red. This effect is known as color irradiation.

ARTISTS' QUALITY WATERCOLOR PAINTS The best quality paints, with high pigment loading and strong colors.

ATMOSPHERE The atmosphere of a painting can be determined by a range of factors: the subject, the weather condition at the time of painting, the effects of light falling on the landscape, the technique, and use of color.

BIAS A color produced from two other colors will have a bias toward the color that has been used in the greater quantity, or the one with the greater tinting strength.

BINDER In a paint, this is the substance that holds the pigment particles together and which allows them to attach to the support. In the case of watercolor, the binder is water-soluble gum.

BLEEDING The tendency of some organic pigments to migrate through a superimposed layer of paint.

BLENDING A soft, gradual transition from one color or tone to another.

BLOCK IN Applying areas of color.

BODY COLOR Also called gouache, a type of paint or painting technique characterized by its opacity.

BROKEN COLOR An effect created by dragging a brush over heavily-textured paper so that the pigment sinks into the troughs and does not completely cover the raised tooth of the paper. A hair-dryer applied over the original wash heightens the broken effect.

BURNISHER Traditionally, a piece of polished stone such as agate has been used to burnish gold leaf and similar materials. In watercolor painting, a burnisher is used to smooth down the fibers of the paper when these have been raised by vigorous handling. Some artists use the back of a fingernail for this purpose.

CANNON A cylindrical container used to measure the hairs for brushes.

CHARCOAL Carbonized wood made by charring willow, vine, or other twigs in airtight containers. Charcoal is one of the oldest drawing materials.

CHROMA The intensity or saturation of a color.

CHROMATIC Drawn or painted in a range of colors.

CLAUDE GLASS *see* Reducing glass

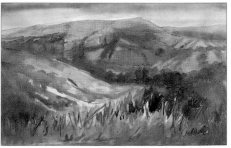

COCKLING The buckling of unstretched paper when wetted.

COLORED NEUTRAL A subtle, unsaturated color, produced by mixing a primary and a secondary in unequal amounts.

COLOR INFLUENCE Adjacent colors have an immediate affect on each other, so that they either enhance or reduce one another's appearance. Adjacent complementary colors appear brighter because each reinforces the effect of the other.

COLOR IRRADIATION The after-effect that results from looking at a very strong color in which you perceive its complementary color. *See also* After-image.

COLOR MIXING Combining two colors or more either in a palette or on the painting, to produce a third color. Different tinting strengths in colors make it very difficult to gauge the exact amounts needed of any two colors to create a specific color. Simple trial and error is often the best means of creating the precise colors needed to produce an effective composition.

COLOR TEMPERATURE A measurement of color in degrees Kelvin. This is of importance to photographers who need to correlate the color temperature of a light source with the type of film they use. As artists we are aware that the color temperature of a room illuminated by electric light is significantly different from (yellower than) that of daylight.

COLOR WHEEL A diagrammatic wheel, in which the colors red and violet at opposite ends of the spectrum are joined to form a full circle of color. Color wheels, or circles, take many forms, but at their simplest, show the three primary colors and the three secondary colors arranged in such a way that each color's complementary is shown opposite it.

COMPLEMENTARY COLORS Those colors of maximum contrast opposite each other on the color wheel. For example, the complementary color of a primary color is the mixture of the other two primaries, *i.e.,* green is the complementary of red because it is made up of yellow and blue, and purple is the complementary of yellow because it is made up of red and blue.

COMPOSITION The arrangement of subjects on the paper. Ideally, these are placed in a harmonious relationship with each other to create a strong sense of balance. In landscape painting perspective is a major part of composition.

CONTÉ CRAYON A proprietary drawing stick in varying degrees of hardness and in a range of black, white, and red earth colors.

COOL COLORS Generally, a color such as blue is considered cool. Distant colors appear more blue due to atmospheric effects and cool colors are therefore said to appear to recede.

CROSS-HATCHING Parallel marks overlaid roughly at right angles to another set of parallel marks.

DEXTRIN Starch made water-soluble by heating. It is used in watercolors as a cheap alternative binder to gum arabic.

DRY BRUSH TECHNIQUE A method of painting in which a paint of a dry or stiff consistency is dragged across the surface of the ridges of paper with a brush to create a broken color effect.

DURABILITY *see* Permanent colors

DURABILITY RATING *see* Lightfastness

EARTH COLORS These are naturally occurring iron oxide pigments *i.e.,* ochres, siennas, and umbers.

EASEL A frame for holding a painting while the artist works on it. Watercolor painters tend to use sketching easels which are of light construction. A good sketching easel allows the painting to be held securely in any position from vertical to horizontal.

ERASER A tool for removing pencil and other marks. In the past, artists used rolled bits of bread or feathers. More recently, artists have used standard rubber erasers, soft putty rubbers, or artgum erasers, although the new plastic erasers are extremely clean and versatile.

EXTENDERS Substances such as chalk or barium sulfate are often used in the manufacture of paint, especially when a particular pigment on its own is so strong that it may cause streakiness.

FELTING In paper manufacture, the process by which plant fibers mat together.

FERRULE The metal part of a brush which surrounds and retains the hairs.

FINDER A rectangular hole to the scale of the artist's paper cut in a small piece of cardboard to act as a framing device. This is held up at arm's length and the scene to be drawn or painted is viewed through it.

FIXATIVE A surface coating that prevents charcoal, chalk, and conté crayon from becoming dusty and from mixing with overlaid color.

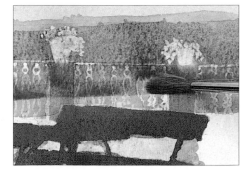

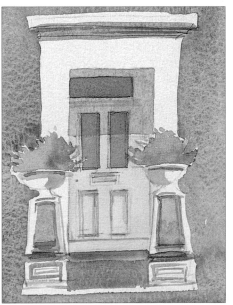

FLAT WASH An application of an even and uniform area of tone and color.

FLOCCULATION Like granulation in appearance, but the result of pigment particles coming together as a result of electrical charges rather than the coarseness of the pigment.

FLOTATION The streaky effect made by lighter pigments as they disperse unevenly on the paper.

FOCAL POINT In a painting, the main area of interest visually.

FUGITIVE Colors that are not lightfast and will fade over a period of time.

GLAZE Primarily an oil painting term, but used in watercolor to describe an overall wash in a single color. This has the effect of unifying the appearance of various colors in a painting.

GLYCERINE The syrupy ingredient of watercolor paints that is used as a humectant or moisture absorber in order to keep them moist.

GOUACHE A type of watercolor paint that is characterized by its opacity.

GOUACHE RESIST Using gouache paint or body color to protect areas of your paper or paint film from further applications of paint. The gouache is subsequently washed off.

GRADED WASH A wash in which the tones move smoothly from dark to light or from light to dark.

GRAIN The degree of texture on the surface of watercolor paper.

GRANULATION The mottled effect made by heavy coarse pigments as they settle into the hollows of the paper. It may be caused by flocculation *(sic)* or by differences in the specific gravity of the pigments.

GRAPHITE PENCIL Standard pencil leads are made from a mixture of graphite and clay. The mixture is fired and subsequently impregnated with molten wax. The proportion of graphite to clay varies and it is this that determines the hardness or softness of the pencil.

GRAPHITE STICK A large-scale pencil lead used for drawing.

GUM ARABIC Gum from the Acacia tree used as a binding material in the manufacture of watercolor paints. Kordofan gum arabic, which takes its name from the region in Sudan from which it comes, is the main type used nowadays.

GUM ARABIC RESIST Covering details of your painting with gum arabic solution to protect the paper or paint film from further applications of paint. The gum arabic is subsequently washed off. Alternatively, mixing gum arabic with paint allows you to lift the paint off more easily later.

"HARD" WATERCOLORS Blocks of straight pigment and gum mixes with no added plasticizer or humectant (such as honey or glycerine), which were used by early watercolor artists. The blocks had to be scrubbed to get the color out but once dry, it could be painted over with little danger of dissolving the paint film.

HATCHING Making tonal gradations by shading with thin parallel marks.

HEEL OF BRUSH The base of the hairs, near the ferrule.

HIGH-KEY COLOR Brilliant and saturated color.

HIGHLIGHT The lightest tone in drawing or painting. In transparent watercolor techniques on white paper, highlights are represented by the white of the paper. In opaque techniques, highlights are represented with opaque white gouache or body color.

HP OR HOT-PRESSED Paper with a very smooth surface.

HUE Description of a color such as red etc.

HUMECTANT Moisture-absorbing additive such as glycerine that is used in the manufacture of watercolors to keep them moist.

IMPASTO A thick application of paint.

INORGANIC PIGMENTS Pigments made from chemical compounds.

INTERNAL SIZING Means of reducing the natural absorbency of paper by adding size at the pulp stage. *See also* Sizing and Surface sizing.

LAID PAPER Paper in which you can detect a ladderlike, horizontal and vertical pattern due to the pattern of the wire mold on which it was made.

LAKE PIGMENTS The pigment produced when a dye is chemically fixed onto an inert base.

LANDSCAPE FORMAT A term used to describe a painting when the width of the composition is longer than the height.

LATEX *see* Masking fluid

LAYING IN The initial painting stage when colors are applied as broad areas of flat color, also known as blocking in.

LIFTING OUT The technique that is used to modify color and create highlights by taking color off the paper using either a brush or sponge.

LIGHTFASTNESS Permanence (or durability) of a color measured by the

Blue Wool Scale in Britain in which the most permanent colors rate 7 or 8 and ASTM (American Standard Test Measure) in the United States in which the most permanent colors rate 1 or 2.

LOCAL COLOR The intrinsic color of an object as seen in an even and diffused light.

LOW-KEY COLOR Muted or unsaturated color. *See also* High-key Color.

LUMINOUS GRAYS Pure grays created by mixing unequal amounts of two complementary colors.

MASKING FLUID A solution of latex in ammonia used for masking out particular areas in a painting. It is available in white or pale yellow; when using white paper it is easier to see where the pale yellow has been painted on although there is a very slight risk that the colored masking fluid will stain the paper.

MASKING OUT The technique of using masking fluid or other materials to protect areas of the watercolor paper while adding washes. With masking fluid, the solution is allowed to dry, paint is applied over it and once that has dried, the masking fluid is gently peeled off.

MONOCHROMATIC Drawn or painted in shades of one color.

MONOFILAMENTS Individual strands of manmade fiber.

MOLD-MADE PAPER The most common form of high quality watercolor paper is made on a cylinder mold machine. The more random arrangement of the fibers in this process as compared to that on commercial machine-made paper gives far greater strength to the paper.

NEGATIVE SHAPES The shape of an object created without directly painting the object itself, so that the colors surrounding the space actually become the outline of the negative shape.

NEUTRAL COLOR Colors created by mixing equal amounts of complementary colors, which then cancel each other out to produce dull, neutral color.

NICKEL TITANATE A modern inorganic yellow pigment of great permanence.

NOT OR COLD-PRESSED Paper with a fine grain or semi-rough surface.

OAK APPLES Oak apples or galls are formed by parasitic insects living off oak trees and tend to appear in the fall. Dense black ink is made by crushing and boiling oak apples.

OPTICAL MIX Color achieved by the visual effect of overlaying or abutting (placing next to each other) distinct colors rather than by mixing them in a palette.

ORGANIC PIGMENTS Pigments made from natural living compounds.

ORIENTAL PAPER Highly absorbent, hand-made paper that has no internal or surface sizing. Some Japanese papers can weigh as little as 12gsm.

OVERLAYING WASHES The technique of painting one wash over another in order to build up a depth of color or tone.

OXGALL A wetting agent that helps the paint to flow more easily on the paper.

PALETTE A shallow container usually made of porcelain or plastic with separate wells for mixing colors.

PERMANENT COLORS Pigments that are lightfast and will not fade over time.

PERSPECTIVE The method of representing three dimensions on a two-dimensional surface. Linear perspective makes objects appear smaller as they

get farther away by means of a geometric system of measurement. Aerial perspective creates a sense of depth by using cooler, paler colors in the distance and warmer, brighter colors in the foreground.

PHTHALOCYANINE Modern organic transparent blue and green (chlorinated copper phthalocyanine) pigments of high tinting strengths and excellent lightfastness. Also known by trade names.

PHYSICAL MIX When a color is arrived at by mixing together several colors on the palette before applying it to the paper.

PIGMENT Solid colored material in the form of discrete particles that forms the basic component of all types of paint.

POOL Intense color that may accumulate on the brush at the end of a wide brushstroke. Usually unwanted.

PRESERVATIVE Substance added to painting materials to act as a fungicide and bacteriacide. This is particularly important in watercolor as watercolor paints are prone to micro-biological growth.

PRIMARY COLORS The three colors, red, blue, and yellow, which cannot be produced by mixing other colors and which, in different combinations, form the basis of all the other colors.

QUINACRIDONE A modern organic transparent red pigment with very good lightfastness.

RECEDING COLOR The perception of a color, usually a cool (blue) one, as being distant from the viewer.

RECESSION The optical illusion of aerial perspective is that the distance recedes into pale hues. This tonal recession is achieved through the use of color tones.

REDUCING GLASS A drawing aid popular in the 18th and 19th centuries. It consisted of a small tinted convex mirror that reflected a reduced and largely monochromatic image of the landscape.

RESIST A method of preventing the paint from coming into contact with the paper or the layer of paint film by interposing a protective coating. Used to preserve

highlights, for example, or to retain a particular color.

ROUGH PAPER Heavily-textured paper, also known as cold-pressed paper.

SABLE Mink tail hair used to make fine watercolor brushes.

SATURATION The degree of intensity of a color. Colors can be saturated, *i.e.,* vivid and of intense hue, or unsaturated (sometimes known as desaturated), *i.e.,* dull, tending toward gray.

SCRATCHING OUT Similar to sgraffito *(sic),* the process of scratching the surface of the paint (wet or dry) to reveal the paint film or paper that lies below. Can be done with a blade or, in wet paint, with the handle of the brush.

SCUMBLING Opaque paint dragged over another layer of paint so that the first layer shows through in patches. In watercolor this is often done with a coarse hair brush, which is slow to absorb moisture.

SECONDARY COLORS Green, orange, and purple, the colors arrived at by mixing two primaries and which lie between them on the color wheel.

SGRAFFITO A technique, usually involving a scalpel or sharp knife, in which dried paint is scraped off the painted surface. Often used for textural effects.

SHADE A color mixed with black.

SHADING Usually refers to the way areas of shadow are represented in a drawing and is invariably linked with tone.

SIZING The coating, either internal or external, of paper. Prepared size usually contains a mixture of gelatine, water, and a preservative. The sizing affects the hardness and absorbency of the paper and consequently the way in which the paint will react on it.

SIZING, NEUTRAL A modern size with a neutral pH that replaces the earlier more acidic sizing materials.

SPATTERING A technique that involves flicking paint off the hairs of a bristle brush or a toothbrush with your nail to create an irregular pattern of paint.

SPECTRUM Light passed through a prism will divide into the colors that are shown on a color wheel. This color spectrum is the basis of all color theory. However, it is based on human observation, and current research suggests that light contains many more colors than can be detected by the human eye.

SPONGING OUT The technique of soaking up paint with a sponge or paper towel so that areas of pigment are lightened or removed from the paper. The technique can be used to rectify mistakes or to create particular effects.

SQUARING UP A grid system used to transfer a sketch or other image accurately to the painting surface. A square grid is superimposed onto the sketch and replicated on the painting surface – often to a larger scale. Complicated areas can be given a more detailed grid. The image is then copied square by square from the original image on to the painting surface.

STAINING POWER The degree to which a pigment stains the paper and resists being washed off or scrubbed out. *See also* Tinting Strength.

STENCIL Cut-out image in card or other material through which paint can be sponged or sprayed.

STIPPLING A method of painting involving the application of tiny dots of color with the tip of the brush.

STRETCHING PAPER The process by which watercolor paper is stretched to prevent it from buckling when paint is applied. The paper is wetted by sponging or dipping briefly in water, it is then attached to a board with gum strip and allowed to dry.

SUBTRACTIVE COLOR MIXING Color mixing with pigments. It is known as subtractive because as more colors are added, the mixture reflects less light and so appears darker. The subtractive pigment primaries are red, yellow, and blue. The physical mixture of all three in equal quantities appears gray.

SURFACE The texture of the paper. In Western papers – as opposed to Oriental – the three standard grades of surface are Rough, Hot-pressed (smooth), and NOT or Cold-pressed (semi-rough).

SURFACE SIZING A means of decreasing the absorbency of a painting surface. Commercially available artists' quality watercolor paints are invariably surface-sized in warm gelatine to allow the paper to withstand vigorous treatment.

TERTIARY COLORS Colors that contain all three primaries.

TINT Color mixed with white. In the case of watercolor, a similar effect is achieved by thinning the paint with water and allowing more of the white surface of the paper to reflect through it.

TINTED PAPER Paper with a slight color. Oatmeal, pale blue, or gray are popular for watercolor.

TINTING STRENGTH The strength of a particular color or pigment.

TOE OF BRUSH The tip of the hairs.

TONE The degree of darkness or lightness of a color. Crumpling a piece of white paper allows you to see a range of tonal contrast.

TRANSPARENT PAINTING Using traditional transparent watercolors and

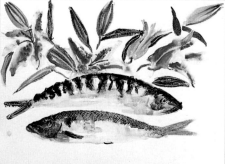

relying for effect on the whiteness of the ground or on the various tones of underpainting.

UNDERPAINTING Preliminary paint layer or wash over which other colors are applied.

UNSATURATED COLOR Sometimes known as desaturated color. A pure, saturated color becomes unsaturated when mixed with another color into a tint or a shade. When three colors are mixed together in unequal amounts, the resultant color can be called a colored neutral.

VARIEGATED WASH A wash in which different colors have been applied in such a way that they run into each other.

VIEWFINDER A cardboard rectangle held to the eye to isolate and frame sections of the scene in front of you.

WARM COLOR Generally, a color such as orange-red is considered warm. In accordance with atmospheric or aerial perspective, warm colors appear to advance toward the viewer whereas cool colors appear to recede.

WASH A layer of color, generally uniform in tone, applied evenly across the paper with a large round or flat wash brush.

WASHING OFF The process of dislodging an area of paint, possibly with a bristle brush dipped in water, or a damp sponge.

WATERLEAF A paper with no internal sizing, and which is consequently highly absorbent.

WAX RESIST The process by which wax crayons or a sliver of a candle are used to protect areas of your paper or paint film from further applications of paint.

WEIGHT Watercolor paper is measured in lbs (pounds per ream) or gsm (grams per square metre). It comes in a large range of weights although the standard machine-made ones are 90lb (190gsm), 140lb (300gsm), 260lb (356gsm) and 300lb (638gsm). The heavier papers, 260lb and over, generally do not need stretching before use.

WET-IN-WET Working with wet paint into wet paint on the surface of the paper.

WET ON DRY Applying a layer of wet paint on to a dry surface.

WOOD-FREE PAPER Good quality paper made from purified, acid-free wood pulp that does not become brittle or yellow with age.

WOVE PAPER Paper in which you can detect the pattern of the wire mold on which it was made, giving it its characteristic woven appearance.

A NOTE ON COLORS, PIGMENTS AND TOXICITY

In recommending Winsor Blue and Winsor Green (which are trade names of the Winsor & Newton Company) we are recommending "phthalocyanine" pigments; other artists' material manufacturers refer to them by their own trade names. These include Phthalo Blue and Green, Monestial Blue and Green and so on. Similarly, in recommending Permanent Rose we are recommending a "quinacridone" pigment. Lemon Yellow Hue, another of our recommended pigments, is also known as Nickel Titanate Yellow. If you have any doubts about which pigment you are buying, refer to the manufacturer's literature.

We have tried to avoid recommending pigments, such as the Chrome colors, which carry a significant health risk. In the case of colors such as the Cadmiums, however, there is nothing commercially available which matches them for color and permanence. But there is no danger in their use nor in that of other pigments provided artists take sensible precautions and avoid licking brushes with paint on them.

A NOTE ON BRUSHES

The brush sizes given here refer to Winsor & Newton brushes. They may vary slightly from those of other manufacturers.

A NOTE ON PAPERS

The surfaces of papers – Rough, Hot-pressed and NOT (semi-rough), vary noticeably from one manufacturer to another so it is worth looking at several before deciding which to buy.

*I*NDEX

ACKNOWLEDGMENTS

Author's acknowlegments

Ray Smith would like to thank Alun Foster and Richard Goodban of Winsor & Newton Ltd, for their expert advice and Jane Gifford for her lovely fresh paintings. Many thanks also to the team at Dorling Kindersley, including Jane Laing, Sean Moore, Tina Vaughan, Gwen Edmonds, and Toni Kay, and in particular to my editor, Emma Foa, for her patience and skill in managing to get a quart into a pint pot, and to Claire Legemah for her lively and beguiling approach to the design. Thanks also to Nigel Partridge for his design help and to Maria D'Orsi for design assistance.

Elizabeth Jane Lloyd would like to thank Mary Fedden, RA, for casting a critical eye over the book; the Royal Academy for its valuable assistance; Emma Pearce at Winsor & Newton Ltd. for her expert advice; and the many artists who agreed to allow their fine paintings to enrich the book. Special thanks go to everyone at Dorling Kindersley, but particularly to my creative and understanding editor, Jane Mason; to Emma Foa, for setting up the project; to Stefan Morris, for his dedication to the graphic design of the book; to Margaret Chang, for her editorial assistance and research; and to all the DK photographers for their cheerful support.

Publisher's acknowledgments

Dorling Kindersley would like to thank: Art for Sale, London; Blue Jay Frames, Possingworth Craft Workshops, Blackboys, East Sussex for its excellent craftmanship; Putnams Paper Suppliers, London for supplying samples; and the Royal Watercolour Society for advice and support. And heartfelt thanks go to our author Elizabeth Jane Lloyd for taking all of us into the fourth dimension of seeing. Thanks also to Alun Foster and Emma Pearce at Winsor and Newton Ltd for helping with queries, to Sharon Finmark for her hard work and long discussions, to Margaret Chang for her editorial assistance, and to Maria D'Orsi for design assistance. Watercolour Colour text researched and written by Susannah Steel.

For *The Complete Guide to Watercolour* Dorling Kindersley would like to thank Caroline Hunt, Julian Gray, and Jane Sarluis for editorial assistance, Martin Dièguez for design assistance, and Richard Bird for indexing.

PICTURE CREDITS